LONDON
UNCOVERED

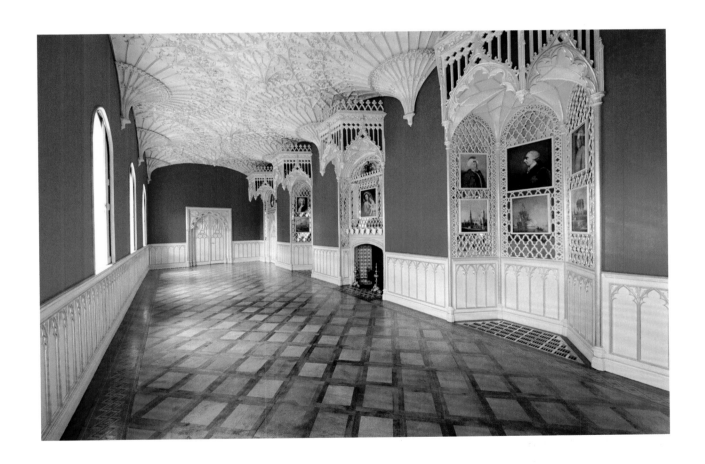

PHOTOGRAPHS BY **PETER DAZELEY**

LONDON
UNCOVERED

TEXT BY **MARK DALY**

F

FRANCES
LINCOLN

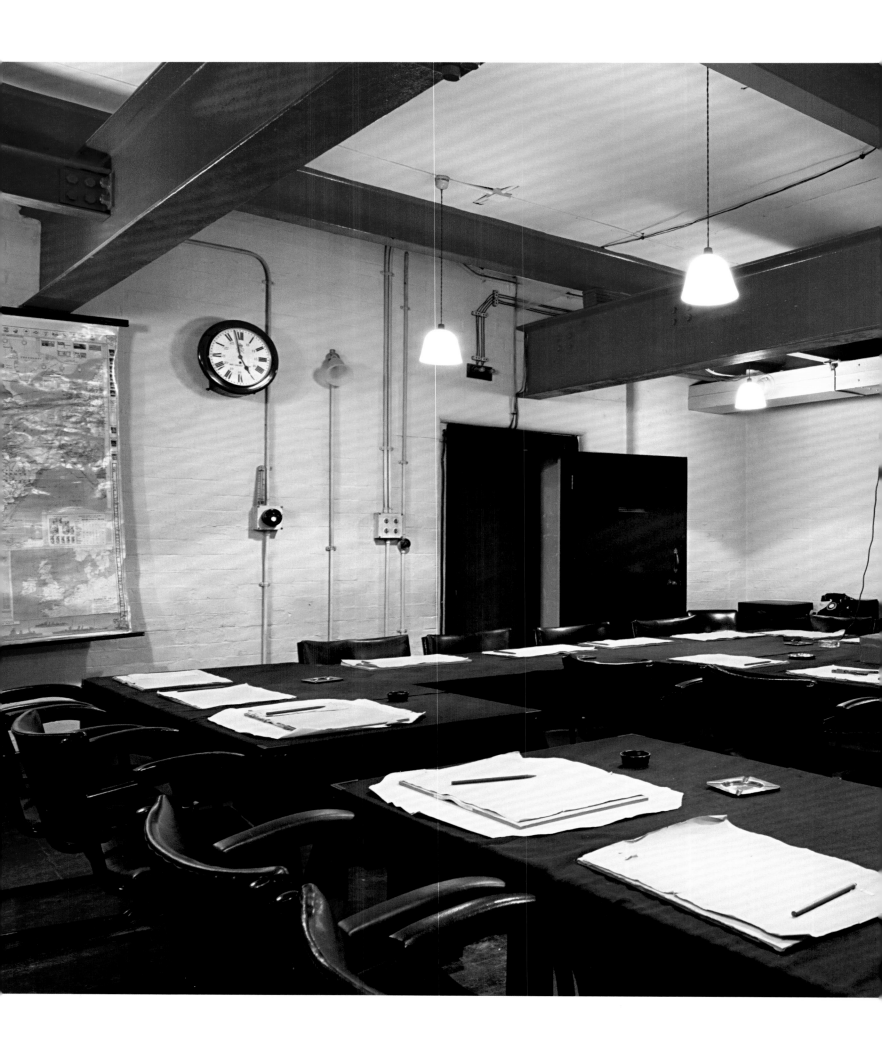

Contents

INTRODUCTION 6

HISTORICAL HOMES 12
*Syon House • Charles Dickens Museum • Apsley House •
Eltham Palace • Leighton House Museum • Strawberry Hill House •
Two Temple Place • Kew Palace and the Royal Botanical Gardens*

FOOD AND DRINK 56
*Ye Olde Cheshire Cheese • Bibendum • L. Manze • Smithfield
Meat Market • The Ivy • The Blackfriar • Berry Bros & Rudd*

PALACES OF ENTERTAINMENT 86
*The Rivoli Ballroom • Wilton's Music Hall • All England Lawn
Tennis and Croquet Club • Regent Street Cinema • The Gate Cinema •
The National Theatre • Normansfield Theatre • Wigmore Hall •
Gala Bingo Club*

PLACES OF WORSHIP 124
*Westminster Cathedral • Welsh Church of Central London •
London Peace Pagoda • Masonic Temple at Andaz Liverpool
Street Hotel • St Bartholomew the Great • Bevis Marks Synagogue •
St Mary-le-Bow • Shri Sanatan Hindu Mandir*

REMARKABLE SHOPS 160
*LASSCO, Brunswick House • L. Cornelissen & Son • Truefitt & Hill
• Steinway & Sons • James Smith & Sons • John Lobb Ltd • The Roof
Gardens in Kensington*

SCIENCE AND EDUCATION 192
*Kempton Steam Museum • Markfield Beam Engine Museum •
Alexander Fleming Laboratory Museum • The Charterhouse •
Old Operating Theatre and Herb Garret • Ragged School Museum •
London Museum of Water & Steam • Royal Institution of Great Britain*

THE INNS OF COURT 230
*The Honourable Society of Lincoln's Inn • The Honourable Society
of Gray's Inn • The Honourable Society of the Middle Temple •
The Honourable Society of the Inner Temple • Temple Church*

UNUSUAL MUSEUMS 256
*Royal Air Force Museum • Horniman Museum • Churchill War
Rooms • Geffrye Museum • HMS Belfast • Massey Shaw •
Monument • Musical Museum • Wimbledon Windmill*

PHOTOGRAPHER'S NOTE 301

INDEX 302

The Cabinet Room, Churchill War Rooms.

Introduction

The sixty-or-so sets of images in this book are collected together under the title *London Uncovered*. They are places brought to life by the creative eye and searching mind of Peter Dazeley, celebrated photographer and lifetime Londoner. 'Uncovered' does not mean the disclosure of a private place, because these buildings and sites are all available to visit without special insider access. The common thread throughout is largely the photographer's ability to uncover a fresh perspective on a special piece of London. The subjects are eclectic, encompassing buildings, monuments in plain sight and walks, with some places famous and others obscure.

Two of the museums pictured are free to enter; the others have entrance charges, as do the historical homes. At the two pubs described here it is customary to buy a drink. Theatre visits will generally require tickets, although some of them offer pre-planned organised tours when performances are not running. Similarly, it is possible to see more areas of the Inns of Court by making an enquiry and pre-booking. It should not be difficult to see inside the places of worship photographed here, while respecting of times and days of worship and observing the protocols required of visitors.

Typical of the locations that possess a grand public profile but whose interiors are rarely explored is the St Pancras Renaissance Hotel. Its Grand Staircase is the centrepiece of a Victorian building brought back from the brink. Originally known as the Midland Grand Hotel, it was a wonder of the late Victorian age when it opened in 1873. Sir Giles Gilbert Scott, designer of the Albert Memorial, was the architect, and his design incorporated hydraulic lifts, speaking tubes, electric call bells, dust chutes and fireproof concrete floors.

The Grand Staircase of the St Pancras Renaissance Hotel, restored according to the scheme of 1901. Figures representing the virtues Industry and Temperance flank the arms of the Midland Railway.

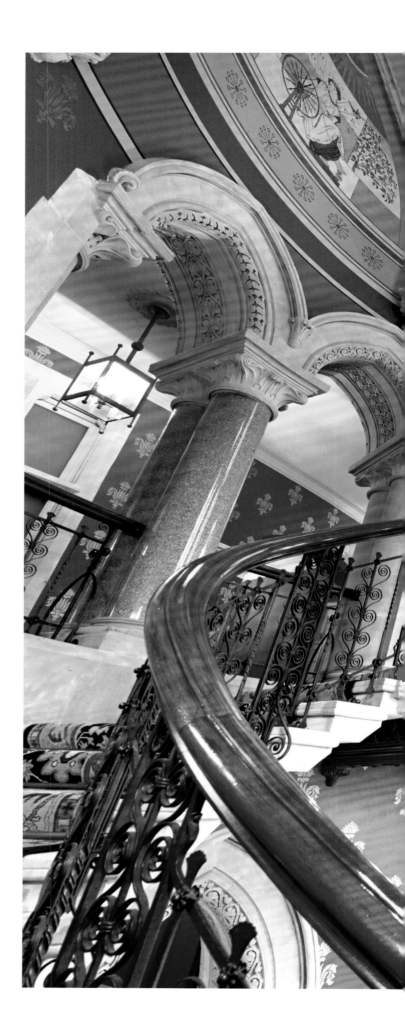

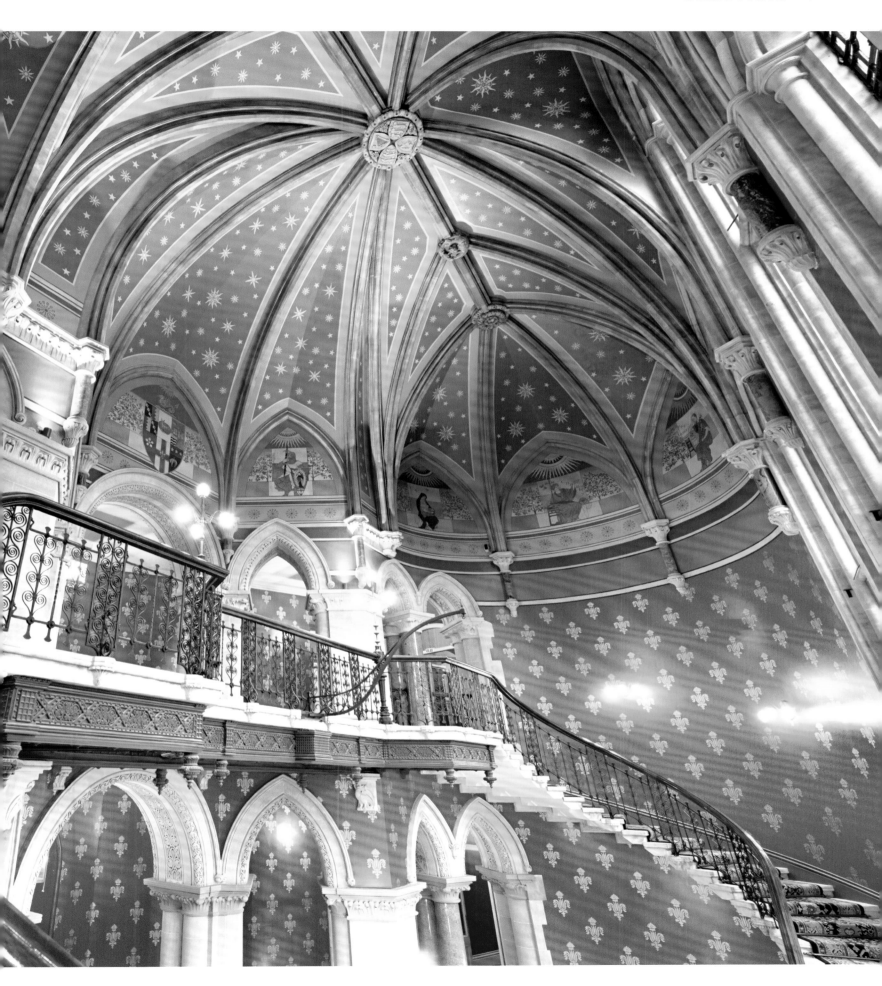

The Midland Grand prospered through the Edwardian age but fell into decline after the First World War. As modern hotel standards improved during the 1920s, one of its main weaknesses – the lack of bathrooms – became more apparent. Few of the 250 bedrooms, heated by coal fires, had attached bathrooms, and public taste was generally turning against Victorian style. In 1933 the Chairman of the LMS Sir Josiah Stamp told architects that the building, while magnificent, 'was completely obsolete and hopeless'. It closed as a hotel two years later. Afterwards known as St Pancras Chambers, it lingered in a long eclipse as offices for the LMS and its successor British Railways.

In the 1960s St Pancras Station lost some of its long-distance services and there were plans and proposals to close both the station and St Pancras Chambers. A rediscovery and growing regard for Victorian architecture in Britain, and a preservation campaign, won Grade I listing status for both the station and the hotel. British Rail finally moved out in 1985, but subsequently, with English Heritage, it restored the exterior and made the structure weatherproof. Except for visits by special groups, and use as a filming location, the building was empty through the 1990s.

The decision to make St Pancras the destination for international trains unlocked the future of the hotel building. The massively rebuilt St Pancras International started to receive Eurostar trains in 2007, and the restored St Pancras Renaissance opened in March 2011.

The St Pancras Renaissance Hotel is typical of London's monuments, undergoing many transformations and renewals. Perhaps the most dramatic example of this is Cleopatra's Needle on the Victoria Embankment. This ancient obelisk stands high beside a road which did not exist until 1869. It defies the classic layer-by-layer history of London, where the deeper you dig, the older you find.

Even the name Cleopatra is misleading. Guidebooks give it little ink, and traffic flowing along the Embankment makes it a noisy place. Yet the obelisk is breathtakingly ancient, older than any of London's fixed outdoor relics, such as the remaining sections of Roman wall, built in AD 200. It predates this by 1,600 years, being one of a pair erected in Heliopolis on the instructions of Pharaoh Thutmose II.

At some time after Egypt became a Roman province, the obelisks were shipped to Alexandria and re-erected at the Caesareum temple, built for Cleopatra, which is the closest justification that can be made for its future name. By then, the columns had travelled almost 750 miles from the place they were quarried. At some later time, the obelisks toppled, long after all understanding of Egypt's hieroglyphic forms was lost. When the fallen obelisks were eyed with interest by British army officers in Egypt after battles against the French in 1801, a subscription was raised to pay for transferring one of the pillars to Britain. After decades of negotiations and failed attempts, it was finally shipped to Britain at great expense in 1877.

The 186-tonne Cleopatra's needle is undeniably a moveable object, and for this reason London antiquarians seem to pay it little attention, but a visitor with imagination can examine the plaques around its base and marvel a little how an artefact with a timeline longer than that of the Parthenon came to embellish a Victorian civic works project.

A visit to Isabella Plantation, another fascinating yet underappreciated outdoor location, requires more careful timing. Approaching this fenced enclave, a visitor might

This highly decorated first-floor curved corridor has been restored to retain the Victorian character.

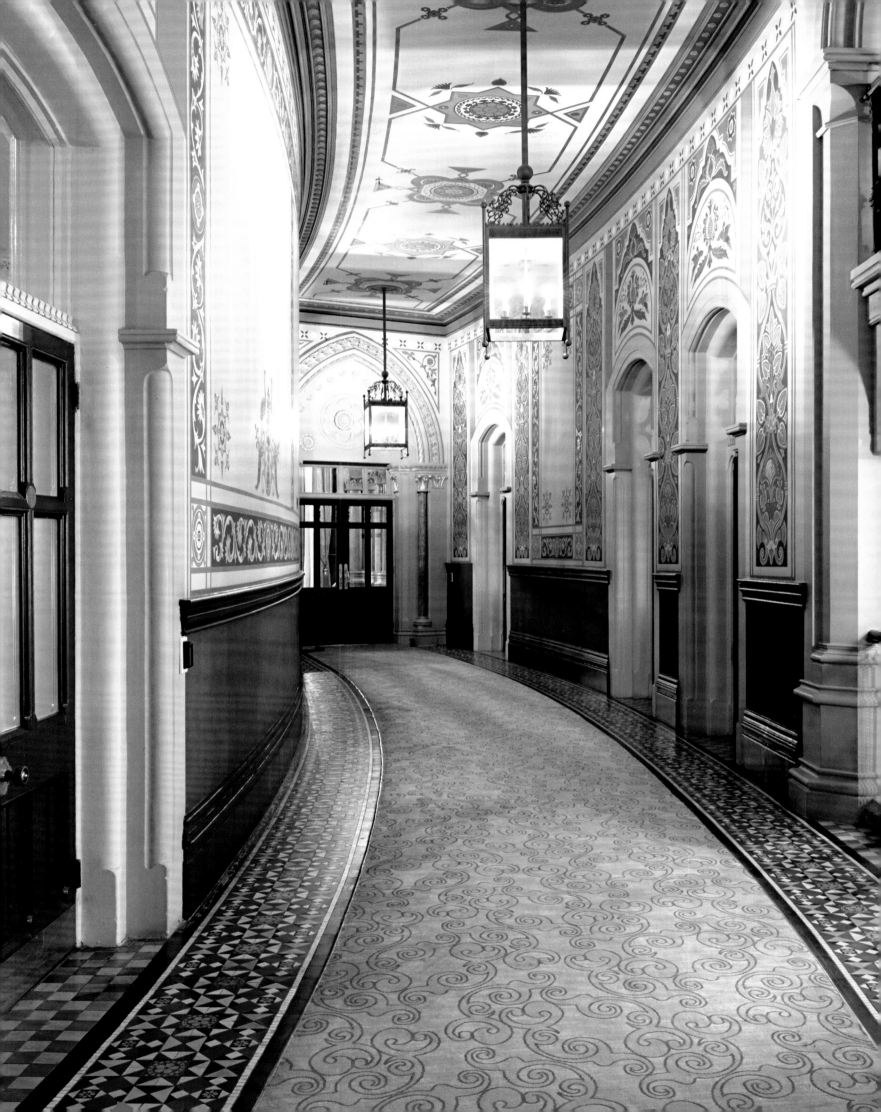

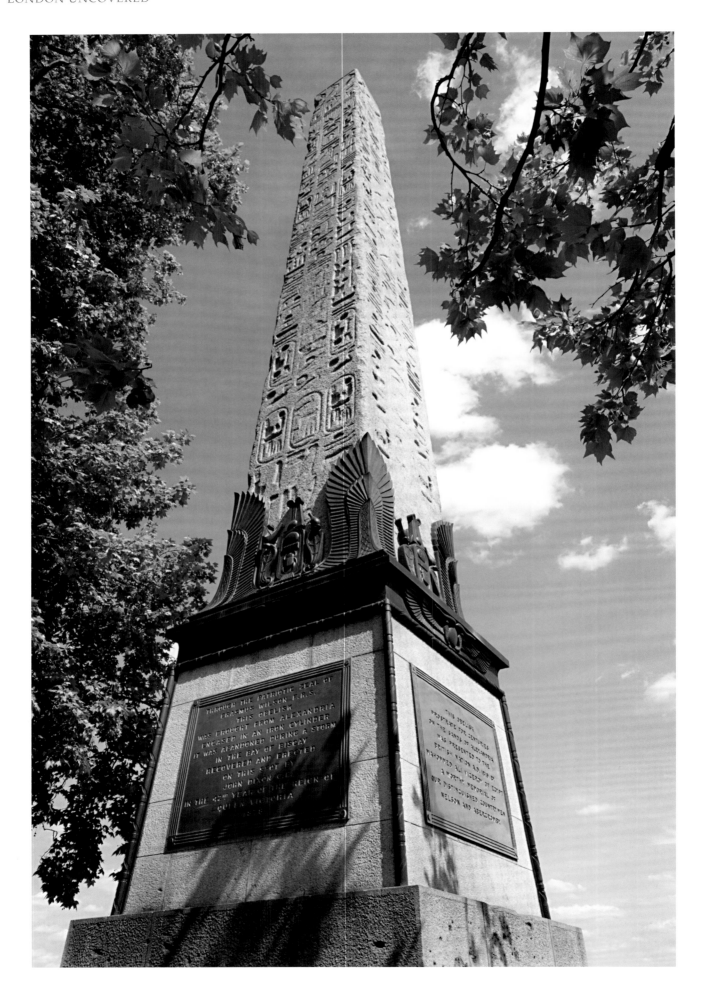

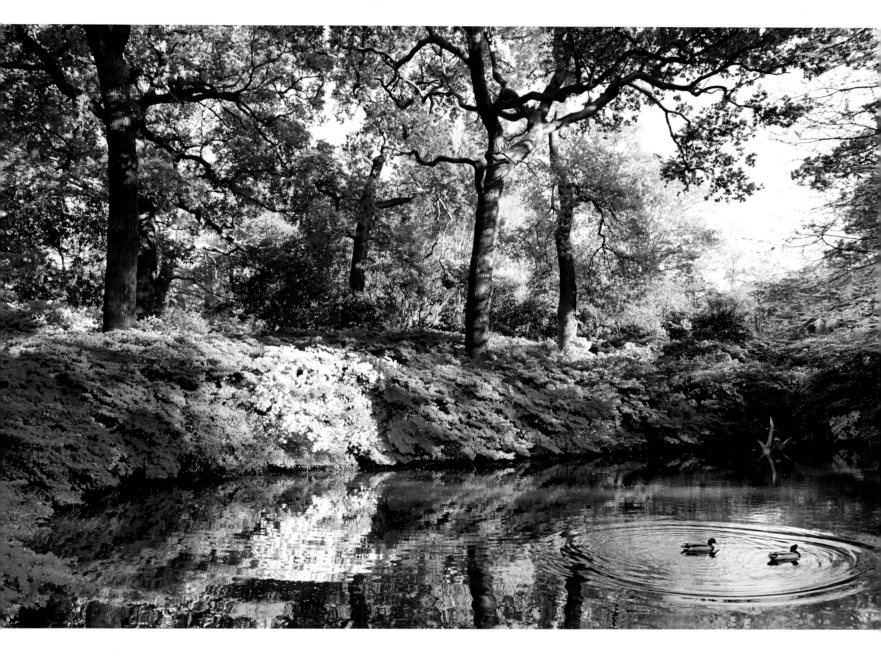

OPPOSITE *Four panels around the plinth of Cleopatra's Needle outline its remarkable history.*

ABOVE *May is the month to see Isabella Plantation's astonishing collection of azaleas.*

form the impression that it is not a public place at all, but it is open from dawn to dusk around the year. It lies completely encircled within Richmond Park, which is itself the biggest enclosed space in London, and is the largest of the eight Royal Parks. The plantation has the feeling of being a secret wooded valley, peaceful and secluded even as airliners bound for Heathrow pass slowly overhead. It can claim to be the most colourful place in London, and late April or early May are best the times to see the display of flowers; the photograph here was taken during the month of May. For the enthusiast, the National Collection of azaleas – introduced to Europe from Japan by plant hunter

Ernest Wilson – is a special attraction. There are ancient oak pollards, 400 years old, predating the 1637 parkland enclosure. Wildlife abounds.

One of the best opportunities to see a concentration of the most interesting places in the capital is the Open House London Festival which is held during September. Open House London is an organisation active since 1992 to promote appreciation of the London's architecture. Some of the places in *London Uncovered*, and in the previous Dazeley collection *Unseen London*, along with hundreds of other buildings, are opened to the public. Visit www.openhouselondon.org.uk.

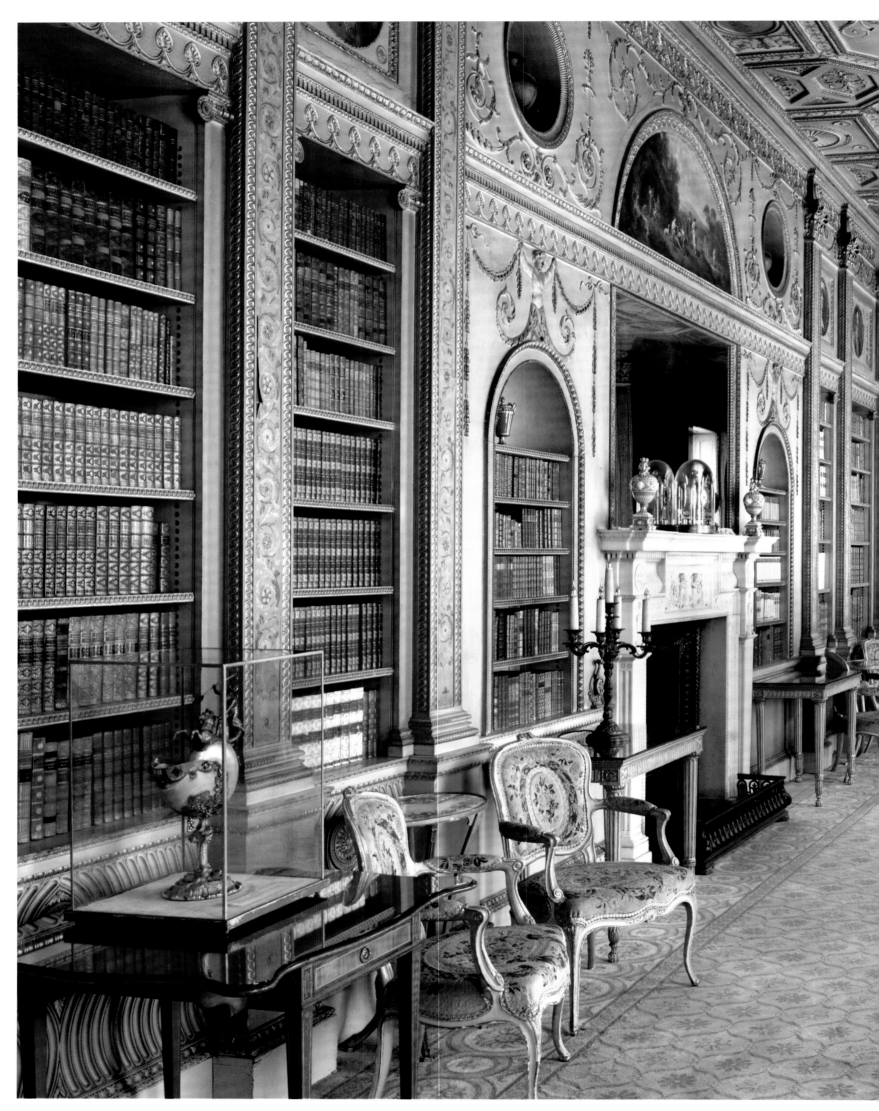

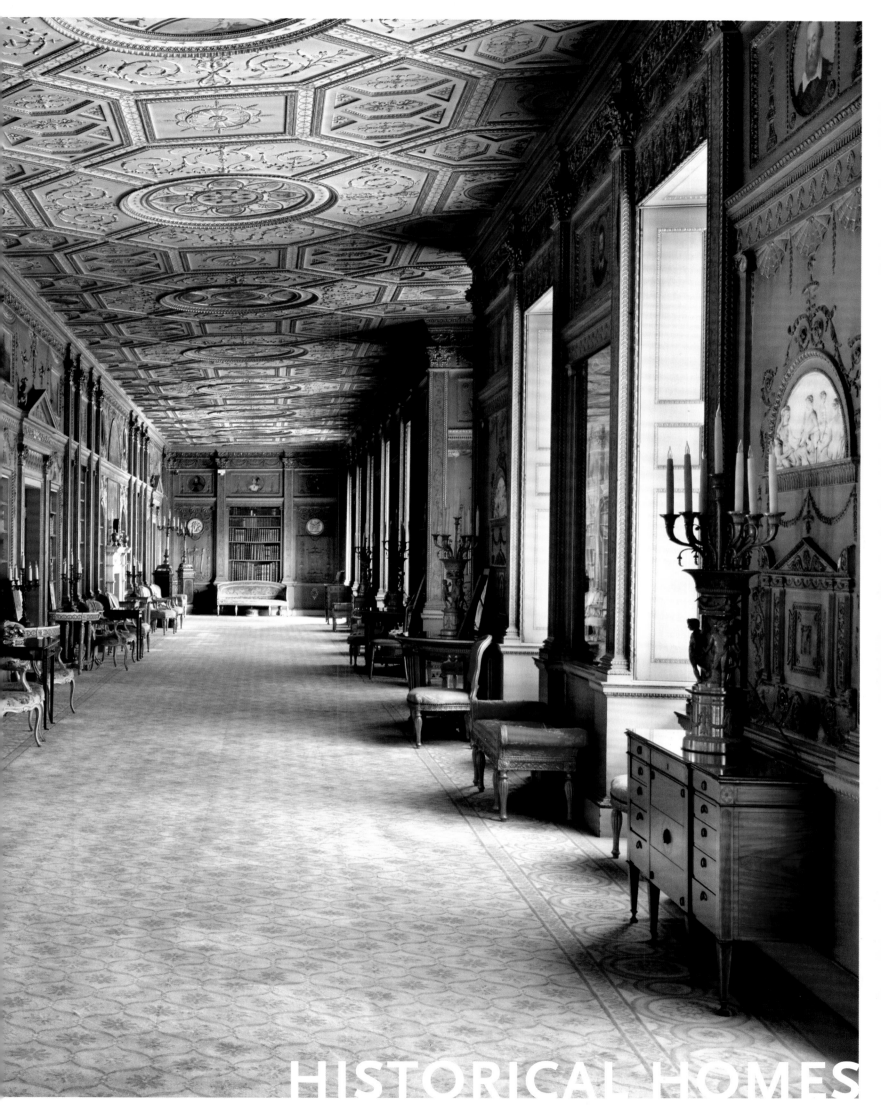

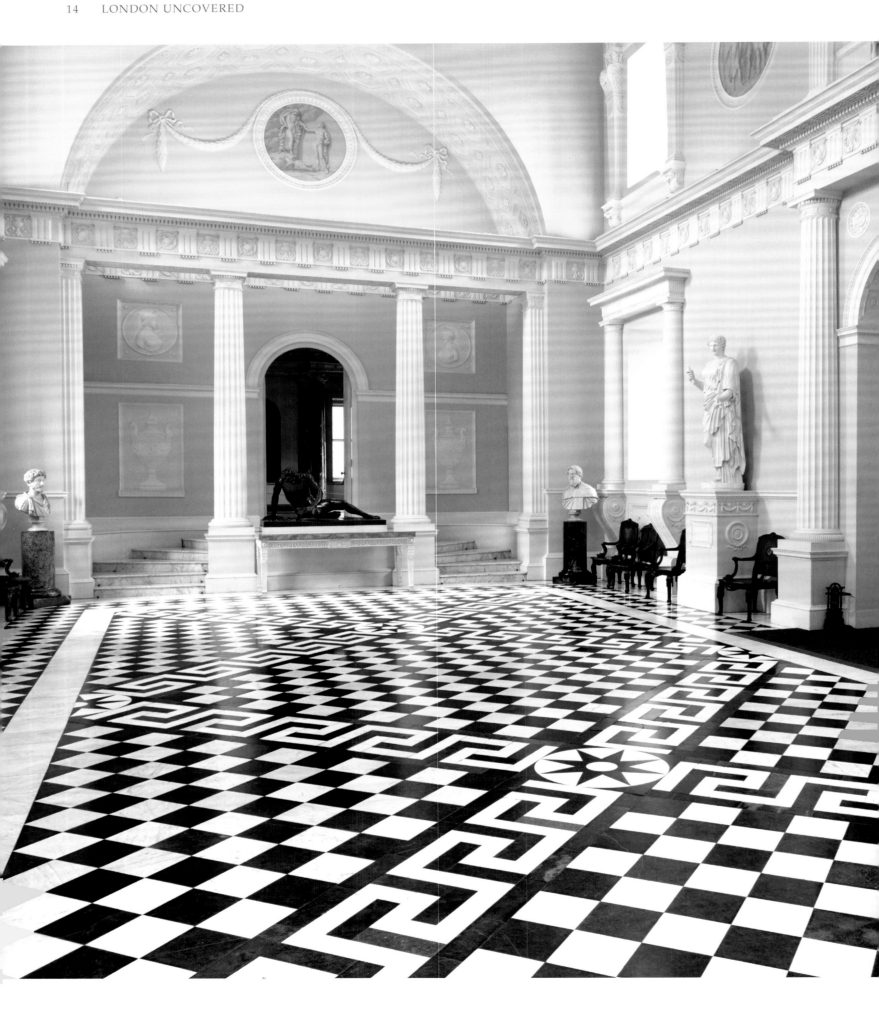

Syon House

Syon House, which belongs to the Duke of Northumberland, is famous for a series of beautiful and civilised rooms, and also as a focus of turbulent and violent events in British history.

Scottish architect and designer Robert Adam was commissioned to create a series of neo-classical interiors at Syon House in 1762. Filled with statues and artefacts shipped from Italy, it was one of the architect-designer's first commissions and defined a style for new grand houses being built for the remainder of the century.

At Syon House, Adam was required to rework a Tudor mansion building which had existed since 1550, with dated and worn interiors, set in unfashionable formal landscape. He was not permitted to change the interior layout, but applied neo-classical decoration and clever design techniques to modernise and vary the sense of proportion of the rooms.

The Great Hall was made to suggest a Roman basilica with Doric columns, black-and-white marble flooring, and statues and busts, including Socrates and Claudius. The room leads to an inner courtyard garden in Italianate style. The Ante Room to the Great Hall forms a colourful contrast and houses further Roman statues and gilded trophy panels inspired by the Villa Madama in Rome.

The State Dining Room has Corinthian columns, decorated in white and gold, and the room's walls have something of a rose hue. The Red Drawing Room, an antechamber to the Long Gallery, has scarlet wall hangings of Spitalfields silk, set off by a red carpet patterned with a honeysuckle design; artworks include Sir Peter Lely's portrait of Charles I, reputedly painted at Syon.

PREVIOUS PAGE *Roundels of the Percy family run the length of the Long Gallery, with portraits of dukes and duchesses on one side, and the Earls of Northumberland on the other.*
LEFT *The Great Hall is modelled on a Roman basilica, adorned with classical statuary, including a replica of the third-century sculpture* The Dying Gaul *in black marble.*

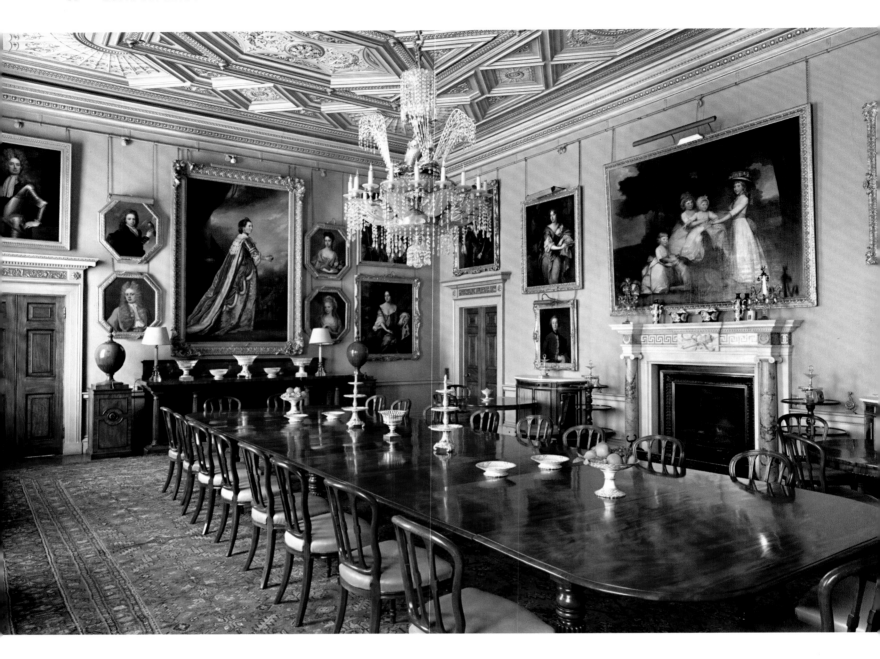

The Duke's Private Dining Room.

In the Long Gallery, Adam replaced the former heavily wood-panelled Tudor space with a design featuring sixty-two Corinthian pilasters, gilded and painted, along with classical trailing stucco mouldings. Roundels of the Percy family run the length of the room, with portraits of dukes and duchesses on one side, and the Earls of Northumberland on the other. The gallery also has two hidden turret rooms, or closets, at either end, one of which is decorated with colourfully painted stucco and complete with a mechanical singing-bird timepiece.

Syon Park's 200 acres of parkland were reworked by Lancelot 'Capability' Brown to include what is known as a serene pleasure garden, containing a long ornamental lake. A large Conservatory, with a total frontage of 230 feet and a glass dome 125 feet wide, was designed and housed the 3rd Duke of Northumberland's exotic flowers, becoming an inspiration for London's Crystal Palace.

The earlier history of Syon was turbulent and violent, mostly in connection with King Henry VIII. Syon Abbey had first existed at this place, and closed during the Dissolution when its spiritual advisor Richard Reynolds was hanged, drawn and quartered for denying the royal supremacy of the King. Henry VIII's fifth wife Catherine Howard was imprisoned at Syon before her execution. Syon was to come into the possession of Edward Seymour, Duke of Somerset, whose sister Jane had been Henry VIII's third

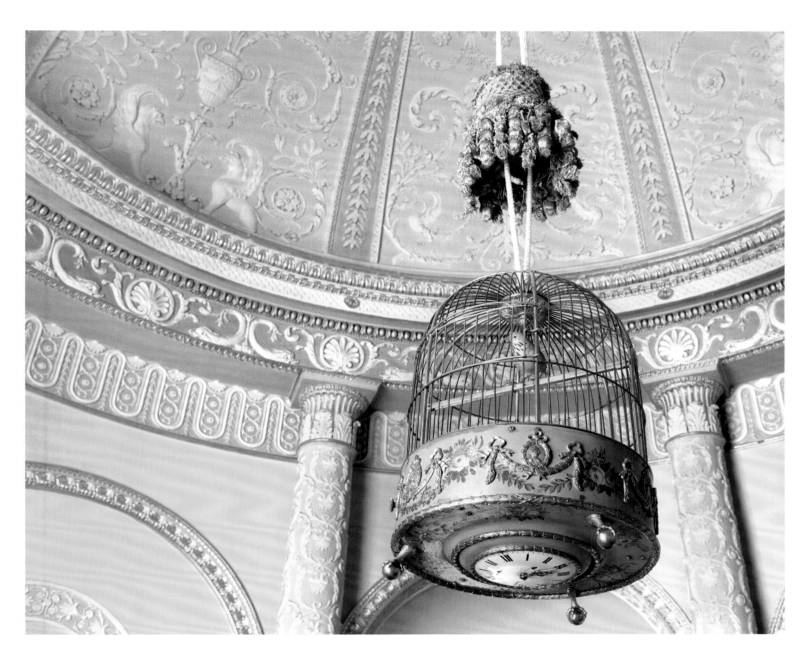

The Round Closet, adorned with a mechanical singing bird. OVERLEAF *Syon House's Conservatory was built for the Duke of Northumberland's rare tropical plant collection.*

queen. Seymour had the house rebuilt around elements of the abbey before his own execution in 1552; Syon passed to John Dudley, 1st Duke of Northumberland, whose son Guildford married the Nine Day Queen, Lady Jane Grey. Nominated as successor by the dying Edward VI, she was cajoled into accepting the Crown by the 1st Duke in Syon's Long Gallery. Shortly after this, she walked to the scaffold, followed by her husband and father-in-law. Syon was acquired by Henry Percy, 9th Earl of Northumberland, in 1594, and has remained in the family ever since.

Princess Victoria, who frequently stayed at Syon House over a period of six years, was instructed here on court manners by Duchess Charlotte Florentia. Princess Victoria's bedroom at Syon House and that of her mother, the Duchess of Kent is preserved.

Syon House is claimed to be the last great 'country' house in private hands remaining in London, a curious definition made possible by its lying 8 miles from the centre of the capital, but within the bounds of Greater London.

VISITING INFORMATION

Syon House, Syon Park, Brentford TW8 8LG

http://www.syonpark.co.uk

House and Gardens open to the public from mid-March to October.

House: Open Wednesdays, Thursdays and Sundays 11am–5pm; last entry 4pm.

Gardens: Open daily 10.30am–5pm; last entry 4pm.

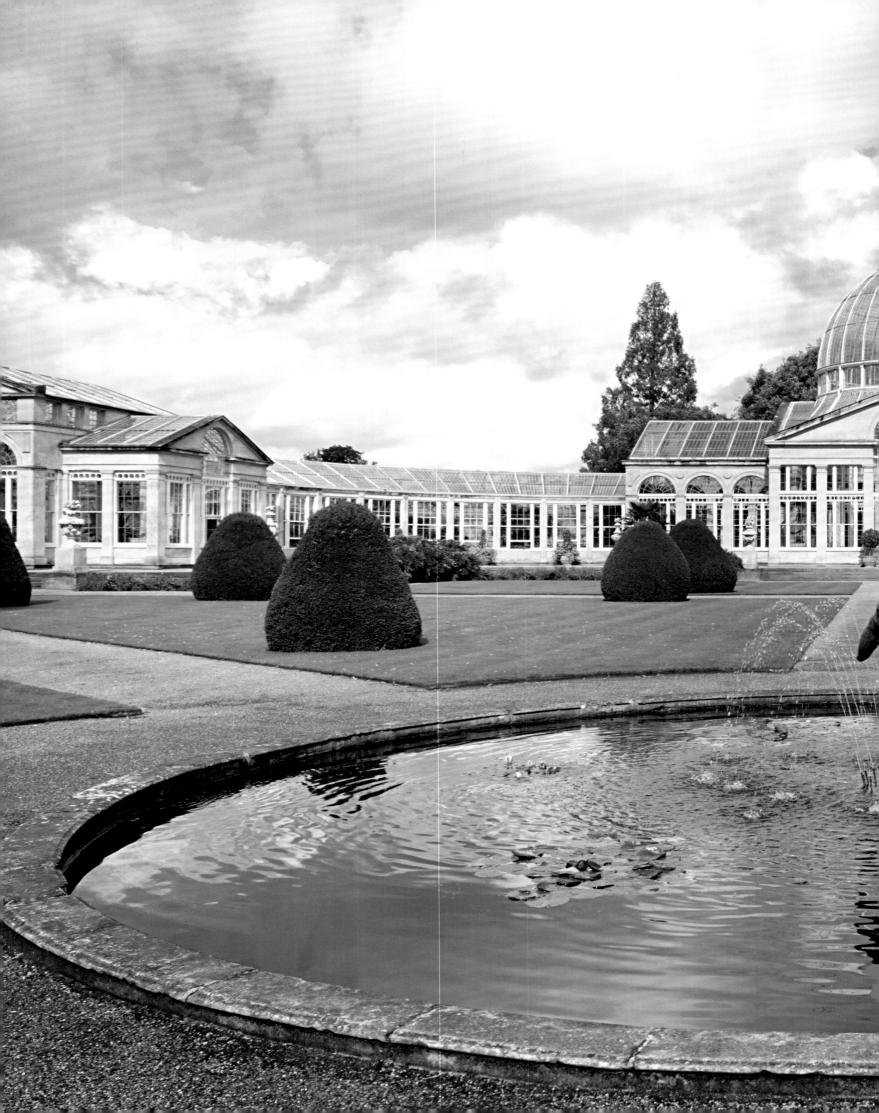

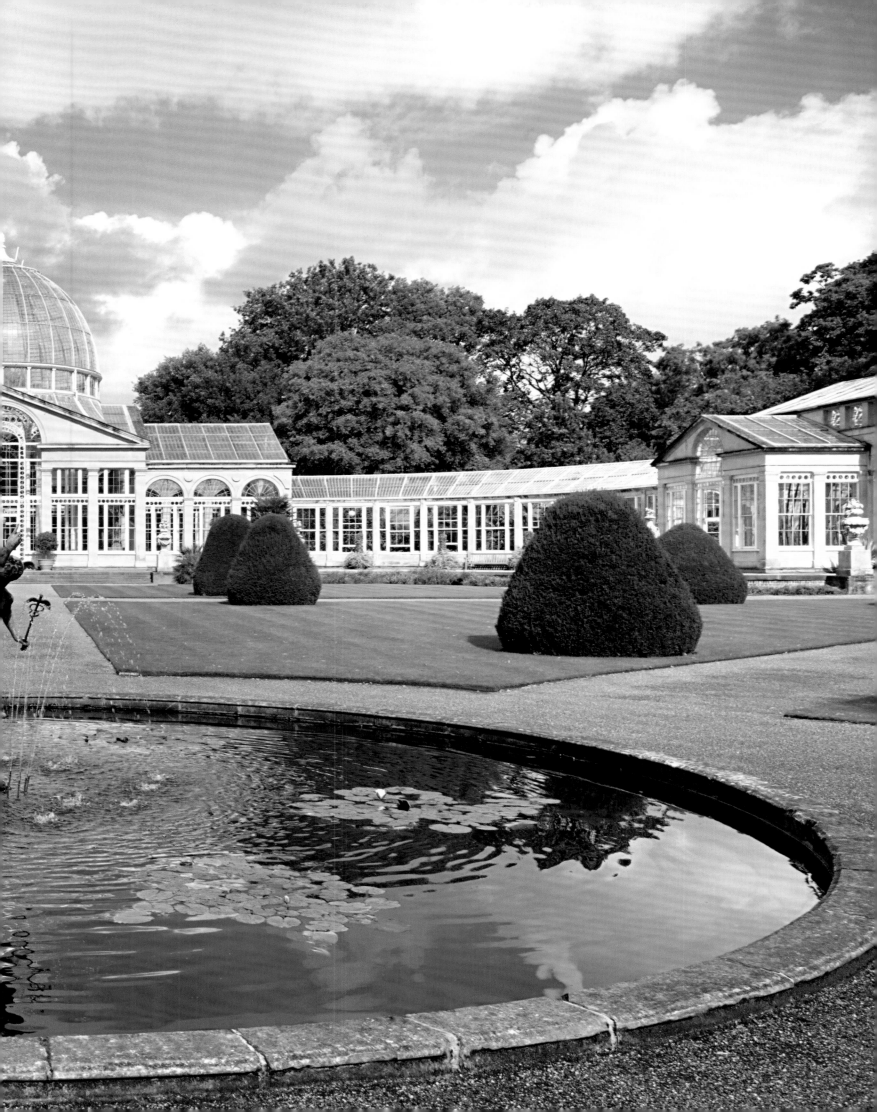

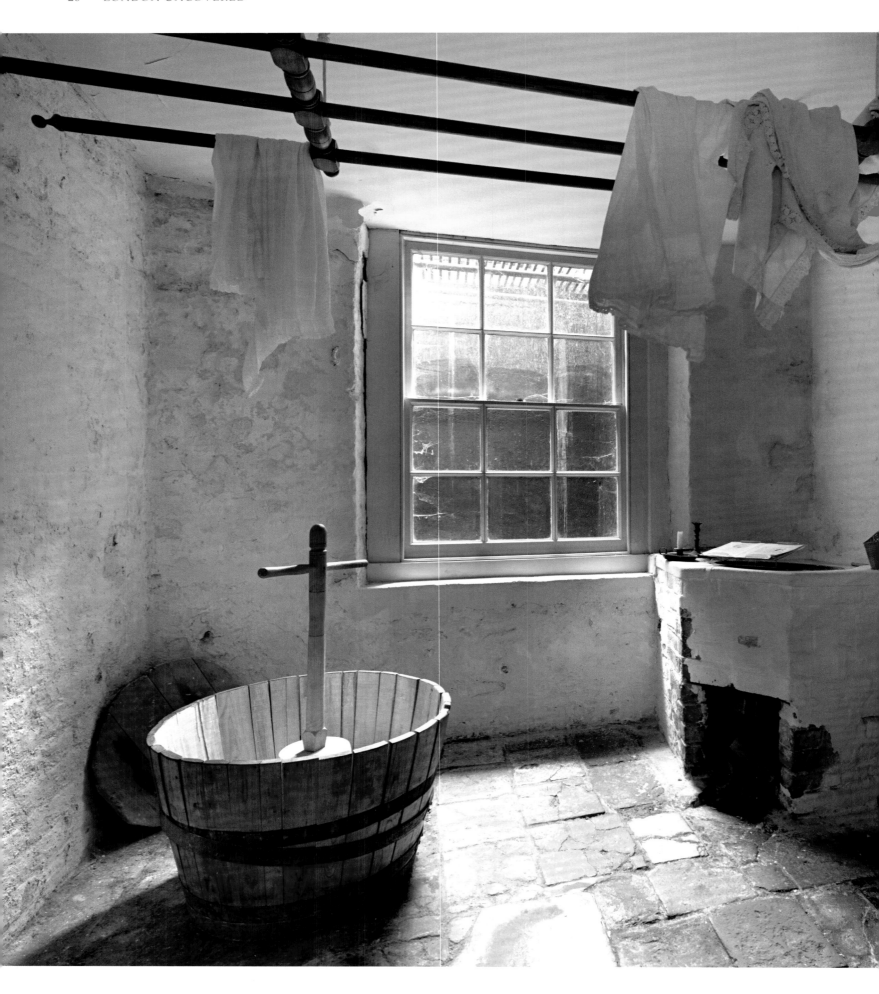

Charles Dickens Museum

The Charles Dickens Museum in Bloomsbury is the last remaining London home of Britain's most famous novelist. The Georgian terraced house, which was built in the first decade of the nineteenth century and where he lived between 1837 and 1839, holds the largest and perhaps most important collection of items relating to Dickens and his work – although there are other locations commemorating the great man, such as Charles Dickens' Birthplace Museum in Portsmouth, the Dickens House Museum in Broadstairs, Gad's Hill Place near Rochester, Dickens World Chatham and the Swiss Cottage in Rochester.

The Dickens Fellowship acquired the two properties at 48 and 49 Doughty Street in 1923, and the house was first opened to the public on 9 June 1925 under the name Dickens House Museum. Like so many London properties, it is more spacious than it looks from outside: built on four floors above ground as well as kitchen, scullery and wash house below.

Dickens (1812–70) was in his twenties during his brief time at the house – which benefited from recent improvements to the area, including fresh water from New River Head that fed the property's two pumps – but they represent two of the most important years of his life. He was relatively unknown when he moved in, but by the time Dickens moved to a bigger house in 1839, he was a household name across much of Britain and further afield.

On the walls are portraits of Dickens and his family, letters written by him and pictures of scenes from many of his books. Busts of both him and some of his contemporaries offer another image of Dickens and those he knew, while recordings in some of the rooms provide the visitor with further illustrations of some of his work. Mannequins dressed in the manner of the day also add to the feeling of being drawn back in time.

The primitive wash house with copper in the corner, which supplied hot water for all household purposes, mainly for washing and occasionally for steaming puddings.

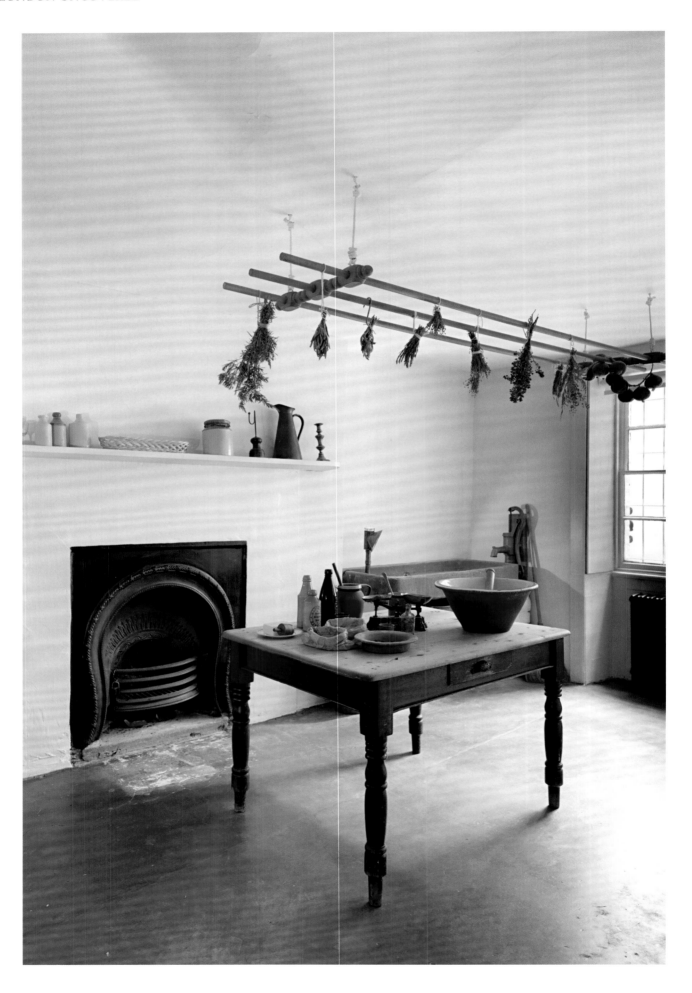

LEFT *The scullery, where some food was prepared, although the kitchen was a separate room in this layered household. The pump is one of two in the house.*

ABOVE *The study, where in the space of two years* The Pickwick Papers *was completed,* Oliver Twist *and* Nicholas Nickelby *written and* Barnaby Rudge *started.*

'My house in town', as he is known to have referred to the property, was where Dickens wrote some of his most famous works, including *Oliver Twist* and *Nicholas Nickleby*, and it displays some of the furniture dating from his time at Doughty Street or other places where he lived, such as Gad's Hill Place, his final home, and his dwelling prior to Doughty Street at Furnival's Inn. Such historical pieces brought from other houses in which Dickens lived include the writing desk at which he worked on *Great Expectations*, *A Tale of Two Cities* and other novels.

The rooms are laid out much as they looked during Dickens' time in Doughty Street and the late Regency-style period during which Dickens resided at the house comes across strongly even today in both its architecture and interior design. The grille from Marshalsea Debtors Prison – where Dickens' father was imprisoned – contrasts with the middle-class surroundings of the comfortable house.

Dickens was known as a generous entertainer, whose circle included actors and other writers of his day; much on display on the ground floor provides evidence of this, including the dining room, set for a meal as it would have been were Dickens and his wife Catherine (*née* Hogarth) expecting guests.

On the first floor, the study includes a collection of books authored by Dickens, as well as many books used by him as background for his own writings. On the floor above, the dressing room and his bedroom reveal a more intimate side of Dickens, with items of his wardrobe and personal grooming.

ABOVE *The nursery is located remotely in a third-floor attic room, alongside the servants' quarters, as was the Victorian custom.*

OPPOSITE ABOVE *The drawing room, where guests were entertained.* OPPOSITE BELOW *The master bedroom: two of Dickens' ten children were born here.*

Also on display is a commode chair used in the last years of his life, which comes from Gad's Hill Place.

Dickens was also a social reformer, and that too is reflected in the museum's collection. Much of the top floor is dedicated to his commentary and protest against those he held responsible for the slum districts and their poor sanitary conditions – politicians as well as landlords – with which he was so familiar (the middle-class district of Bloomsbury was bordered by some far less salubrious areas) and which coloured much of his work. Prison conditions were also a focus, and reflected in items on display at the museum.

The floor plan is much as it was in the 1830s, while an inventory of fixtures and fittings from the 1830s has provided a clear picture of how the interior of the house might have looked.

Attention to detail, such as period clothing on hooks in the basement, add veracity and draw the visitor back to the time of a man whose books continue to be read avidly today.

VISITING INFORMATION

Charles Dickens Museum, 48 Doughty Street, WC1N 2LX

http://dickensmuseum.com

Open 10am–5pm Tuesdays–Sundays; last entry 4pm.

Closed on Mondays, except Bank Holidays.

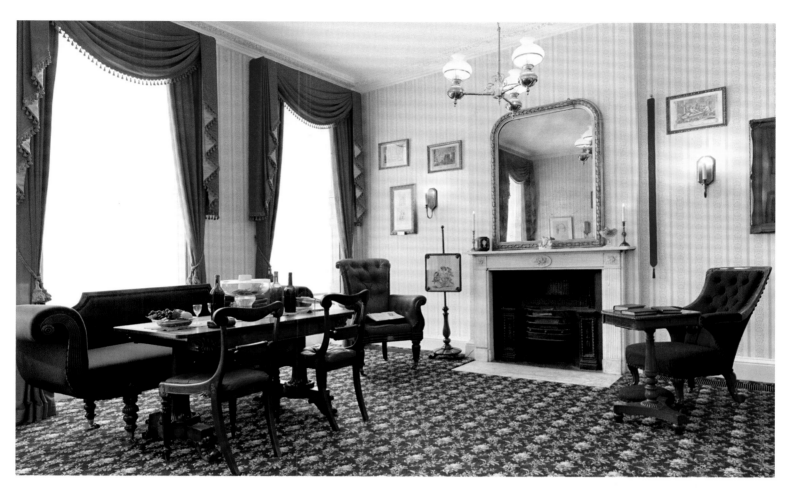

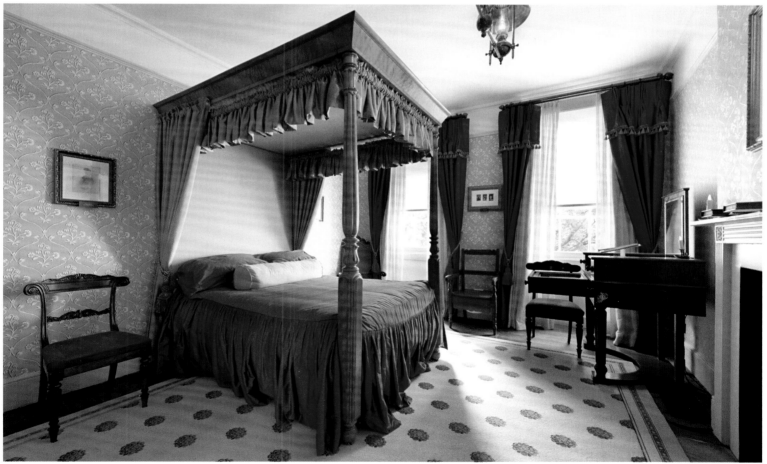

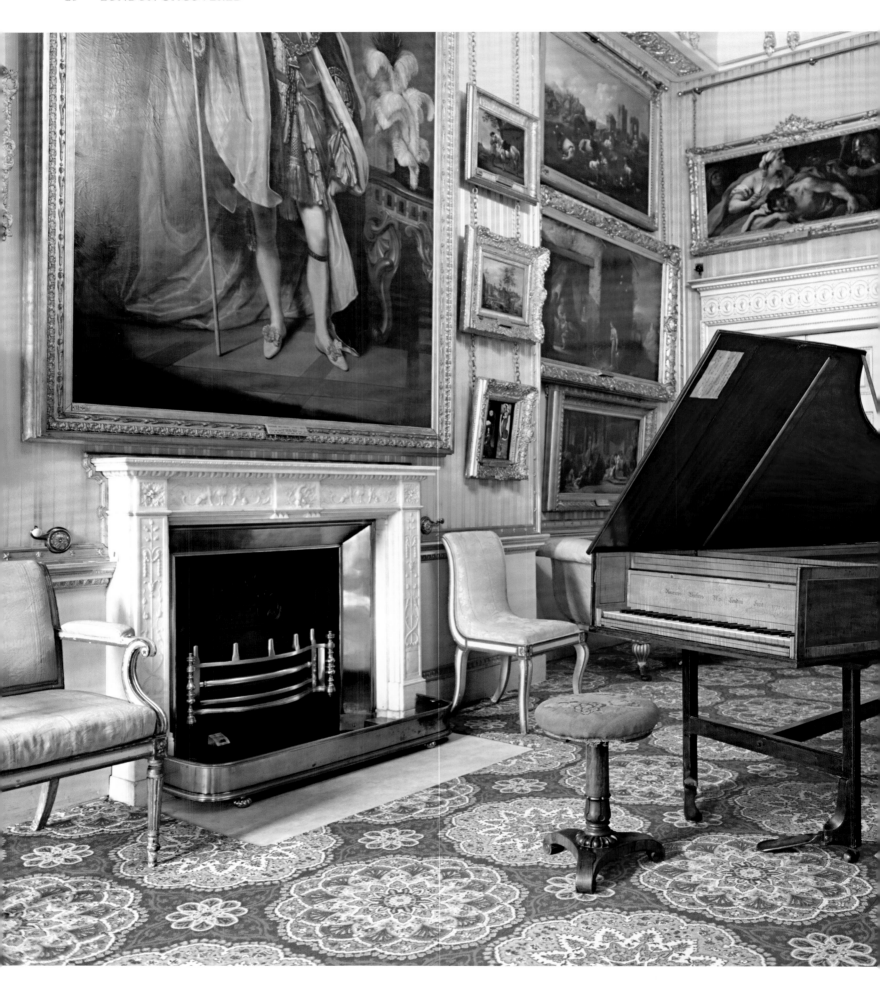

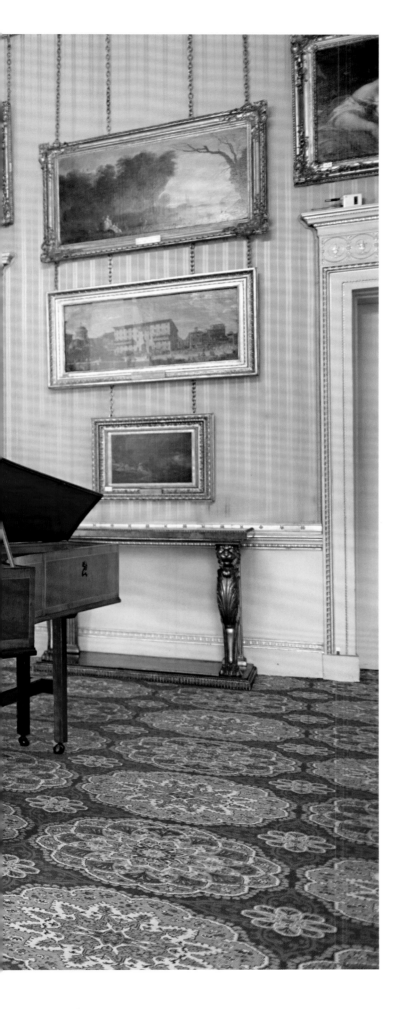

Apsley House

The first London house seen by travellers entering from the west through the old turnpike toll gates at the edge of town was Apsley House, famous for being the home of the Duke of Wellington. According to legend at least, it was therefore known as Number One London. The true address today is 149 Piccadilly, and it is still a London home for the current Duke of Wellington. It is also the home to a collection of decorative and fine art, and is a good example of Regency style.

A smaller red brick house designed by Robert Adam existed on this site, taking its name from the first owner Lord Apsley, the Lord Chancellor. In 1807, it was bought by Richard Wellesley, 1st Marquess Wellesley, once Governor-General of India, who lived there lavishly and ran out of money. He sold the house to his younger brother, Arthur Wellesley, the Duke of Wellington. Wellington bought the house anonymously to save his brother embarrassment and solve his bankruptcy. He required a better London base from which to pursue his career in politics.

Wellington commissioned Benjamin Dean Wyatt, his former private secretary in Dublin turned architect, to renovate and refurbish Apsley House. Work was planned in two phases, the first beginning in 1819, when Wyatt clad the brick exterior in Bath stone and added an extension of three storeys to the north-east, including a state dining room, where today a magnificent silver-and-gilt dinner service, a gift to Wellington in 1816 by the Portuguese Council of Regency, is on view.

Wellington's political career rose when George IV summoned him in 1828, appointing him the person most likely to command the confidence of the Commons as Prime Minister. This prompted the second stage of Apsley House works: a new staircase and the Waterloo Gallery, with its seven-mirrored window shutters inspired by the Galerie des Glaces at Versailles, and designed in

The oldest surviving English grand piano from 1772, on show in the Piccadilly Drawing Room.

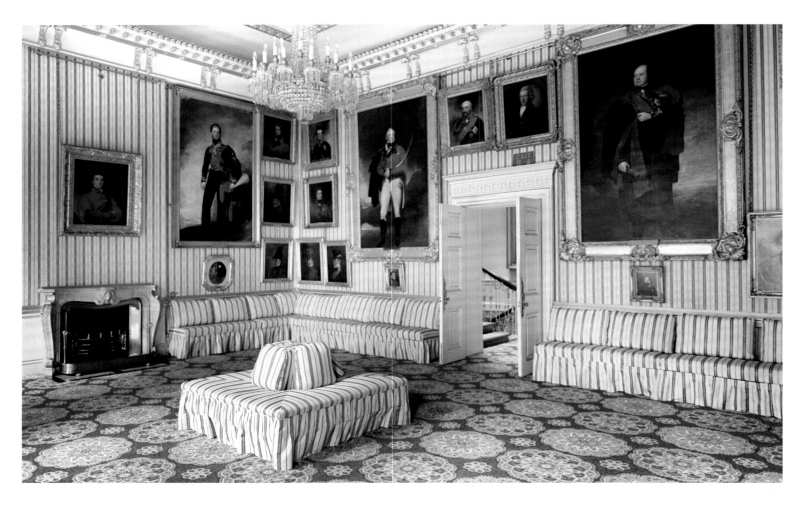

ABOVE *The Striped Drawing Room.* OPPOSITE *Exterior.* OVERLEAF *The Waterloo Gallery, named in celebration of the defeat of Napoleon, is a highlight of the building.*

the style of Louis XIV. Each year, this room hosts a banquet to commemorate the victory of 18 June 1815 at Waterloo. Finished in 1830, the Long Chamber on the west front was used by Wellington to house his personal art collection. Some of this was war booty from the baggage train of a vanquished Joseph Bonaparte after the Battle of Vittoria in 1813, ending the French occupation of Spain. Despite what was possibly a tongue-in-cheek offer to return those works to their legal owner, Ferdinand VII of Spain, a grateful monarch presented the collection to Wellington. The doors of the Long Chamber were designed by Harriet Arbuthnot, a society hostess and close friend of Wellington.

Apart from many paintings of the British, French, Flemish and Italian schools, further treasures at Apsley House include a pair of candelabra gifted by Nicholas I of Russia, urns from Charles XIV of Sweden, a dinner service presented by Frederick William III of Prussia, and a Egyptian Revival dinner service of Sèvres porcelain, given by Louis XVIII of France. Fragments of the original Adam design survive at Apsley House in ornate plaster ceilings, friezes and marble chimney-pieces, in the Portico and the Piccadilly Drawing Rooms.

Wellington's popularity declined in office, partly through his opposition to the first Reform Bill. He had to contend with the London mob who threw bricks through the windows of Apsley House in 1831. While iron railings at the front of the property had been added by Wyatt in 1830, that damage persuaded Wellington to have iron shutters fitted to the windows in the event of future vandalism.

After the Second World War, Gerald Wellesley, 7th Duke of Wellington, gave both the house and its most important contents to the nation, under the Wellington Museum Act 1947, giving the family the right to occupy a section 'so long as there is a Duke of Wellington'. The family continuity here has been unbroken since 1807, and the 9th Duke of Wellington, on taking up the title in 2015, said that he and his family would continue to use the private rooms in this apartment at Apsley House. Others parts of Apsley House are open to the public.

VISITING INFORMATION

Apsley House, 149 Piccadilly, W1J 7NT

http://www.english-heritage.org.uk

Opening times vary. Check online.

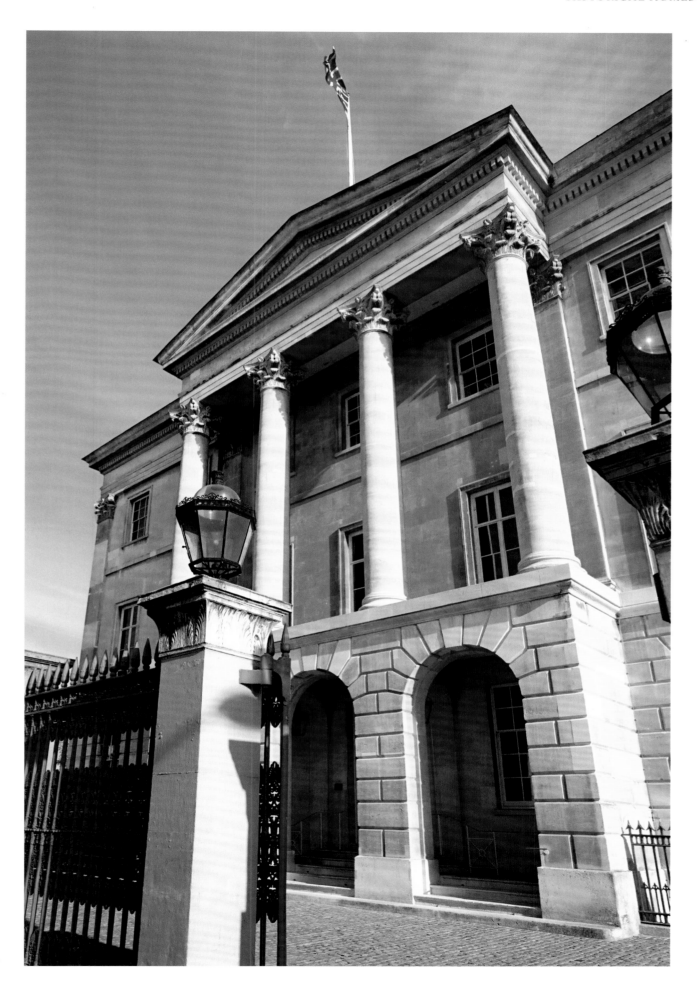

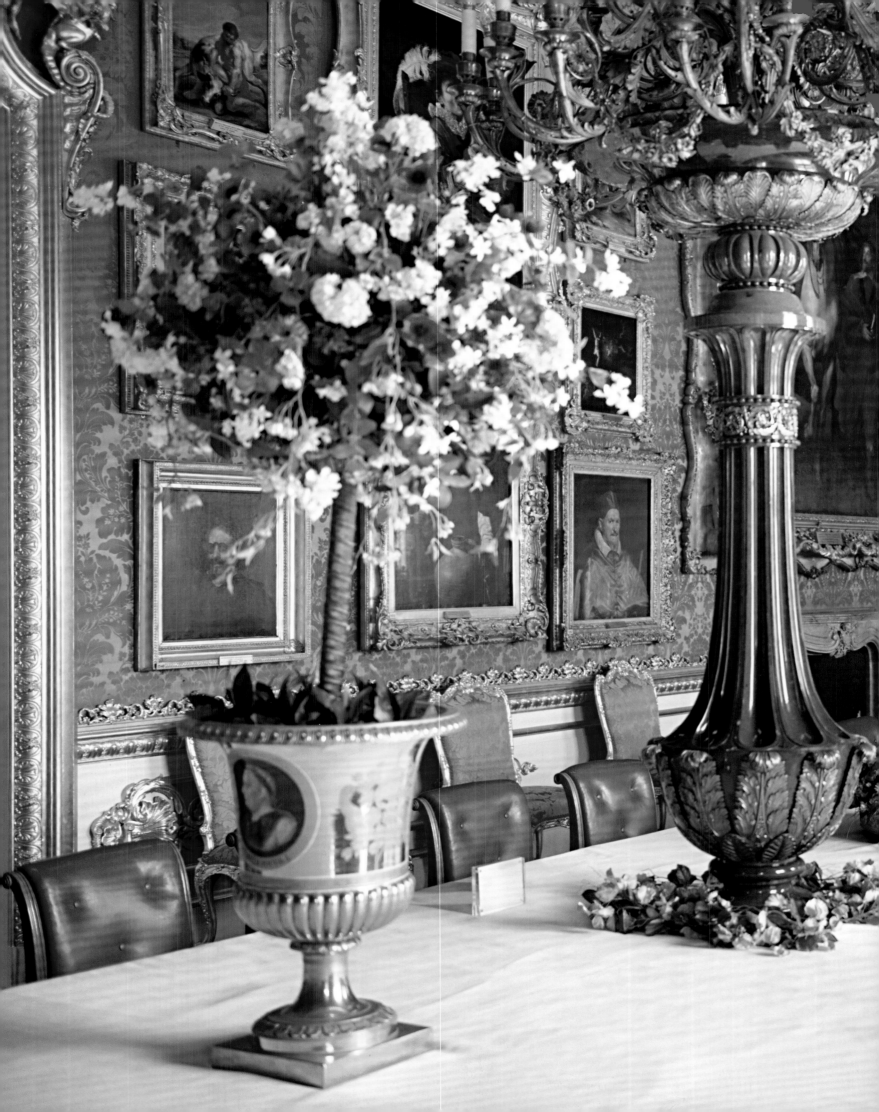

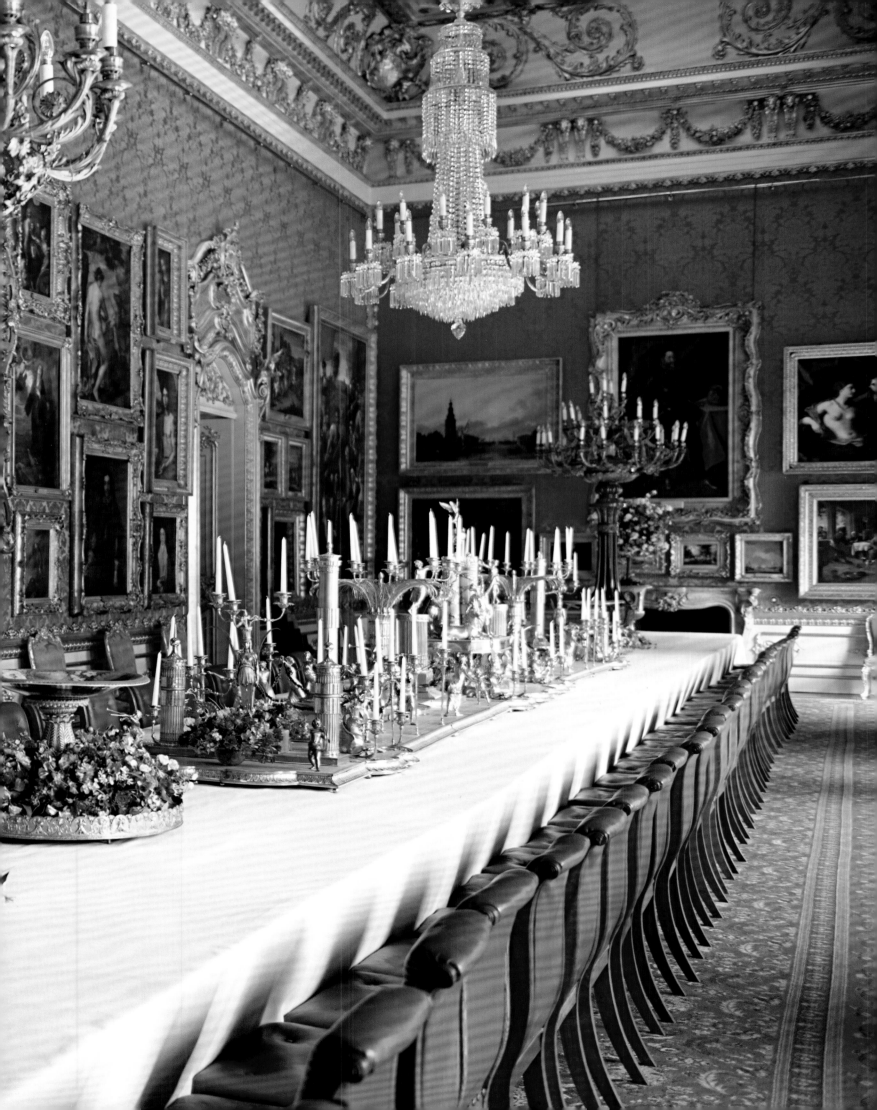

Eltham Palace

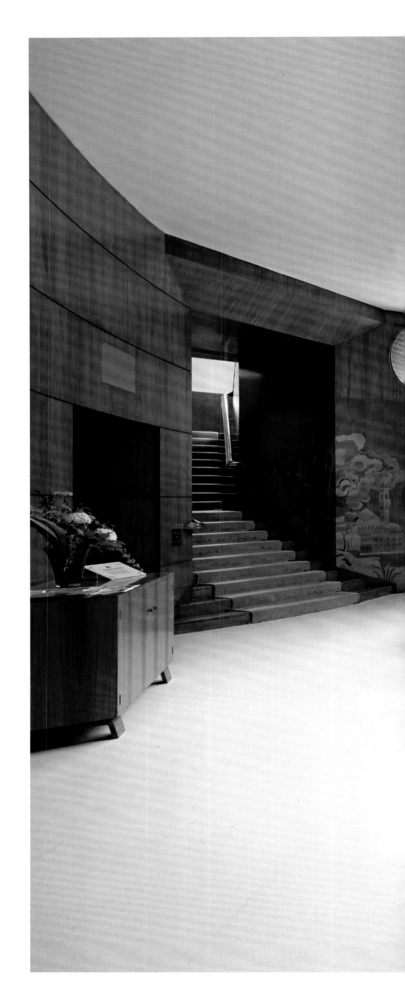

Eltham Palace is unique and unrepeatable: a luxurious modernist home integrated with the Great Hall of a royal residence built for King Edward IV.

In the early 1930s, wealthy couple Stephen and Virginia Courtauld were looking for a semi-rural retreat near London for entertaining and displaying their art collection. On the edge of south-east London lay the remains of Eltham Palace, disused as a royal house since the 1600s, comprising mostly the Great Hall. This had narrowly been saved from dereliction by the Office of Works. It is not clear whether the idea came from the Courtaulds themselves, or from their architects John Seeley and Paul Paget, but it took a measure of vision and imagination to see that a house could be created there. A leasehold and building permission were obtained from the Crown, and a new house was designed and built between 1933 and 1936. One wing directly joined the Great Hall, and a semi-circular colonnade linked it to another new wing beyond. Outside, a high degree of visual harmonisation between old and new was achieved by using red brick and stone dressing.

Inside, the Courtaulds then had a free hand to develop some spectacularly modern rooms and spaces, deploying leading designers and craftsmen and the highest-quality woods from around the world. Swedish artist Jerk Werkmäster, architect and designer Rolf Engströmer and Italian interior designer Peter Malacredia were tasked with producing a series of interiors in varying styles.

Eltham Place has a triangular entrance hall with walls lined with Australian blackbean veneer and decorated with marquetry that includes background scenes from Italy and Scandinavia. Light streams in from a glass dome. The dining room carries contrasting tones and textures on its surfaces

The entrance hall.

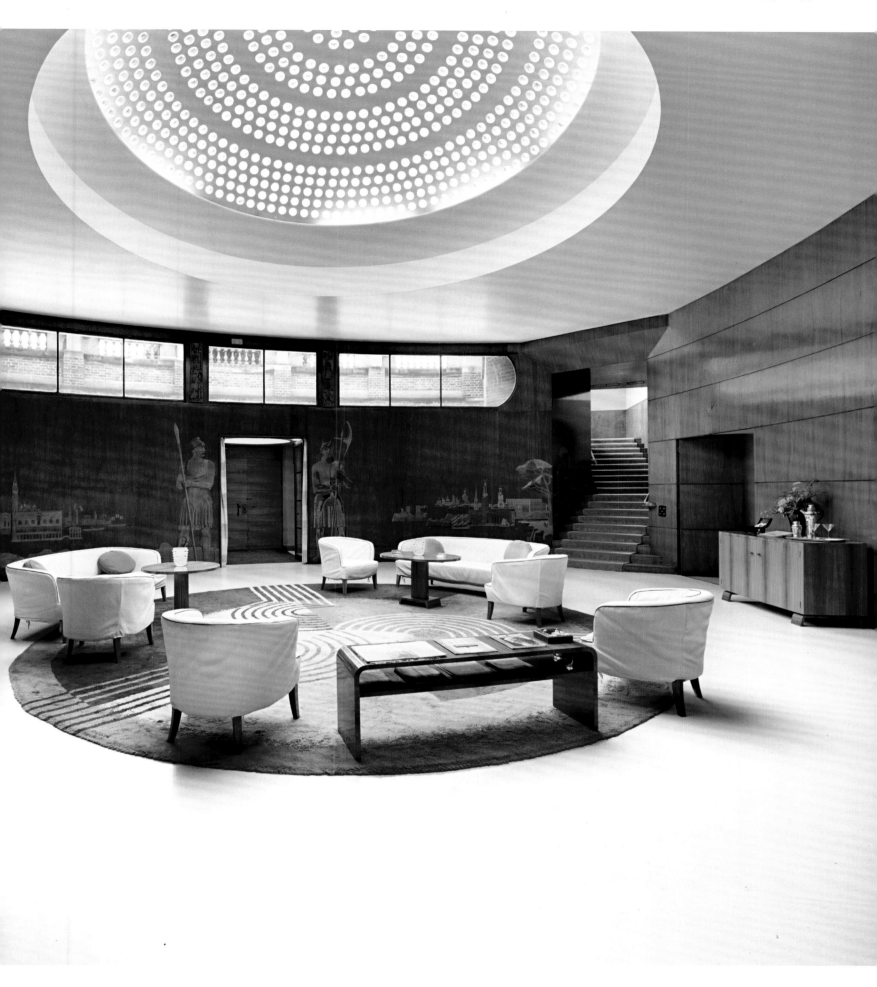

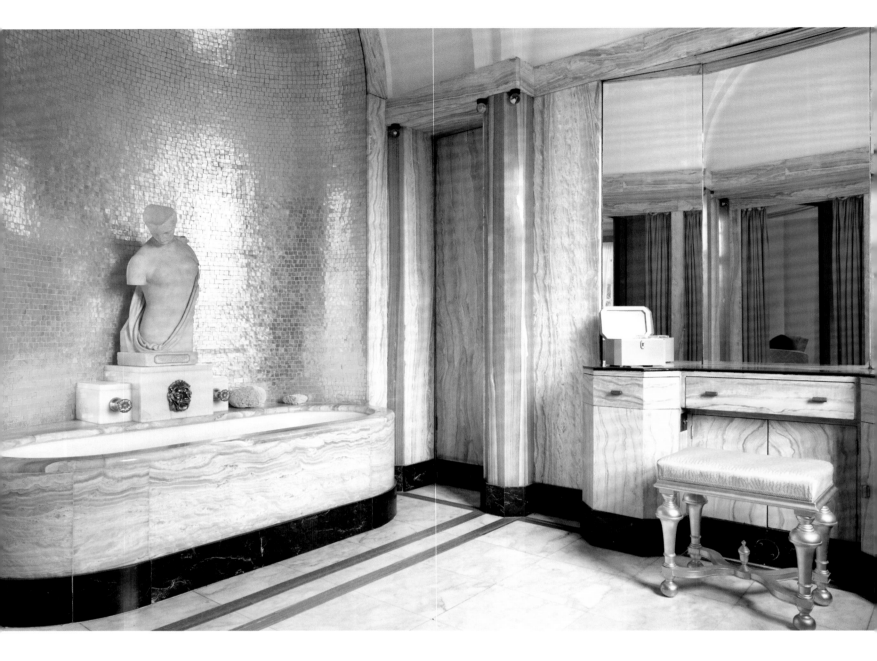

ABOVE *Virginia Courtauld's bathroom.* OPPOSITE *The Great Hall.*

with bird's-eye maple veneer walls and an aluminium-leaf ceiling. Animals and birds, drawn from life at London Zoo, decorate black-and-silver doors. False beams are decorated with Hungarian folk art.

On the first floor, the overall look has been described as Cunard Style, reflecting the influence of the luxurious ocean-liner cabins and staterooms of the age, featuring built-in furniture and smooth veneered surfaces, often with curved ends. The most exotic room is Virginia Courtauld's vaulted Art Deco bathroom, with gold mosaic and onyx, complete with gold-plated bath taps and a statue of the goddess Psyche. Stephen Courtauld's suite is an aspen-panelled bedroom with a vitreous-blue mosaic bathroom.

There is also modern technology in the form of electric fires, built-in audio and, more doubtfully, a centralised vacuum cleaner system, with pipes and sockets built into the skirting of each room. The Courtaulds also created an impressionist garden around the remains of the palace's old moat and bridges. Stephen Courtauld was a member of the Courtauld textile family, financial director of Ealing Studios and a trustee of the Royal Opera House. In the late 1930s the parties at Eltham Palace were filled with celebrity guests.

In recent years, several other rooms at Eltham have been opened to visitors, including Virginia Courtauld's recreated walk-in wardrobe, and a map room, where

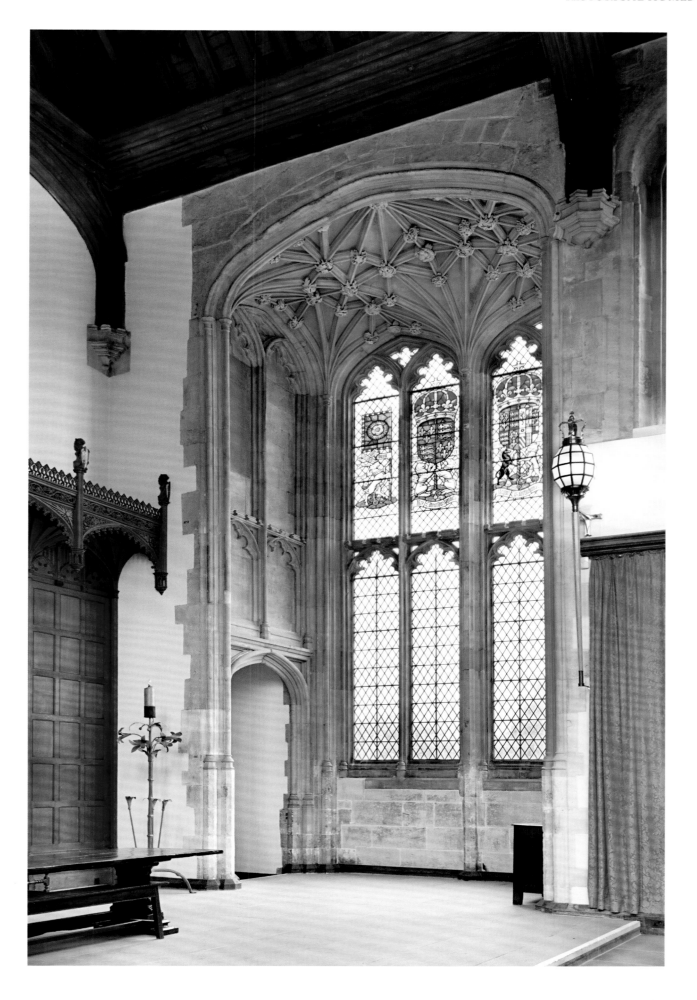

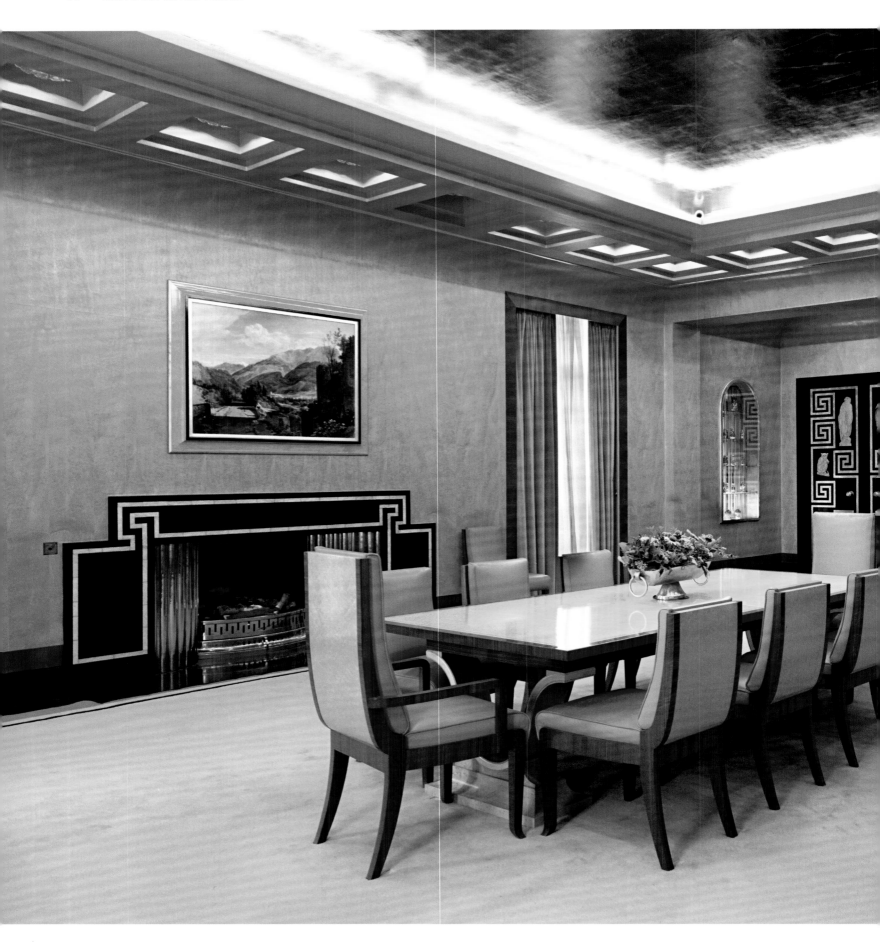

The dining room.

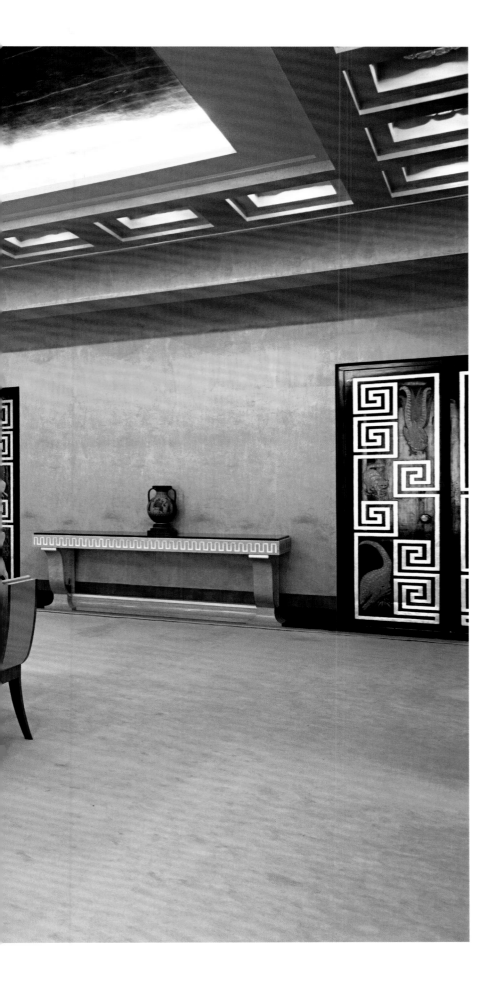

the family's secretary planned their extensive worldwide travels by liner, yacht and aircraft. Conservators uncovered large maps of areas to which the Courtaulds travelled pasted to the walls. Vignettes were painted onto the walls around the maps, depicting scenes and characters from around the world. A billiards room, photographic dark room and a luxurious underground air-raid shelter have also been opened.

The preserved Great Hall is of false hammer-beam construction, with the short vertical posts morticed into the ends of the arch-braced horizontal hammer-beams, with curved wind-braces to strengthen the roof trusses. Intending the Great Hall to be used as a music room, the Courtaulds had a minstrels' gallery added at one end. Much of the 1930s work represents the owners' and architects' concept of what a medieval great hall should look like. Stephen Courtauld's collection of Jacobean furniture remains here.

It was the nation's need to preserve the Great Hall, and the Courtaulds' agreement to do that as part of building their house, that unlocked the project in the first place. English Heritage suggests that particular support from the former Ministry of Works Ancient Monument Inspector Sir Charles Peers, who had overseen previous preservation work on the Hall, played a crucial role. The prevailing official attitude to preservation favoured fencing a site off, introducing information placards and surrounding it with lawns – essentially converting it into an archaeological site. At Eltham, a novel, possibly unique, response to the problem of conserving a historic building has been created.

The tenure of the Courtaulds at Eltham ended in 1944, and the house became the headquarters of the Royal Army Education Corps until 1992. English Heritage adopted Eltham Palace in 1995.

VISITING INFORMATION

Eltham Palace, Court Yard, Greenwich, SE9 5QE

http://www.english-heritage.org.uk

Opening times vary. Check online.

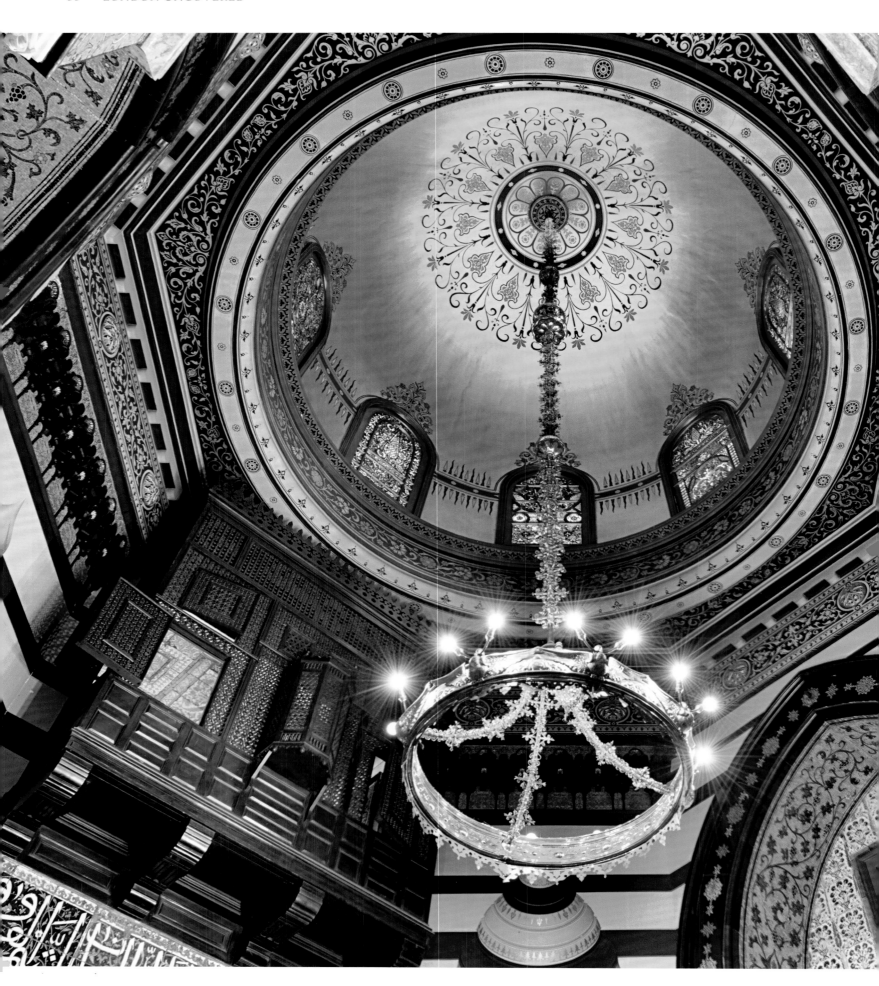

Leighton House Museum

The best-known picture by the Victorian painter Lord Frederic Leighton is *Flaming June*, a sleeping classical maiden reproduced on thousands of cards and posters, but the artist's own house at 12 Holland Park Road also deserves recognition as a great creation. Built in stages over thirty years behind plain unadorned red brick exterior walls, it was at first a modestly sized house with six rooms. It was designed as a studio-home – a place to live and paint – and the walls were soon hung with Leighton's own paintings and others by his peers. The house was ready for occupation in 1866, and was to set a style for the studio-home among Victorian London painters, and indeed for a particular Holland Park circle of artists.

The architect for Leighton's house was his friend George Aitchison, and they worked again together in 1879 to create a further wing. This included the spectacular Arab Hall, inspired by a room in the twelfth-century Arab-Norman castle at Zisa, near Palermo. The space rises into a high gilded dome, and the walls are decorated with 600 individual tiles – mostly from Damascus and dating from the sixteenth century – with a lattice window from Egypt. The supporting columns, mosaic frieze, screens and some stained glass were made by contemporary leading artists. A pool with a fountain was set in a Victorian mosaic floor.

Leighton House décor included red flocked wallpaper, ebony cabinetry and paintings and prints by great European artists including Tintoretto and Corot. The house was expanded eventually to ten rooms, the last addition being the Silk Room, a gallery space lined with green silk to display the collection of contemporary paintings, including pictures by John Everett Millais, George Frederic Watts, and John Singer Sargent.

The dome of the Arab Hall is gilded with tiles, mostly from Damascus.

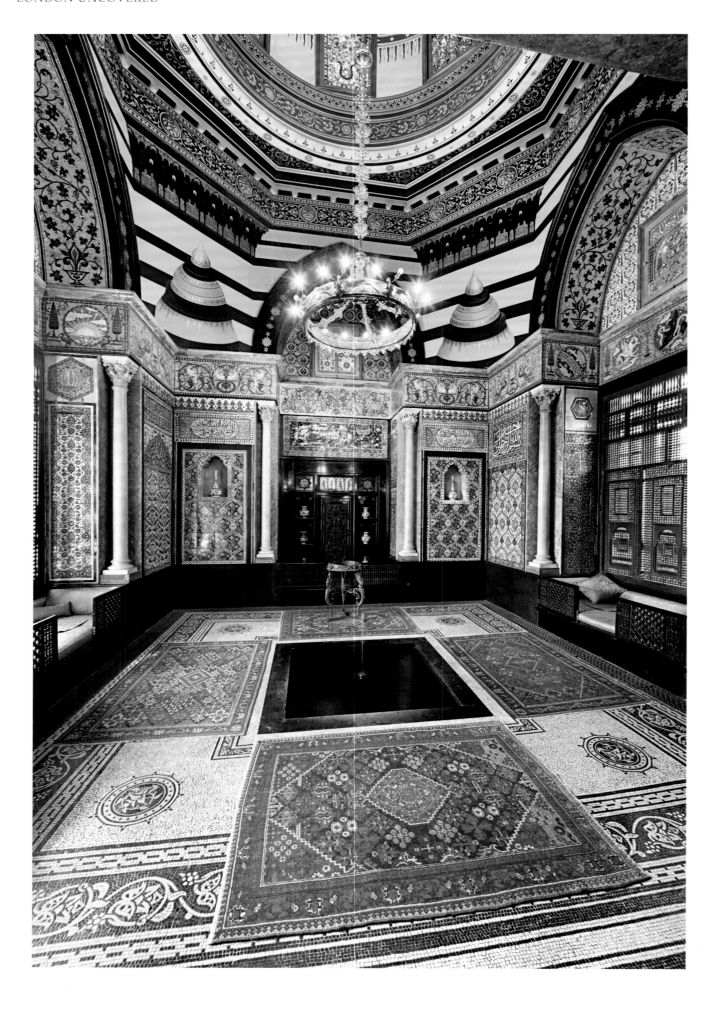

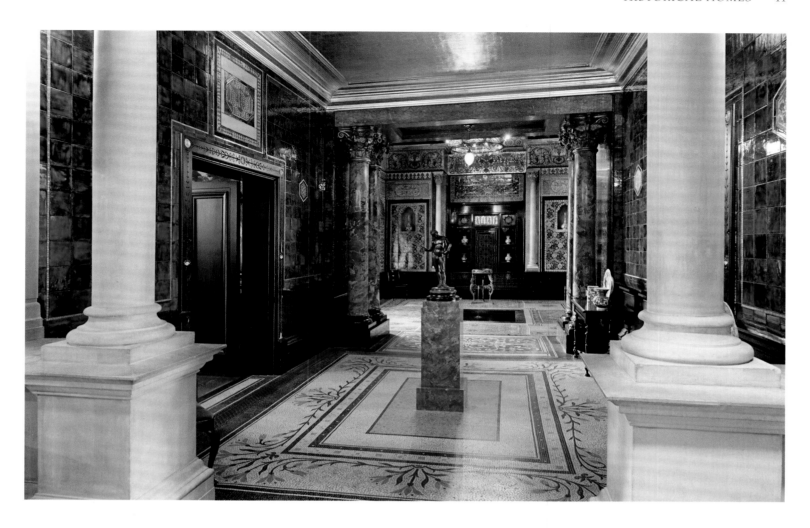

OPPOSITE *The mosaics and marbles for the Arab Hall were all sourced in London.*

ABOVE *The Narcissus Hall, with bronze figure by Leighton. Iridescent blue tiles by Victorian craftsmen represent the waters in which Narcissus observed his reflection.*

Frederic Leighton was an enigmatic and contradictory character, devoted to an artistic life, but tempered by distinct Victorian attitudes. He was well-connected and achieved considerable fame, being appointed President of the Royal Academy in 1878 and serving diligently, working from from his desk in the library until his death in 1896. The dining room was well-used as he entertained generously, and musical soirées were regularly held in the large studio. But there was no guest bedroom, his own bedroom was modest and simple and his bed was small. Leighton lived in the house alone, save for his servants, for three decades. Aside from the splendid entrance hall and staircase, Leighton House has a second side entrance and stairs, where the artists' female models, who were to pose nude, were taken directly to the studio. The house was sometimes opened to poor members of the public, generally when the artist was away travelling and collecting.

Leighton's death came shortly after he was raised to the peerage. Most of his collections of fine art and furniture were sold at auction soon after his death and dispersed. Attempts were made to preserve the house through the Leighton House Committee. It was not until 1926 that Kensington Borough Council purchased the freehold for £2,750. The house was difficult to exploit and protect usefully, but the Arab Hall and Narcissus Hall survived largely intact. Parts of the decoration came to be covered in emulsion and lining paper and strip lighting was fitted. Between 2008 and 2010 Leighton House was closed for extensive refurbishment and restoration at a cost of £1.6 million and returned close to the state it was in Leighton's day, with many pieces of furniture and textiles reproduced and original paintings and pieces loaned back for display. Some 550 books of 23.5 carat gold leaf were needed to restore the dome in the Arab Room.

VISITING INFORMATION

Leighton House Museum, 12 Holland Park Road, London W14 8LZ

https://www.rbkc.gov.uk

Open daily 10.00am–5.30pm, except Tuesdays; last entry at 5pm.

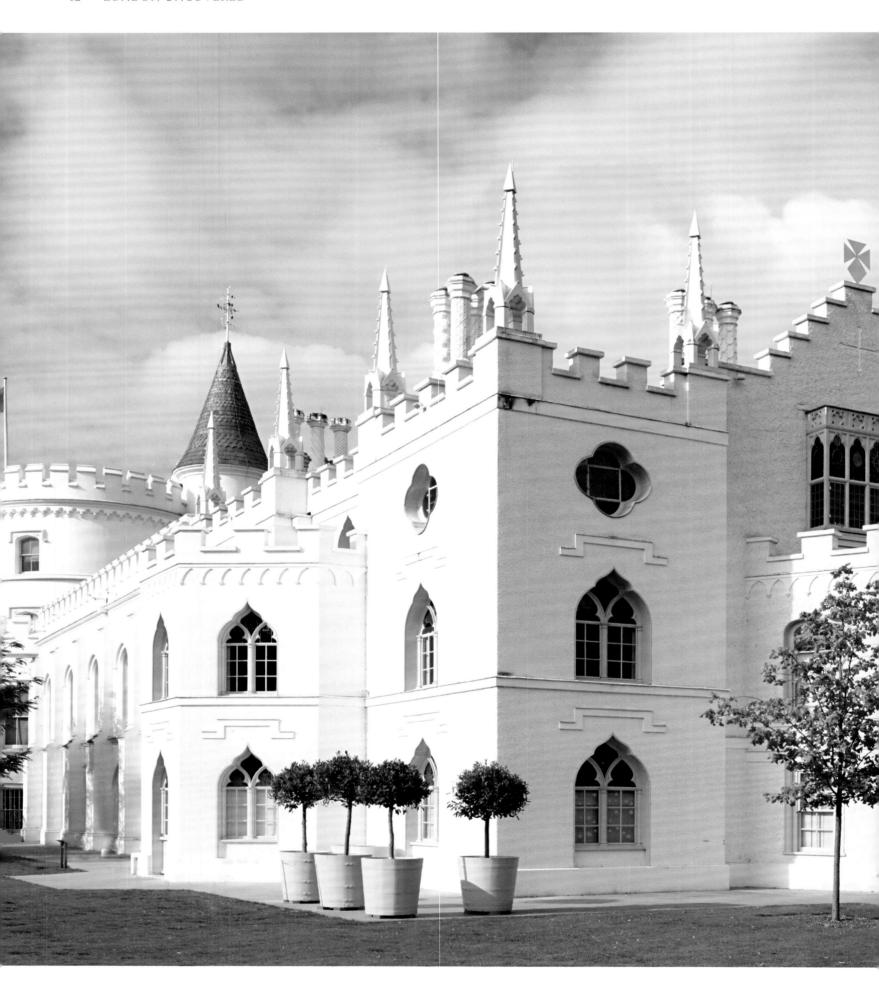

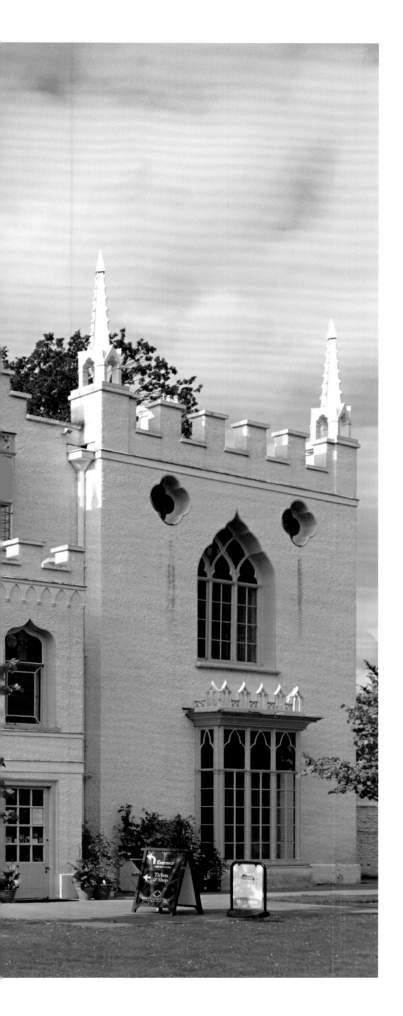

Strawberry Hill House

Strawberry Hill House at Twickenham, the building which is held to have pioneered the neo-gothic style in England, is surprisingly light, airy and elegant. Some architectural historians argue that it has a style better described as a whimsical alternative to rococo. Whatever the definition, Strawberry Hill is fascinating place to visit and has recently been restored mostly to its original state, as conceived by its creator Horace Walpole.

Between 1747 and 1797, Walpole transformed a villa known as Chopp'd Straw Hall into a castle-cathedral, complete with towers, battlements and stained glass, all against the grain of prevailing classicism in contemporary architecture. He made additions to the building in stages, without an overarching plan. Walpole drew on illustrated references to rose windows, pointed arches and medieval churches for features and design details inside and out.

The library's carved bookcases were inspired by some doors in Old St Paul's Cathedral; the ceiling of the Holbein Chamber is modelled on the Queen's Dressing Room at Windsor, while the fireplace is based on a tomb at Canterbury Cathedral. The design for the pierced screen was inspired by a choir screen at Rouen Cathedral. Gothic arches from Prince Arthur's tomb in Worcester Cathedral were an inspiration for the decoration of the walls of the hall and staircase.

The Gallery was the main room for entertaining, and the restoration starting in 2007 has returned the window heights to their original dimensions. The high gothic dado which surrounds the room was also renovated. The ceiling, with its *papier mâché* moulding, has been restored and re-gilded, and the walls are hung with crimson damask.

Part castle, part cathedral, no Corinthian columns, no classical symmetry: the exterior's once-dull rendering has been white-limewashed back to its original appearance.

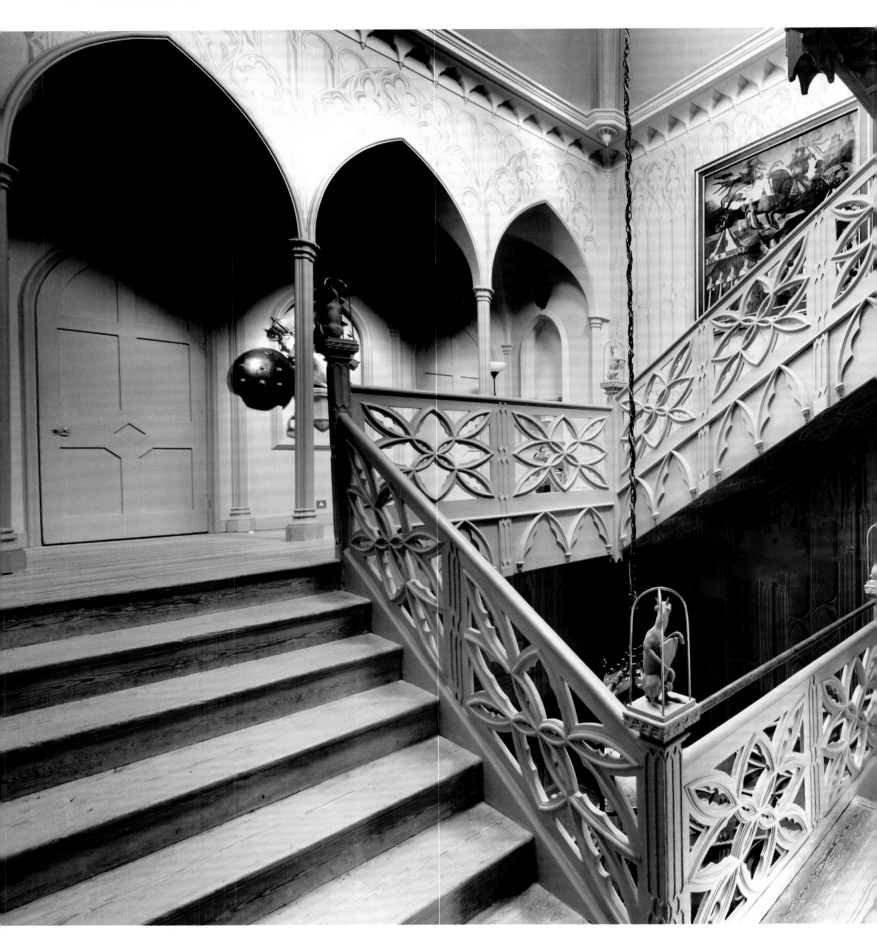

The hall and staircase, intended to generate gothic gloom.

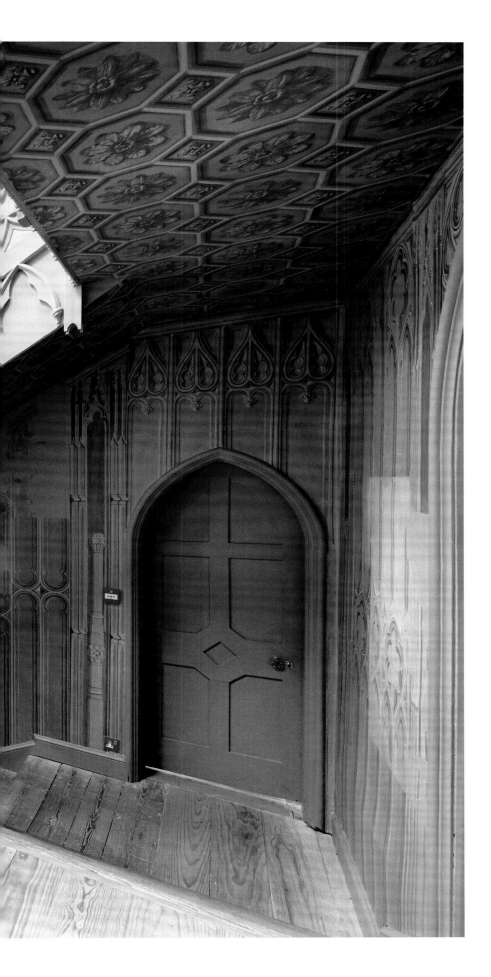

A lost element of Strawberry Hill is Walpole's collection, which was once housed in the room known as The Tribune. Comprising hundreds of pictures, statues, ceramics, vases and *objets d'art*, it was dispersed in a great sale of 1842. The current location of many of the objects is known, and the Strawberry Hill Collection Trust together with the Strawberry Hill Trust is seeking to return the objects sold to the house.

Descriptions applied to Strawberry Hill have ranged from fairy-tale to eccentric to romantic; its creator Horace Walpole was an antiquarian, author, collector and Whig politician, son of the first British Prime Minister Robert Walpole. He was a dilettante rich enough to indulge fully his imagination, and he described Strawberry Hill as a 'plaything'. His novel *The Castle of Otranto*, published in 1764, prefigured the forthcoming 'Gothick' idiom, including such elements as cursed noblemen, supernatural events, monks, princesses, romantic love, violent death and a dark castle. A visitor to Strawberry Hill today might struggle to make the connection, but Walpole certainly intended the house to be a gothic experience, requiring a walk through a supposedly gloomy hall and up the darkened grey stairway before emerging into the bright and colourful chambers above. He did coin the word 'gloomth' in a letter ('one has satisfaction in imprinting the gloomth of abbeys and cathedrals on one's house') but to the modern eye the spaces do not seem to qualify. The restoration has even returned the exterior to its original gleaming lime-washed white finish; it was once described as resembling a wedding cake.

Strawberry Hill did not suffer too badly after Walpole's death. The house devolved upon the Waldegrave family, certain extensions and additions were made, and some rooms open today have retained the later nineteenth- and twentieth-century details. From 1925, it was a training college for teachers, now St Mary's University College, and the gallery was once used as a lecture theatre. Now the university mostly has its own buildings on the Strawberry Hill site. Although the fabric of the house was largely intact, much decay was found during

ABOVE *The Round Room is hung with scarlet silk. The ceiling design is based on a round window in Old St Paul's Cathedral.*

OPPOSITE *The Holbein Room once held paintings by the master. The ceiling is embossed* papier mâché, *the fireplace inspired by a tomb in Canterbury Cathedral.*

the restoration. This was launched in 2007, with £9 million Heritage Lottery funding, greatly enabled by Strawberry Hill being one of the best-documented houses anywhere. Walpole wrote copiously about his gothic castle and commissioned a set of drawings and paintings to record its changes, all of which were available to the restorers, who are steadily opening more of Walpole's rooms to visitors.

VISITING INFORMATION

Strawberry Hill, 268 Waldegrave Road, Twickenham TW1 4ST

http://www.strawberryhillhouse.org.uk

House open daily except Thursday and Friday.

Timed entry system. Buy tickets online to guarantee entry

at a specific time, or to book tours.

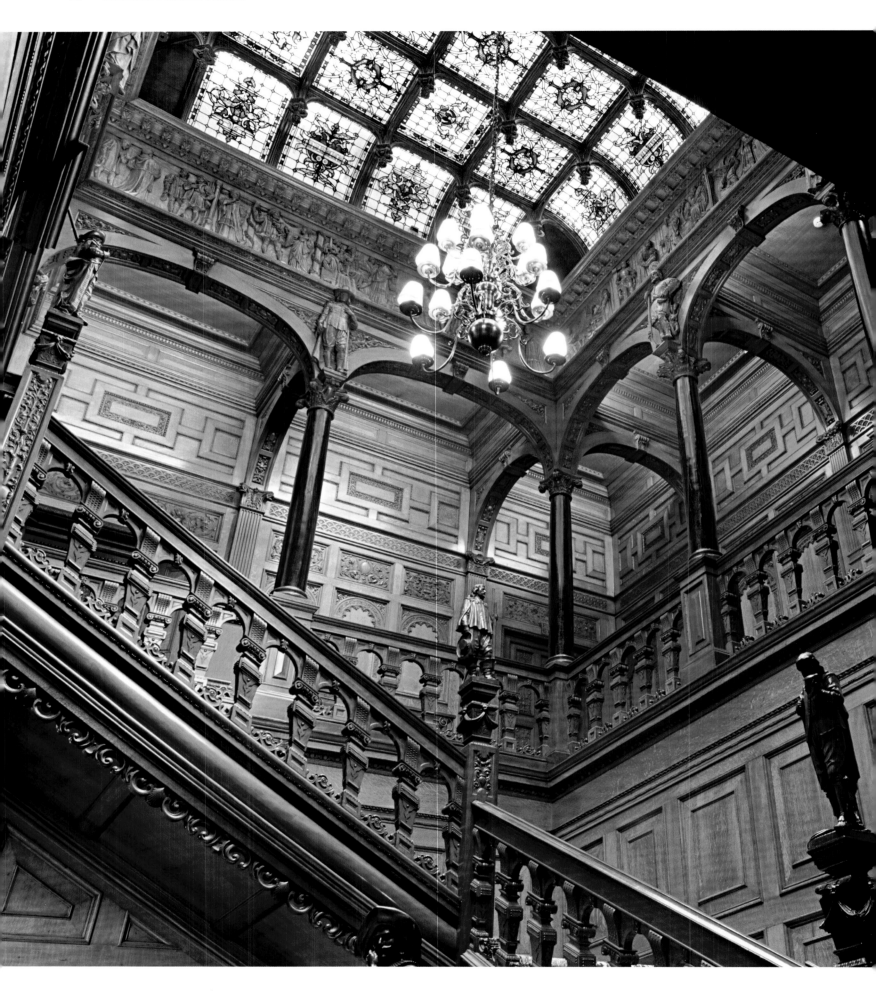

Two Temple Place

For more than a hundred years the building at No. 2 Temple Place was noted only for what could be seen on the outside: on the roof, an elegant oversized copper weathervane in the shape of fifteenth-century ship and, flanking the entrance, lamp-pillars bearing statues of cherubs talking on a telephone.

The picturesque exterior always hinted the building was not an old historic artefact, and when this Tudor mansion in miniature was opened to visitors for the first time in 2011 an indulgent late-Victorian fantasy was revealed. Two Temple Place has an extraordinary interior. Its panelled rooms are embellished with romantic decorative details reflecting the interests and tastes of the man who commissioned it, William Waldorf Astor.

Astor had settled with his family in England in 1891, disenchanted with his native New York. The building was designed as the Astor Estate Office, the headquarters of a real estate and financial empire for the richest man in the world. It was completed between 1893 and 1895. Astor's other properties included a London home at Carlton House Terrace, the country house Cliveden in Buckinghamshire, and later Hever Castle in Kent, but the estate office was his most favoured home for much of his life. Although the Astor family did not live there, there was a small bedroom for William Waldorf's personal use.

It is impossible to identify a single theme or style to the interior, although characters from literature inform and inhabit much of the decorative detail. Astor's favourite novel was *The Three Musketeers* by Alexandre Dumas and, inspired by this, the mahogany staircase carries statues of seven

Staircase Hall, with its solid ebony columns, carved frieze and skylight. D'Artagnan looks across to Madame Constance Bonacieux, Milady de Winter, Aramis and Athos, with Porthos above.

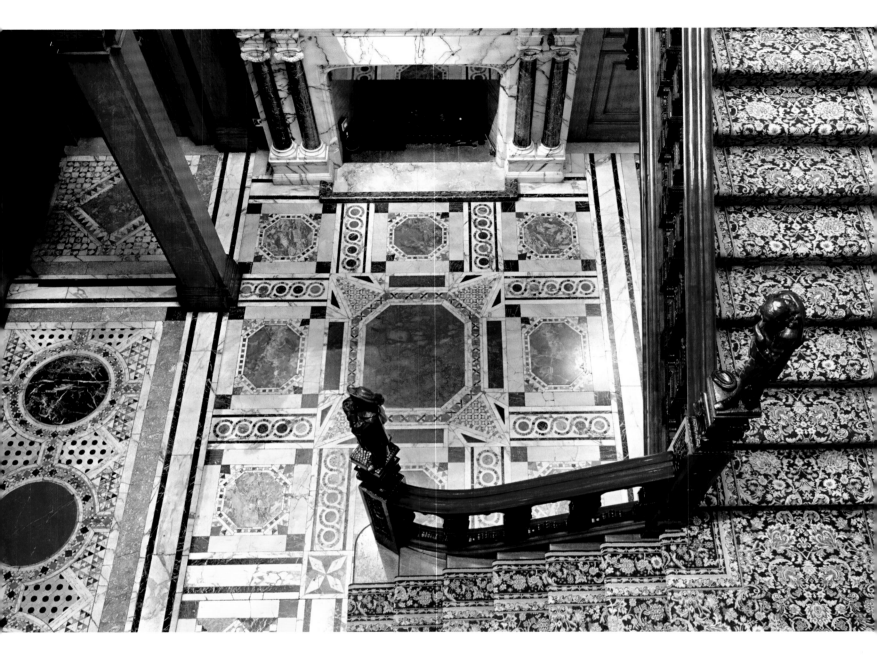

The floor is in inlaid multicoloured marble, in geometric patterns, inspired by Italian churches.

characters from the novel on the newel posts. Six further statuettes around the staircase gallery are of figures from American literature. Above these, ten solid ebony columns carry an oak frieze carved with eighty-two characters in scenes from Shakespeare's plays. Although the decorative subjects can be described as eccentric or illogical, the quality of materials and craftsmanship everywhere is to the highest standard.

The upper hall, with its hammer-beamed ceiling, was once Astor's office, and has a detailed frieze of fifty heads modelled in low relief, and figures from literature and history. The Lady of Shalott and Otto von Bismark are side by side, together with Voltaire, Machiavelli, Anne Boleyn and Christopher Columbus. The main doorway is panelled with bronzes of nine female figures from Arthurian legend. Stained-glass windows at each end depict sunrise and sunset, and seemingly a narrative from a nameless story.

Astor purchased a plot of land close to the recently established Victoria Embankment, once the factory of Gwynne & Co. pump makers, under the shadow of the towering Middle Temple library on the east side. There are only two floors and a basement, and most of the space was devoted to offices. Safety and security was a leading feature of the design, which included a large strongroom in the basement. The architect was John Loughborough Pearson, a leading Gothic Revivalist who had designed

Truro Cathedral. The craftsmen and artists who worked on the decoration were selected by Pearson. Astor worked closely with Pearson, particularly on the detailing of the interior.

William Waldorf Astor was a cultured and complex man, at various times newspaper publisher, financier, real estate investor, hotelier, lawyer, diplomat and politician. After establishing the Astor family in England, and gaining a reputation as a benefactor and philanthropist, he sought honours and was made a peer in 1916.

The decoration of the Astor estate office is a celebration of the literature and history of the Old World, with a dash of the New World of the Americas, and a celebration of modern technology.

The building has changed hands only three times since the Astor family sold the property in 1922, each owner taking good care of the premises, although it was badly damaged in July 1944 by a flying bomb, which exploded on the neighbouring building to the west. The last commercial owner was the medical products company Smith & Nephew, who added a wing to the west, and gave it the name Two Temple Place. It was acquired by the charitable organisation the Bulldog Trust in 1999. It operates as a headquarters and a gallery for the Bulldog Trust and is open to the public for annual winter exhibitions between January and April each year.

VISITING INFORMATION

Two Temple Place, WC2R 3BD

http://www.twotempleplace.org

Open during exhibitions every day except Tuesdays.

The Great Hall, once Astor's office, shows undecorated stonework at the ends and panelling in pencil cedar. The hammer-beam ceiling is Spanish mahogany.

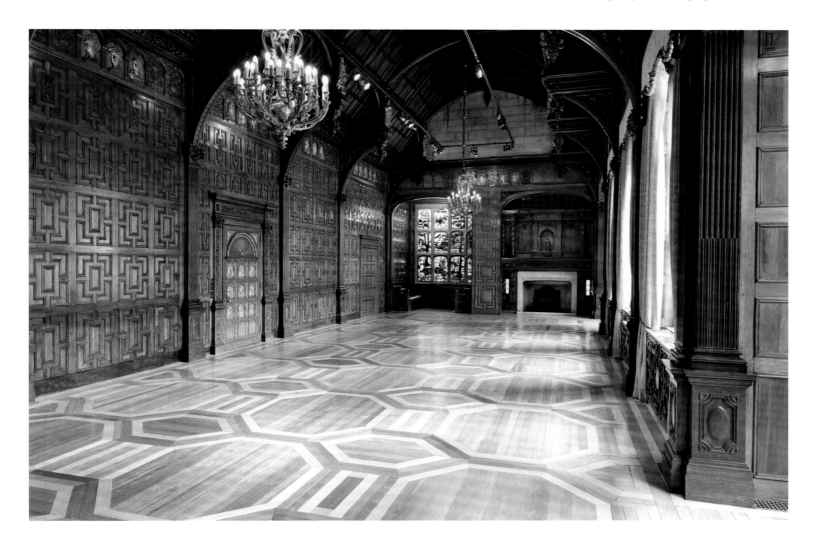

Kew Palace and The Royal Botanical Gardens

The Royal Botanical Gardens at Kew enjoy ever-changing panoramas through the seasons in the trees and flowers, but not everything changes in the Kew landscape. One of the unexpected pleasures for a visitor is finding the dozens of buildings, historic and modern, functional and decorative – gallery, temple and folly – scattered across the gardens. More than forty buildings at Kew have listed status.

The gardens at Kew were formed around the royal residences that came to be built from the sixteenth century near the hunting area of Richmond deer park. It was Princess Augusta, the mother of George III, who is crediting with founding the garden. It became more scientifically purposeful in the 1840s, as it developed into the focal point for horticultural collection and research for the British Empire.

Kew's signature building is the spectacularly curvaceous Palm House, a highly advanced structure when built in 1844–8. Architect Decimus Burton had drawn an arched nave with supporting columns, which was going to be executed completely in cast iron; but iron founder Richard Turner proposed slimmer, rolled wrought-iron sections just coming into use for ship construction, and these were used for the ribs instead. This enabled an increase in the apparent glazed area, which made the building structure lighter in weight and gave it its characteristic airy appearance. The humidity necessary in such a building caused corrosion to take its toll. Extensive restoration between 1955 and 1957 saw its glazing bars cleaned and new glass introduced, but a longer-term solution was needed. Between 1984 and 1988, the Palm House was emptied for the first time in its history, dismantled, restored and rebuilt. Wrought iron was no longer available, and 16

The oldest building in the gardens is Kew Palace itself, the survivor of three palaces which once existed here.

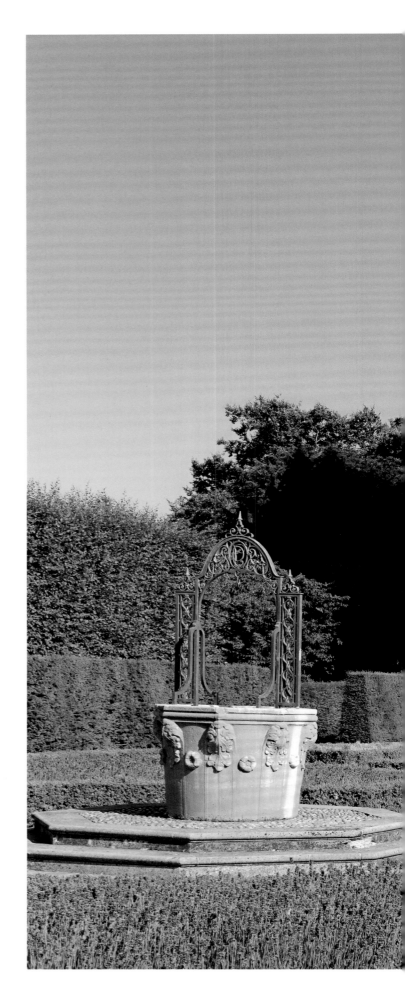

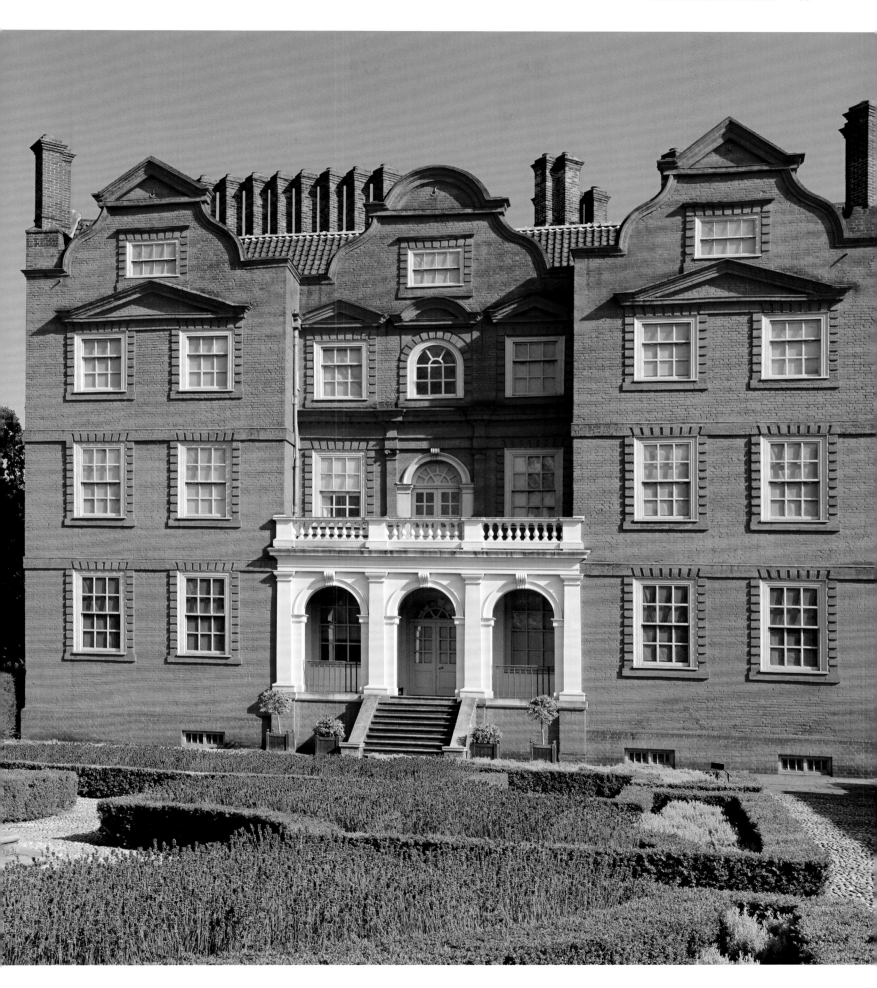

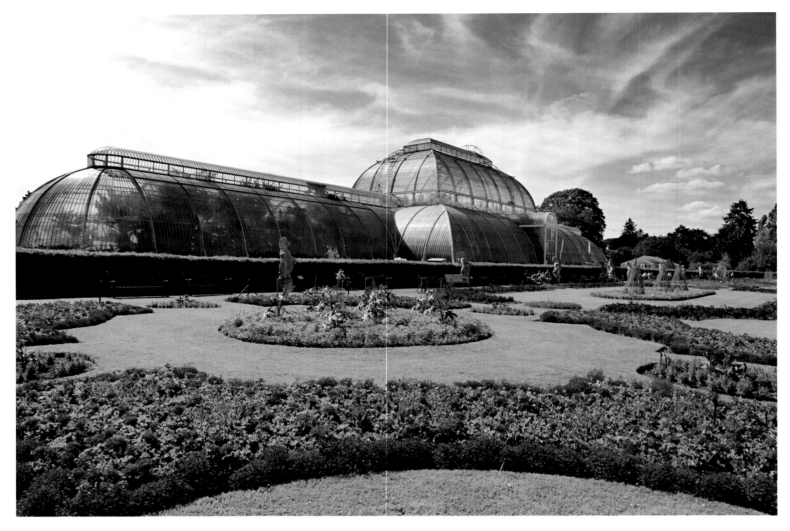

Kew's signature building is the spectacularly curvaceous Palm House, a highly advanced structure when built in 1844–8.

kilometres of replica stainless-steel glazing bars were put into place to hold 16,000 panes of toughened safety glass.

The south wing houses plants from Africa and the Indian Ocean islands; the central section has plants from the Americas; and the North displays Asia. In the basement, the Marine Aquarium recreates four marine habitats. This was where the coke-fired steam-heating boilers were once housed, supplied by an underground narrow-gauge railway. It is now gas heated.

Undergoing massive restoration between 2013 and 2018 is the Temperate House, claimed to be the largest Victorian glasshouse in the world. It is of more straightforward construction than the Palm House, using flat glass and required to generate a milder environment, but more than twice the size. The collection of great Victorian glass buildings is completed by the Waterlily House, open during the spring and summer months, which also houses ferns, papyrus and hanging gourds.

Two oriental buildings, the pagoda from 1762 and the Chokushi-Mon Japanese Gateway are found at the southern edge of Kew Gardens. In the modern age, the Princess of Wales Conservatory, opened in 1987 and named after Princess Augusta, is notable for not possessing any vertical side walls. Partly below ground level, it houses ten landscaped zones, from desert to rainforest.

The oldest building in the gardens is Kew Palace itself, the survivor of three palaces which once existed here. This red brick mansion house was built by a wealthy merchant of Dutch descent in 1631. Its Flemish-style stepped-gable architecture and riverside location were widely admired, and it was eventually leased and purchased by the Crown. It is associated with first with George II, whose daughters lived there, and then George III. Together with his wife Queen Charlotte, George III was happy at Kew until his illness developed, and the house became a royal retreat, rather than a palace for lavish entertaining. A summerhouse cottage was built for Queen Charlotte as a place to rest on long walks through the grounds, and

this remains close to southern boundary of the gardens, another of Kew's secret buildings.

Kew Palace, known as the Dutch House, was never intended to be a main royal residence. The most important royal home at Kew was the White House, which existed nearby, until it was demolished in 1803 to be replaced by a riverside Castellated Palace. This building was never completed, however, partly due to the King's worsening illness, while the Dutch House survived. After Queen Charlotte died there in 1818, its relatively modest rooms were closed for many years until Queen Victoria, George III's grand-daughter, opened the palace to the public in 1898. Historic Royal Palaces reopened it in 2006 after restoration. Across the other side of the lawns lie the Royal Kitchens, also open to visitors.

VISITING INFORMATION

Kew Palace, Royal Botanic Gardens, Kew, Richmond, Surrey, TW9 3AB

http://www.hrp.org.uk

The botanical gardens are open every day of the year except 24 and 25 December.

Kew Palace is open in the summer months only.

The collection of great Victorian glass buildings is completed by the Waterlily House, open during the spring and summer months, which also houses ferns, papyrus and hanging gourds.

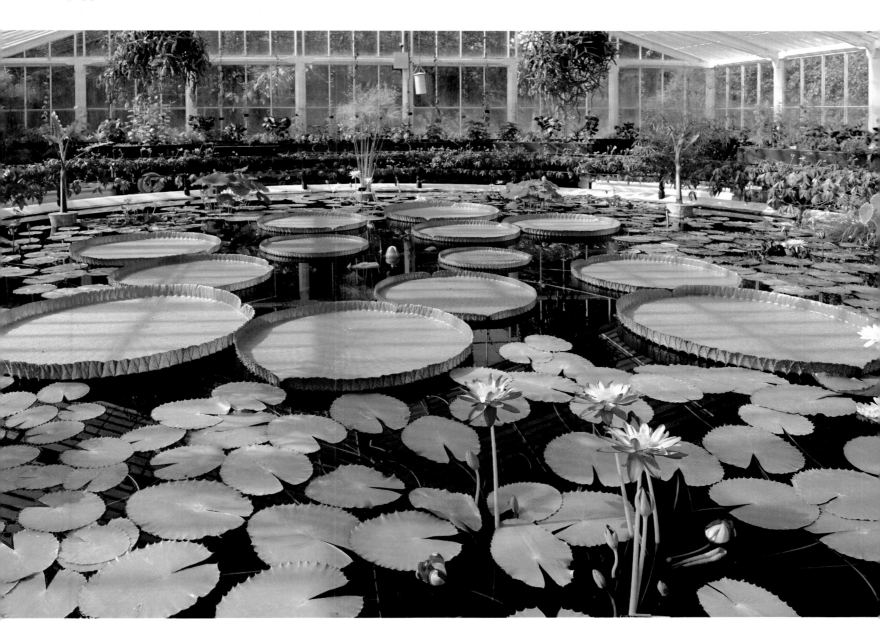

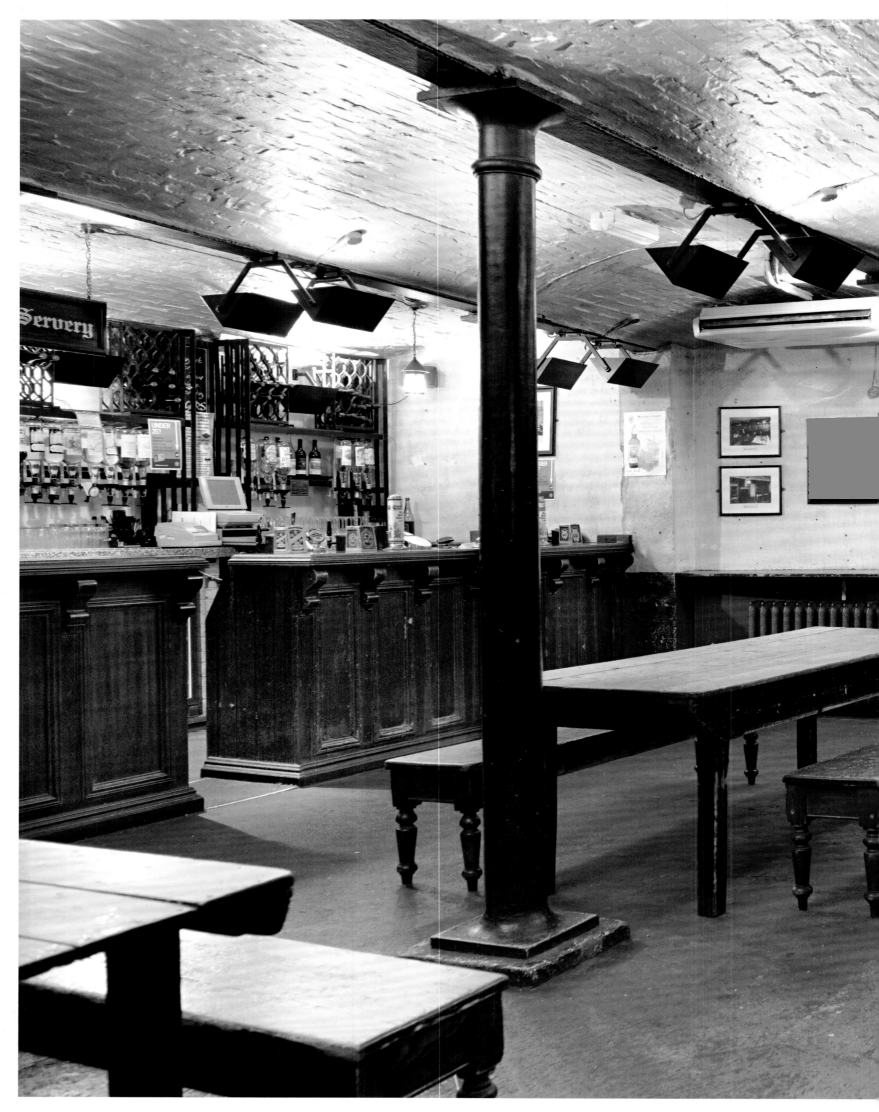

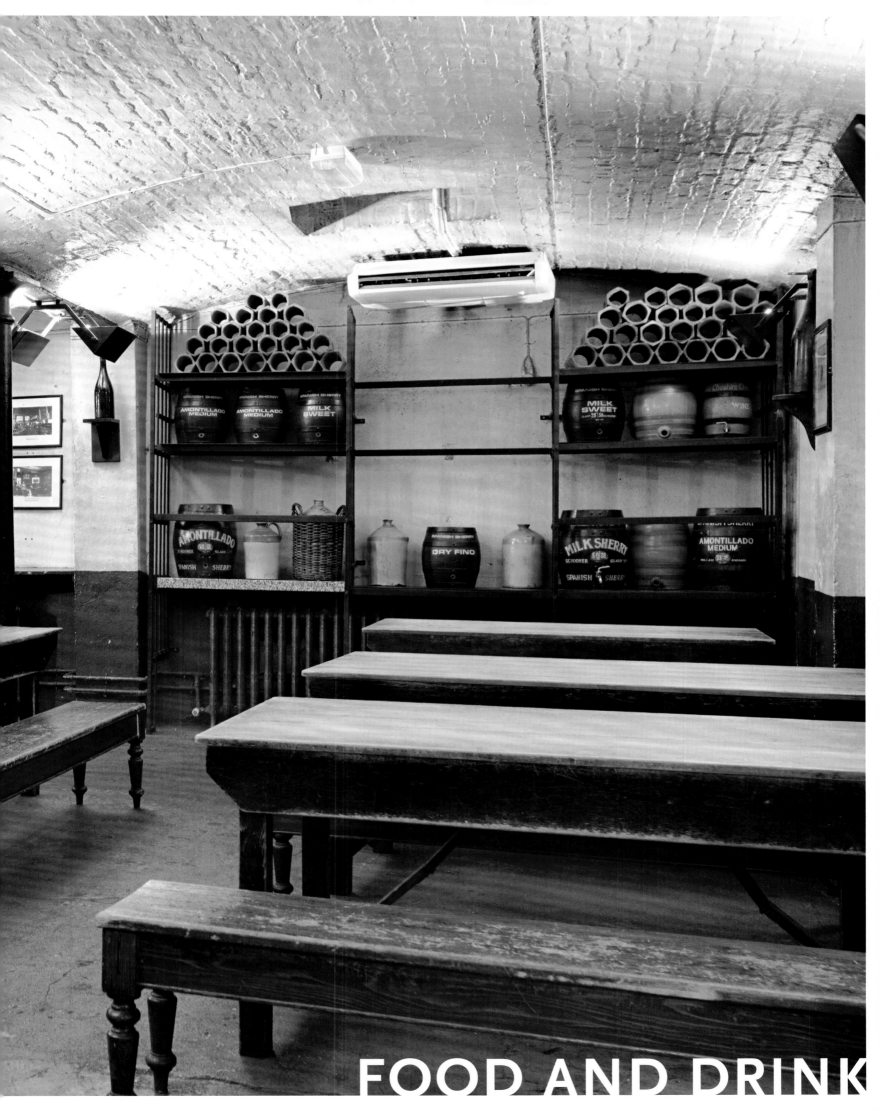

FOOD AND DRINK

Ye Olde Cheshire Cheese

Ye Olde Cheshire Cheese, one of London's most atmospheric pubs, requires two signs to attract and direct its customers. The first hangs outside 145 Fleet Street, the pub's address, but where no door exists. The second sign lies over the pub's entrance to the side, in a narrow alley called Wine Office Court. There is little hint here of the warren of bars, eating places and function rooms that are to be found inside the rambling pub.

The Cheese, as it is known by regulars, is a charming and bewildering place, because there are perhaps ten rooms on different upper levels, all connected by several narrow staircases, and two levels of cellars. Natural lighting is restricted, but its paneled wood and brick interiors give drinkers and eaters a feeling of welcome and intimacy.

A thirteenth-century Carmelite Monastery guesthouse originally occupied the site. The vaulted cellars are from the 1530s, but elsewhere the building dates from 1667 and the major rebuilding that was required as a result of the destruction wrought by the Great Fire of London. Layers of history have obscured the origins of its antique name. There was a Horn Tavern on Fleet Street recorded in 1538, and this may have been rebuilt and renamed after the Great Fire. A sign by the entrance dates its history to that rebuilding during the reign of Charles II, and it has continued trading during the reigns of fifteen sovereigns from James II onwards.

Its patrons have included many among the historical literary elite. It is particularly associated with Dr Samuel Johnson, who resided close to The Cheese in Gough Square. He is most famous for his *Dictionary* – published in 1755 – and the author,

PREVIOUS PAGE *The vaulted cellar bar lays claim to monastic roots with a Whitefriars Carmelite priory that once stretched from Fleet Street to the Thames.*

RIGHT *The old Chop Room restaurant on the ground floor. Low levels of lighting are said to be mandatory throughout the pub.*

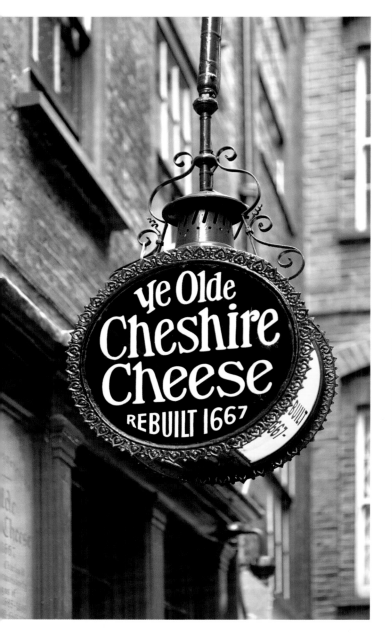

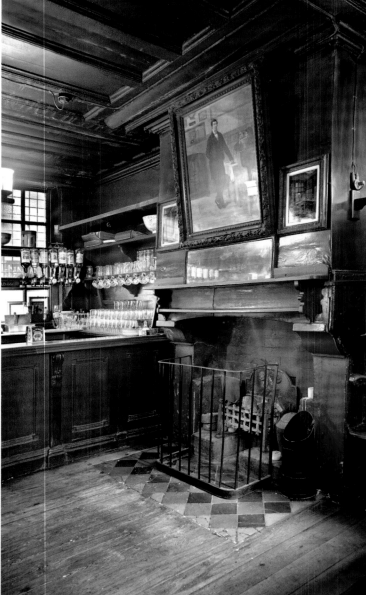

LEFT *This lamp marks the main entrance on the side of the pub; the origin of The Cheshire Cheese's name remains a mystery.*

RIGHT *In the ground-floor bar, there is sawdust on the floor and a fireplace under pictures related to history of The Cheese.*

editor, biographer, critic, essayist and raconteur would have known the establishment well, although opinions differ as to the extent he was a genuine Cheese regular.

Another sign declares that visitors included Oliver Goldsmith (a good friend of Johnson's best known as the author of *The Vicar of Wakefield*), P.G. Wodehouse, Wilkie Collins, Arthur Conan Doyle and even a visiting Mark Twain. All preferred the warmth of an alehouse to the more stuffy surroundings of gentlemen's clubs in the smarter areas of London, while the location of the tavern conjures up literary images of the maze of dark streets and alleyways inhabited by characters portrayed in Dickens' works.

Dickens knew The Cheese. This is believed to be where Sydney Carton takes Charles Darnay in *A Tale of Two Cities* 'down Ludgate Hill to Fleet Street and up a covered way into a tavern' to restore his strength 'with a good plain dinner and good wine'. The Irish poet W.B. Yeats and the Rhymers' Club met here in the 1890s, seated downstairs in high double-seated pews with a table between. He wrote: 'After supper at which we drank old ale and other time-honored liquors, we adjourned to a smoking-room at the top of the house, which we came to look upon as our sanctum. There long clays or churchwarden pipes were smoked.'

The Cheese makes the most of its literary links, even if some of the legends are hard to pin down or verify, but there is no doubting its journalistic connections.

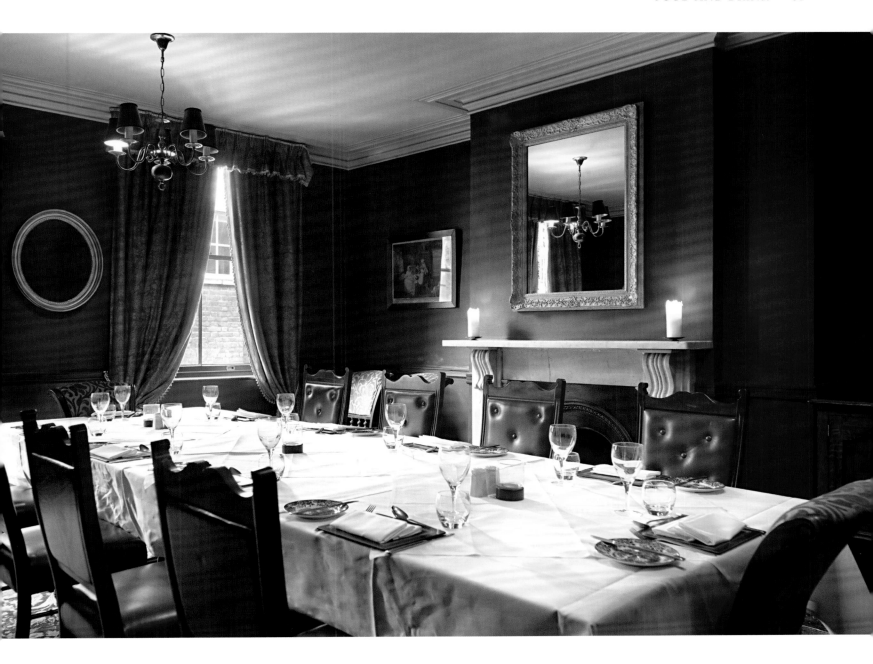

The Directors' Dining Room for functions on the fourth floor.

Fleet Street – named after the River Fleet that still flows close by, but long hidden underground – was for centuries associated with printing, and the area became home in the twentieth century to many of Britain's national newspapers, as well as wire services and agencies. During those years, The Cheese became almost notorious as a sawdust-carpeted watering hole for journalists and newspaper print workers, especially for those with guests or those who wanted to avoid some of the more open dens of Fleet Street. It was a place for reporters to argue the merits of a potentially exclusive story, to entertain contacts or simply to drink. New print technology caused a migration from Fleet Street before the end of the 1980s.

The Cheese is also known for a non-human regular. An African grey parrot called Polly that was associated with the pub for many years until its death in 1926 is preserved on display above one of the bars.

Now forming part of the Sam Smith brewery chain, Ye Olde Cheshire Cheese has no website, in keeping with its old-fashioned charm, and real fires continue to add to the ambience that makes it a warming location for those in search of London's hidden depths.

VISITING INFORMATION

Ye Olde Cheshire Cheese, 145 Fleet Street, EC4A 2BU

Open 11am–11pm Monday–Saturday, 12pm–4pm Sunday.

Bibendum

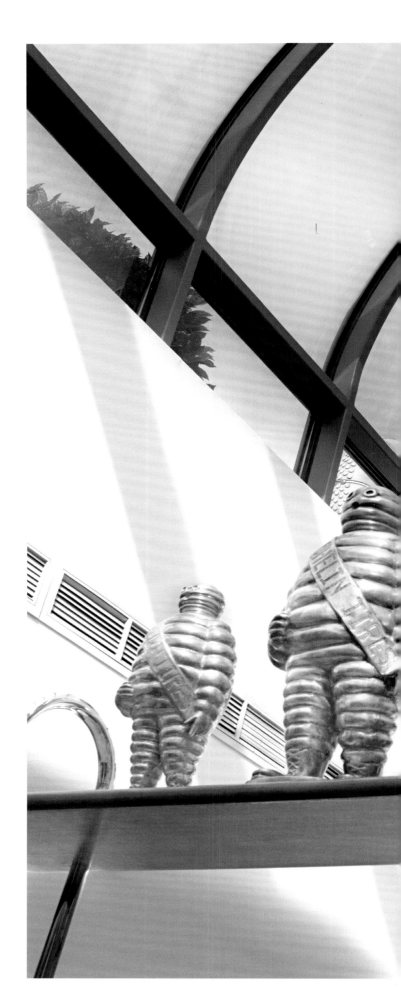

A unique industrial building, bearing one of the most recognisable figures in corporate advertising, became a smart new Chelsea restaurant in 1987. Bibendum is the name of the Conran restaurant at 81 Fulham Road, and also the true name of the Michelin Man mascot, who decorates the extraordinary building known as Michelin House.

French tyre manufacturer Michelin started work on a London headquarters incorporating a tyre depot in 1910. The building was one of the first in central London to use the Hennebique reinforced-concrete method used for warehouses, as local authorities started to allow wider use of this new type of construction. This would have enabled smooth unembellished concrete walls from top to bottom, but Michelin House emerged as an extravagantly styled palace, glazed with terracotta, and with monogrammed decorative ironwork. Two glass cupolas sit on turrets in the form of stacked tyres. The Michelin identity is everywhere: in script, corporate colours and signage, in the shapes of wheels and tyres, representations of rubber plants, and in the form of Bibendum himself on stained-glass windows and mosaic floors. Pictorial tiles, by Gilardoni Fils et Cie, depict motor sporting scenes from the Edwardian age, celebrating Michelin's early motor sporting successes.

Overall, the building represented an audacious corporate statement, a pioneer of branding and public relations. No architect is associated with the building, which was handled in-house by a Michelin engineer named François Espinasse and by the British-based agency for the Hennebique system. No particular architectural style is followed; Michelin House did not quite conform to the style of the Art Noveau period. Opening in 1911, it even seems to anticipate elements of Art Deco style by ten or fifteen years. It does owe something to the imagination of Edouard and André Michelin, the brothers who, while building an empire based on bicycle tyres, developed a shrewd notion of corporate identity and publicity. An inspired action was

Stained glass closely based on one the first Michelin posters of 1898, the tyre-man who absorbs and drinks up obstacles on the road.

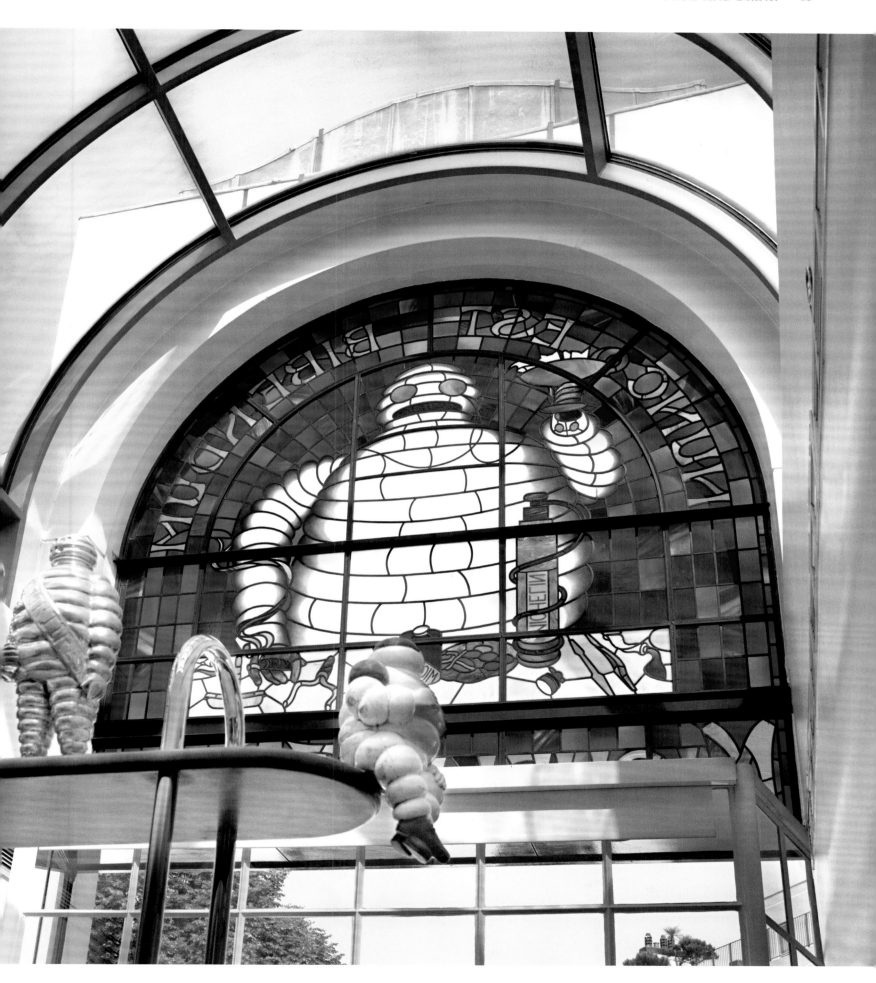

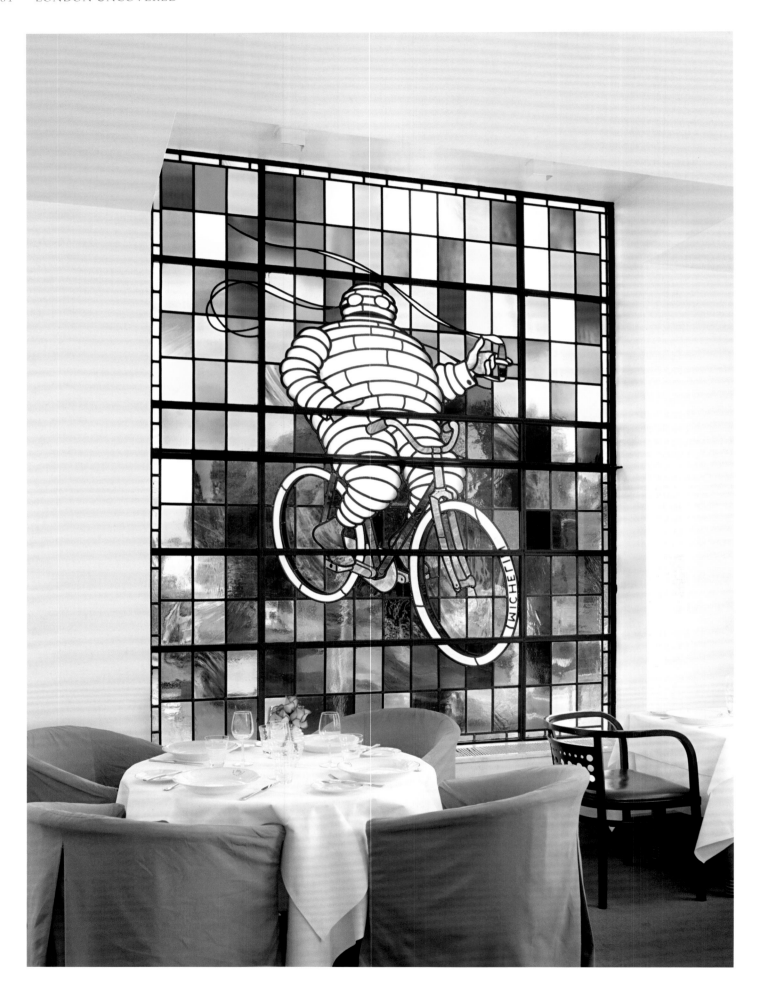

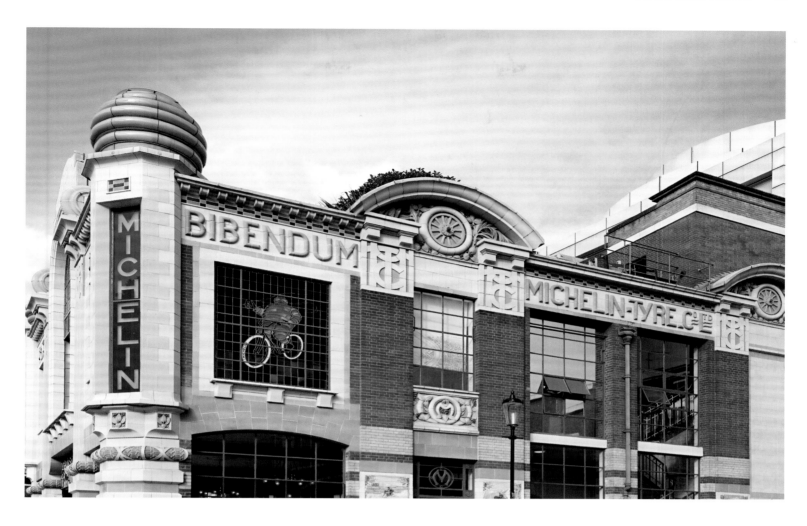

their development of a cartoonist's image into the company trademark symbol Bibendum, the tyre-man who drinks up obstacles on the road with the motto 'Nunc est Bibendum', meaning 'now is the time to drink'.

When the Michelin company finally departed and sold the Fulham Road building in 1985, it was purchased by Sir Terence Conran, restaurateur, designer and retailer, and Paul Hamlyn, publisher. Extensive architectural work followed, adding a new floor and a steel-and-glass addition on the west side. A Conran shop, extensive office space, and oyster bar, café and restaurant on the first and ground floors were opened.

The new Bibendum restaurant, with Simon Hopkinson as chef and joint proprietor, continued the Michelin synergy that linked travel to eating places, guidebooks and maps. It re-introduced three stained-glass windows into what had become a luxurious dining room. This required extensive research of old photographic material to replicate the original windows as precisely as possible.

The three original windows in the first floor offices at Michelin House had been taken down in 1939 and placed in packing cases before removal to the company's factory at Stoke-on-Trent for safe keeping during the war. When the company completed an audit in 1948, the windows could not be found. There were rumours that the stained glass had been spotted at various times during the 1960s and 1980s. In 2010, as the 100th anniversary of Michelin House approached, the tyre-maker declared an amnesty in a bid to find the missing windows. A confidential hotline and a webpage were advertised by Michelin and hundreds of reports came in, some suggesting the windows were still in Staffordshire, or could be found in Australia or Canada. But none of the leads generated by the appeal led to the missing windows.

VISITING INFORMATION

Michelin House, 81 Fulham Road, SW3 6RD

http://www.bibendum.co.uk

Book online.

L. Manze

The L. Manze establishment on Walthamstow High Street is a classic example of an unmistakeable London building type: the eel, pie and mash shop. This was recognised by English Heritage when it was awarded Grade II listing in October 2013.

One of the reasons given for the listing is the shop's interior, which is particularly stylish and exceptionally complete and original. The walls are lined with green-and-white tiles, with a frieze of wreaths joined by ribbons running around the top. Bevelled-edge mirrors are inset. Marble-topped tables are fixed to the pink-and-grey terrazzo floor in a series of seating booths, with benches within high-backed timber partitions. The cream-coloured ceiling appears to be tiled, but is made of pressed-tin panels. Manze is a shop-restaurant, and the serving area has marble counters and shelves, old-fashioned zinc-and-hardwood work surfaces and an antique cash register. On a small counter there is a place where fresh eels were once displayed on ice.

Outside, a black Vitrolite glass fascia bears the shop name in gold drop-shadow capitals. It is clear that the sash windows once worked as serving hatches for takeaway sales. The shop was opened in 1929, and a strong modern image was carried throughout, while incorporating traditional Victorian elements. A pie and mash shop has to look like this. The architect was Herbert Wright, who was responsible for several other commercial properties in north London on the Clerkenwell and Pentonville Roads, but none as memorable as L. Manze.

Eel, pie and mash shops started in London during the 1860s, developing from the street sellers who sold pies and eels: cheap food. Eels may have been an original pie filling. The social historian Henry Mayhew described how hundreds of street sellers were soon supplanted by pie and mash shops. By 1874 there were thirty-three listed in the London trade directories,

The dining room has tin ceiling panels, the seating is fixed, the floor is terrazzo and all is original.

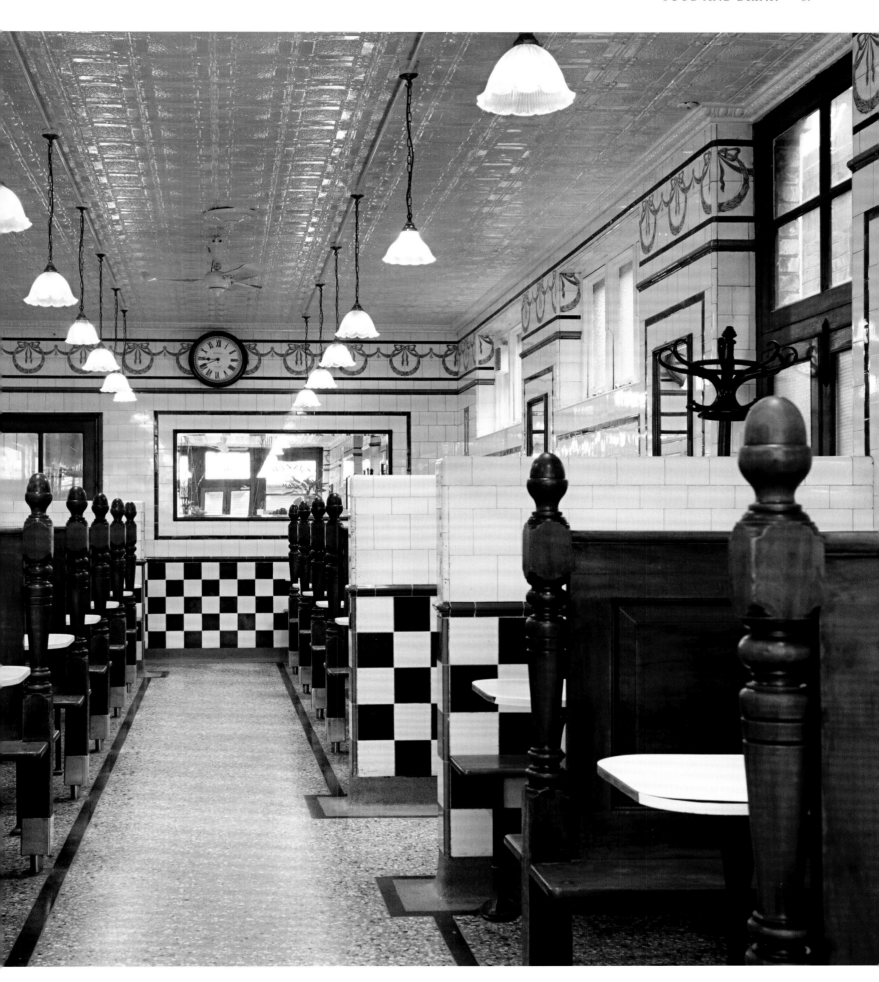

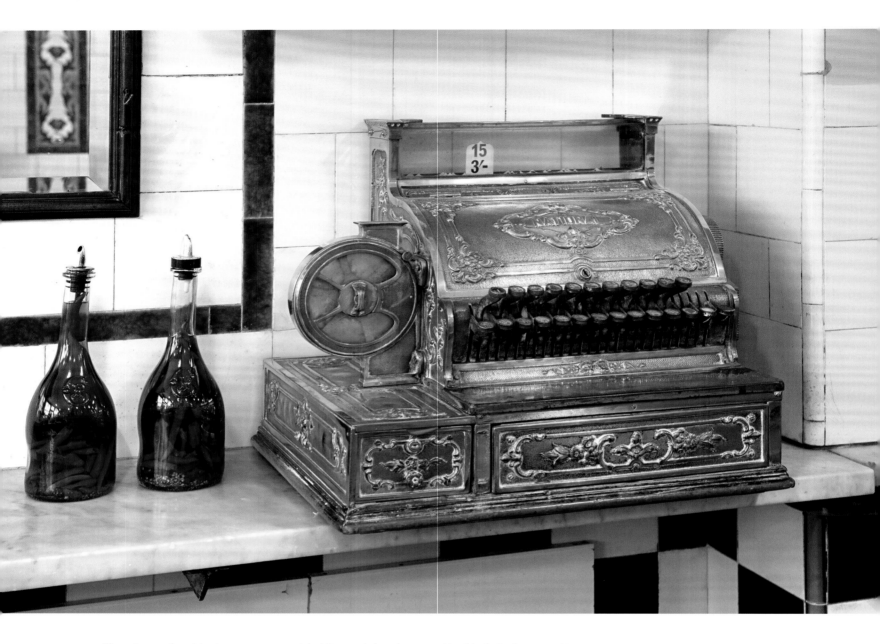

ABOVE *The antique cash register is now an ornament, but it seems to have been operational in decimal currency times.*

OPPOSITE ABOVE *On opening in 1929, the black glass fascia was up-to-the-minute.* OPPOSITE BELOW *Pies are cooked fresh every day on the premises.*

and in February 2016 there were still around twenty-five traditional pie and mash shops with London postcodes, according to the Pie & Mash Club, with fifty-two more further outlying. There was a strong history of particular families being associated with the business: the Cookes, Manzes, Burroughs, Kellys and Goddards, and some of those names can still be found on pie and mash shopfronts today.

The Manze family came to England from Italy in 1878. Michele Manze married a daughter of pie shop operator Robert Cooke, and opened a number of shops, and in turn his son Luigi opened the L. Manze Walthamstow shop, which was run by the family until 1970. Current owner Jacqueline Cooper and family have run the shop since 1986. Shops of the M. Manze empire continue, and the original one of these at 87 Tower Bridge Road in Bermondsey won listed status in 1998.

There is clearly growing respect for the architecture and cultural significance of eel, pie and mash shops, and, in the age of funky food, possibly a greater enthusiasm for the menu: the pies, which are made every day on the premises, and for the mash and mysterious liquor.

VISITING INFORMATION

L. Manze, 76 Walthamstow High Street, E17 7LD

Open 10am–5pm Monday–Saturday.

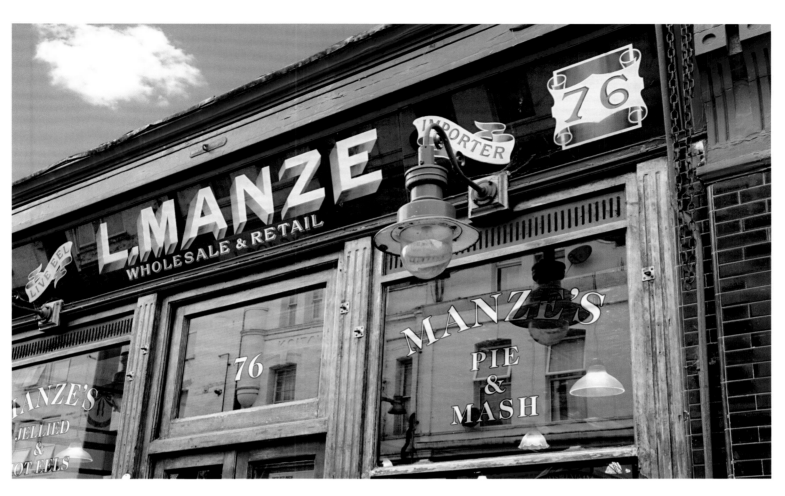

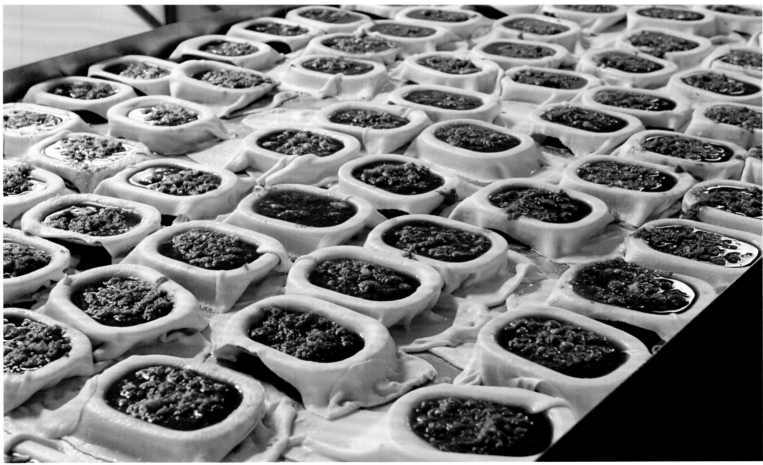

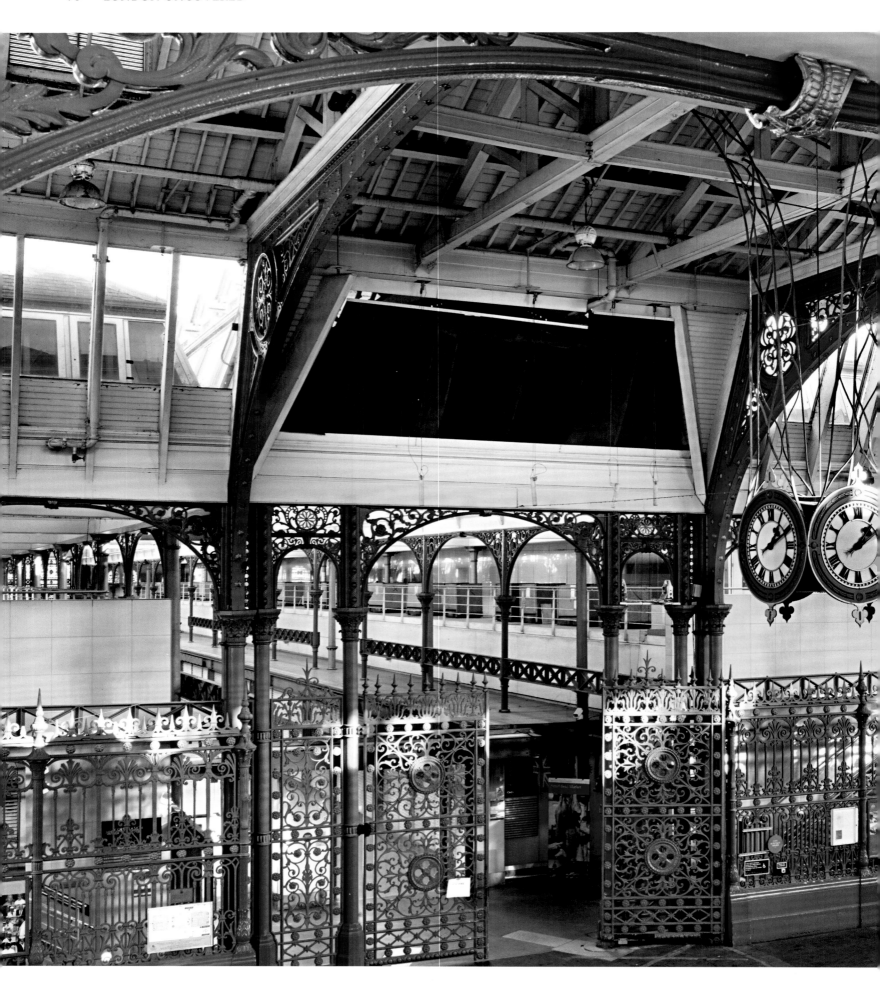

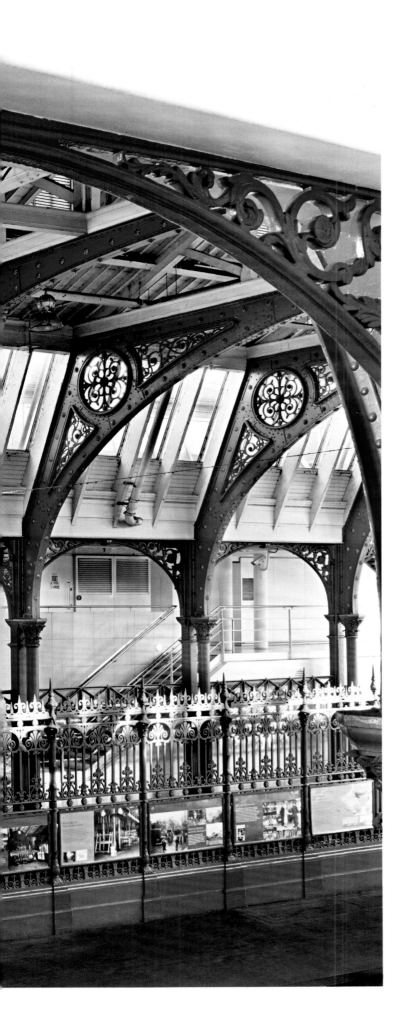

Smithfield Meat Market

Smithfield Meat Market is the great survivor of the wholesale markets of central London. It is owned by the City of London and operates in its original 1868 buildings inside the northern edge of the Square Mile. Properly known as London Central Markets, it handles over 100,000 tonnes of meat each year. Its architect was Horace Jones, who designed Tower Bridge. One of the surprises of Smithfield is how much of the original has survived. The goods yard is now a car park, but is served by the same spiral ramp, with the rotunda garden inside. The hydraulic lifts that raised the meat to market have gone, but Metropolitan tracks remain below as the busy Thameslink and Crossrail lines. The poultry market building alongside dates from 1875. Following a fire in 1958 this was rebuilt in 1963 with a clear span-domed roof.

The major changes to the market have been to working practices. Besides butchers and cutters, some trades dated back 130 years: the 'drawers back', the 'pitchers', 'humpers' and 'bummarees'. Most of that has gone, and in the 1990s the inside of the east and west wings was transformed. What once were open arcades with individual stalls were converted into more than forty temperature-controlled areas for tenants, together with sealed loading bays and an overhead hookline meat-handling system.

VISITING INFORMATION

London Central Markets, EC1A 9PS

http://www.smithfieldmarket.com

The Market officially closes at midday, but it is best seen during its working hours between 3am–7am. Walking tours take place once a month. Book in advance.

The Grand Avenue screen and gates restored to original colour scheme of 1868. The traders are located beyond the gates. A four-faced drum clock by Thwaites & Reed of Clerkenwell was installed in 1870 and hand-wound for almost a century before conversion to electricity.

The Ivy

Look at a map showing the two square miles known as Theatreland, put in a pin in the central point, and there you will find the Ivy restaurant. It is has existed for more than a hundred years on a sharp corner of West Street and Litchfield Street, near Covent Garden. The Ivy is rated as one of the most stylish dining spaces in London, and is inseparable from the world of show business, theatre, celebrity and the arts.

As its reputation has grown, it has gone through many changes of ownership and several redesigns. The latest was a major reworking in 2014–15 by Brudnizki Design Studio, which updated throughout the traditional Ivy theme of green-and-red leather and mohair-trimmed seating. It introduced an island bar, employing advanced lighting techniques and mirrors, into the wood-panelled dining room, with a mixture of tables and banquettes.

From the outside, the diamond-patterned stained-glass windows are the signature feature, the randomly placed coloured panes offering illumination and a discrete environment for the diners inside. It's hard to see inside from the street.

Another Ivy tradition, one that dates from a refurbishment in 1990 by M.J. Long, is its inclusion of modern art, and this has been maintained and updated. Some of the pieces were specifically tailored to the room and some make witty connections with the world around the Ivy. Terry Farrell, the sculptor who created famous dancing hares, contributed *Stage Door Johnny*, a top-hatted theatre-going bronze hare. Other artworks are by Damien Hirst, Peter Blake, Tracey Emin, Patrick Caulfield and Eduardo Paolozzi.

The Ivy opened in 1917, initially as an unlicensed one-room café in what was then a narrow house in West Street. Ivy legend says that the restaurant's name was chosen after the original proprietor, Abel Giandellini, apologised for noisy building work in progress. He was told by customer Alice Delysia, a notable revue actress of the day, not to worry. 'We'll cling

The island bar was introduced to The Ivy as part of its most recent refit in 2014–15.

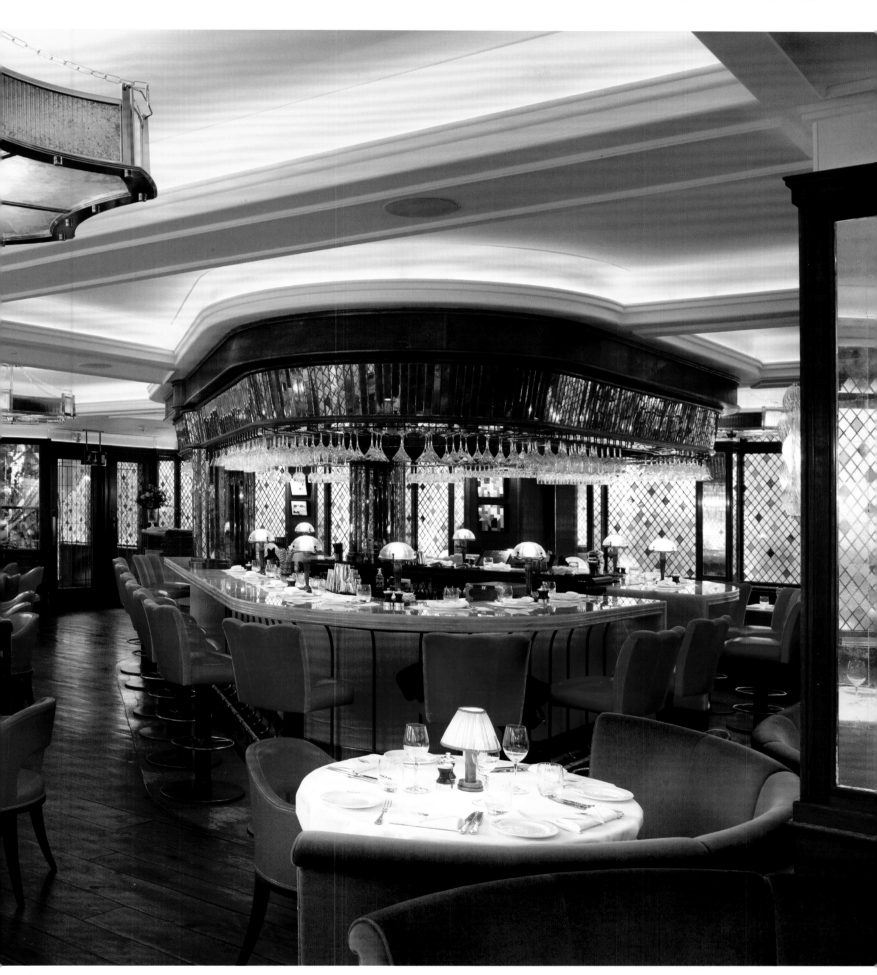

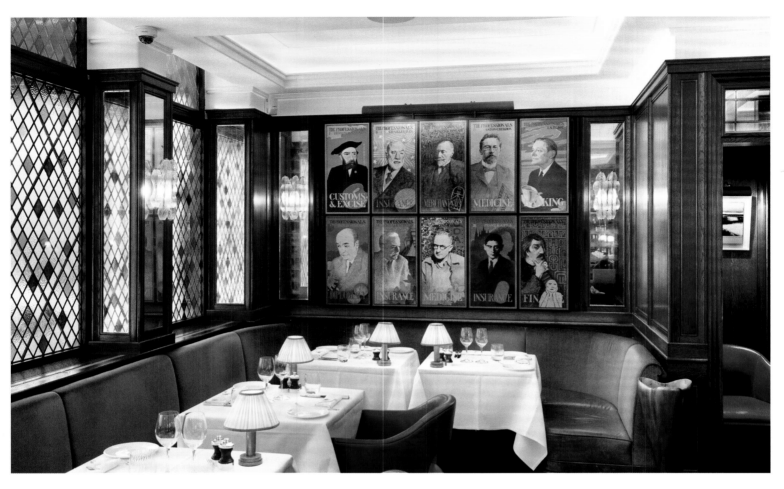

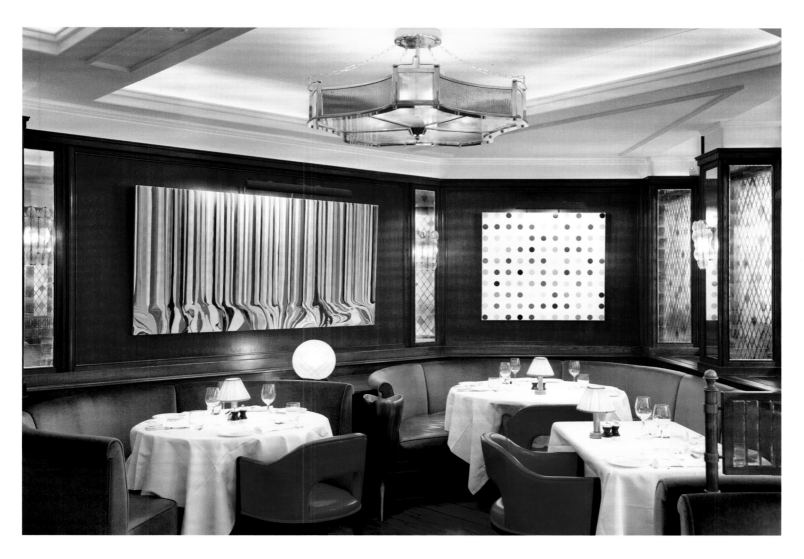

OPPOSITE *Tom Phillips'* The Professionals: *ten panels in the style of old-fashioned cigarette cards, depicting modernist artists in various fields. Each of them, while devoted to creativity, also had surprising professions. By the entrance, a stained glass window* Paper Moon *by Patrick Caulfield includes theatrical dressing room light bulbs. In the foreground is an untitled brass strap screen of mechanistic shapes by Eduardo Paolozzi.*

ABOVE *Paintings by Ian Davenport and Damien Hirst.*

together like the ivy on the old garden wall,' she said told him, paraphrasing a line from a popular song of the time.

The Ivy's menus are not based on any one style or regional cuisine, but are described by the restaurant itself as 'modern dishes with international influences, with a particular nod to Southern Europe and Asia'. There are modest dishes such as liver and onions, and the Ivy burger and shepherd's pie are famed, maintaining a connection with the days when the café sold cheap meals to actors. A leading theatre critic has claimed that the Ivy is affectionately known as 'the works canteen' by certain actors, but the critic or the actors may have been ironic. Writer and restaurant critic A.A. Gill said 'a table at the Ivy is one of the most sought after pieces of furniture in London'.

The original one-room lino-floored café was extended in 1920, and in 1928 the establishment was properly rebuilt to fill out into the space occupied by the Ivy today. The restaurant now seats more than 100 people, and there is a private dining room upstairs. During the 1930s its reputation grew under manager Mario Gallati, who went on to open Le Caprice in 1947. The Ivy clientèle soon expanded to include politicians, writers and those from what is today described as the media. The Giandellini–Gallati era ended with the sale of the Ivy to the Wheeler's group of restaurants, then to the Forte Foundation. Briefly closed, the Ivy was revived by Jeremy King and Chris Corbin in 1990 and is now owned by Caprice Holdings.

VISITING INFORMATION

The Ivy, 1–5 West Street, WC2H 9NQ

http://www.the-ivy.co.uk

Book online.

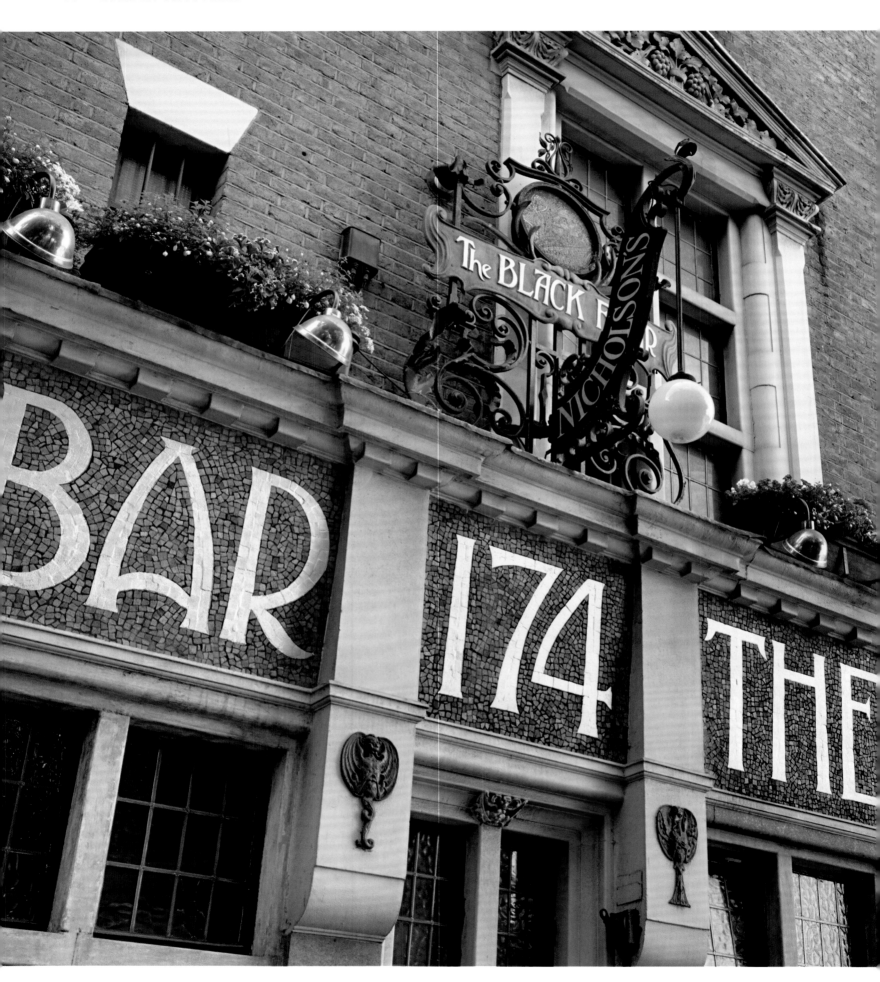

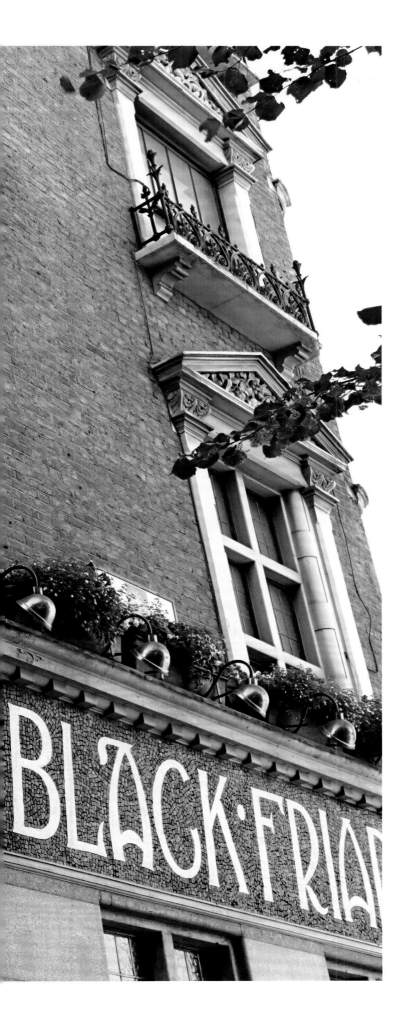

The Blackfriar

The Blackfriar pub on Queen Victoria Street stands like half-opened book, with the stone figure of a friar embedded on its spine. Inside lies an Arts and Crafts-styled fantasy world unlike any pub in London.

The multi-coloured marble-faced walls are adorned with pictorial panels and friezes. The decorative theme is based on monks and good spirits, with happy friars living jolly lives. Monks are depicted fishing, gardening, washing and pushing a wheelbarrow carrying a trussed pig. Everywhere there are mosaics, copper reliefs, scripts bearing axioms, stained glass, brass, mahogany and mirrors. A light-hearted design touch is applied with high-quality materials used throughout. Outside, the style continues: the clock on the spine has a mosaic face and even the strictly commercial signage for 'Worthington Ales in a Bottle' and 'Booths Gin' is rendered in copper relief with Arts and Crafts fonts, flanked by figures of friars. All of this was inspired by the Dominican monastery that existed close to site between 1221 and 1538, and gave its name to the Blackfriars area.

A late addition to the pub, beyond the original bars, was the Grotto, a barrel-ceilinged room lined with alabaster and marble, built out into a vault under the neighbouring railway, separated from the saloon by three arches. There are no windows, but mirrors are used to good effect. Despite the apparent constraints of its shape, The Blackfriar is deceptively roomy.

The pub was built in 1875, but did not gain its special interior until it was remodelled in 1903. Herbert Fuller-Clark was the architect, and sculptors Henry Poole, Frederick Callcott and carver Nathaniel Hitch were employed to create the decorative features. The curious shape of The Blackfriar can be understood by its position next to the old London, Chatham and Dover Railway line running alongside, which existed before the pub was built. The back wall of the pub was built right against both

The striking signage in green-and-gold mosaic dates from the 1903 remodelling.

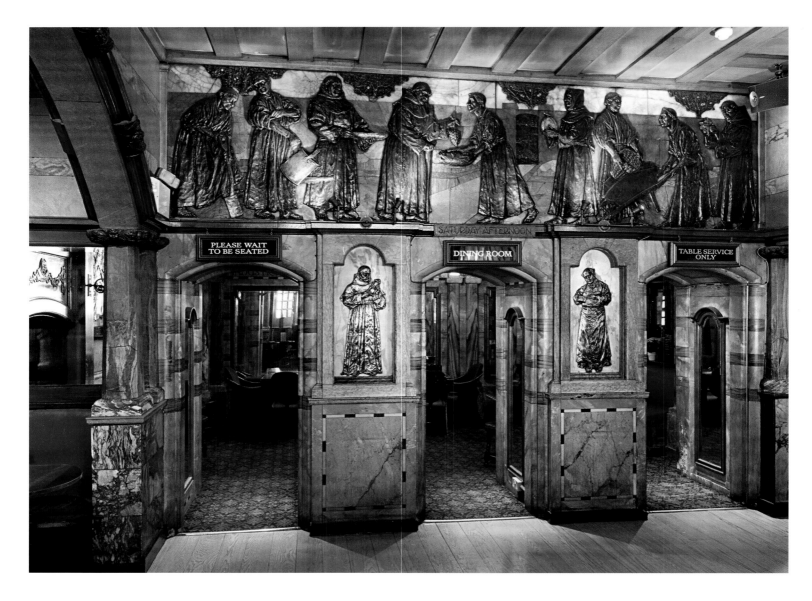

ABOVE *'Merrie England' scenes of frolicking friars are displayed in copper relief.* OPPOSITE *Standing alone, The Blackfriar fitted tightly into its previous surroundings.*

the railway and a signal box that straddled several tracks at this point. Back then, the railway bridge over Queen Victoria Street was tight against the pub because it was more than twice as wide as the bridge in place today. It was the reduction of tracks and the narrowing of the bridge that cast The Blackfriar adrift. The pointed end of The Blackfriar was generated by the need to fit into the irregular ground plan of streets existing at the time.

The Blackfriar was under threat in 1964, when the area around it was slated for redevelopment and the pub marked down for demolition. The preservation movement was at that time gathering support, after early setbacks in London, and a campaign by the Victorian Society, led by poet Sir John Betjeman and Lady Dartmouth, saved it.

In a pub bristling with interesting features, there is a plaque outside making a possibly tenuous claim: 'It is believed that Emperor Charles V, the Papal Magistrate and Henry VIII's

court sat on this very site during the dissolution of Henry VIII's marriage to Catherine of Aragon in 1532.' Elsewhere, it has been recorded that during the proceedings King Henry detested the stink of the Fleet River, which flowed into the Thames at this place.

London's lost Fleet River certainly now flows underground a few feet from The Blackfriar, and nearby it is possible to find fragments of stonework from the lost abbey of Blackfriars, and the theatres and courtyards that supplanted it in Shakespeare's time. There is a true whiff of history at this spot and a maze of streets to explore just a few steps away.

VISITING INFORMATION

The Blackfriar, 174 Queen Victoria Street, EC4V 4EG

http://www.nicholsonspubs.co.uk

Open 9am–11pm Monday–Saturday, 12pm–10.30pm Sundays.

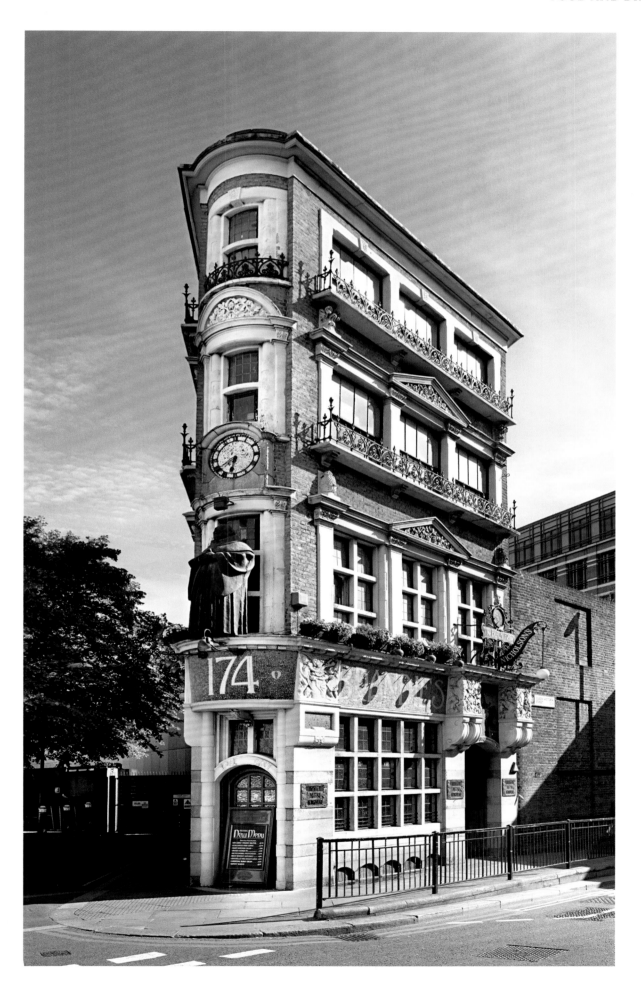

Berry Bros & Rudd

At street level it is hard to guess the full extent of Berry Bros & Rudd, Wine & Spirit Merchants, but there are clear signs of its antiquity. The windows of No. 3 St James's Street proclaim that it was established in the seventeenth century, and the paintwork on the frontage appears ancient, apparently black but in reality the darkest possible shade of green. Wine cellars below the shop extend for 2 acres to the back, front and side of the building.

A hanging sign outside shows a coffee mill, which was one of the shop's first lines of business, along with tea, snuff, sugar and spices, mostly imported from the New World. It was opened as a grocer's store in 1698 by a widow named Bourne, possibly Katherine Bourne, and served the increasingly fashionable area of St James's with its coffee and chocolate houses. Her descendants, including one George Berry, shifted the business emphasis to wine by the early nineteenth century.

Inside the panelled shop with its sloping wooden floor, hangs a large set of scales once used to weigh goods and, curiously, some of the customers. It used to be fashionable for men to have themselves weighed while they made their purchases, a set of scales being scarce domestic devices and knowledge of weight showing an awareness of health. At Berry Bros, the ledger has recorded since 1756 the results of some illustrious subjects, including the Regency dandy Beau Brummell, who was weighed here several times, Lord Byron, Lord Melbourne and Sir Robert Peel.

In the time of Beau Brummell, wine was not regarded as a luxury item, for however expensive it was the bottle was always worth more. Wine was bought by the cask, and the servant whose job it was to put the cask wine into bottles was called the 'bottler', from which the word 'butler' derives. Bottling only became economical in the early twentieth century; any vessels

One of a vast network of wine cellars belonging to Berry Bros & Rudd.

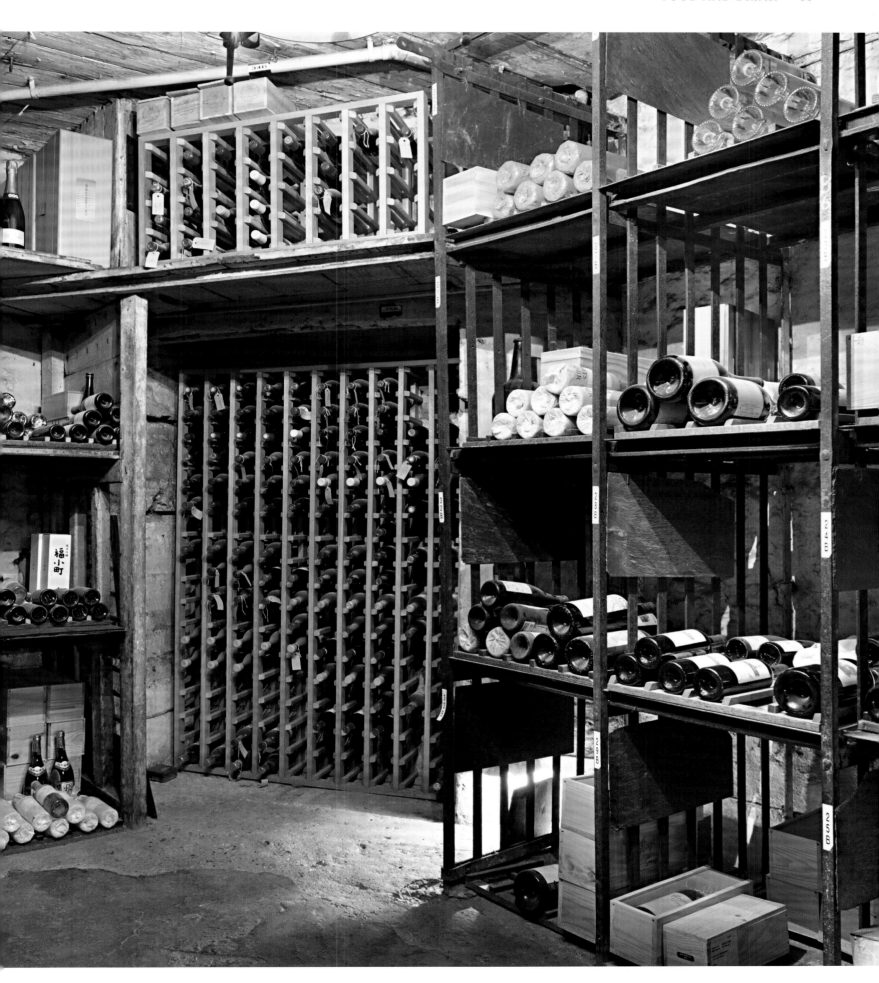

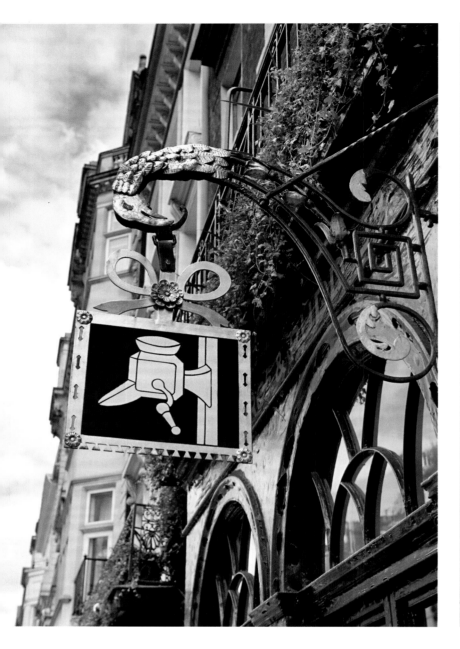

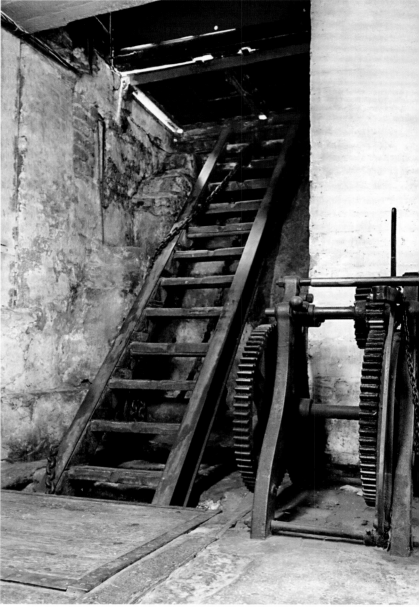

dating from older times are now rare and expensive. Berry Bros & Rudd displays an antique collection of these.

Berry Bros & Rudd are Britain's oldest wine and spirit merchants, still operating under the ownership and management the Berry and Rudd families, now an international company with offices in Hong Kong, Singapore and Japan, and buying and selling wines from around the world. As well as having long history, they claim to be the first wine merchants to open an online wine shop in 1994, and to establish an online wine broking exchange. The main warehouse in Basingstoke opened as recently as 1967, while No. 3 St James's Street continues as the flagship

store and continues to expand its cellars.

One of these is Pickering Cellar, which extends under Pickering Place behind, dating from at least the seventeenth century. At the entrance is an alcove where Louis Napoleon, nephew to Napoleon Bonaparte, once took refuge in a dangerous moment during the Chartist riots of the 1840s. He lived nearby on King Street, exiled following his second failed coup to become President of France. He and George Berry were friends and, together with the chef of The Athenaeum, had joined the militia to suppress the riots. When Louis Napoleon departed in 1848 he left his truncheon behind. It still hangs outside the cellar.

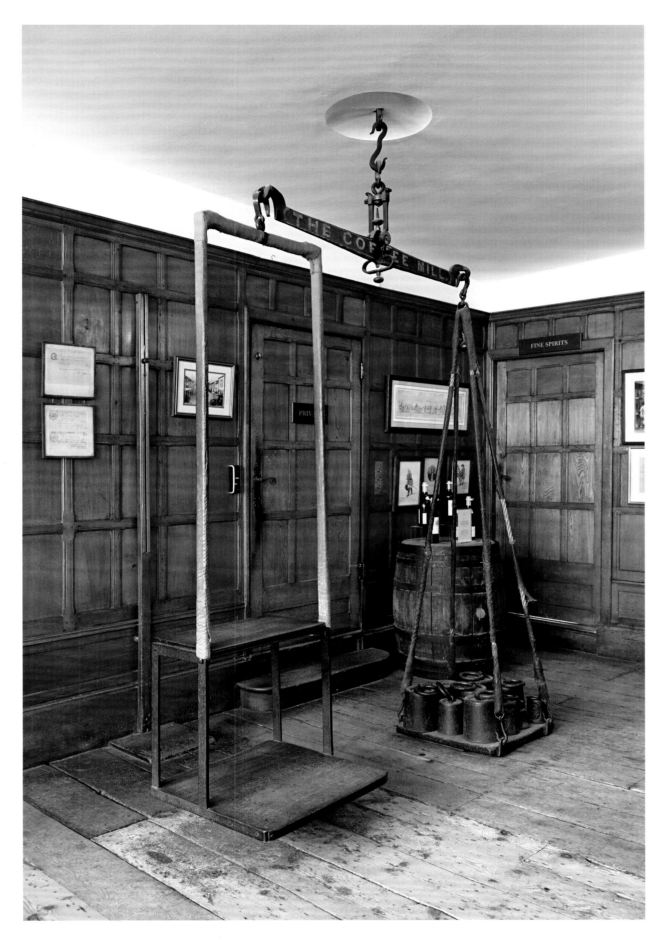

An original set of scales for coffee, and occasionally people.

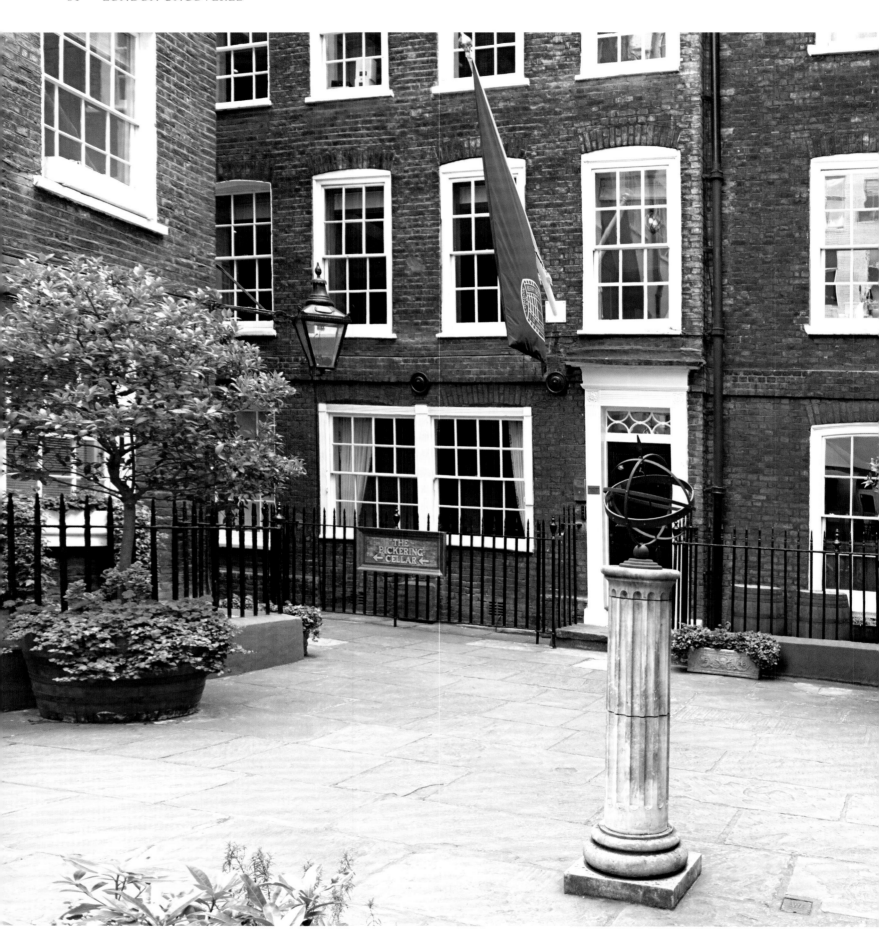

Pickering Place, the smallest public square in London.

The space was once employed as a bottling cellar. Barrels were lowered on a hoist that is still sometimes used to take wine down from street level. The cellar is home to Berry Bros & Rudd's wine school.

Another cellar is accessed through a discrete door in one of the houses in the courtyard behind. This is Sussex Cellar, built on two levels, in which thirty-six can dine. It is named after the Duke of Sussex, one of seven royal dukes who were customers of the company in the early nineteenth century. The cellar is a modernised space, influenced by Spanish bodegas, using tiles to create archways and columns through the mezzanine and the sub-basement level.

A walk through the alley to the side of Berry Bros & Rudd leads to Pickering Place, claimed to be the oldest and the smallest public courtyard in London. This gas-lit enclave, with a sundial in the form of an astrolabe at the centre, is surrounded by five houses; over time it was home to a gambling den, bear-baiting, cockfighting, dog fighting and a number of duels, one of which was fought by Beau Brummell. It was once the site of Henry VIII's royal tennis court, with remnants of one wall remaining below ground. Prime Minister Lord Palmerston lived in the square, and later the novelist Graham Greene. No. 3 Pickering Place is the Berry Bros & Rudd Townhouse, home to receptions in its Green Room and Long Room.

The most curious feature of the wainscoted alley leading to Pickering Place is described by a plaque just inside the entrance. A doorway here once led upstairs to the rooms used by the Texas Legation between 1836 and 1845. Effectively the Embassy of the Republic of Texas in Britain, it was established to support the international cause of the country, which was then a sovereign republic independent from the United States and Mexico. General Sam Houston, the Texan President, dispatched a diplomatic representative to London who worked in rooms leased from the wine merchants.

VISITING INFORMATION

Berry Bros & Rudd, 3 St James's Street, SW1A 1EG

http://www.bbr.com

Open 10am–9pm Monday–Friday; 10am–5pm Saturday.

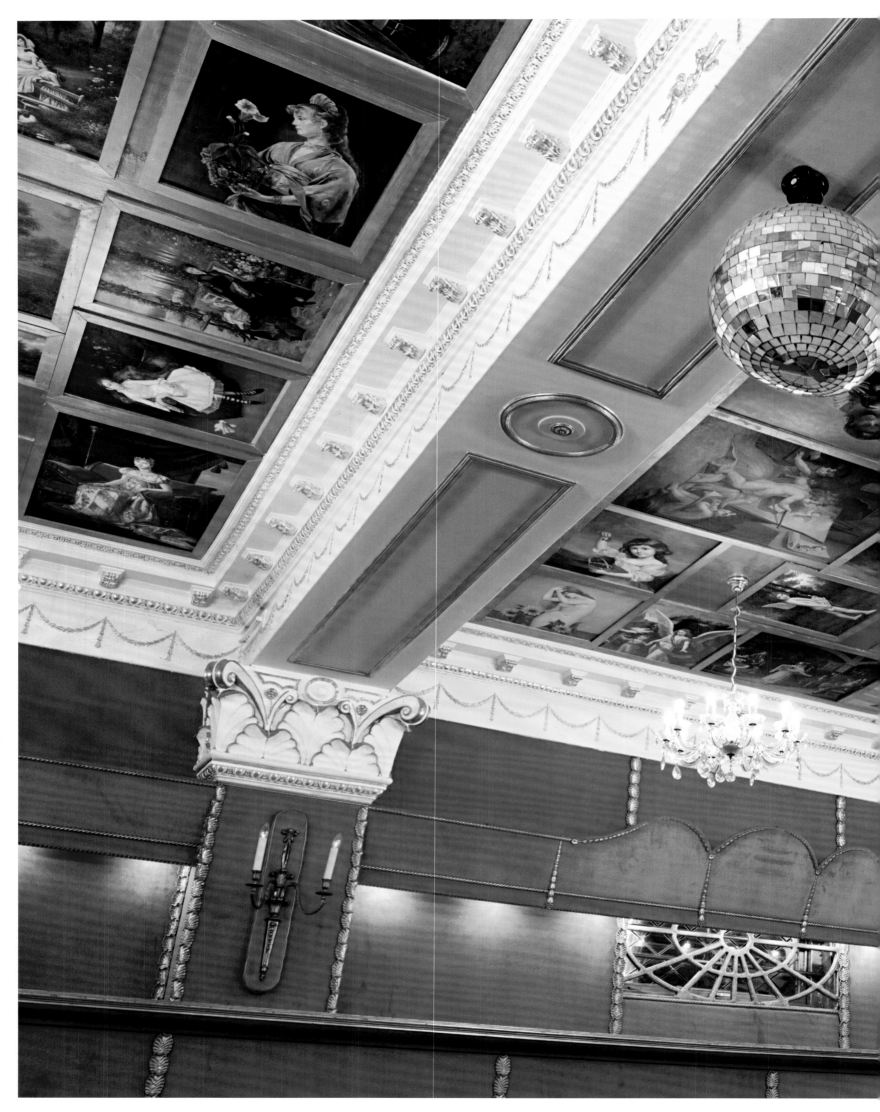

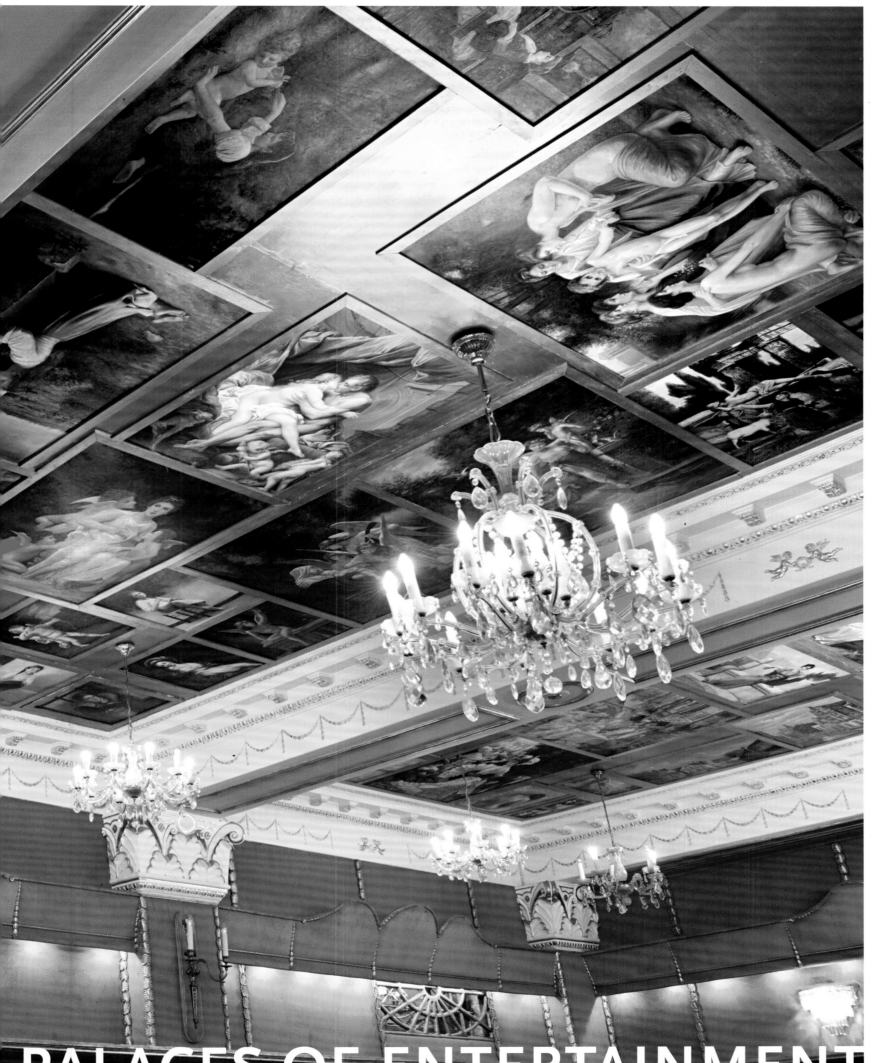

PALACES OF ENTERTAINMENT

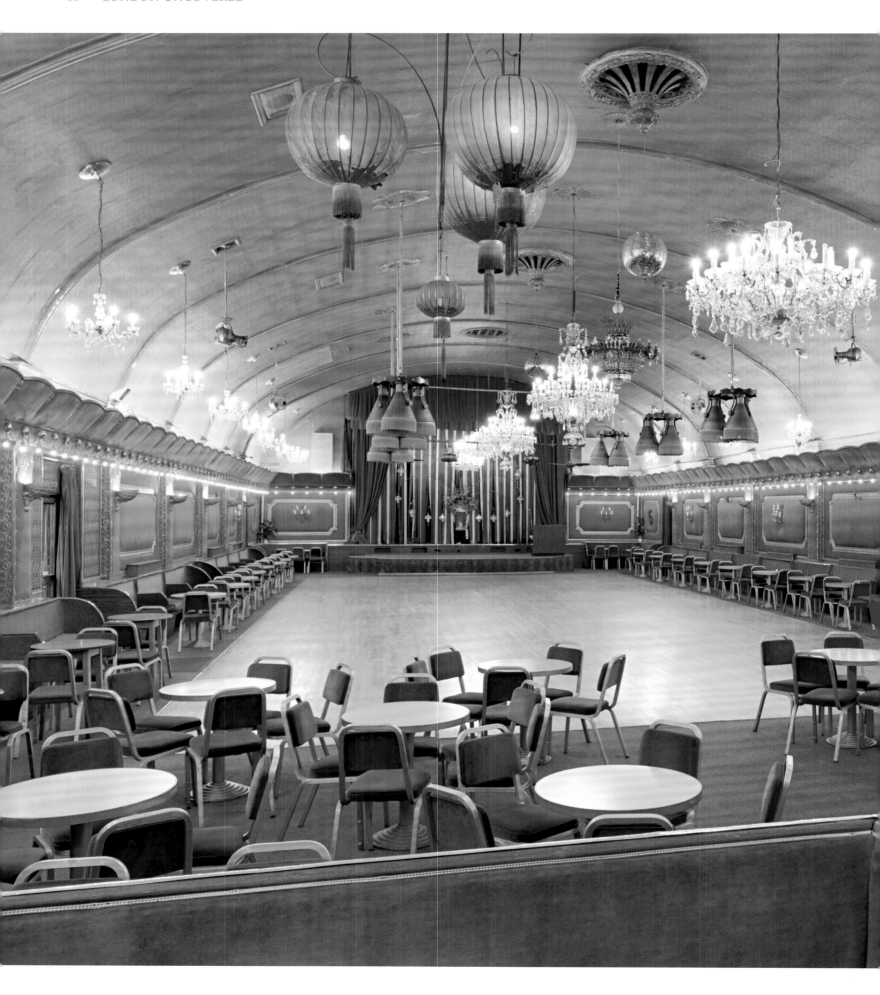

The Rivoli Ballroom

The Rivoli Ballroom is a wonderful anachronism, unveiled at the dawn of the 1960s to evoke the style of an age just passed, and as years have passed its charm has increased.

In the scarlet-and-gilt ballroom there is a riot of influences at work. Illumination is by Chinese lanterns, French chandeliers, glitterballs, candelabra and scallop sconce uplighters. Wall decorations consist of padded red velour panels with pelmets and gilt framing. At the end is a proscenium with a red plush curtain and raised stage for the band; at the opposite side, a raised viewing dais. Banquettes, fixed tables and paired chairs run along each side for couples. The most important feature is the sprung Canadian maple dance floor. Only the barrel-vaulted ceiling was left unchanged from the ballroom's former life as a cinema.

The building started out as the Crofton Park Picture Palace in 1913, a modest cinema typical of its time, built without a balcony and seating 525. In 1931, it was re-named the Rivoli Cinema, a café was installed, and outside a façade was added in Art Deco style, including pilasters topped with plasterwork urns and a raised parapet. The seating capacity was increased to 700 in an extended auditorium.

It remained an independently operated cinema into the 1950s, squeezed by the growth of television and the grip on film distribution held by the ABC and Rank chains, which controlled the latest Hollywood releases. The last picture show for the Rivoli Cinema was an incongruous double bill of *Reach for the Sky* and *The Nat 'King' Cole Musical Story*, shown on 2 March 1957, after which the building was closed

PREVIOUS PAGE *Chandeliers, disco balls and reproduction oil paintings on the ceiling of the Gold Ballroom.*

LEFT *The vaulted ceiling in the ballroom is the only visible legacy of Rivoli's cinema ancestry.*

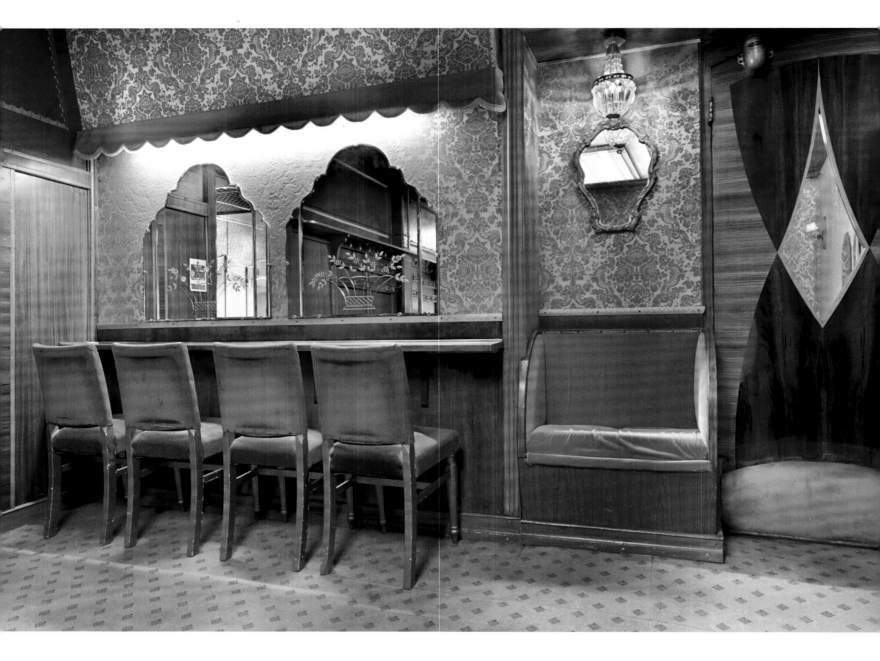

Red plush continues in the Ladies' Powder Room. The design of intersecting curves seen in the marquetry on the door is continued from the foyer.

for more than two and half years. A local businessman and dance enthusiast named Leonard Tomlin applied to have the cinema converted into a dance hall, and plans were approved by the local authority in September 1958. It opened on Boxing Day 1959.

As revealed then, the Rivoli Ballroom did not conform to one particular style or period, although it certainly harked back to before the Second World War, possibly aiming for the 1920s. It is self-consciously retrospective, and there is signage for facilities described as the 'Ladies' Powder Room' and the 'Gentlemen's Cloakroom'. The foyer has marquetry panelling with decorated doors.

Bars were added on each side of the dance floor, and a second function room seems to date from this time: a neo-classical gold-walled room in Adam style. The ceiling is covered with reproductions of old romantic rococo-style oil paintings.

Producers of music videos have discovered the Rivoli as an atmospheric location. Elton John's 'I Guess That's Why They Call It The Blues' was filmed there in 1983, and the following year part of Tina Turner's *Private Dancer*, setting a trend for more to follow, and also for television commercials and trailers. Scenes for at least six feature films have been shot here, including *Spy Game*, where its

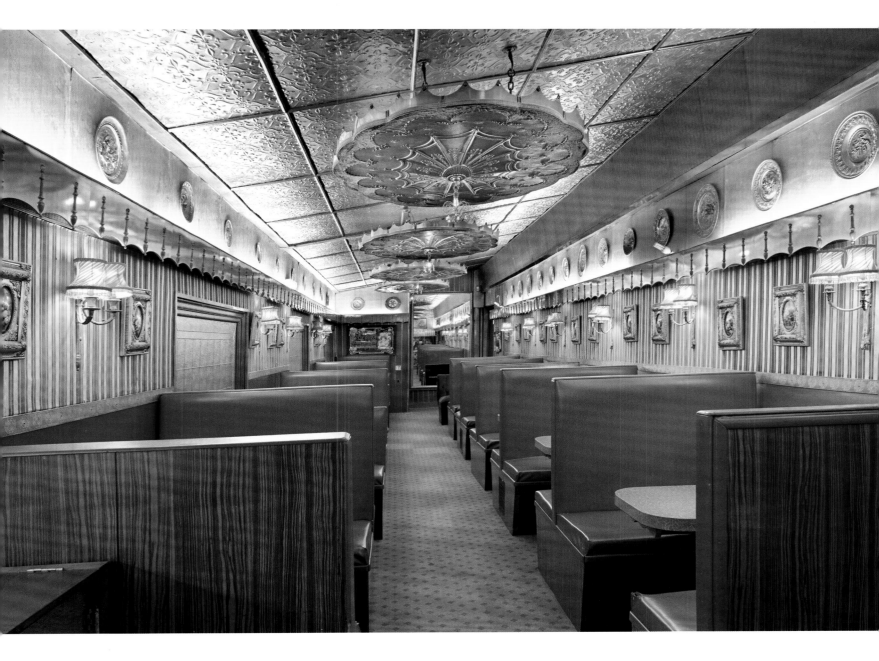

The side bar buffet with booths was added during the Rivoli's conversion to a ballroom.

bar masquerades as an East Berlin location for Brad Pitt and Robert Redford. It has also been a nightclub for crime film *Legend*, a restaurant in *Muppets Most Wanted* and in *Avengers: Age of Ultron* it appears in a flashback sequence where dancers perform the lindy hop.

In January 2008, the building was Grade II listed by English Heritage, which cited its 'highly unusual interior', the total effect of which is 'luxuriant, exotic and deeply theatrical'.

It served a live music venue for smaller bands through the 1960s and, more recently, for numerous fashion shoots. Ballroom, Latin, salsa and jive dancing continue at the Rivoli. It is tempting to see it as a romantic survivor sustained over time by the elegant art of ballroom. The sign outside the Rivoli still declares 'Dancing Tonight'.

VISITING INFORMATION

Rivoli Ballroom, 350 Brockley Road, SE4 2BY

http://www.rivoliballroom.com

Open for events year round.

Wilton's Music Hall

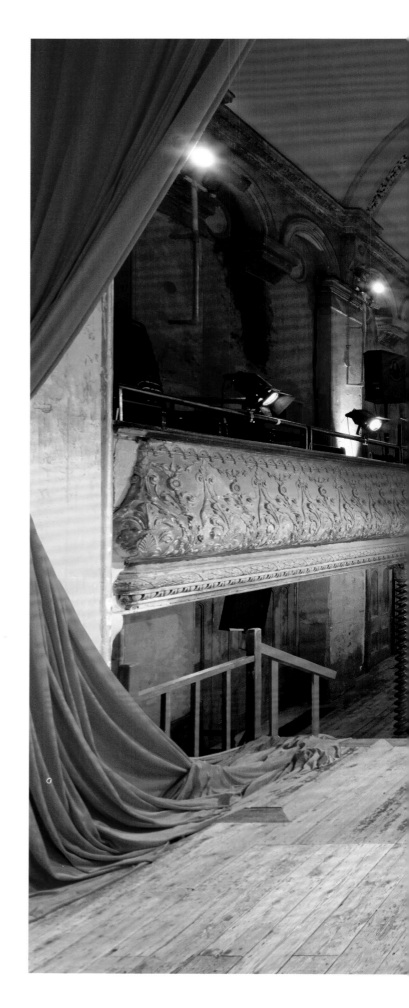

The survival and conservation of Wilton's Music Hall, the oldest remaining musical hall anywhere, was a struggle that lasted fifty years and the scars can be clearly seen. That was the aim of the restorers, who in 2015 completed what has been described as 'a kind of invisible mending', which gave a sound structure and preserved an astonishing patina.

In the early 1850s, John Wilton built an entertainment hall behind three Georgian houses in Graces Alley, in the area between Whitechapel and Wapping. One of these properties was a pub known as The Mahogany Bar, which already had a concert room behind. Wilton soon acquired the lease on an adjoining house, and built a second, bigger auditorium in 1859, one of the first built specifically for emerging style of music hall entertainment. It suffered a fire in 1877 and was rebuilt, but operated as a theatre for only four more years. One of the last turns was the legendary George Leybourne, performing in the character of the singing and dancing dandy 'Champagne Charlie'.

The hall was taken over by the Wesleyan Methodists, who reopened it as The Mahogany Bar Mission, after dispensing with the namesake wooden counter and bar where alcohol had been sold. Services were held in the theatre, and the building played a community role in chapters of East End history, including serving as a soup kitchen during the dockers' strike of 1889, and delivering relief to shelterers during the Blitz of 1940–1. The Methodists ran the mission until 1956, and afterwards the building operated as the Coppermill Rag-Sorting depot. Wilton's Music Hall should then have been swept away as part of a widespread slum clearance programme by London County Council in 1964, and demolition plans were drawn up. But at a public meeting for the closure, John Betjeman, poet laureate and pioneering conservationist, and theatre historian John

The view from the stage. The auditorium is in muted colours now. The gallery was once gilded and the alcoves filled with mirrors.

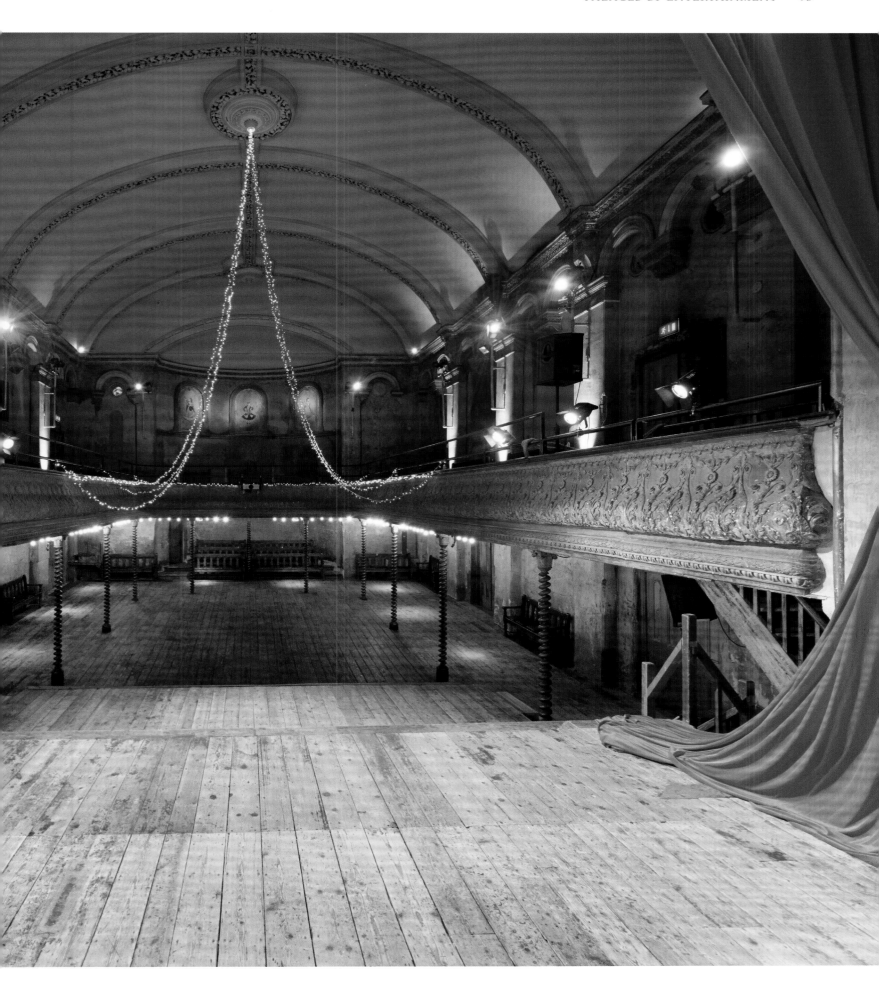

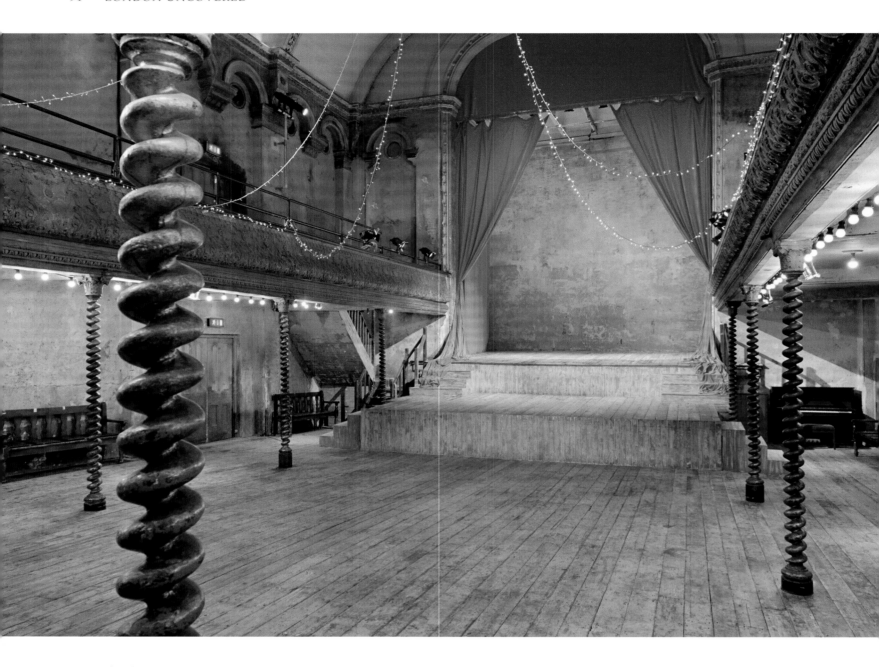

ABOVE *The helical-twist barley-sugar columns supporting the gallery date from 1859.*

OPPOSITE *The gas-lit entrance was originally the door to a pub; Wilton's Music Hall! is landlocked by surrounding buildings.*

Earle, spoke in support of keeping it. The building gained listed status in 1971, but the structure was semi-derelict. Fundraising efforts and restoration started and stalled. A trickle of piecemeal building work kept Wilton's standing, aided by a diet of film location and music video work.

Firstly, the London Music Hall Trust funded some work in in the 1980s and the building became a little more secure. A significant milestone was the first live act before an audience since 1881, a performance recitation of T.S. Eliot's *The Wasteland* in 1997 by Fiona Shaw, a staging that was praised for perfectly harnessing verse to Wilton's own poetic melancholy. The Wilton Music Hall Trust, formed

in 2004, financed the restoration of the music hall itself in the 'conservative repair' style and the houses at the front were rebuilt. Nearly all the original features were retained, while introducing modern heating, electrical and lighting systems.

Wilton's Music Hall hosts opera, puppetry, classical music, cabaret, dance and magic shows, and also offers tours. These take place on some Mondays.

VISITING INFORMATION

Wilton's Music Hall, 1 Graces Alley, E1 8JB

http://www.wiltons.org.uk

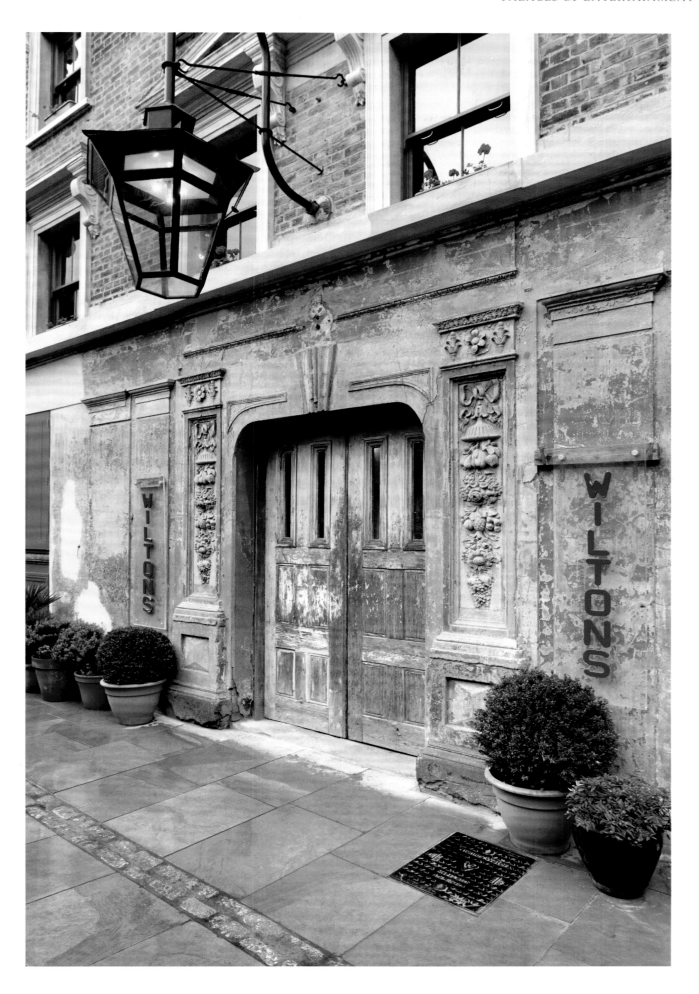

All England Lawn Tennis and Croquet Club

Few walks in London can rival the sheer air of excitement generated on a mid-summer's day when striding from Wimbledon rail station, situated on the flat, up over the hill, through Wimbledon village, to the long expanse of Church Road, the home of Wimbledon Lawn Tennis and Croquet Club. Between late June and early July, what would otherwise be a leafy suburb, just another one of the city's villages, is abuzz with the energy and passion of world-class sport. Suburban calm is replaced by the circus of the international tennis circuit.

The Wimbledon Lawn Tennis and Croquet Club was founded in 1869 as a croquet club, with tennis being incorporated into its title in 1877. Initially, its home was located at nearby Worple Road, only moving to the current Church Road site in 1922. Today, the venue comprises two major show courts, seventeen 'outside' courts, impressive media and practice facilities (a further twenty-two courts) as well as eateries, tourist shops and a permanent archive and museum. In addition to the Championships proper, the Club has also hosted Olympic tennis, occasional Davis Cup ties, and an important annual international junior tournament (Girls and Boys, since 1947). The Championship tournament is one of the four grand slams shared out between Melbourne, Paris and New York. It is the only remaining grass tournament at its level.

There are Wimbledon rules. These range from the 8mm height of the grass on the lawns to the detailed requirements for the players' clothes (whites are still imposed, despite corporate sponsors' designs). Perhaps the real magic of the place has been its ability to adapt and change, keeping up with trends in the modern game while also seamlessly maintaining a strong sense of tradition. Certainly the Club and the Championship have moved with the times. For example, rain delays are now a thing

Preparing the grass at Centre Court, rain protected since 2009.

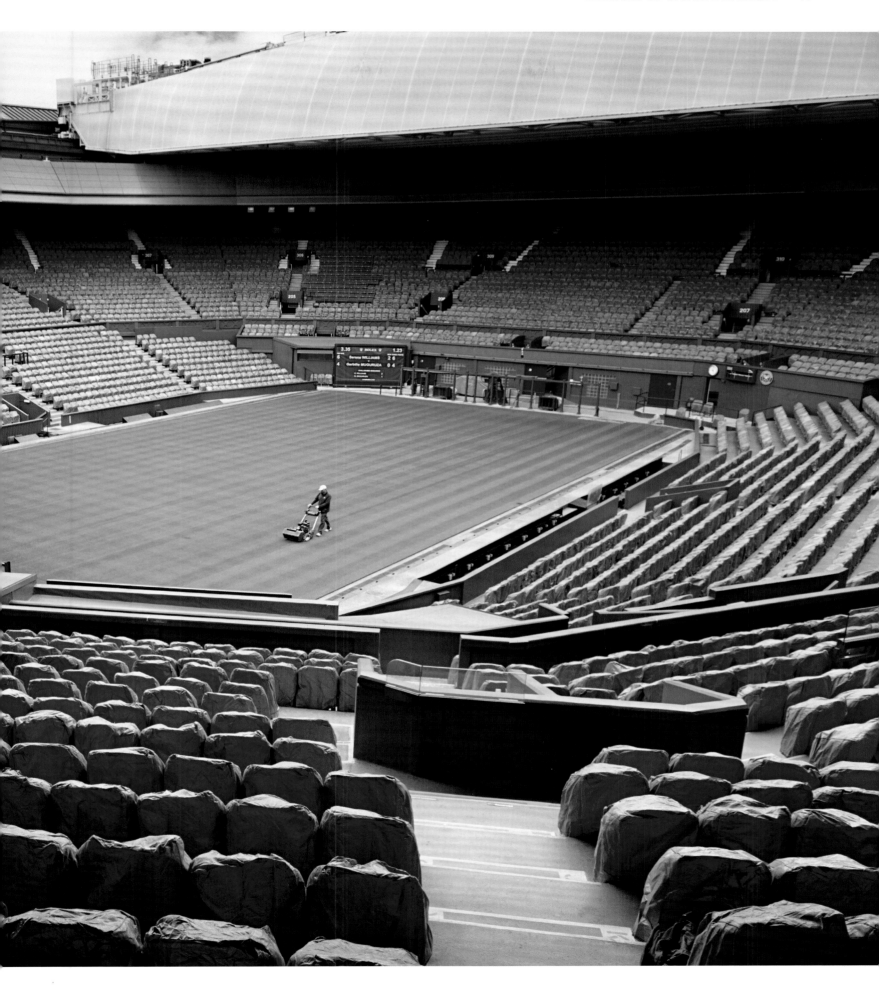

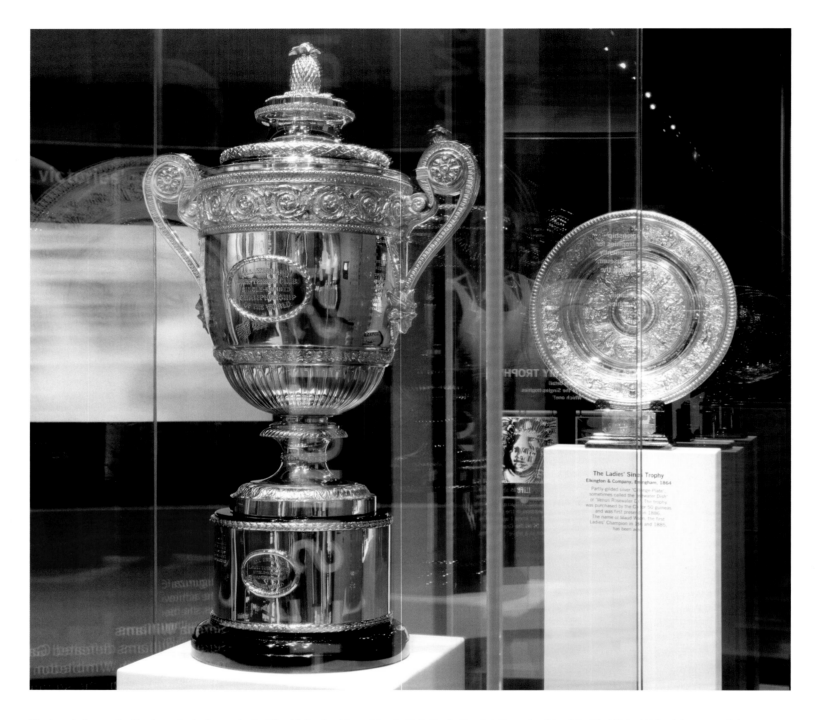

The inscription on the Gentlemen's singles trophy is: 'The All England Lawn Tennis Club Single Handed Championship of the World'. In 2009, with no space left to engrave names, a plinth with an ornamented silver band was designed to accompany the Cup. The Ladies' singles trophy is a silver salver, sometimes called the Rosewater Dish. Winners receive a three-quarter size replicas of the trophies.

of the past, a covered Centre Court being opened in 2009. Similarly, the old Number One court, which backed directly on to its more prestigious neighbour, was completely rebuilt, and is today a more comfortable, if less evocative, arena than in the past. The critical Hawk-Eye electronic line rule system was introduced in 2006, and has become as much of the show as the strawberries and cream. For Wimbledon fans, the essential thing is that all these substantial changes have been successfully incorporated into the traditions of the past. This

process of silent modernisation has been relatively smooth because the existing order is so well-established, and that is assisted by the great sense of intimacy of the place. Show court sight-lines remain excellent, enabling the spectator to become engrossed in every point. So-called outside courts constantly host exciting contests, especially in the first week of the Championships when many of the top-ranked players find themselves located just a few feet from the fans. Courts nestle close beside each other and the action is never far

from view. The speed of play is therefore tangible, the balls ripping backwards and forwards at speeds that often defy the human eye.

Wimbledon has witnessed some of the most entertaining tennis matches of all time, and personalities have also often shone through the score-lines. Few can forget the rise of the junior Boris Becker (first victorious in 1985), the cool elegance of Björn Borg, and the will to win of a generation of American greats (McEnroe, Connors, Agassi). In 1987, it was the Australian Pat Cash who added to the rituals of the tournament when he invented the tradition of the final-day victor clambering to their family and trainers in the crowd, now almost obligatory. The Ladies' competition has generally witnessed more skill than individual flamboyance. In recent times the victories of outside bets (Jana Novotná, Marion Bartoli, Petra Kvitová) have nevertheless made that part of the competition more exciting than the serve and double-fault routine that sometimes dogs the men's draw.

It is important to recall that for years the special atmosphere for British fans was precisely *not* to have a home favourite who could win. The rise of first Tim Henman and then Andy Murray changed that, and for at least the last fifteen years there are far more partisan crowds than ever.

The record books tell us that the first male victor was Spencer Gore (1877) and the triumphant equivalent female contestant was Maud Watson (1884). Three men share the record for most championships won: William Renshaw (1880s), Pete Sampras (1990s) and Roger Federer (2000s). In the Ladies' singles, the pre-eminent figure, with nine championship victories, is Martina Navratilova.

VISITING INFORMATION

All England Lawn Tennis and Croquet Club, Church Road, SW19 5AE

http://www.wimbledon.com

Wimbledon Lawn Tennis Museum open daily 10am–5.30pm; last entry 5pm.

Tours may be booked online.

The three latest English Ladies' champions. A successor is awaited.

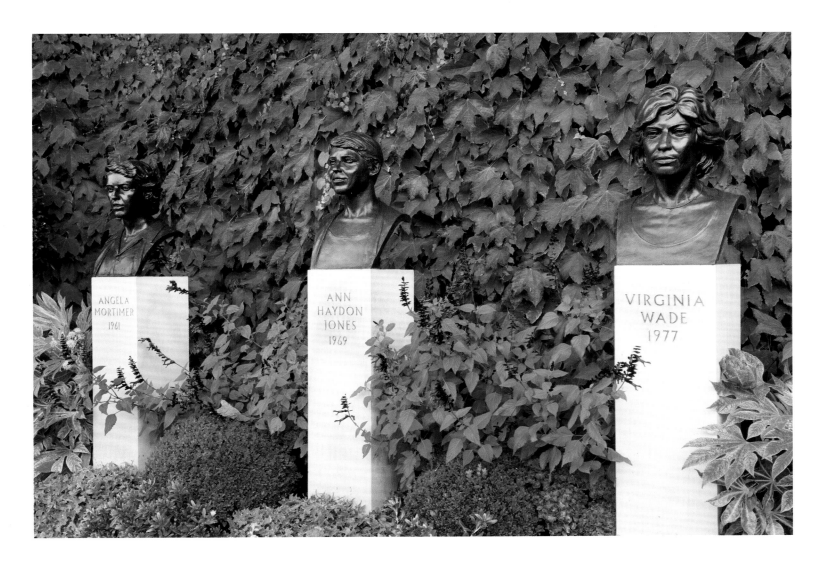

Regent Street Cinema

When architect Tim Ronalds came to design the rebuild of the Regent Street Cinema in 2010, he described it as like discovering a burial chamber in a pyramid, finding what was then a lecture theatre inside an Art Deco cinema, which had been built inside a Victorian galleried theatre. In its latest restored form, Regent Street Cinema seats 187 in an auditorium decorated with neo-classical plasterwork, all in the style of 1927. Hidden above the barrel-vaulted ceiling is the original 1848 cast-iron roof structure. A Compton organ installed in 1936 has been retained.

Across its history the cinema has projected early scientific demonstrations, Victorian novelty illusions, newsreels, and mainstream and art-house films. A type of cinema pre-history was the lantern slides projected with live-actions shows, and a popular illusion known as 'Mr Pepper's Ghost', based on Charles Dickens' *The Haunted Man*, first performed in 1862. The Lumière projections launched its role as a picture house, and the cinema was leased out by the nearby Polytechnic of Central London and operated under the names Cameo-News, Cameo-Poly and Cameo-Classic. In recent memory, it was one of central London's major art-house cinemas, specialising in foreign films during the golden age of classic European cinema. Its fortunes declined afterwards and, after a short period as a live theatre, it briefly went back to cinema use, before closing in 1980 and reverting to the polytechnic, now the University of Westminster.

The restoration was to the latest acoustic and visual standards with 4K digital projection equipment, while maintaining 8mm, 16mm and 35mm optical projection. Regent Street Cinema maintains diverse programming with double bills, world cinema, modern independent and classic films.

VISITING INFORMATION

Regent Street Cinema, 309 Regent Street, W1B 2UW

https://www.regentstreetcinema.com

The George and Dragon plaque above the auditorium is an emblem of the old polytechnic.

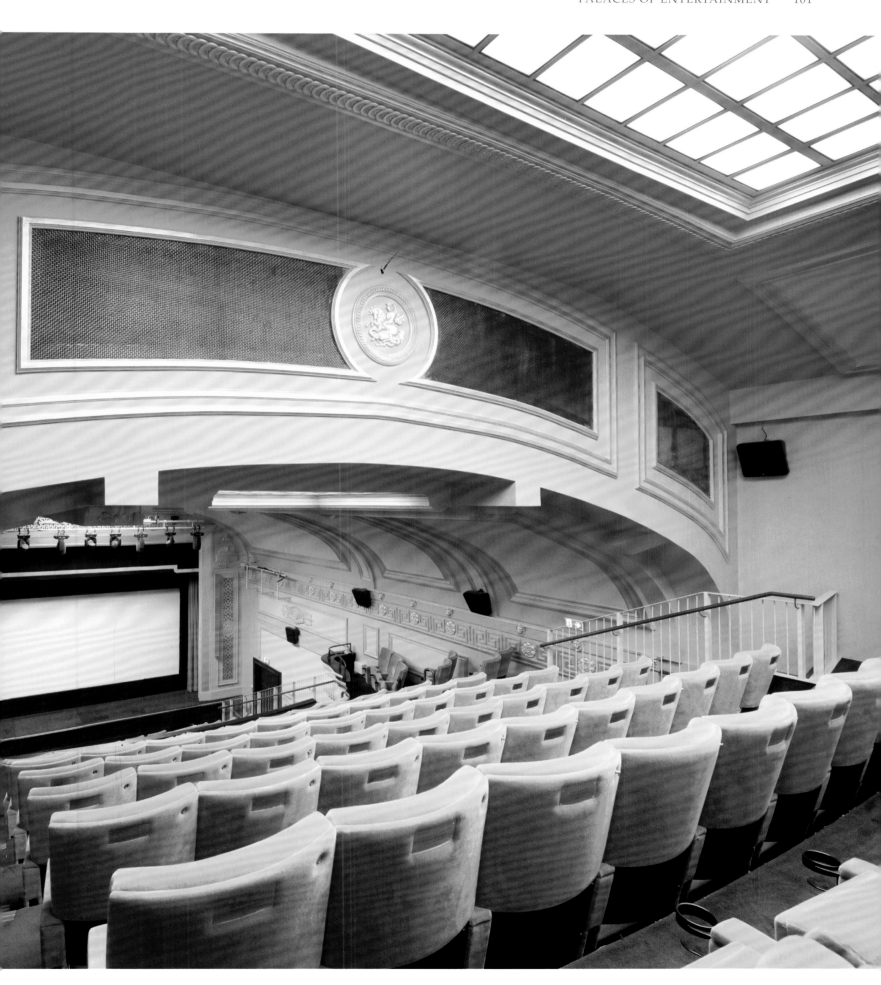

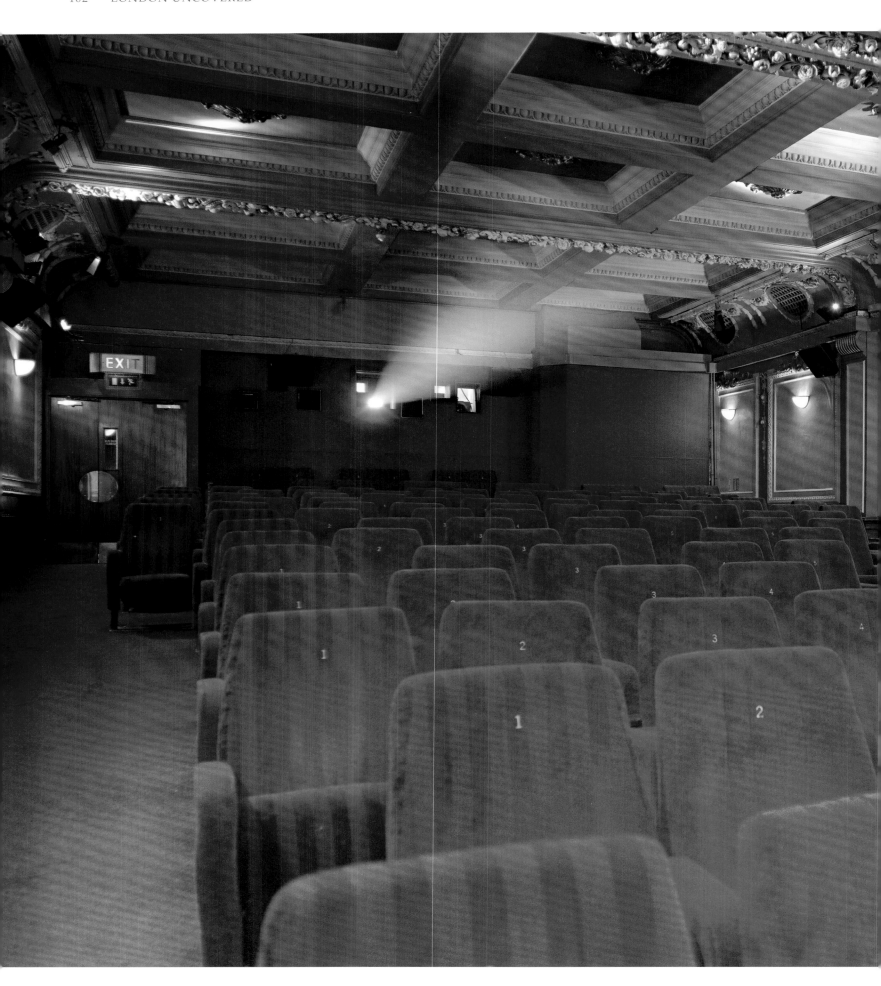

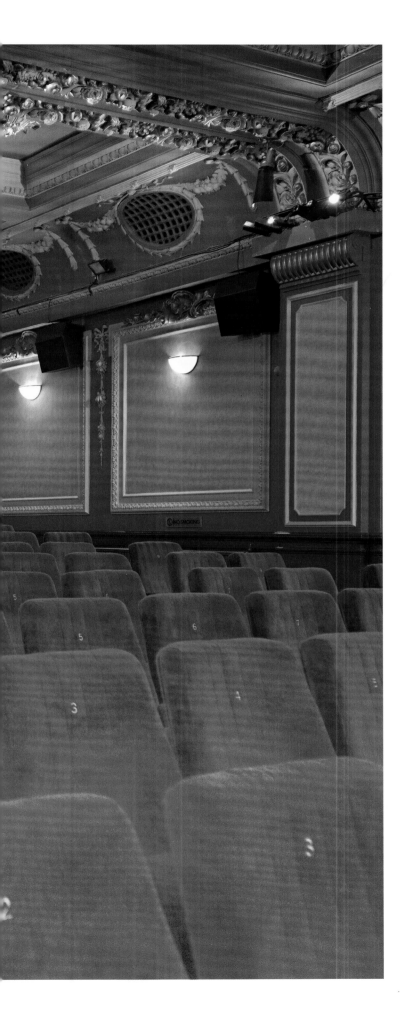

The Gate Cinema

Notting Hill is home to a good selection of cinemas, the most intimate of which is The Gate. The unremarkable façade on Notting Hill Gate gives no clue to what lies within: 180 comfortable red plush seats on a single floor, in a perfectly preserved baroque Edwardian room. The auditorium dates from 1911, when the Golden Bells Restaurant was converted into a picture house named the Electric Palace by architect William Hancock, one of at least five conversions he designed during the first London cinema boom before the First World War.

By 1934, it was the Embassy, and then renamed the Classic Cinema in 1957. Much of the magic of any cinema lies in its programming, and the Classic Cinema made its mark by becoming a popular revival house, screening many classic Hollywood films. A speciality was the screening of late shows every night of the week, and it was routine to see long queues outside at 11pm. In 1974, it became the Gate Cinema, operated by independent distributor Cinegate. In the art house tradition, it successfully programmed Fassbinder's early films, Jarman's *Sebastiane* and *La Cage aux Folles*.

In 1994, the Gate Cinema was designated a Grade II listed building by English Heritage, which found a little-altered early cinema auditorium with exceptionally lavish decoration. There is 'abundant plaster fruit' on the ceilings, walls divided into bays by pilasters, mouldings, foliage scrolls and roundels. The dominant colours remain red and gold. It was restored in 2004 with the addition of air conditioning. The Gate Cinema continues as a popular cinema with varied art house programming, and is now operated by the Picturehouse Cinemas chain.

VISITING INFORMATION

Gate Cinema, 87 Notting Hill Gate, W11 3JZ

https://www.picturehouses.com

While the seating in the Gate is modern, its decoration is true to 1911.

The National Theatre

With three auditoriums staging more than a thousand performances of twenty-five or more different plays at the South Bank each year, the National Theatre is a massive and powerful machine for drama.

Ambitious in concept and epically protracted in its gestation, the National Theatre experienced 100 years of prehistory, negotiations, ideas and planning before the foundation stone was laid on the South Bank in 1951. Even that provided to be a false start, and the site changed three times before building work properly started in 1969 for completion in 1976. After controversy over its funding, architecture and leadership, the National Theatre has established itself as a serious and eclectic place for all classic drama, distinct from the commercial theatre of the West End, while still building a reputation for staging and launching popular hits. Shakespeare has been the most performed playwright, while *War Horse* is the most successful play in the NT's history.

The NT is rare among theatres in handling nearly all parts of production in-house, including set-building, scene-painting, digital design, and costume- and prop-making. More than 700 people work on its 5-acre site. There can be seven productions in the repertoire at any one time, including tours and transfers. The National possesses all the tools to do this job.

Largest of its auditoriums is the Olivier, which can accommodate 1,150 people. When the theatre was planned, open-stage arenas were rare. The spirit of its inspiration was the Greek amphitheatre at Epidaurus, and the architect for the National Theatre, Denys Lasdun, developed the idea from a simple sketch showing an open stage placed in the corner of a square room. The Olivier is large for the number of seats it contains, and the NT claims that no place in the Olivier is far from the actors' point of

The Lyttleton Theatre with its adjustable proscenium, and a mostly bare-stage adaption of Turgenev's Three Days in the Country, *designed by Mark Thomson.*

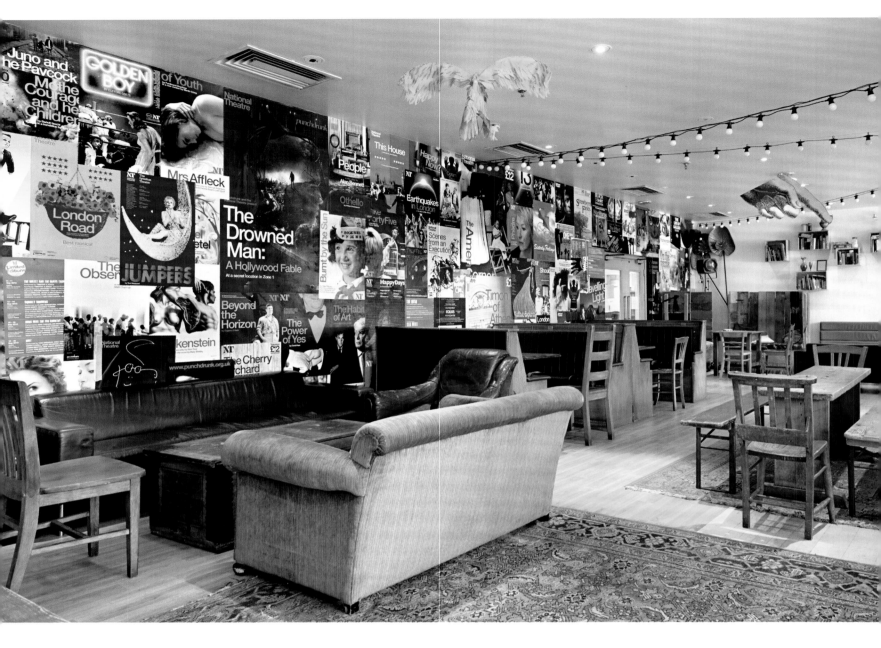

The National has one Green Room, which is used by actors from all of the theatres.

command, and the span of the seats matches their effective field of vision. It possesses one of the largest pieces of stage machinery in Britain: the drum revolve, a 125-tonne double turntable several decks deep, which incorporates two lifts. As the Olivier itself is three floors above ground level, the revolve operates over five storeys. It was built into the original design, but for more than ten years it was used mainly for shifting scenery from the dock before being properly deployed dramatically. The electrical drive and control systems have been replaced and strengthened. Since then, the drum has been in regular use, serving many shows, allowing a ship to rise and sink, or a castle to appear out of the mist.

When the NT was designed, a proscenium stage was also specified, and this was the Lyttleton, which can house an audience of 890. The proscenium is adjustable and can be open-ended, or made to create an orchestra pit for up to twenty musicians. The third schemed theatre was the Cottesloe – now Dorfman – a smaller rectangular space that can have the stage installed at one end, lengthways or in the round.

The NT's first artistic director was Sir Laurence Olivier, appointed in 1962, with the company lodging at the Old Vic while the South Bank theatre was built. Peter Hall took the NT into the new building and was director until 1988, and is credited with harnessing the full potential of its three

ABOVE *A props table at the NT; all props can be made in-house, and more than 21,000 pieces are held by the hire department.*

OVERLEAF *This staging of Timberlake Wertenbaker's* Our Country's Good, *designed by Peter McKintosh, used the drum revolve seen on the right.*

playhouses and setting a wide repertoire.

When completed, the cast-concrete edifice of the NT, with its terraces and fly towers, was found forbidding by some critics, and has been said to resemble a fortified position on the bank of the river. Prince Charles described it as, 'a clever way of building a nuclear power station in the middle of London without anyone objecting', and in 1976 the South Bank area itself was bleak and undeveloped, and remained that way for most of the decade afterwards. As the NT overcame controversy and criticism, and found success on its stages, the South Bank area itself came to be transformed, with the establishment of Tate Modern, the Globe Theatre and London Eye.

In 2015, under the NT Future programme, the theatre unveiled a series of updates to make itself more open and accessible, including the Clore Learning Centre, with its classes and workshops, the Sherling High-Level Walkway, which gives visitors views into the backstage Max Rayne production workshops for set construction and design.

VISITING INFORMATION

National Theatre, Upper Ground, SE1 9PX

http://www.nationaltheatre.org.uk/discover/backstage-tours

Building open 9.30am–11pm Monday–Saturday, 12pm–6pm Sunday.

It is possible to explore the unseen areas of the theatre on daily backstage tours.

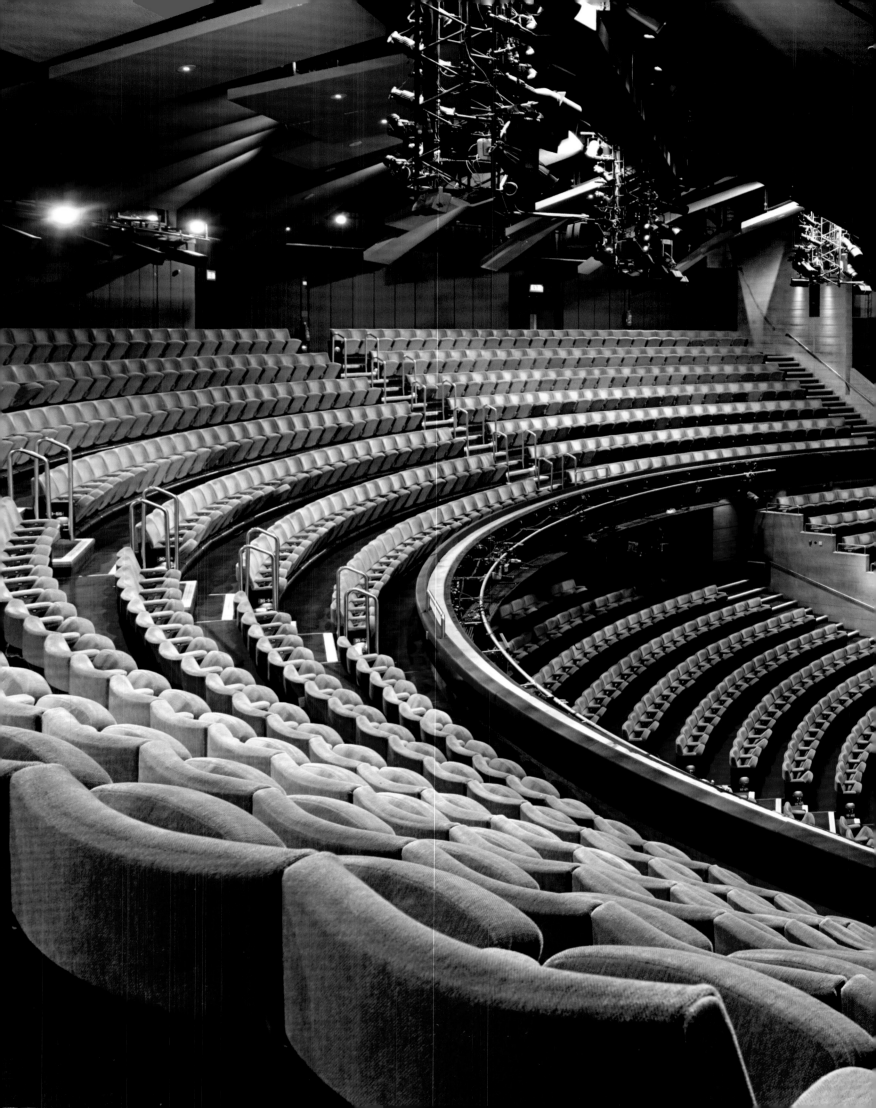

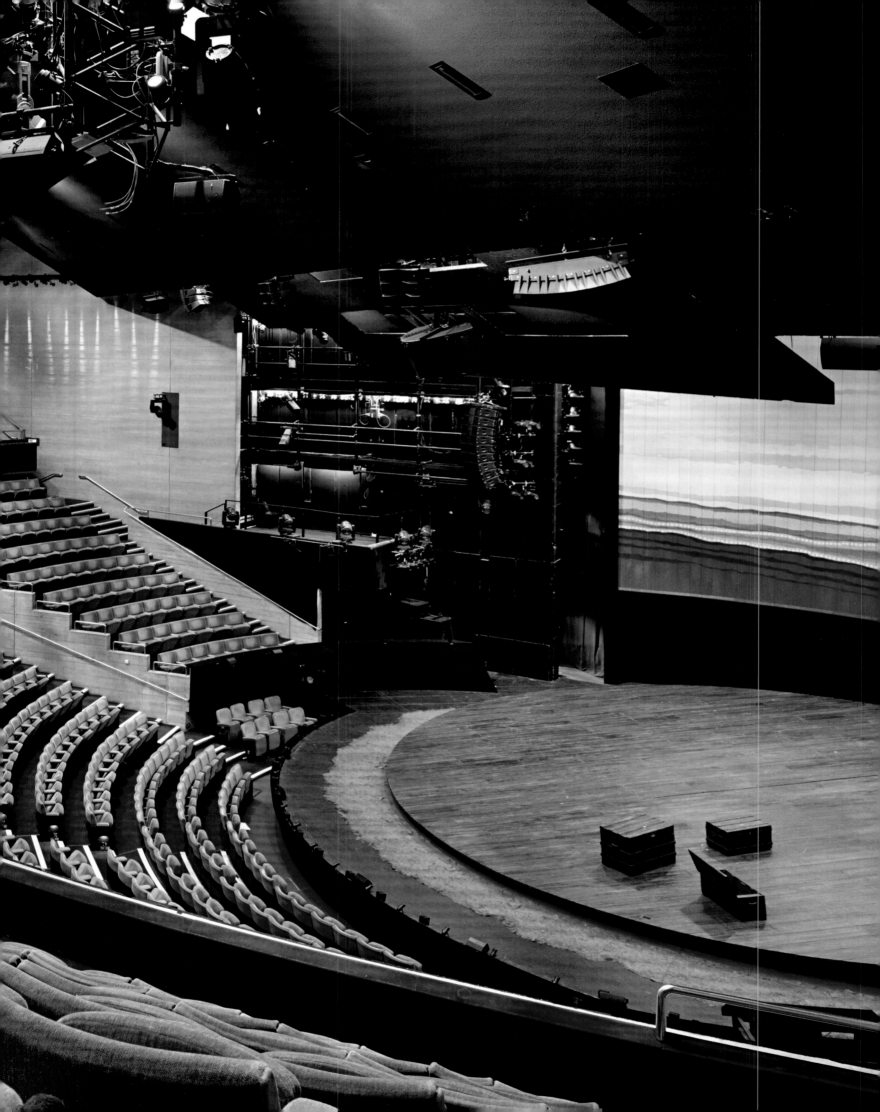

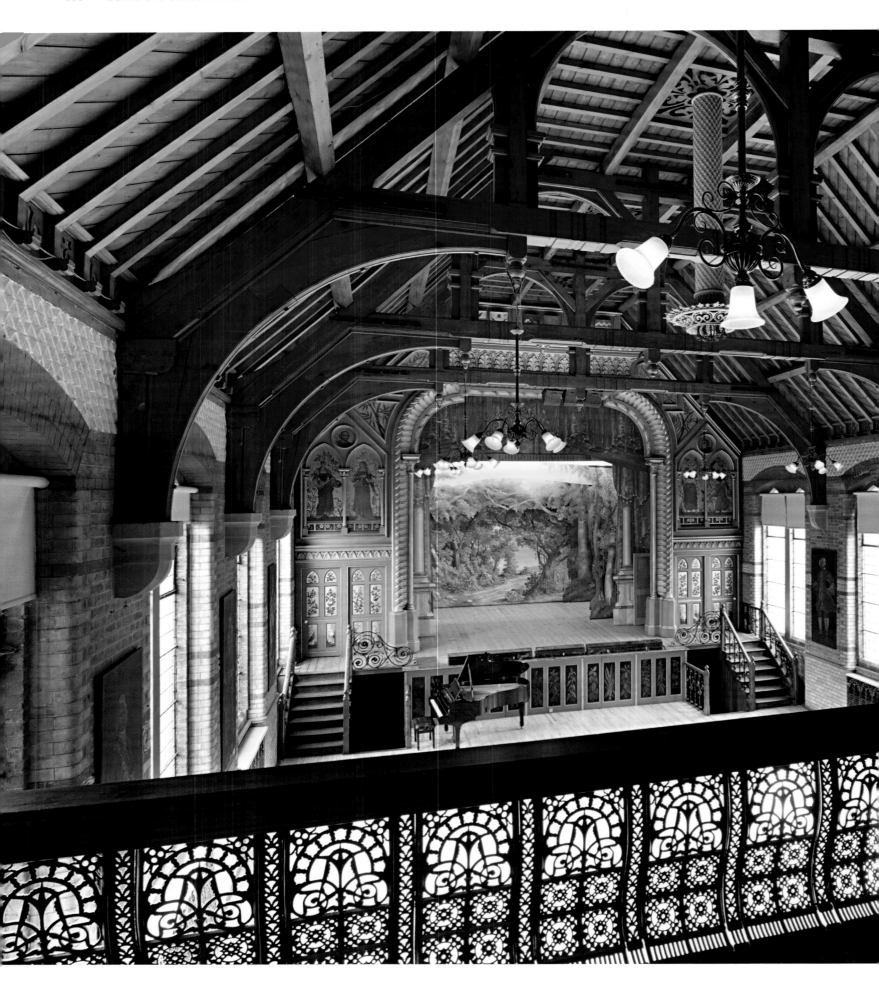

Normansfield Theatre

The marvel of Normansfield is how an 1879 proscenium stage theatre survived unaltered in a time capsule, to be restored and reopened 125 years later. The theatre is a tribute to the medical pioneer Dr John Haydon Langdon Down, who gave his name to the congenital chromosomal imbalance known as Down's Syndrome. At Teddington in south-west London, he had commissioned a sanatorium called Normansfield, developed from 1868 as a home for the learning-disabled, and licensed as a private asylum with classrooms, workshops and a farm. Dr Langdon Down's progressive views on treatment valued the role of drama, music and entertainment as a therapeutic tool, and in June 1879 an entertainment hall was opened.

The proscenium is richly coloured and gilded and is surrounded by elaborately decorated panels on all sides. Four doors – two functional and two false – flank the stage. These were expertly painted, as were the panels on the riser at the front of the stage. Some researchers have attributed certain of these pictures to Marianne North, the notable botanical painter whose pictures are displayed at Kew, although that has not been established beyond doubt. Above the doors are four pre-Raphaelite paintings presenting the muses Tragedy, Painting, Music and Comedy; the artist is unknown.

Displayed on the walls are six wooden panels with paintings of figures in period costume. These are characters from Gilbert and Sullivan's *Ruddigore*, and came from the original Savoy Theatre production of the operetta, where they functioned in the production as swivelling doors, although no explanation of why they came to Normansfield has been uncovered.

Normansfield's scene-changing system and its collection of stock scenery are rare surviving examples of the apparatus and illusion of theatre that started to disappear at the end of

Normansfield could originally seat at least 350, and includes a stepped gallery with an ornate iron front.

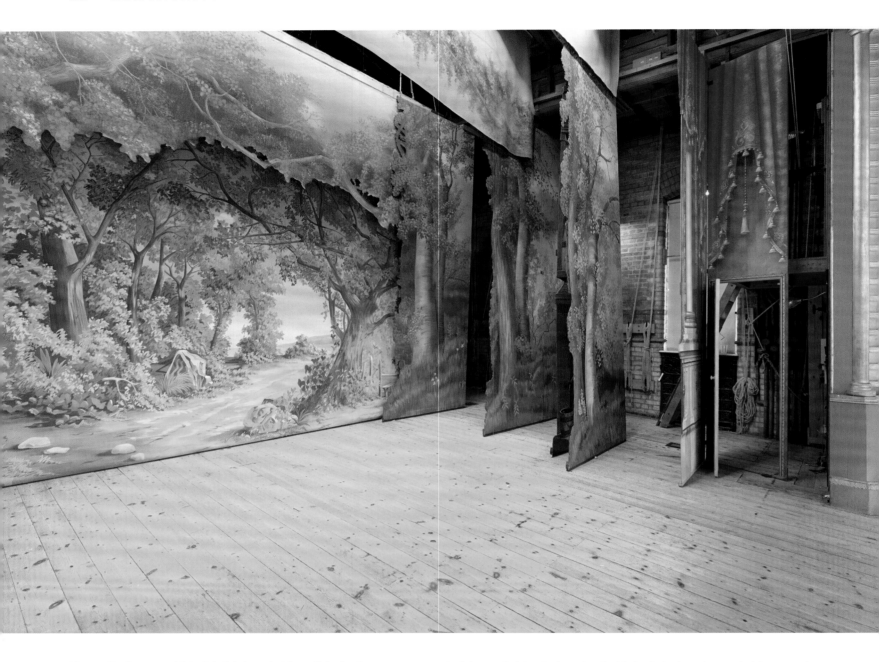

The woodland scene on this backcloth is framed with profiled wing flats as an avenue to lead the eye; the hinged wing painted with classical column is part of a false proscenium.

nineteenth century. In addition, more than eighty painted flats have survived, depicting landscapes, gardens, palaces, baronial halls or splendid rooms, capable of creating a setting for a range of plays from melodrama to pantomime, together with backcloths and borders to frame the scene. Theatrical scenery of the time tended to have a short life, pieces being remodelled or scrapped. New systems of overhead scenery-changing were introduced in the commercial theatre shortly after this, but Normansfield did not update its scenic groove system or scenery. When the most ambitious theatrical productions, staged at Normansfield by an amateur company drawn from staff and friends, came to an end around 1908, a long hibernation

began of the stage and scenery.

For Normansfield as a medical care institution the running costs started to exceed the income from fees after 1945, and the National Health Service took it over in June 1951. It was then known as Normansfield Hospital. At this time the stage was rarely used for any kind of performance, but the hall remained in use for therapeutic group sessions, meetings and as a badminton court. Some damage was inflicted on the wooden panels. The fragile disused scenery was stored unseen, but everything remained intact and not quite forgotten.

Normansfield Hospital continued to develop until the end of the 1960s, but afterwards changes in healthcare

The pendant 'sun burner', a combined gas chandelier and ventilator, as installed in 1879.

policy and programmes such as Care in the Community were to be introduced, and the hospital was steadily run down. Long before the closure, in the early 1980s, a Theatre Project Committee started negotiations about preservation with the health authorities, which continued for more than ten years. The Friends of Normansfield, the Theatres Trust, the Greater London Council, English Heritage and Richmond Council were all eventually engaged. When Normansfield closed as a hospital in 1997, the scenery was removed and stored for conservation, and much of the site used to build new housing. As a part of permission to develop the housing, Laing Homes restored the hall and stage with as few changes as possible. Some of the scenery

was replicated and returned. The building, still known as Normansfield Theatre, is now owned and managed by the Down's Syndrome Association as the Langdon Down Centre, which includes a Museum of Learning Disability and the historical archive material of Dr Langdon Down.

VISITING INFORMATION

Normansfield Theatre, Langdon Down Centre, 2a Langdon Park, Teddington TW11 9PS

http://www.langdondowncentre.org.uk

Open 10am–1pm on Saturdays, and a number of public performance events are staged in the theatre each year.

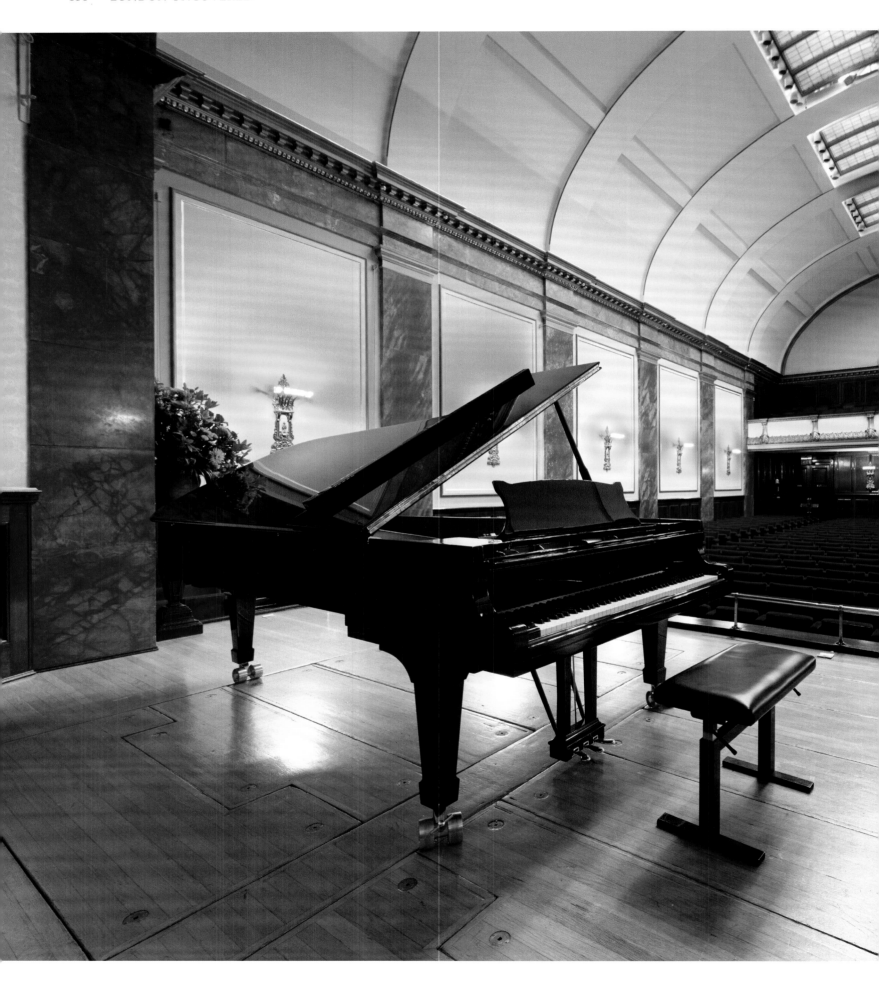

Wigmore Hall

Wigmore Hall is one of the most highly rated venues in Europe, with its stage perfectly sized for soloists and chamber musicians. It frequently provides a showcase for young artists making their professional London debuts, and the repertoire extends from the Renaissance to contemporary jazz and new compositions.

The auditorium's most famed feature is its responsive acoustic quality, widely praised, but hard to explain in terms of modern design science. During the refurbishment of the hall in 2003–4, acoustic engineers were commissioned to investigate this elusive embedded quality and concluded that 'the geometry would not be favoured by current day designs, yet it is revered by international musicians and audiences alike'. Although the overall rectangular shape is favourable to a good sound, many of the most elegant features – such as the elliptical ceiling, the apse and half cupola – are concave focusing surfaces, which would certainly not be favoured today. The writer Vikram Seth described Wigmore Hall as 'the sacred shoe-box of chamber music', referring to both its proportions and its reputation.

In May 1901, German piano manufacturer Bechstein opened a showroom and concert hall in London at 36 Wigmore Street. For the hall, Bechstein commissioned architect Thomas Edward Collcutt, whose portfolio included the Savoy Hotel, the Palace Theatre in Cambridge Circus, Lloyd's Register Building and interiors for twelve P&O liners. He designed an auditorium in a neo-Renaissance style, panelled in mahogany with a frieze in red Verona marble surmounted by gilt moulding. In the foyer, marble and alabaster decorate the walls and floor. A Sicilian marble stairway with an alabaster handrail climbs to the balcony. Today, Wigmore Hall retains most of its original features, including some gas lights, which are still lit for every concert. During the Edwardian age, it was called Bechstein

A grand piano is positioned just inside the apse, which contains most of the stage.

Hall, and hosted music from artists such as Nellie Melba and Enrico Caruso. Composers Camille Saint-Saëns and Percy Grainger performed here and its reputation as a recital venue grew rapidly.

During the First World War, the British government wound up German-owned companies. Bechstein's assets were seized as enemy property, and the hall was sold at auction, the buyer being Debenhams. Included in the sale were the showroom and 137 pianos. Rented out under a long lease, the hall re-opened under the name Wigmore Hall and Piano Galleries in 1917. In the 1920s and 1930s Casals and Segovia performed here and the Wigmore Hall flourished. From 1946, the management of the hall was taken over by the Arts Council Music Department. During the 1950s, Elisabeth Schwarzkopf and Joan Sutherland sang, and Benjamin Britten and Peter Pears performed. Westminster City Council took over the lease in 1986. Since 1992 it has been owned by the Wigmore Hall Trust, which in 2005 purchased a long lease of 300 years.

As for the treasured acoustic, special care was taken to preserve this quality during the most recent restoration. There are 552 seats on a flat floor in the stalls and in the balcony. After a series of tests, the temptation to rake the floor for better sightlines was resisted. The carpeting – a feature which is held to go against good acoustic qualities – was retained. Another detail, rarely noticed by visitors, is found on the ceiling, where there are a series of glazed laylights allowing daylight to enter the auditorium. One laylight is incomplete. During restoration in 2004, it was found that the light nearest the stage was missing four panels. The architect proposed reinstatement of the glass for the best visual effect, but before that was done the acoustic specialists investigated the effect of putting the glass panels back. After a series of tests with musicians and skilled listeners, with the openings covered and uncovered, the openings were left as they were.

VISITING INFORMATION

36 Wigmore Street, London W1U 2BP

http://wigmore-hall.org.uk

Open for public concerts all year round.

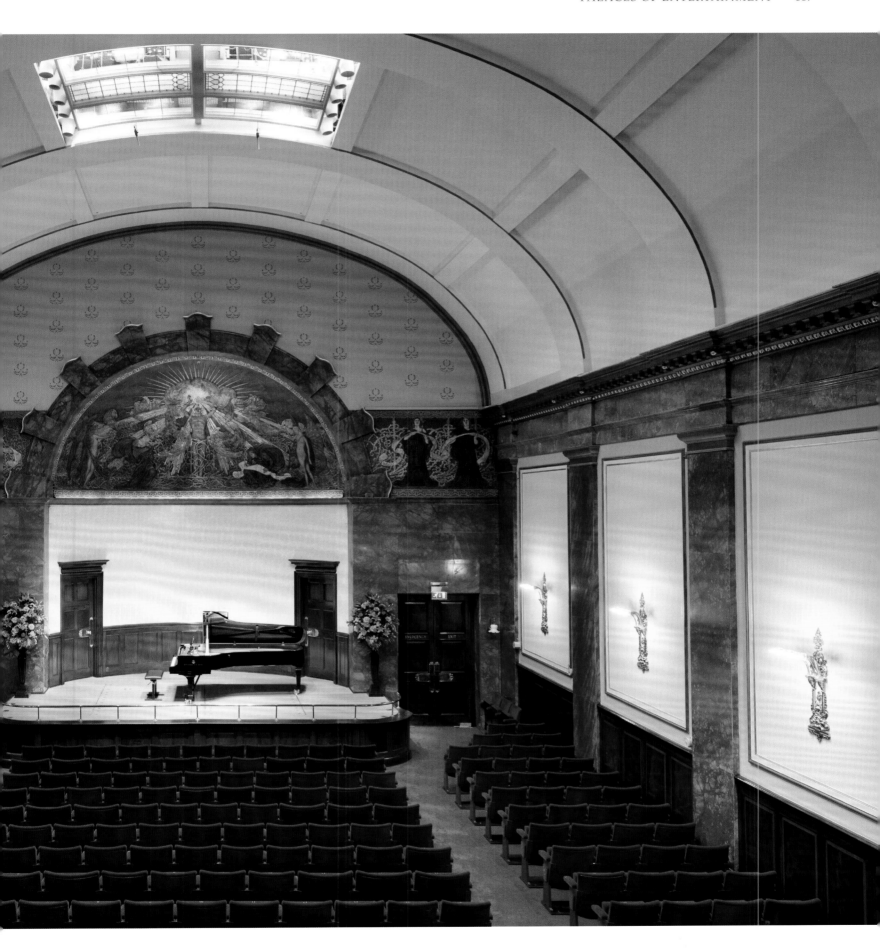

Marble, mahogany and plaster on walls and ceiling line the perfect auditorium for small chamber ensembles; symbolist painting depicts music as the fruit of divine inspiration.

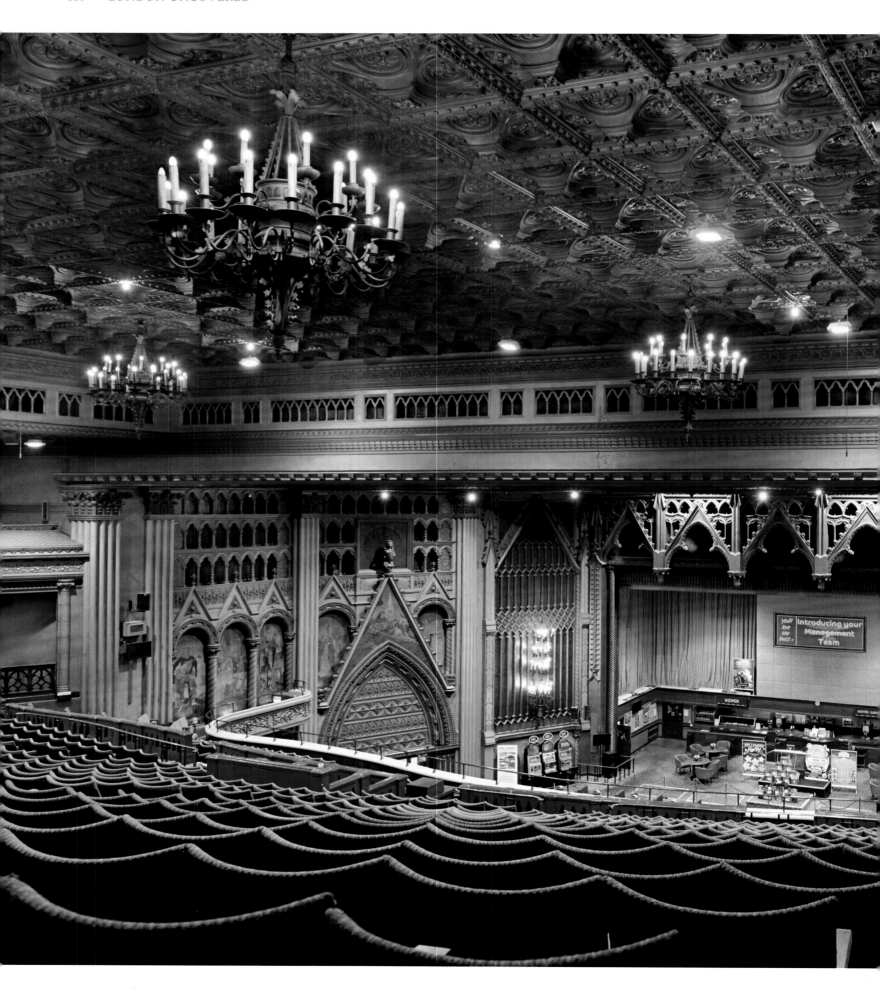

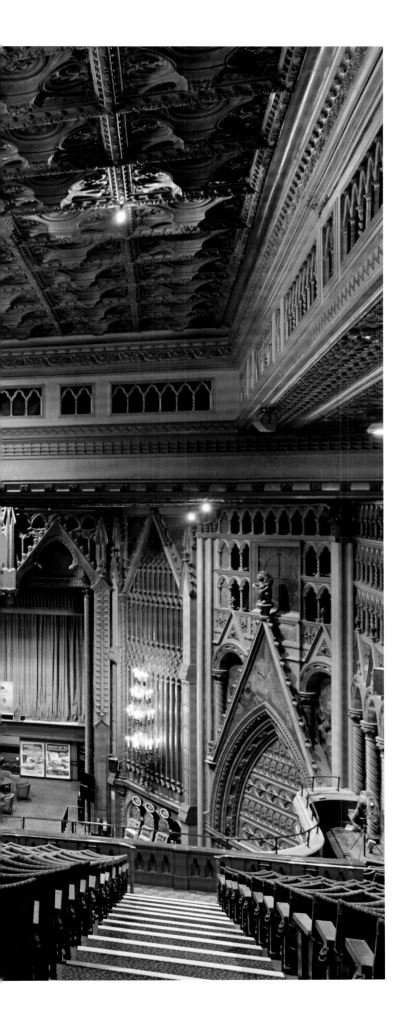

Gala Bingo Club

The emergence of lavish movie theatres in Britain was spurred by rivalry among cinema chains ABC, Gaumont and Odeon between the coming of the talkies in 1928 and the start of war in 1939. The most spectacular of all the super picture palaces created in that era was the Granada Tooting, which continues today as the Gala Bingo Club, with its extraordinary interior well-preserved.

The up-and-coming Granada cinema circuit was being developed by Sidney Bernstein, owner of Bernstein's Theatres Ltd, and he hired Theodore Komisarjevsky, a cosmopolitan designer-director, who had created productions on the stage in London, Paris and New York. Komisarjevsky was trained in architecture, and had worked as a theatre producer in his native Russia, also working in ballet and opera. He had come to London in 1919 and his creative reputation grew rapidly beyond that of being simply a set designer. He was first hired by Bernstein to work on the interior of the Phoenix Theatre in Charing Cross Road. His third design commission for Bernstein was the new cinema at Tooting, which became a sensation on its opening in 1931. It was not the Italianate-style façade and entrance designed by architect Cecil Massey that generated the excitement, but Komisarjevsky's Venetian Gothic interior.

It owed much to a design trend known as the 'atmospheric theatre', which started in the United States. This was characterised by putting complex decoration on the cinema's side walls to create a fantasy world, typically evoking an Italian garden or a Spanish courtyard, a Moorish city or an Asian temple, sometimes with a cleverly lit sky-painted ceiling. The Granada Tooting was in the atmospheric style, but the choice of Venetian Gothic was startlingly original,

From the gallery, the spirit of the Doge's Palace in Venice is evoked.

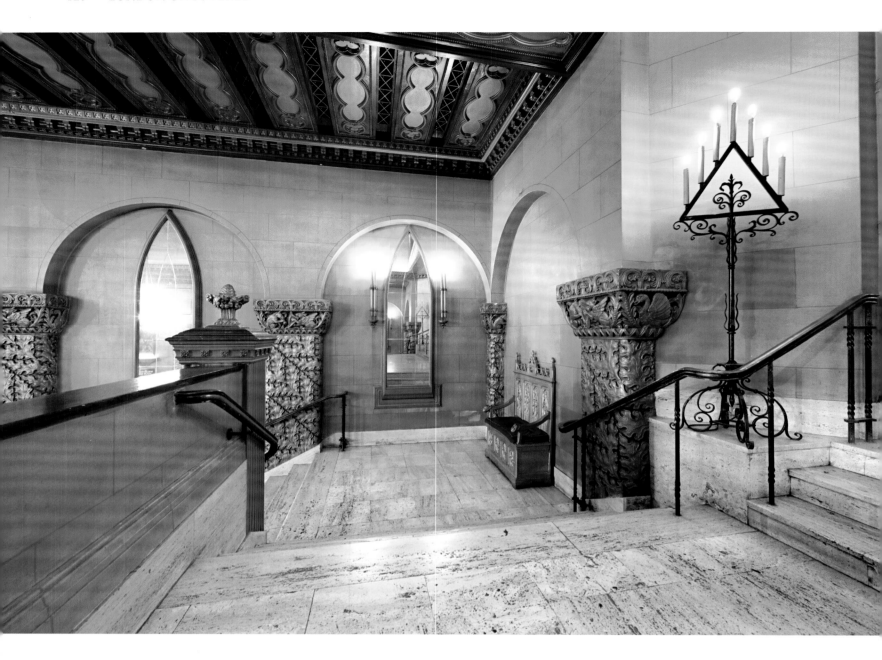

The entrance staircase, with every detail, including the bench seat, designed by Theodore Komisarjevsky.

and came entirely from the imagination of Komisarjevsky. Gothic arches are found all over the auditorium, around the proscenium, on the side walls and over the doors, some with colonnades and gables. Some of the arches are filled with paintings in a medieval style: of musicians, a wimpled maiden and an African drummer. There are false back-lit windows, stained glass, a ceiling over the stalls painted with blue sky and clouds, and a coffered ceiling behind. It was 'the world of the Palazzo on the Grand Canal, recreated in the midst of south London', according to architectural historian David Atwell.

Everywhere there is a rich theatricality of decoration. The grand foyer evokes a gigantic baronial hall from the middle ages, with a beamed ceiling and carved panelling. At the top of the main stairs, the balcony lobby is a cloister, with more than seventy mirrored arches in a hall of mirrors for those going to take their seat in the circle.

The sheer scale and opulence of the Granada is overpowering to modern eyes, and any cinema with a single auditorium capacity of more than 3,000 is hard to understand in the age of the multiplex. Yet cinemas then were offering audiences a rare escape from the humdrum everyday world, based on the fantasy provided by the film on the screen and the fantasy realm of the picture palace environment.

Tooting Granada has a wide, deep stage, designed for

live performance, and an orchestra pit. There are two organs, one of which is a Wurlitzer that rises from the stage in classic style, and whose console was once coupled to a white grand piano on stage. In Bernstein Theatres the programming of films and live acts was eclectic. There would sometimes be two feature films, or one film with a variety show. At other times a circus performed, and the pantomime *Jack in the Beanstalk* with a cast of sixty. After the war came Frank Sinatra, Jerry Lee Lewis, Gene Vincent, The Beatles, Roy Orbison, The Rolling Stones and Jimi Hendrix. The last live act was The Bee Gees in 1968. As cinema audiences diminished to 600 per week by the

1971, closure was inevitable, and the last film was shown November 1973. It re-opened as a Granada Bingo Club and was taken over by Gala Bingo in 1991. It is the only Grade I listed former cinema in England.

VISITING INFORMATION

Gala Bingo Club, 50–60 Mitcham Road, SW17 9NA

www.galabingo.com/clubs/tooting

Open 10.30am–11pm Monday–Saturday; 11.30am–11pm Sundays.

BELOW *The hall of mirrors in the gallery lobby offers a dazzling optical infinity effect.*

FOLLOWING PAGE *The gothic arches and gables are original; later came the seating for the café and for bingo, which has saved the old Granada.*

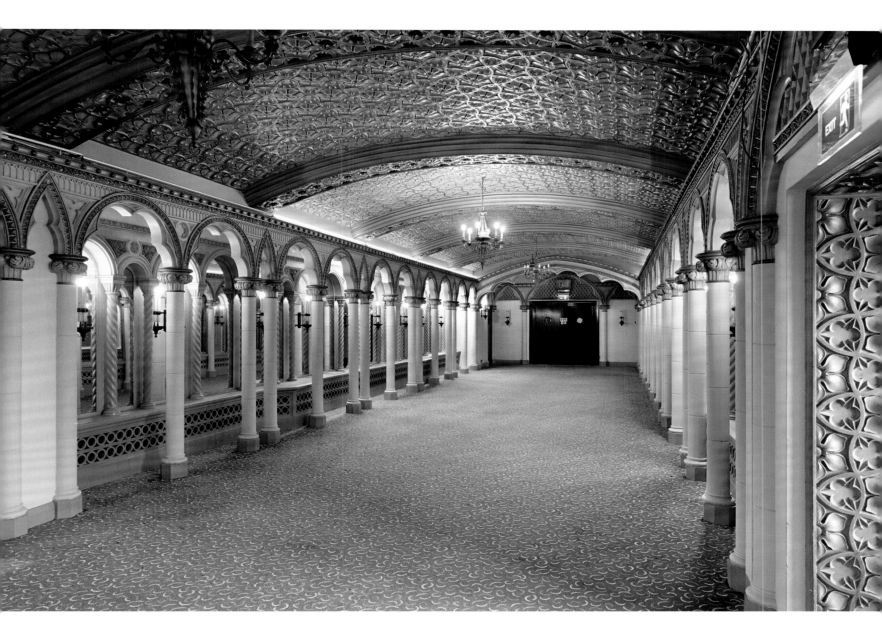

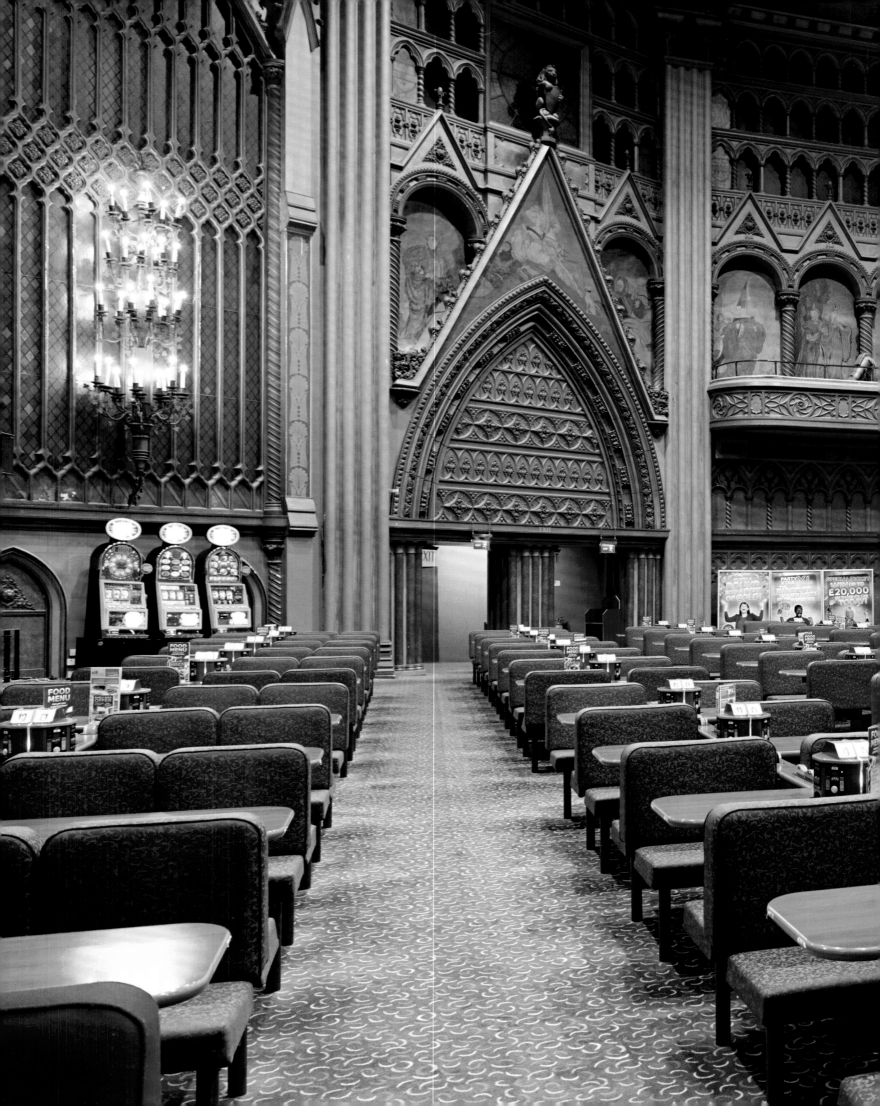

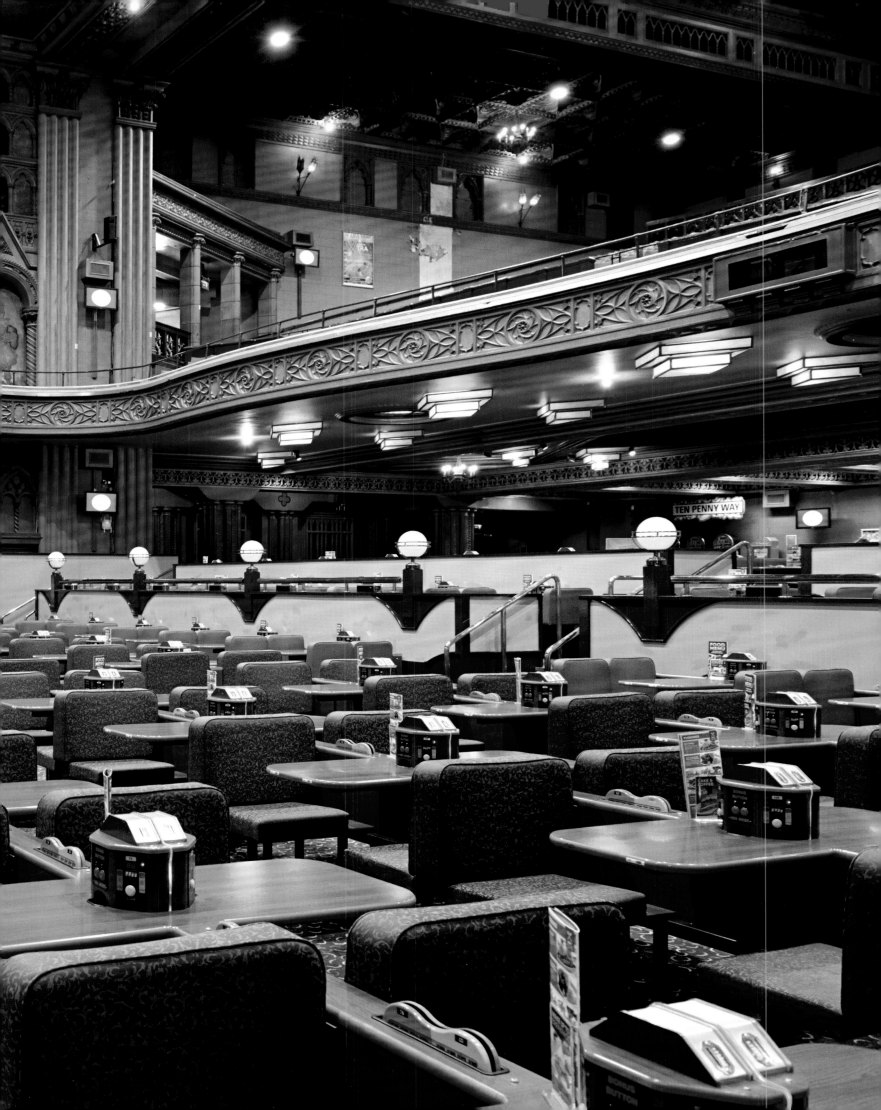

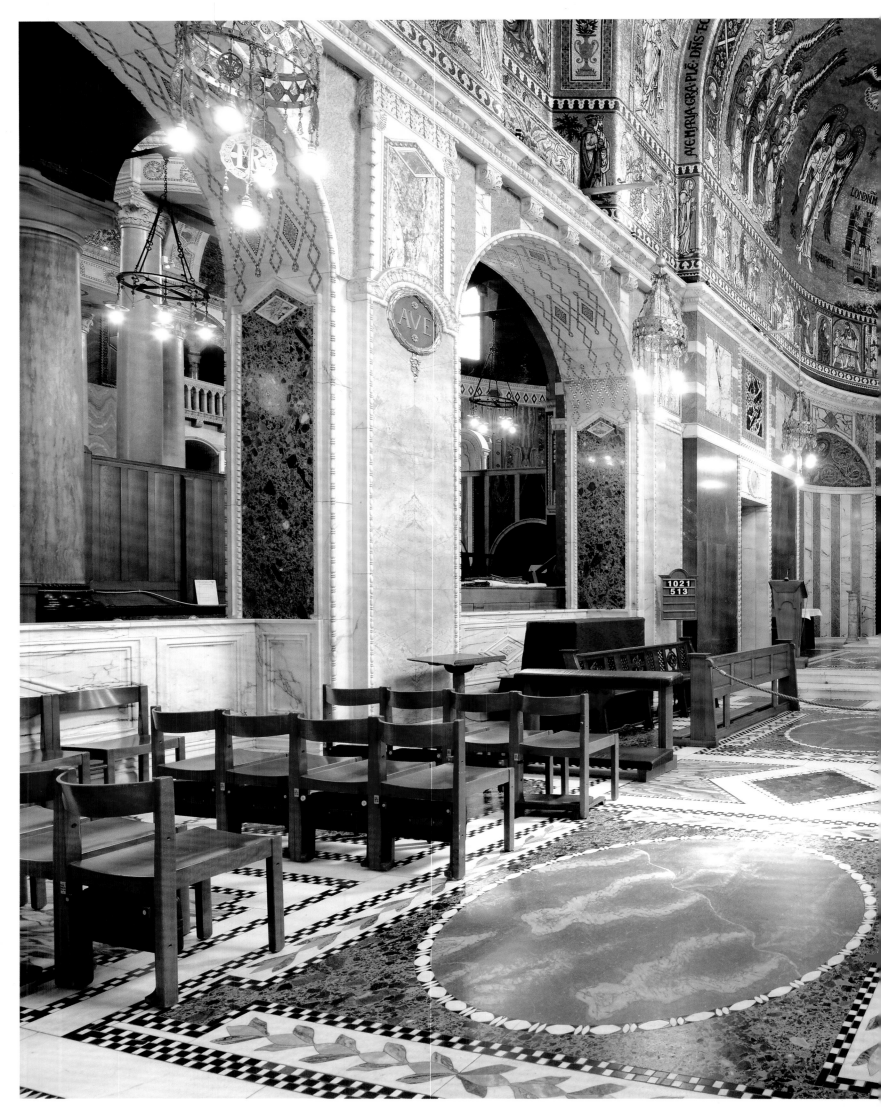

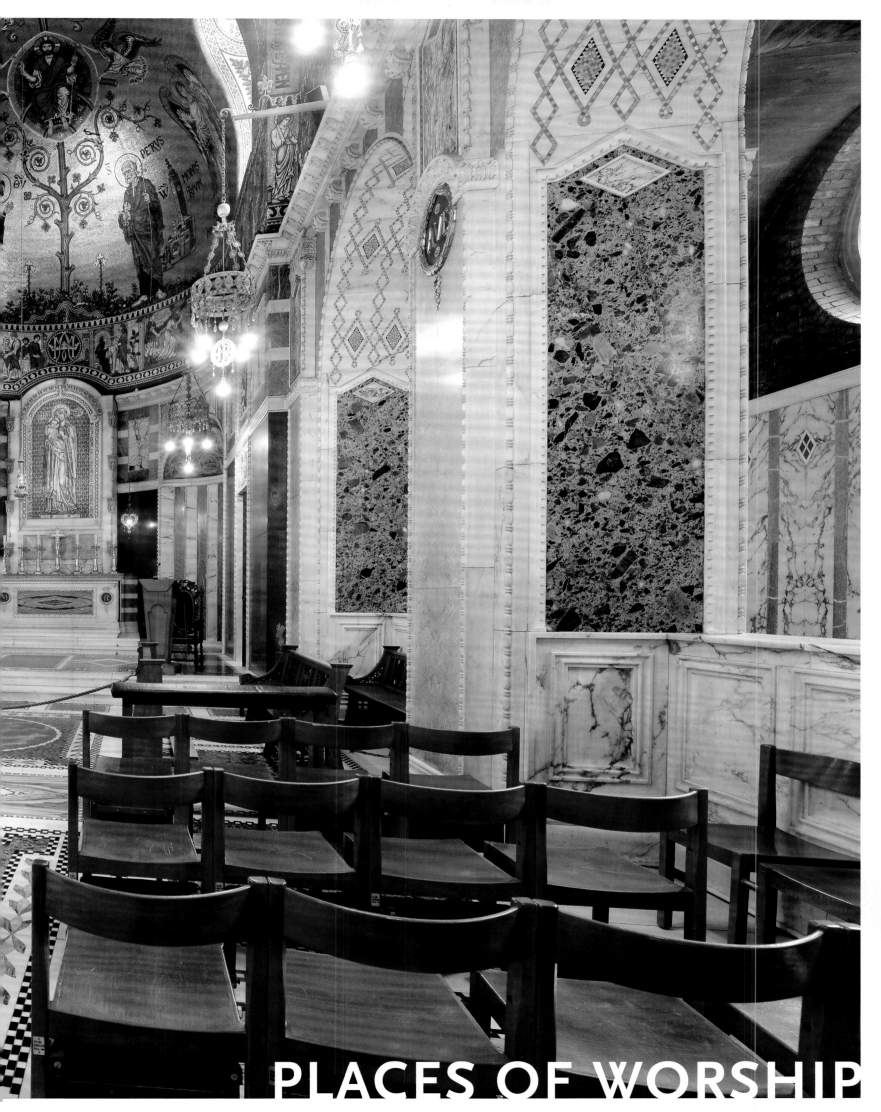

PLACES OF WORSHIP

Westminster Cathedral

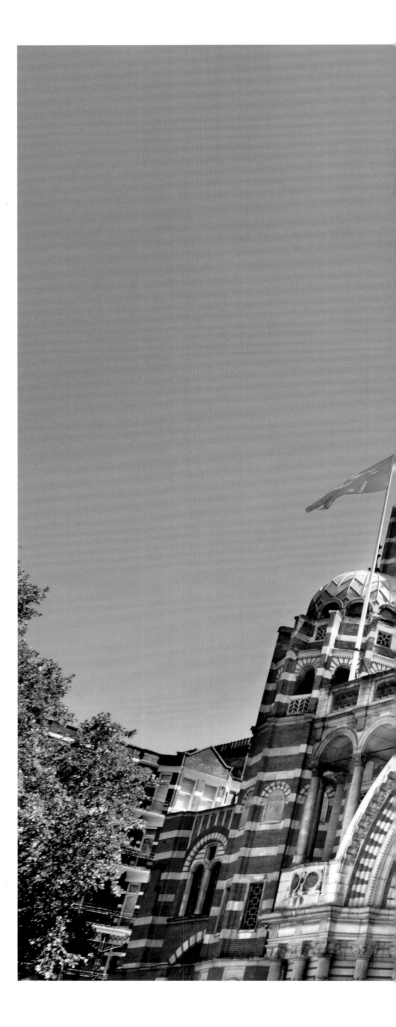

Westminster Cathedral's horizontal bands of red brick and white Portland stone are its visual signature and part of its neo-Byzantine architectural style. Its lofty campanile tower and long and tall continuous nave caused a great stir on completion in 1903.

The cathedral came to be built that way because of a particular set of requirements that emerged following the restoration of the Roman Catholic hierarchy in England and Wales in 1850. A cathedral was needed in London. Forty years of ambitious plans and ideas followed, and a massive gothic cathedral was schemed on a site close to Victoria station, but never started. In 1892, the third Archbishop of Westminster Cardinal Herbert Vaughan was installed, and he knew that a neo-gothic cathedral crafted from stone by masons would take decades to build. At the same time it was important that a new cathedral did not appear to rival Westminster Abbey in its appearance. There was also a need to build a proper congregational church, putting the sight and sound of the mass in front a large number of worshippers.

Cardinal Vaughan appointed architect John Francis Bentley and worked closely with him. There had been a revival in interest in Byzantine arts, and basilica churches in Italy were studied. The chosen design was a space without a crossing or transepts and – most importantly – it would be made in brick, like the great buildings of Constantinople. Practical and spiritual, this design would enable swift construction and interior decoration could be completed later.

Building spanned the turn of the centuries, but was quickly accomplished between 1895 and 1903. Saucer domes of brick and concrete – three over the nave and one over the sanctuary

PREVIOUS PAGE *The Lady Chapel walls are clad in marble and the altar reredos is a mosaic of the Virgin and Child.*

RIGHT *The Cathedral comprises almost twelve and a half million bricks from tower top to foundation.*

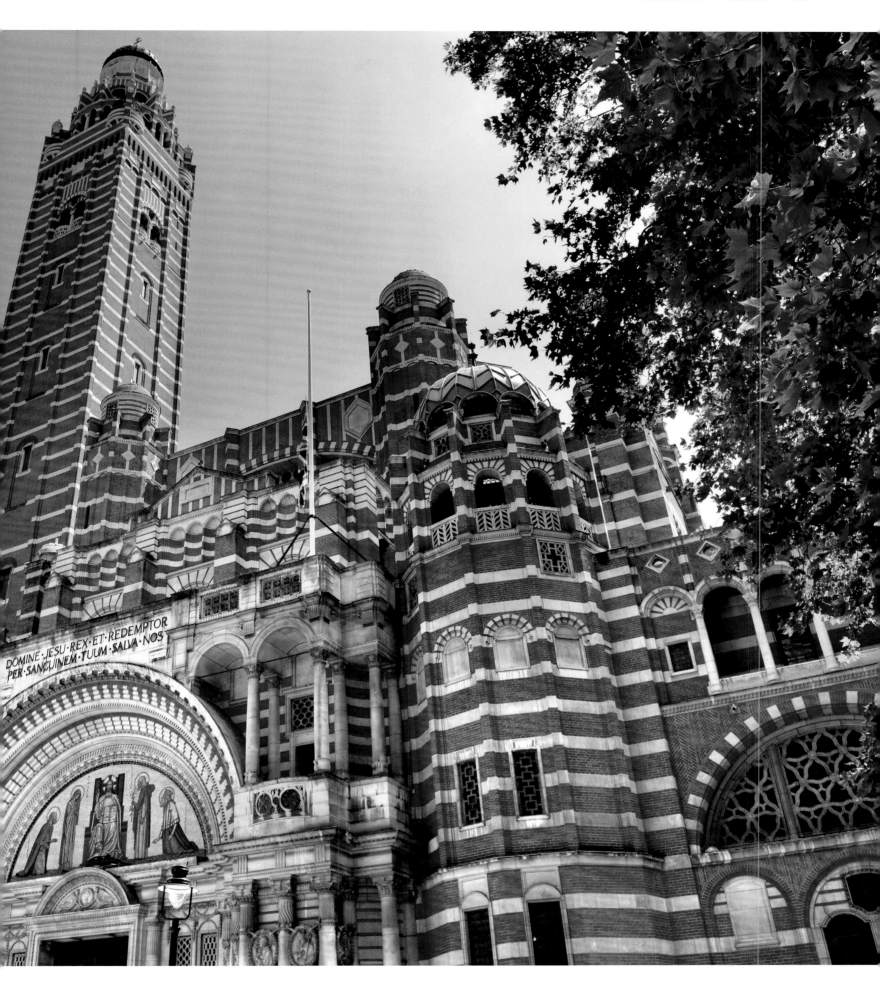

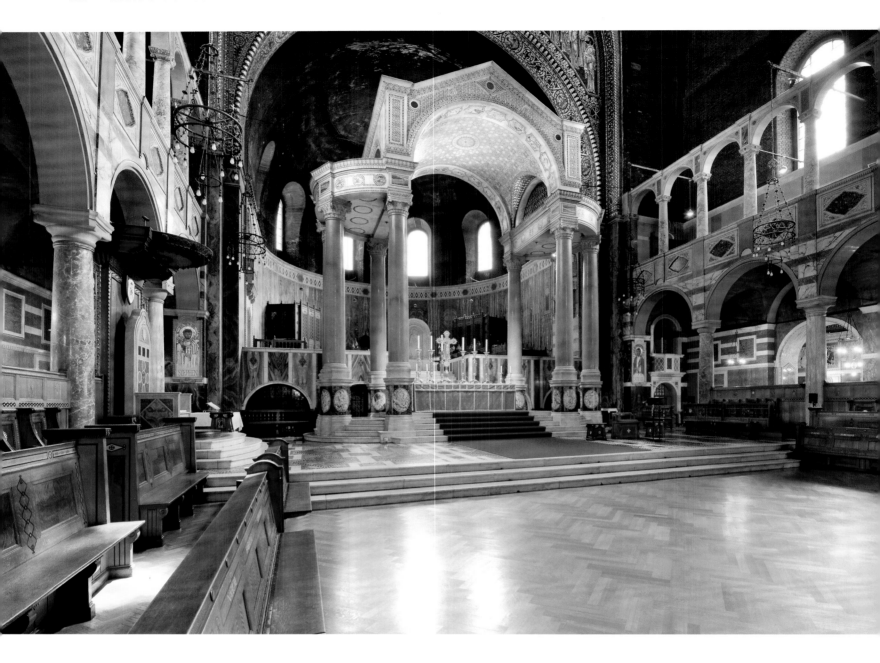

– comprised the roof. Construction elsewhere was of non-reinforced load-bearing bricks throughout, with just a small number of iron ties. A little under twelve and a half million bricks were used in its construction, including Staffordshire blue engineering bricks, mostly hidden in the foundation, orange-red facing Bracknell bricks for the exterior and London Stock bricks for the internal lining of the building. It is the London stock that makes the deepest impression on many visitors today, because thousands of those bricks remain visible inside on the ceilings and arches, left rough

for mosaics that have yet to be applied, testimony to the unfinished state of Westminster Cathedral. The gloomy brick-vaulted areas over lavish marble lower walls have become part of its character. The marble wall panelling is generally complete throughout.

There is no pictorial stained glass anywhere in the cathedral. A distinctive feature is the baldachin, which is the canopy over the altar: a massive structure supported by columns of yellow marble.

To the sides of the nave and sanctuary are eleven chapels,

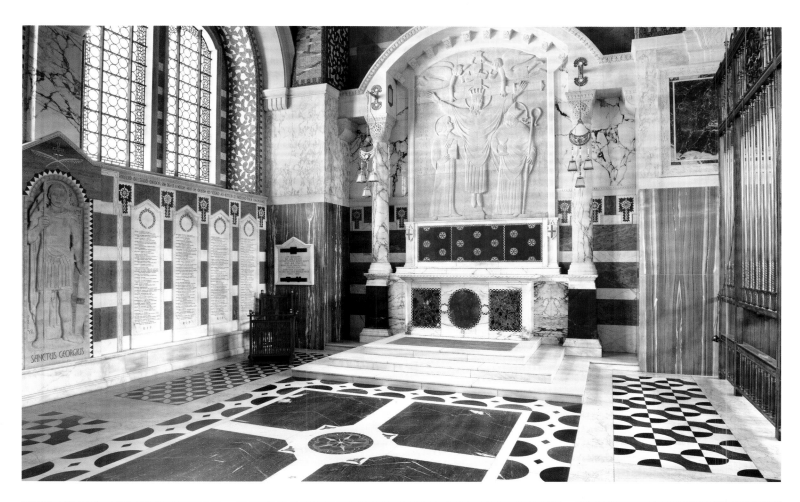

each different in character. An example is the Chapel of St George and the English Martyrs, with the floor bearing an English rose; and the rose motif is continued behind the altar and around the walls. On either side of the altar, the red cross of St George is displayed on marble shields. Panels list servicemen who gave their lives in battle. Above the altar is the last carving by Eric Gill, portraying Christ on the cross. To his left is St Thomas More, Lord Chancellor of England; to his right, St John Fisher, Bishop of Rochester, both executed for their refusal to deny the Supremacy of the Pope under Henry VIII. The marble floors and walls here were completed in 1931, and in recent years mosaics were applied to the upper walls and ceiling.

The Holy Souls Chapel is the only one to be completely designed by the cathedral architect John Francis Bentley himself. Every detail of the marblework and the grille was drawn by him and the mosaic decoration was executed by an artist before the cathedral was consecrated. Otherwise, the architect, who died in 1902, left no finished mosaics in the cathedral and very little in the way of drawings and designs. Subsequent architects and designers, supervised from 1936 by the Cathedral Art Committee, have decided on the mosaics and other areas of decoration, which have been the subject of controversy on several occasions, with work stopping and starting, generating letters to *The Times* about style and value and changes of plans.

The building is visually well-integrated with its surroundings, and several blocks of late Victorian and Edwardian mansion flats nearby have banded red brick and white stones façades in a style sometimes called Victorian Romanesque. These were built on land sold by the church when the cathedral was being developed.

Westminster Roman Catholic Cathedral is the mother church of that faith in England and Wales, and its largest place of worship.

VISITING INFORMATION

Westminster Cathedral, 42 Francis Street, SW1P 1QW

http://www.westminstercathedral.org.uk

Open 8am–7pm Monday–Friday, 10am–1pm Saturday–Sunday.

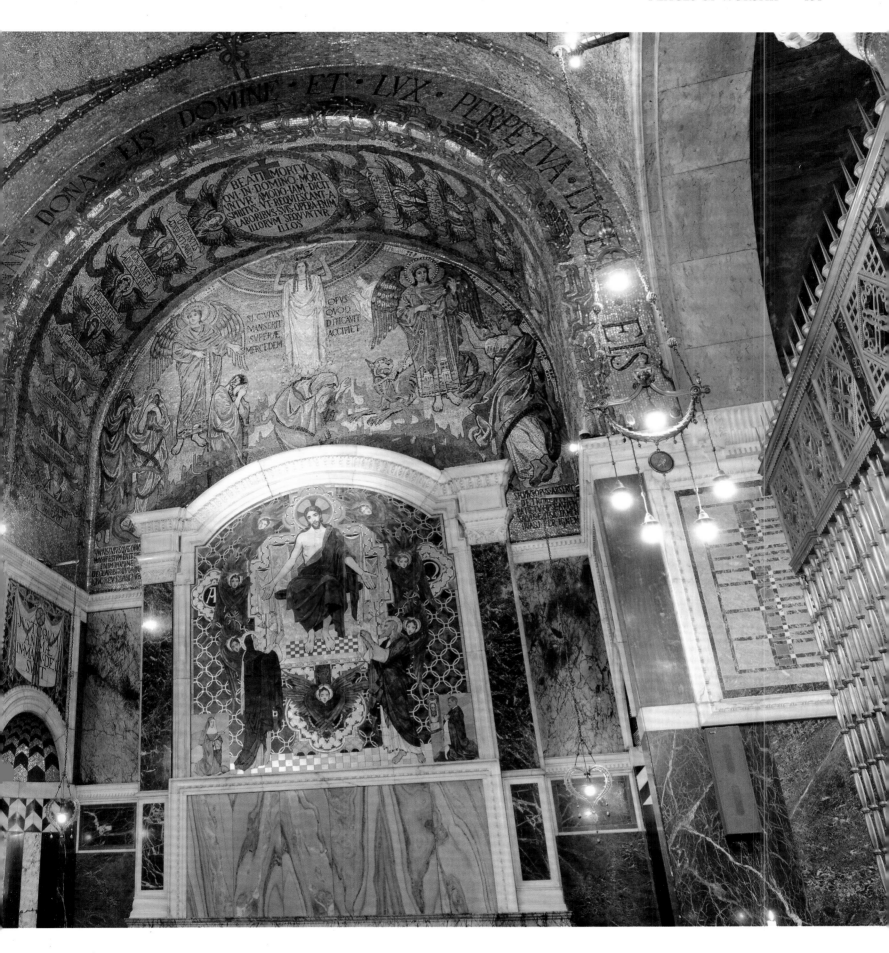

Holy Souls was the first chapel completed, and the only one fully developed to the plan of the architect.

Welsh Church of Central London

One of the most elegant non-conformist chapels in London is the Welsh Baptist Chapel on Eastcastle Street, in the heart of the West End. Although chapels in all non-conformist Welsh denominations – Presbyterian, Methodist, Baptist and Independent – were built in London from 1788 onwards, the establishment of a chapel at such a prestigious location was a considerable coup for the Baptist church, and it drew a wide congregation, particularly from the increasing numbers of young Welsh in London.

At Castle Street East, as the address was then known, a building known as Franklin Hall had been hired by organisations as diverse as the Food Reform Society and the British National Association of Spiritualists. In 1865, the Welsh Baptists signed an agreement with the owner renting the building by the year before buying the lease of the site in 1880, and subsequently commissioning Owen Lewis, a Chapel Street Elder and architect, to design a new building. A leading member of the congregation, Dan Harries Evans (with a fast-growing drapery store nearby, later known as D.H. Evans), made a contribution of £200 to the building fund. Evans was the son-in-law of the first minister at Castle Street.

Lewis's design cleverly exploited what was a narrow, constricted site at street level. It uses only two red-brick-built main storeys, albeit with five levels. It is fronted by a double flight of balustraded staircases. The architectural writer Ian Nairn praised the way 'the whole front is cut away' and this confers a dignified look to the entrance, which would otherwise start on the inside edge of the pavement. The chapel is adorned with white stone, has a majestic four-column Corinthian colonnade, and a roof of slate said to be mined from Penrhyn Quarry near Bethesda.

The organ, installed in 1909, dwarfs the pulpit.

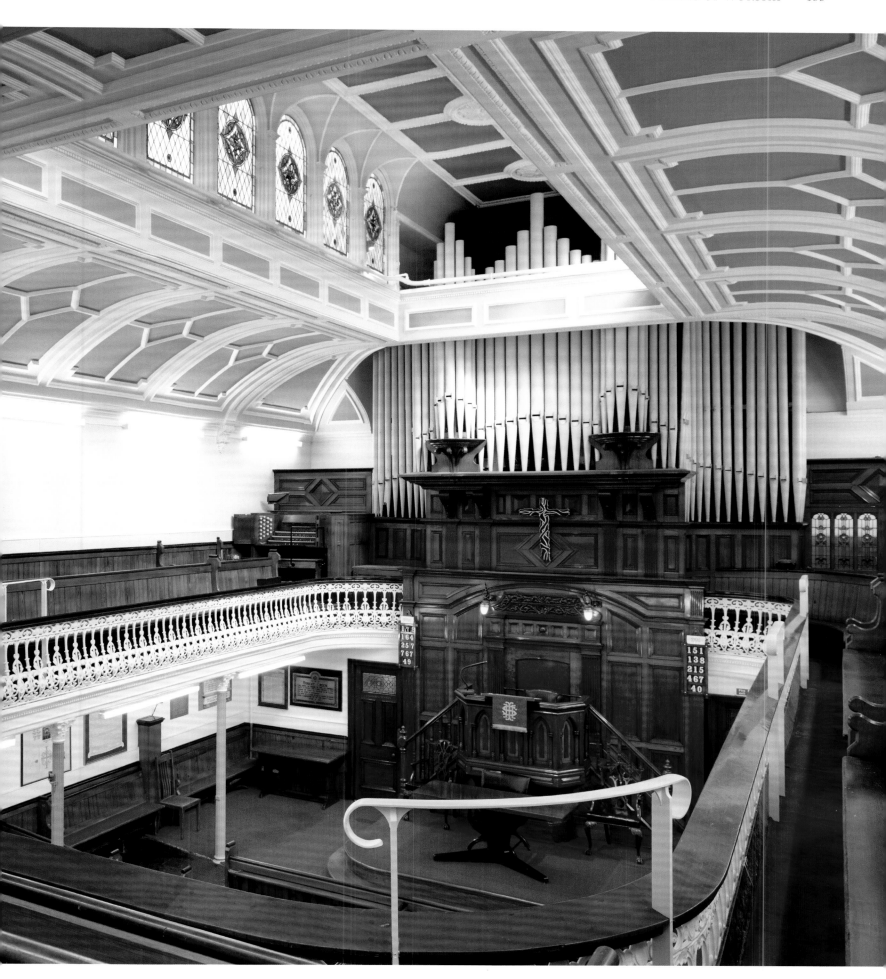

Internally, the chapel soars to the lantern, with fourteen stained-glass windows on three sides, while blue ceiling work suggests a celestial mood. Under this, a gallery on three sides is enclosed by decorative iron balustrades. The enormous three-manual pipe organ, which cost £1,000 when fitted in 1909, dwarfs the pulpit box.

It was all far advanced from the 'gloomy shed' school of chapel architecture that had started not long before in rural Wales and translated to the industrial areas of the cities. The Welsh Baptists in London had come a long way since 1611, when an early Baptist meeting took place in Spitalfields. It was not until 1689 that the English Parliament passed the Toleration Act, in which some latitude for freedom of worship was permitted. By 1810 there was a Baptist meeting house in Deptford.

The Welsh Baptist Chapel in London thrived, and played a role in elevating the status of Wales and Welshness in London, aided to some extent by David Lloyd George joining the congregation in 1906. He often spoke from the pulpit. When he was Prime Minister, one of the most notable social events of 1917 in London took place at the Baptist Chapel attended and watched by hundreds of people. This can be seen in a Pathé newsreel film capturing of the marriage of David Lloyd George's daughter to Captain Thomas Carey Evans, a widely publicised wartime event with a prominent place given to injured soldiers and invited munition workers.

Fourteen stained-glass windows in the splendid roof lantern, built in 1889: the architecture of non-conformism in its golden age.

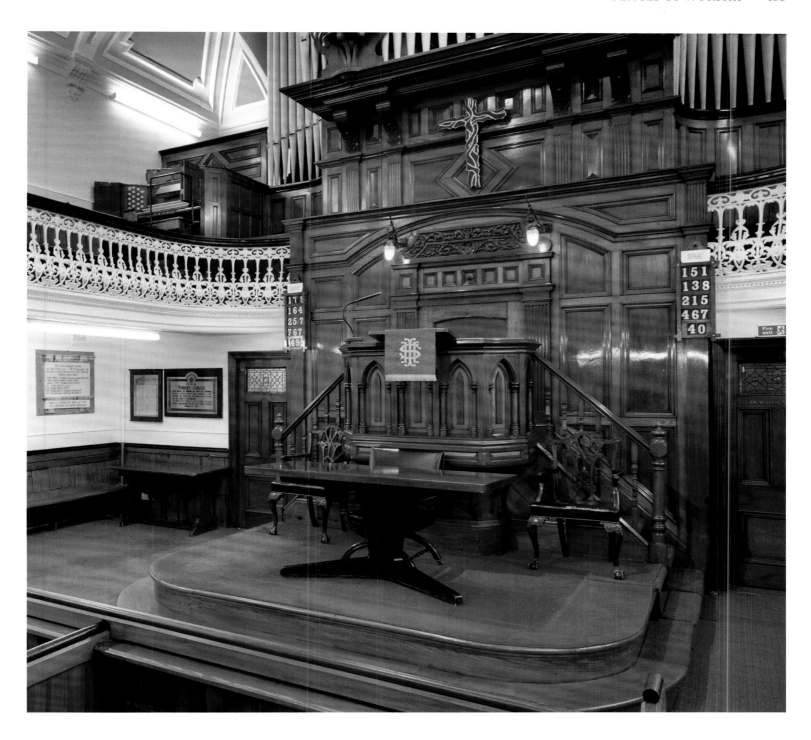

The communion table and the pulpit box, where Lloyd George was a frequent speaker.

In a refurbishment of 2013–15, the chapel was completely restored, including the basement church hall and kitchen and two self-contained apartments on the top levels. The building was re-roofed in Welsh slate.

The United Welsh Church in Central London, or EGCLL (Eglwys Gymraeg Canol Llundain), came into being in 2006, when the Baptist Chapel joined with the Independent Church at King's Cross and the Independent Church at Radnor Walk. The three churches still exist in law but they worship as one congregation at Eastcastle Street. Services are bilingual.

VISITING INFORMATION

The Welsh Church of Central London, 30 Eastcastle Street, W1W 8DJ

http://www.egcll.org

Opening times vary.

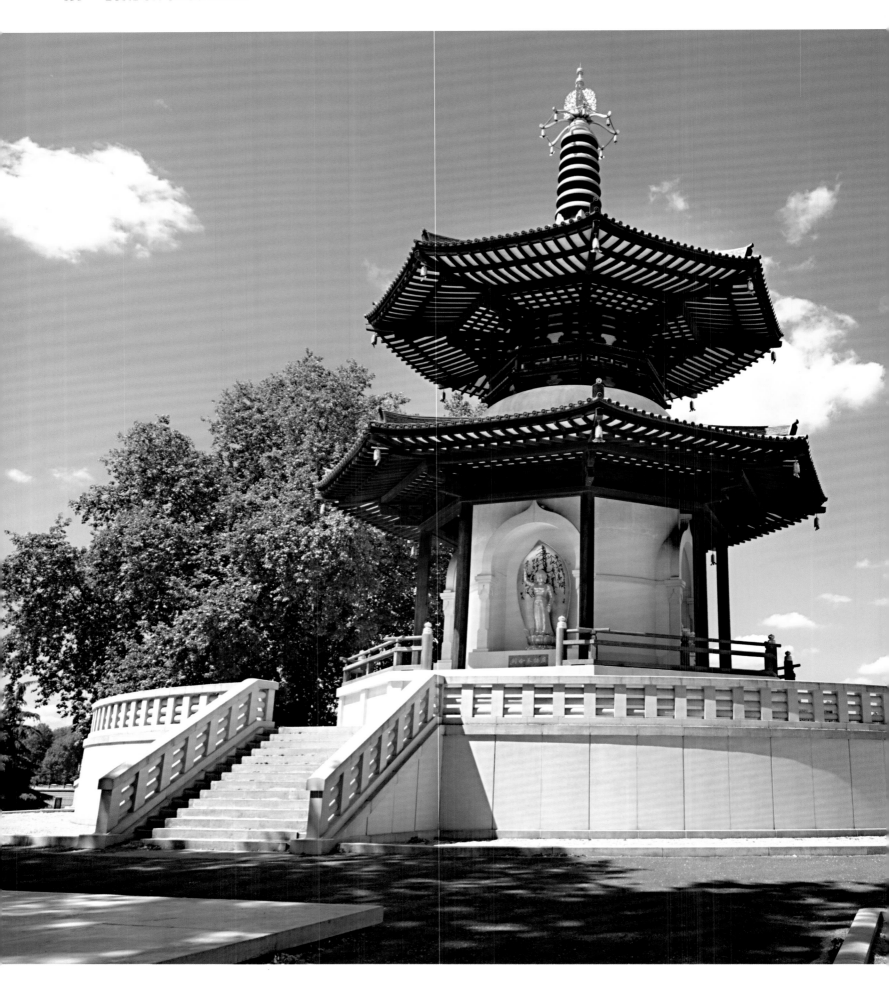

London Peace Pagoda

The London Peace Pagoda sits in Battersea Park, close to the river between Albert Bridge and Chelsea Bridge on the esplanade, which was a main feature of the original Victorian park that opened in 1858. Permission to build the pagoda there was the last legislative action of the Greater London Council, and mildly controversial at the time as one of a series of populist and pacifist alternative moves, putting the GLC at odds with the government. In the event, the pagoda gained approval with the local population and visitors, and was one of the first measures that started to revitalise the once run-down park.

The offer to build a peace pagoda in London came from the Nipponzan Myohoji Buddhist Order, a movement that emerged from the Nichiren sect of Japanese Buddhism. The Order already had a centre in Britain after building a Peace Pagoda at Milton Keynes in 1980, and had been constructing peace pagodas around the world in Europe, Asia and the United States since 1947. A working party of fifty volunteers, including Buddhist monks, helped to construct the Battersea pagoda in 1984 and 1985.

The double-roofed, eight-sided pagoda is made of concrete and wood. The ceremonial platform, with bamboo-styled balustrades recreated in concrete, and surrounding landscaping, was created by the Heritage Lottery Fund and Wandsworth Council. The iconography of the four gilt-bronze statues lies in the Buddha's hand gestures, known as *mudras*. They describe stages in the Supreme Buddha's life: birth, contemplation leading to enlightenment, teaching and nirvana.

VISITING INFORMATION

Battersea Peace Pagoda, Battersea Park, SW11 4NJ

http://www.batterseapark.org

The park is open daily from 8am until dusk.

The south-facing Buddha statue gesture denotes fearlessness and protection.

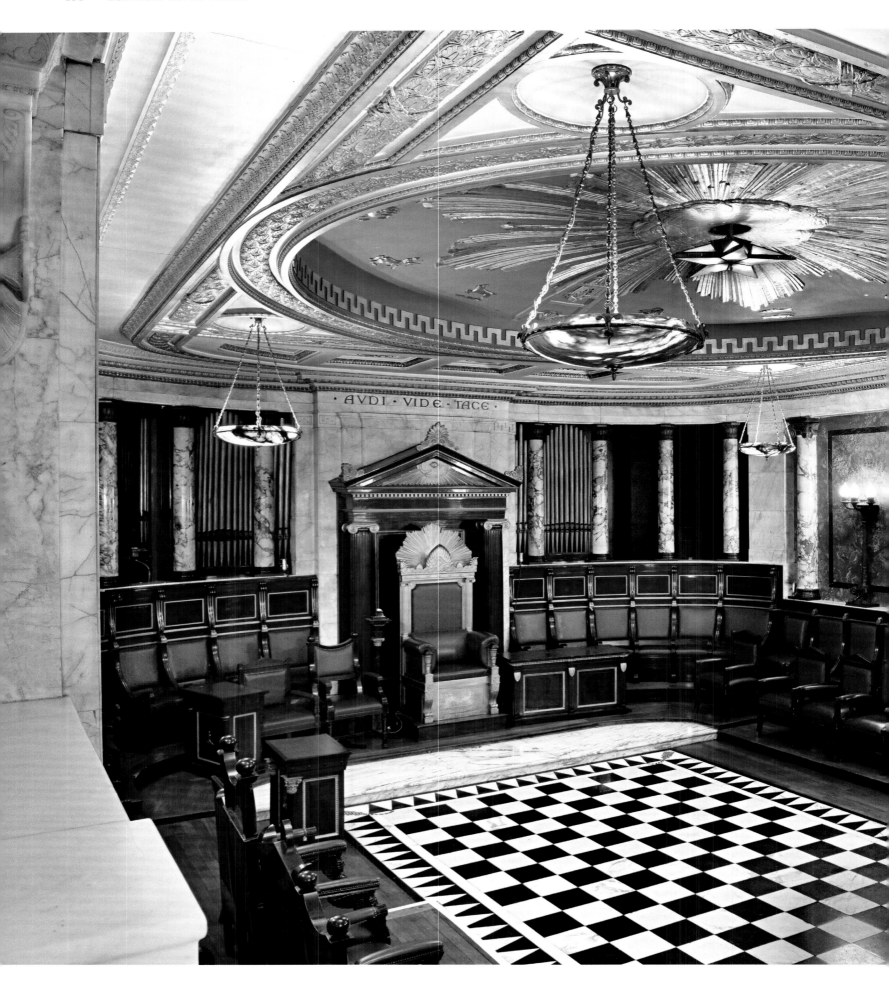

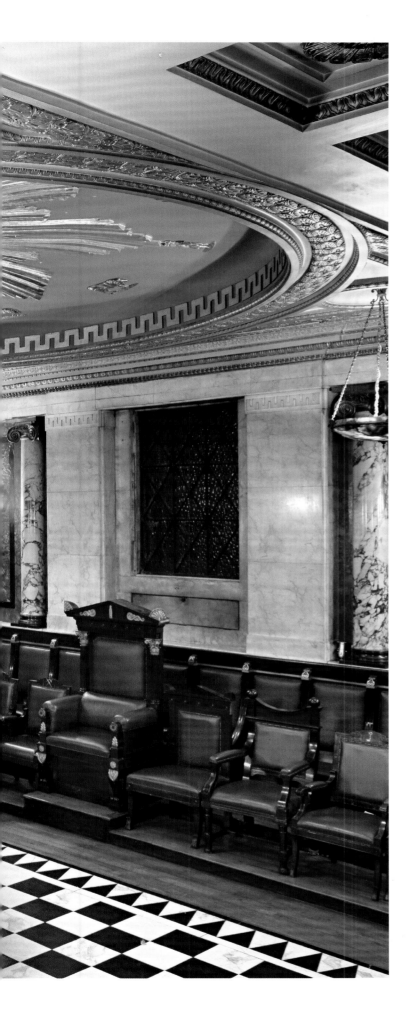

Masonic Temple at Andaz Liverpool Street Hotel

It is strange that a railway hotel at a major London terminus should include an elaborate masonic temple. That hotel is today known as the Andaz Liverpool Street, and the temple remains on the first floor. It is in regular use for fashion shows, product launches, wedding receptions and cabaret dinners, and has even hosted a festival of horror mystery films. Stranger still, when the hotel was known as the Great Eastern, it until quite recently housed not one, but two masonic temples.

The Great Eastern Hotel was opened in 1884 at the front of Liverpool Street station, serving as the new terminus for railway routes from East Anglia. Designed by father and son Charles and Charles Edward Barry, it had a vast number of bedrooms but only a few bathrooms, in the late Victorian style. In response to growing demand for hotel accommodation, the ground plan of the hotel was doubled between 1898 and 1901 and a masonic temple constructed in the basement.

It was a time of growth for Freemasonry, and several hotels built across England by the main railway companies at that time were to include a lodge room. Far larger and more lavish than any of them was the second masonic temple at the Great Eastern, consecrated in November 1912. Lord Claud Hamilton, Chairman of the Great Eastern Railway, together with family members and other railway company directors who were also Freemasons, commissioned the temple and paid for it out of their own pockets. The architects were Brown & Barrow, Alexander Brown being the Grand Superintendent of Works for the United Grand Lodge of England. It was in some ways a corporate statement for the railway company, costing £50,000 at the time, more than £4 million by today's standards. This did not include the cost

The pipe organ, by Norman and Beard of London, was integrated into the original design of the Temple in 1912. The black-and-white checkerboard flooring is symbolic of diversity and duality.

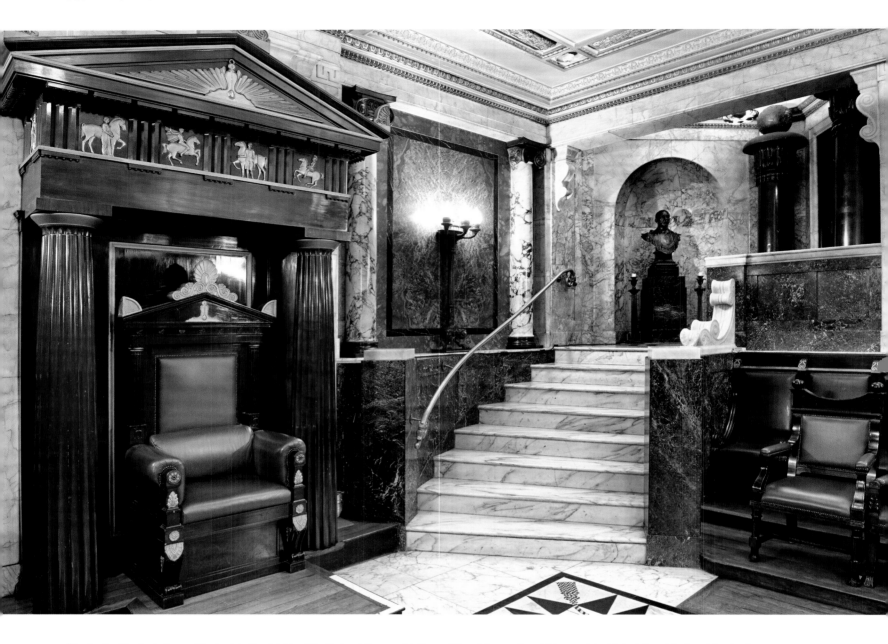

The Senior Warden's throne. The bust to the right is of the Duke of Connaught, Queen Victoria's son, Grand Master of the United Grand Lodge of England.

of structural alterations needed to strengthen the building because of the decision to place the temple on the first floor, and the sheer weight of the materials used. Italian craftsmen were bought over to supervise the marble work. This room was called the Grecian Masonic Temple, and the previous one the Egyptian Temple.

It is the Grecian Temple which exists unchanged today, accessed by twenty-seven steps up a winding staircase through a mahogany-panelled anteroom. The visitor must then descend more marble steps to the sunken floor of the temple. Above is a sunburst ceiling, painted with signs of the zodiac and a ladder to heaven bearing the virtues Faith, Hope and Charity. There are hand-carved mahogany chairs for the Worshipful Master and the Senior and Junior Wardens.

The space features rare marbles of three different types, offset by Doric columns around the doorway at one end and Ionic at the other. There is even a pipe organ integrated into the wall. The black-and-white chequered marble floor is a classic masonic feature.

The hotel eventually closed in 1996 and was sold. In spring 2000, the Great Eastern Hotel reopened its doors to reveal an extensive restoration. At the start of 2006, the property changed ownership again. Hyatt Hotels & Resorts now operates it the under the Andaz brand, a five-star boutique hotel with 267 rooms, all of them different.

It was inevitable, given the temple's mysterious imagery and windowless secrecy, that a strange story should develop and attach itself to the room. This bears repeating, if only

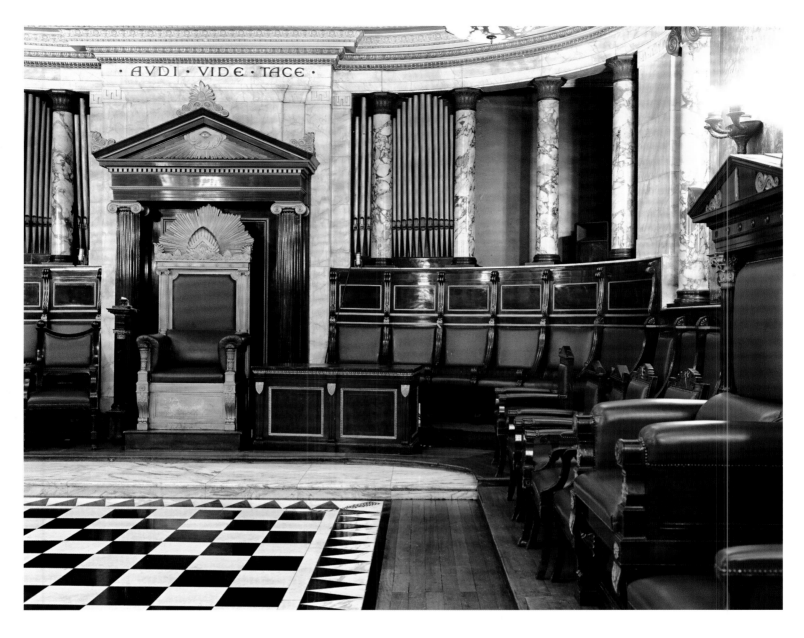

The Worshipful Master's gilded chair, under the motto Audi, Vide, Tace ('Hear, See, Be Silent'), overlooks the Grecian Temple.

because it is included in the hotel company's official profile of the space. For decades it is said that staff at the Great Eastern Hotel regularly walked past an inconspicuous looking wall, unaware of what lay behind it. During reconstruction, someone examining the drawings for the building noticed there was an additional room that had long been kept a secret. The wall was demolished, and the temple was rediscovered in the 1990s after years of disuse. For the temple to slip from corporate memory and be sealed up in disuse must be closer to myth than fact. Others suggest that the Grecian Temple was always in regular use until the hotel closed for refurbishment, and it is still occasionally used for Masonic purposes today.

Meanwhile, the Egyptian Temple was transformed into a gym and fitness centre during the hotel remodelling, but not entirely obliterated. Some of the guests working the cardio machines in the basement gym may look and wonder about the origin of the splendid doorway, the painted Egyptian lotus buds on the red-and-gold pilasters, and the traces remaining of a splendid ceiling.

VISITING INFORMATION

The Andaz Liverpool Street Hotel, 40 Liverpool Steet, EC2M 7QN

http://london.liverpoolstreet.andaz.hyatt.com

The Grecian Temple is sometimes open during the Open House London

festival: http://www.openhouselondon.org.uk

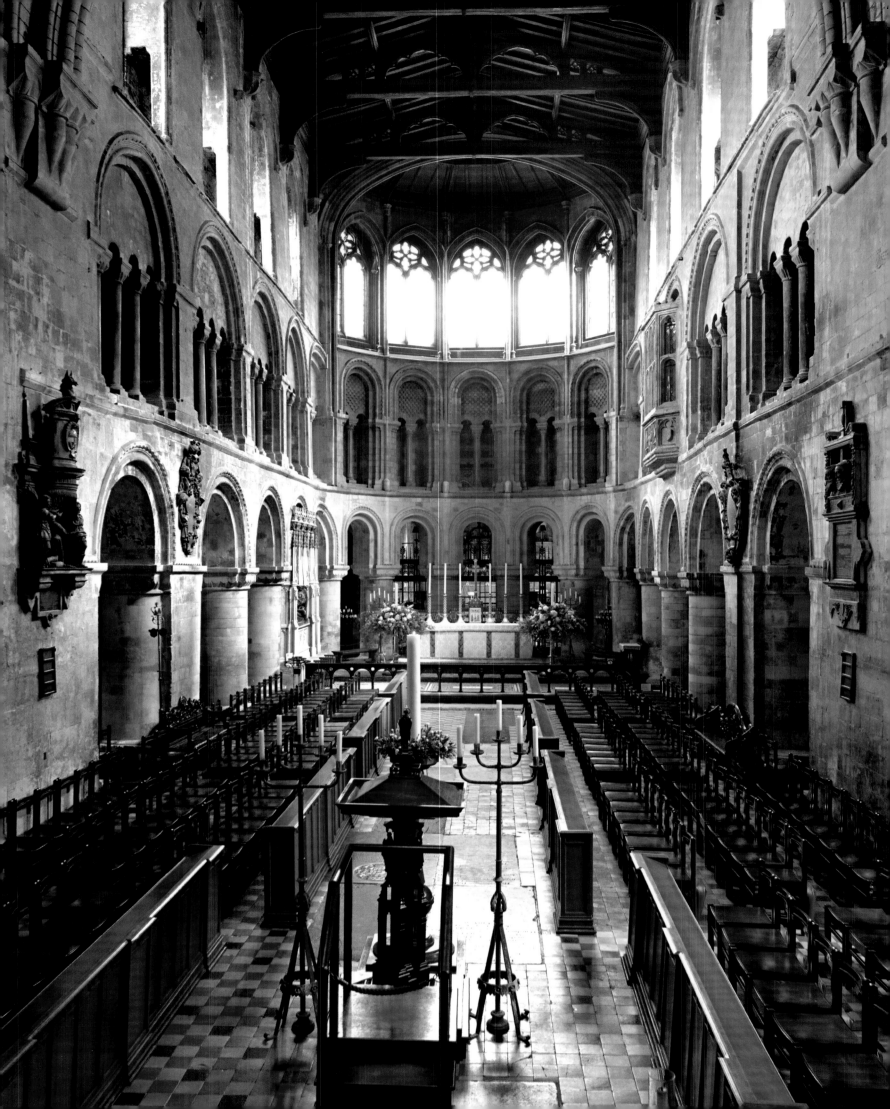

St Bartholomew the Great

The church of St Bartholomew is one of the great survivors of English architecture. It dates from 1123 and is, by some 500 years, the oldest parish church in London. Many of its near-contemporaries perished in the Great Fire of London, from which it escaped unscathed. It was partly demolished during the Reformation and was mostly given over to secular use, but emerged again following a timely, if heavy-handed, Victorian restoration. The drama continued when it was damaged in a Zeppelin raid during the First World War, but it took the London Blitz of 1940–1 in its stride.

The church today is not much more than a fragment of the original. St Bartholomew's was once the main church of an Augustinian priory that once ranked among the grandest buildings in London. The modern visitor who enters its grounds through the Tudor Gate from West Smithfield is unwittingly passing through the original west door of the church. The stone archway, embedded in the later timber structure, is all that survives of the great nave, which was demolished in the 1540s, the priory having been sold to Sir Richard Rich following the Dissolution of the Monasteries.

The structure that remains is therefore merely the chancel of the mighty original church with the Lady Chapel beyond. The church limped along, with services continuing in the choir while Sir Richard, a future Lord Chancellor and one of the most rapacious figures of an era not characterised by restraint, exploited the commercial potential of the remainder. The cloisters became stables and the crypt was turned over to storing coal and wine. The Lady Chapel found use as a house, then a printing works, and it was here that Benjamin Franklin, later a key figure in the American Revolution, was employed while briefly in London from 1724. A blacksmith's forge occupied the remains of the north transept and its walls are blackened by soot to this day.

St Bartholomew's bears heavy scars from the Reformation, but some of the medieval glory remains. The splendid tomb of Prior Rahere, the order's founder, survives on the north side of the choir, though it post-dates his death in 1143 by almost 250 years. It was rebuilt in 1405 and features a painted effigy, guarded by an angel bearing a shield with the priory's arms. This splendid tomb is thought to have replaced Rahere's original, and probably much more modest resting place, in order to attract suitable offerings from the faithful. It is directly overlooked by one of the most remarkable survivals, a beautiful oriel window inserted in the original clerestory by Prior Bolton in 1515 to enable him to observe both the conduct of the monks in the church below and the number of donations on Rahere's tomb.

The eastern end of the church is, visually, the most memorable element of the interior. A remarkable progression of architectural styles rises from the narrow Norman arches behind the altar up to fourteenth-century clerestory arches and Victorian windows above. Unfortunately, this is also among the least authentic elements of the church, as paintings from 1830 show an entirely different east end. The riddle is resolved by the fact that St Bartholomew's was heavily reconstructed (or restored, as the Victorians put it) from 1884–96. The architect of this huge endeavour, was Sir Aston Webb, whose most celebrated project in London was the facade of Buckingham Palace, including the famous balcony on which the Royal Family appears after state occasions.

The nave of St Bartholomew the Great has seen many reconstructions and rebuilds; the eastern end was extensively reimagined in 1884–96.

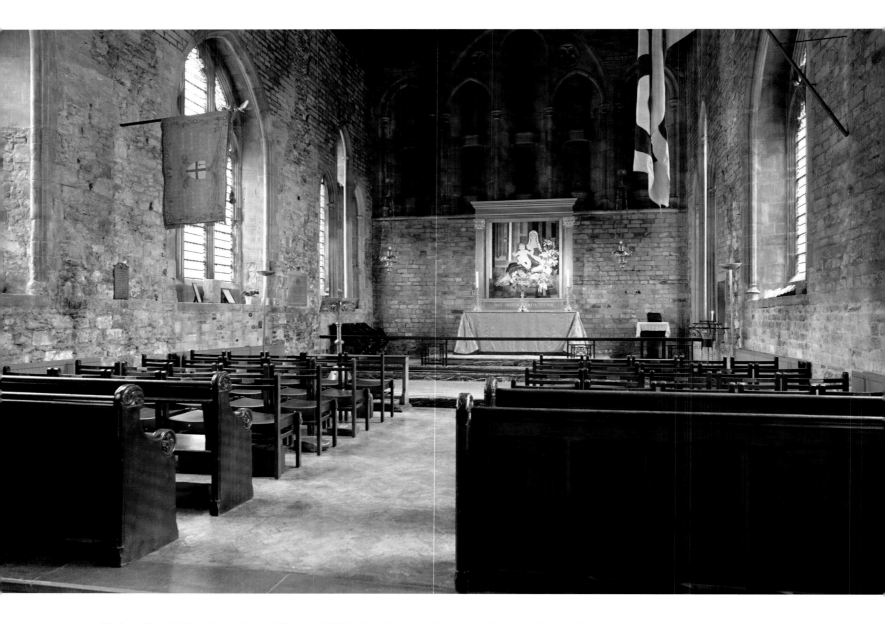

ABOVE *The Lady Chapel. The painting of the Madonna and Child above the altar is by the Spanish artist Alfredo Roldán. It was unveiled in 1999.*
OPPOSITE *The north door of Bartholomew the Great on Cloth Fair is a Victorian addition.*

Webb is not remembered for outstanding architectural flair. Even his biographer admitted: 'his talent was considered by many to be more practical than artistic'. But when Webb came on the scene practical solutions were what St Bartholomew's needed above all else. The church was almost derelict and, as one critic observed: 'though purists might disapprove of the measures [taken by Webb] without them there might well have been no St Bartholomew's today'. Webb's twelve-year project secured the structure and reversed some of the work of previous generations, including the east end, where the original apse had been removed and so was comprehensively rebuilt. In addition, the present Lady Chapel, which now contains the colours of the RAF's City of London squadron, was heavily reconstructed by Webb, and the current organ was installed in the east end of the church during this period. Webb built a new entrance on the north side and reclad the entire exterior, much of it in a chequered effect achieved through white stone and knapped flint. St Bartholomew's has no memorial to Webb, but there is a poignant tribute to his son. High up in the Tudor Gate stands a carved wooden saint which was erected for Philip Webb, who was killed in action in September 1916.

VISITING INFORMATION

St Bartholomew the Great, Cloth Fair, EC1A 7JQ

http://www.greatstbarts.com

Opening times vary.

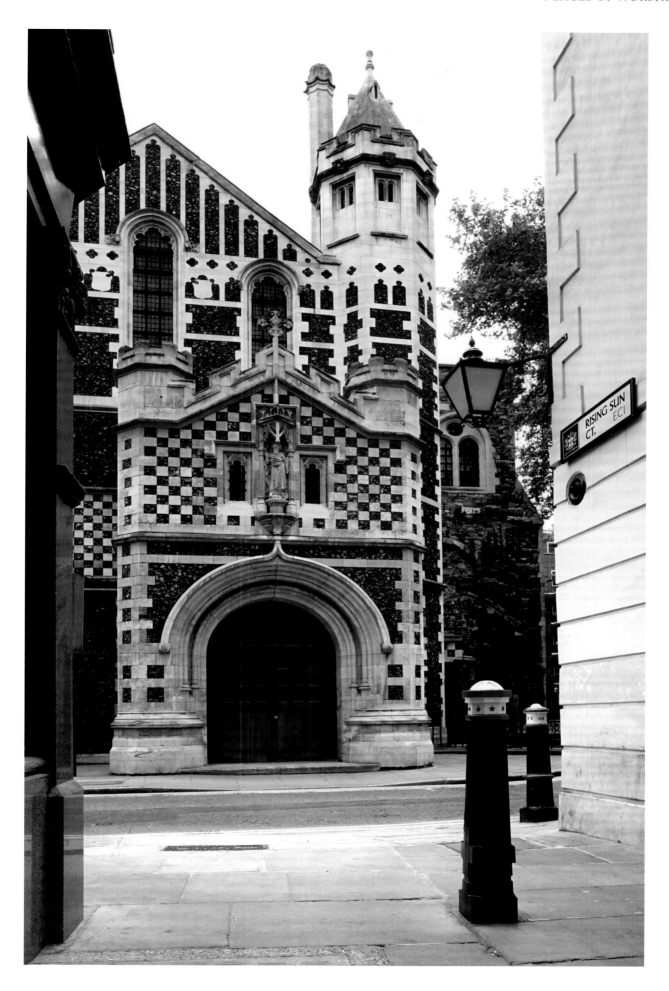

Bevis Marks Synagogue

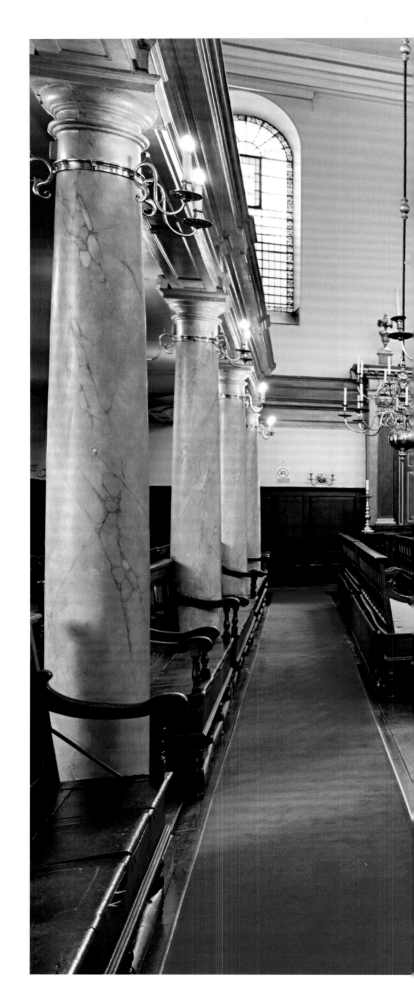

Bevis Marks Synagogue is the oldest Jewish house of worship in London, and the only synagogue in Europe to have held regular services continuously for over 300 years. It stands in a quiet courtyard behind a gated stone archway in the City of London. The inscription in Hebrew above the entrance reads: 'Sanctified to the Lord, Holy Congregation, Gate of Heaven, New Year 5462', which represents the year 1702. The synagogue is virtually unchanged from that date.

Portuguese and Spanish Sephardic Jews were permitted to re-establish and practice their religion in England after 1656 when Oliver Cromwell relaxed the exclusion laws, and a small synagogue was established in London. As more Jews arrived fleeing the Inquisition, a larger synagogue was commissioned. When the building contract was signed in February 1699, jews were still not permitted to build on the public thoroughfare, and the synagogue was sited in a discreet yard just off what is now Bevis Marks Street. The exterior style of the building was much like other City of London churches of the time. The builder was Joseph Avis, a Quaker Merchant Taylor liveryman and carpenter, who had worked for Sir Christopher Wren on St Bride's Fleet Street and on St James's in Piccadilly.

There are two legends about the construction of Bevis Marks that cannot be verified, but are said to reflect shifting political attitudes of the time. One is that Princess Anne, later Queen Anne, presented an oak beam from a Royal Navy warship for incorporation in the roof, showing royal support from the House of Stuart. The other claims that Joseph Avis returned the profit he had made on the contract, saying he would not profit by building a House of God, showing friendship from the Puritan side.

The main inspiration for the layout and decoration of the interior was the Amsterdam Synagogue, influential because it

All the furniture and decoration date back to the opening in 1702.

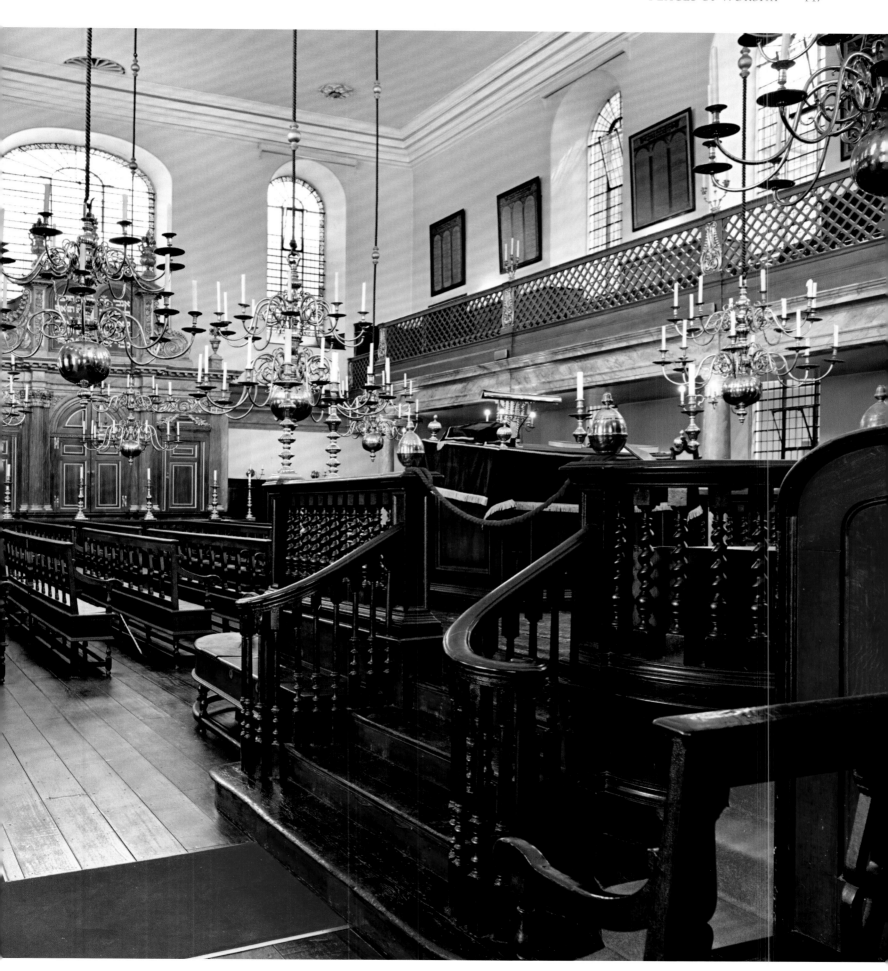

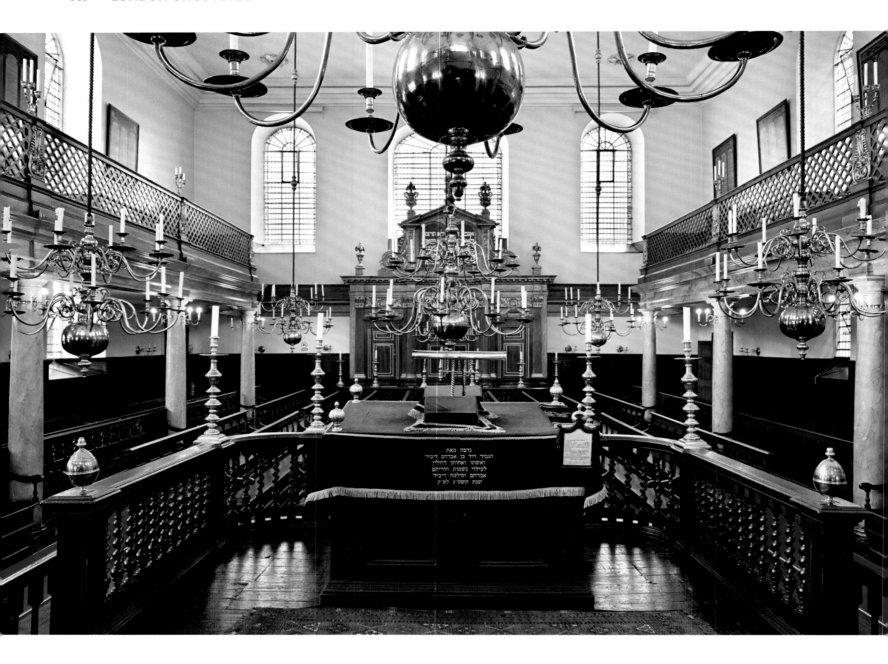

The reader's desk inside the Bimah, covered by a blue throw with gold embroidery and fringe. The women's gallery is behind wrought-iron grilles above to the left and right.

represented a rare enclave for Jewish worshippers of the age. Twelve Doric columns, representing the twelve tribes of Israel, support the upper women's gallery. In front of the Ark and around the reading desk are ten large candlesticks, emblematic of the Commandments. The seven suspended brass candelabra represent the days of the week; the largest central lamp for the Shabbat was a gift from the Amsterdam Synagogue. Candles are still lit for festivals and weddings. The heavy dark doors with original iron locks and massive keys are still in use.

The Ark containing the Torah scrolls appears to be made of coloured marble, but is painted oak and the interior is lined with Spanish gilded leather. Benches are positioned on the east–west axis and face inwards around two aisles for the procession of the Torah. Some of the benches in the back rows may be the oldest items in the building, the original seats brought from the preceding Creechurch Lane synagogue of 1657. The end-of-bench seat once occupied by Sir Moses Montefiore, Victorian financier and banker, activist, philanthropist and Sheriff of London, who was a leading worshipper at Bevis Marks, is roped off and reserved for important visitors, such as Prince Charles and Prince Philip for the 300th and 250th anniversaries respectively.

A fire destroyed the roof in 1738; it was replaced in 1749, but for many years the synagogue escaped much of the destruction that London experienced. It was located in the

area of densest bombing of London during the air attacks of 1940–5, and was surrounded by areas of widespread devastation, but no bomb fell directly on Bevis Marks Street, and it escaped with only minor damage. It was the Baltic Exchange and Bishopgate bombs of 1992 and 1993 that caused more considerable damage to the synagogue, requiring new ceiling joists and floorboards. The work was completed in 1995.

At first, the synagogue was built on a leased plot of land, but in 1747 Benjamin Mendes da Costa bought the leasehold of the ground and presented it to the congregation. For Sephardic believers, Bevis Marks was the leading centre of the Anglo-Jewish world for 150 years, until the shifting of the community from the City changed the balance across London. The traditional Sephardic Spanish-Portuguese service is still celebrated. Today, Bevis Marks is the synagogue of the Square Mile, and also an important place for explorers of the City, nominated by Jewish Heritage for the European Routes of Jewish Culture.

VISITING INFORMATION

Bevis Marks Synagogue, 4 Heneage Lane, EC3A 5DQ

http://www.sephardi.org.uk/bevis-marks

Open mornings except Saturdays. Book tours: maurice@sephardi.org.uk.

The Torah scrolls and the Ark, which is hand-carved from oak, with the doors grained to imitate mahogany. The columns and base are painted to resemble coloured marble.

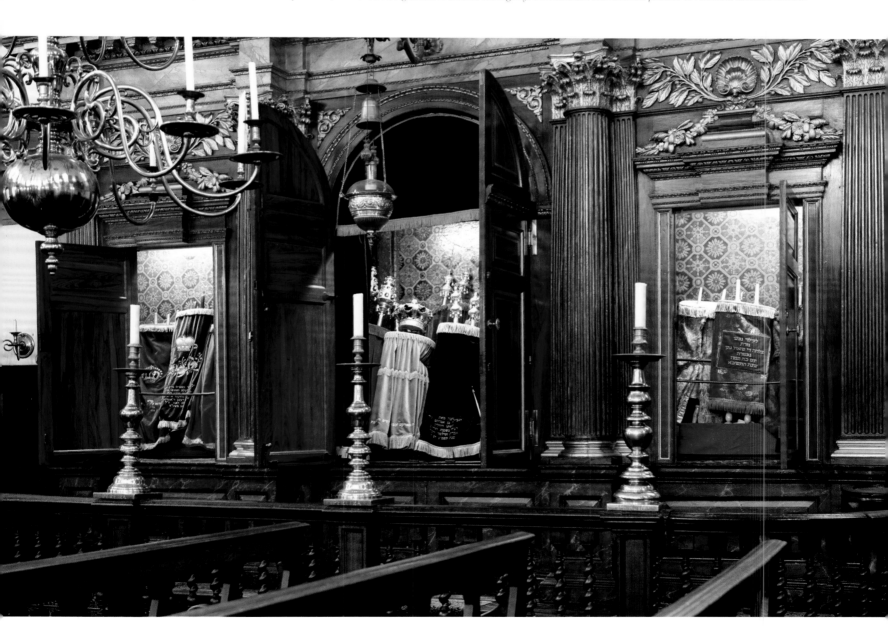

St Mary-le-Bow

The most famous set of church bells in London have been destroyed twice by fire, and the church in which they ring has twice been rebuilt from its ashes. St Mary-le-Bow Cheapside was one of eighty-eight churches destroyed by the Great Fire of London. It was rebuilt to the design of Sir Christopher Wren on a plan inspired by the Basilica of Constantine in Rome, scaled to about one third of the original's dimensions. The latest version of St Mary-le-Bow seen today is largely to this original Wren specification, although it is a rebuilding.

Peeling back the layers of history at St Mary-le-Bow, founded at a date close to 1080 as the London headquarters of the Archbishops of Canterbury, reveals a turbulent past. The first church building on this spot lost its roof to the freakish London Tornado of 1091; in 1271 the steeple collapsed into the neighbouring market of Cheapside.

St Mary-le-Bow derives its name from the bows, or arches, found in the crypt, which was built partly using salvaged Roman bricks.

According to legend, Dick Whittington was recalled to London by Bow Bells. If true, this occurred in 1392, given what is known about his terms as Lord Mayor. In folklore, the bells of St Mary-le-Bow do indeed define a Cockney, as only those born within earshot of their chimes can describe themselves as true Cockneys. This is believed to derive from a way of making a distinction between those who lived in the country and those who lived in London, as St Mary stood on the north-eastern edge of medieval London.

There are certainly records of bells from 1469, with five bells in operation by 1515. The activity of modern bellringing dates

Restored to its seventeenth-century style with modern decoration, the nave has a pendant
cross over the nave, depicting Christ surrounded by figures of the Virgin Mary, St John,
Mary Magdalen, and the centurion; two pulpits were added at the same time.

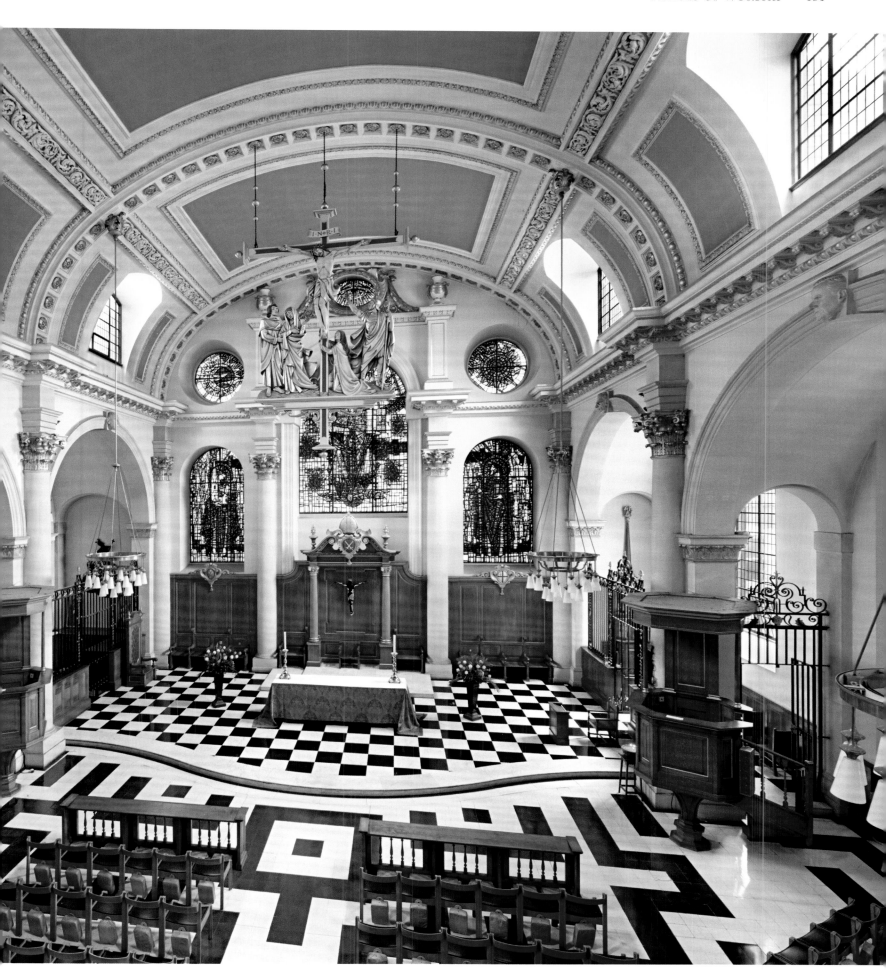

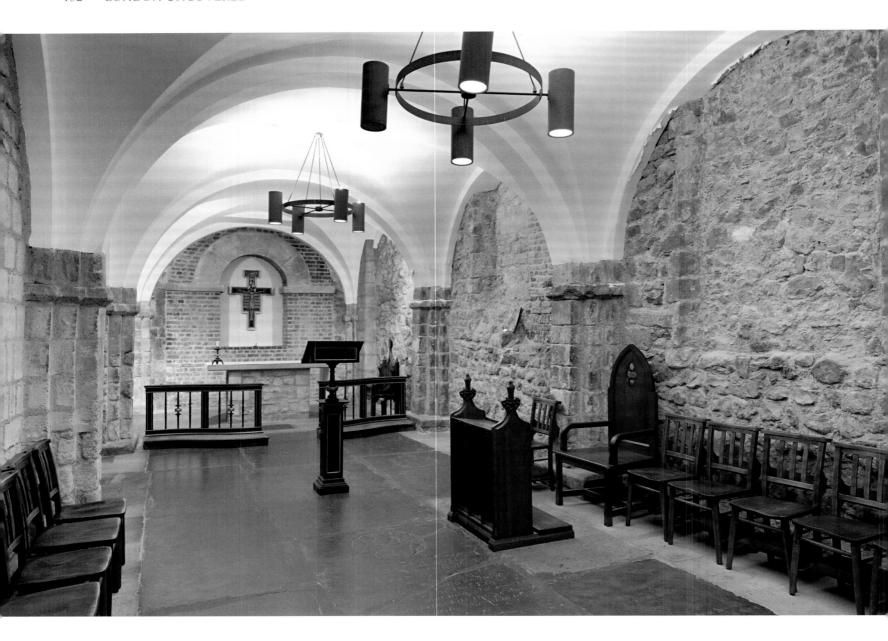

Chrisopher Wren believed the crypt to be Roman, but it was built in the eleventh century and once stood above ground level; in places the original window shapes can be seen.

from the seventeenth century and this was being practised at St Mary before the Great Fire. The church was one of fifty-one rebuilt after the fire. In the new Wren church a peal of eight bells was introduced, growing to ten in 1762.

St Mary-le-Bow was victim again in the worst single night of the Blitz, completely gutted on 10–11 May 1941. Only the exterior walls remained standing, alongside the shell of Wren's tower and spire, although the belfry had collapsed and the bells melted. Restoration of the building did not start until 1956 and proceeded slowly. New foundations were driven around the old crypt and the tower rebuilt around a concrete drum. Bells were cast in 1956 at the Whitechapel Bell Foundry, using salvaged metal from the originals, and the massive mounting frame

was made from oriental wood.

In December 1961, the restored bells of St Mary-le-Bow rang out again, and one of the bellringers that day was Prince Philip, Duke of Edinburgh. The church was formally consecrated in 1964.

The Wren church of 1671–3 had been faithfully recreated, and its reputation as one of the most beautiful churches in the City restored. The lightness of the tunnel vault is achieved with ornamental panelling in blue and white and by clerestory windows over the frieze. The nave comprises three bays with slender aisles divided by wide round-headed arches resting upon compound piers.

St Mary-le-Bow gained some modern decorations and features. Two pulpits were introduced on restoration

Bow Bells. The largest tenor bell weighs more than 2 tonnes.

by the rector Joseph McCulloch, and used for weekly public debates on matters holy and secular, which were broadcast on radio. Suspended above the nave, a gilt pedant cross adorned with figures at the Crucifixion, made in Oberammergau, was a gift from the German people to the church in 1964. Modern stained glass includes Christ in Majesty surrounded by the seven gifts of the Holy Spirit in the central window over the altar. Other windows in the west wall tell the story of the government of the City of London. The north-east chapel houses a bronze relief of St Michael and the Dragon, placed in memory of Norwegian resistance members who died in the Second World War. The sculpture was given by the people of Norway and unveiled by King Olav V in 1966.

A statue of Captain John Smith of Jamestown, early American colonist and founder of Virginia, once a parishioner of St Mary-le-Bow, stands in the churchyard.

VISITING INFORMATION

St Mary-le-Bow, Cheapside, EC2N 6AU

http://www.stmarylebow.co.uk

Open to visitors and worshippers on most weekdays, but not usually at weekends.

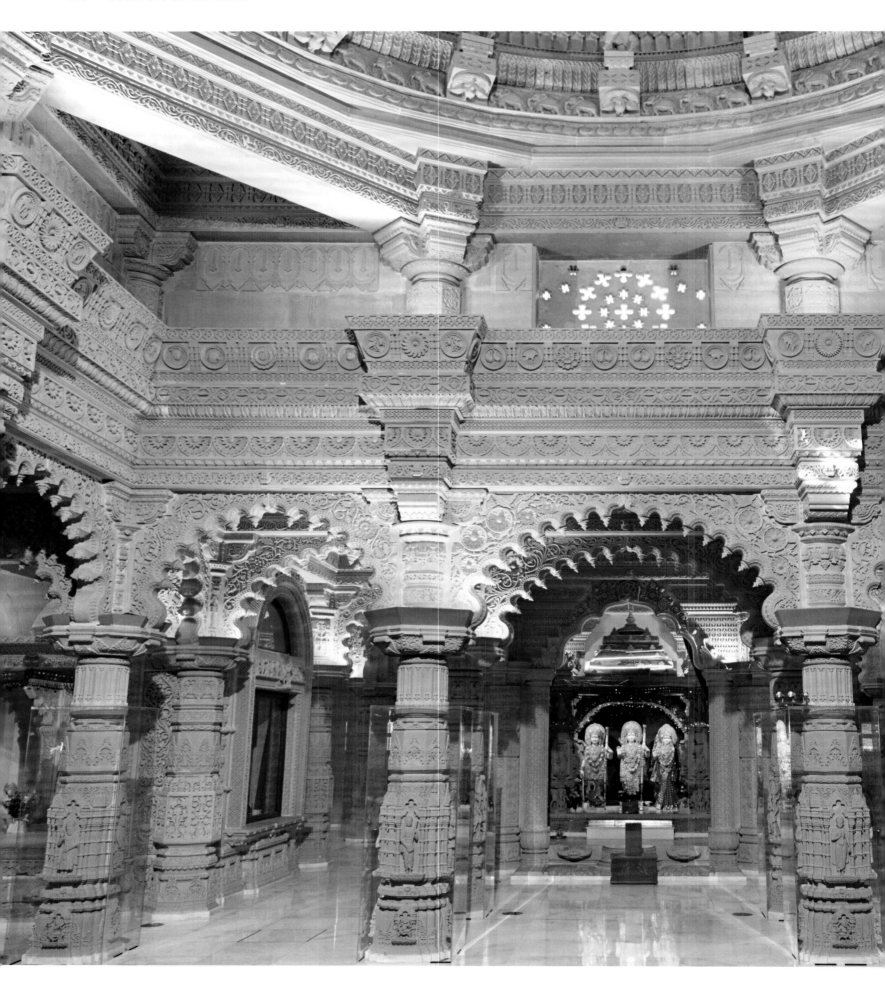

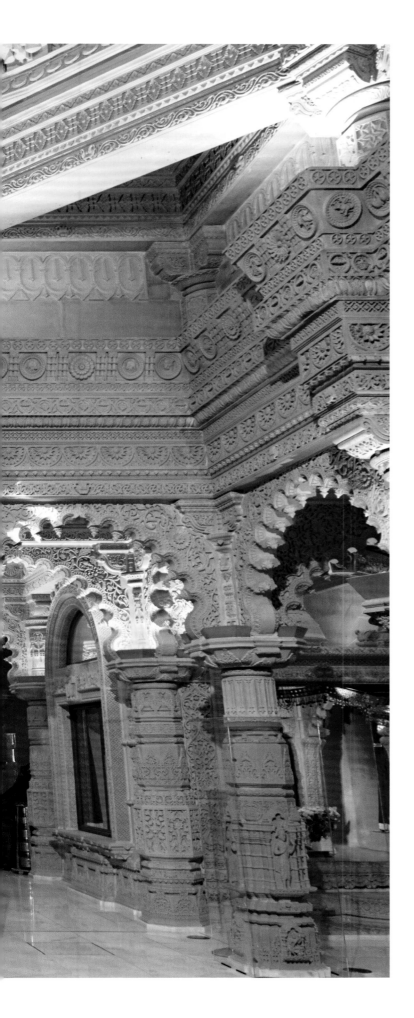

Shri Sanatan Hindu Mandir

The architecture of the Shri Sanatan Hindu Temple in Wembley has impressed thousands with its dazzling decorative complexity since its completion in 2010. Its intricately carved bright sand-coloured walls and domes are established as an unmistakable landmark on the Ealing Road.

Construction of the Shri Sanatan Mandir, like all Hindu Temples, is based on the scripture of the Shilpa Shastras, which contain design rules and standards. According to this tradition, it is laid out on numerical and geometrical principles based on a grid. The temple is close to square in plan, aligned with its main doors facing to the east.

For the first-time visitor, the most striking impression is made by numerous intricate forms of carving, which cover not only the exterior and interior walls, but also the ceilings and the pillars supporting the domes. The patterns have been derived from Hindu legends such as the *Mahabharata*, *Ramayana* and *Shrimad Bhagavatam*. Carvings also recognise non-Hindus Mother Teresa and Guru Nanak. Each of the 210 pillars depicts a famous event from Hindu scripture. Elsewhere on the stonework, rosettes, feathers and leaves are all hand-carved. The only unadorned surface is the smooth expanse of marble floor.

Many of the component pieces were carved in limestone in the small town of Sola in the state of Gujarat, before being shipped to UK and assembled. Yellow Jaisalmer limestone is seen on the exterior and pink Bansipahad marble inside, all the stone coming from India. The architectural style is described as being in the Northern Indian tradition. No architect's name is associated with the temple.

There are eleven inner temples and eighteen sanctums housing forty-one *murtis*, including the following deities:

The view into the temple from the main entrance. Shri Ram Darbar is glimpsed.

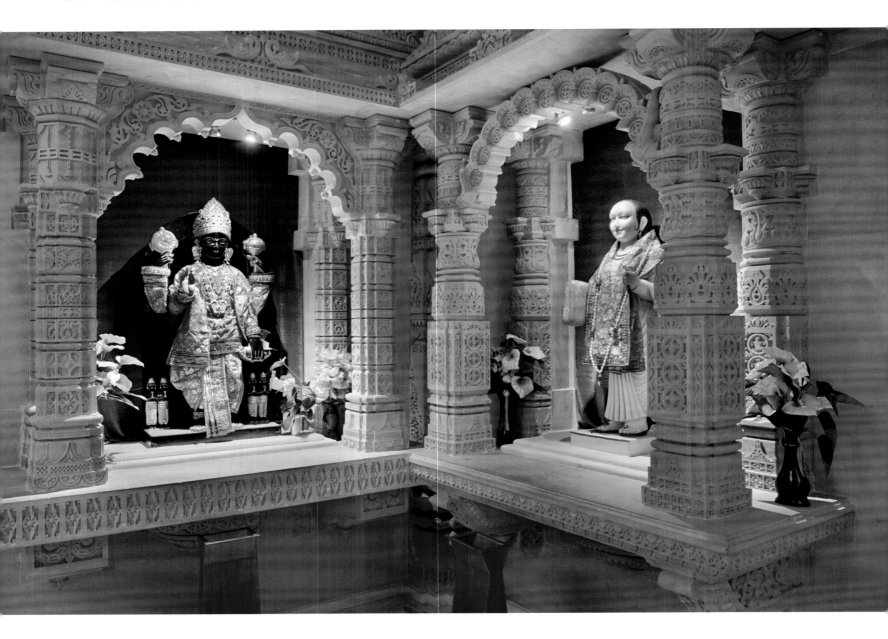

Gods and goddesses depicted inside the temple include Shri Ranchod Raiji (left); more than forty-one deities and spiritual preceptors are represented.

Shri Ganeshji, Shri Jalaram Bapa, Shri Hanumanji, Shri Sahajanand Swami, Shri Amba Mataji, Shri Simandhar Swami, Shri Radha Krishna, Shri Ram Darbar, Shri Shrinathji, Shri Tirupati Balaji, and Shri Shiv Parivar.

No underlying structural steel framework was used in the temple, nor is there even a single small subsidiary metallic beam or bolt anywhere. For spiritual reasons, iron-based materials are considered inauspicious in Hindu culture. All masonry is designed to be self load-bearing. Only copper, silver or gold is permitted in construction, and there is indeed gold here at the highest point of the temple, in the gold-plated adornment on the spires, properly known as Dhaja Dand. Measured here, the temple is 66 feet high. The Shri Sanatan Mandir at

Wembley Temple covers 2.4 acres.

The Shri Sanatan Hindu Mandir was constructed over fourteen years using funds raised by the charity Shri Vallabh Nidhi UK. It opened in the summer of 2010 with the Pran Prathistha ceremony to infuse spirit into the statues. The BBC reported then that its construction had cost £16 million.

VISITING INFORMATION

Shri Sanatan Hinu Mandir, Ealing Road, Wembley HA0 4TA

http://www.svnuk.org/our-temples/wembley-temple/

Open every day. Each morning and evening there are prayers in keeping with Hindu tradition. Visitors must remove their shoes to enter the temple.

TOP AND ABOVE *Two types of limestone are used for the interior and exterior; the colour on the outside is described as yellow.*

OVERLEAF *The temple entrance, aligned to the east, is framed by a separate archway.*

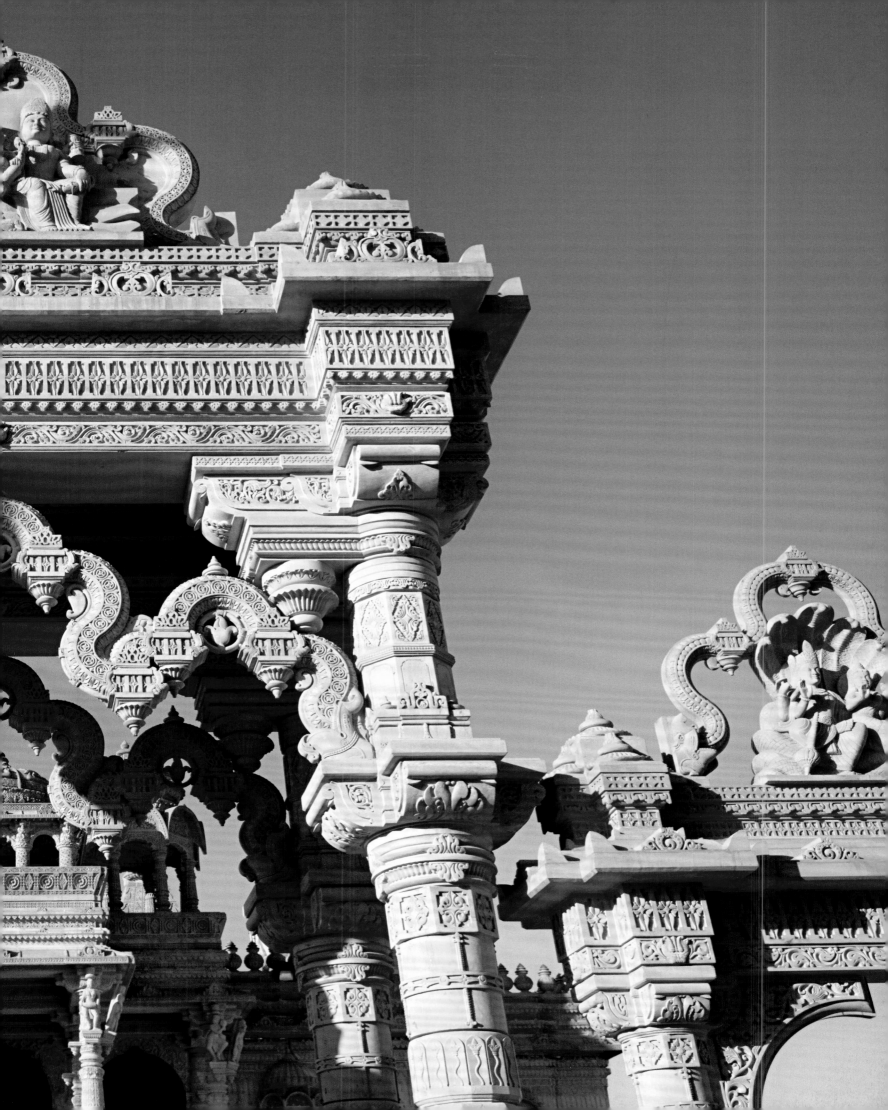

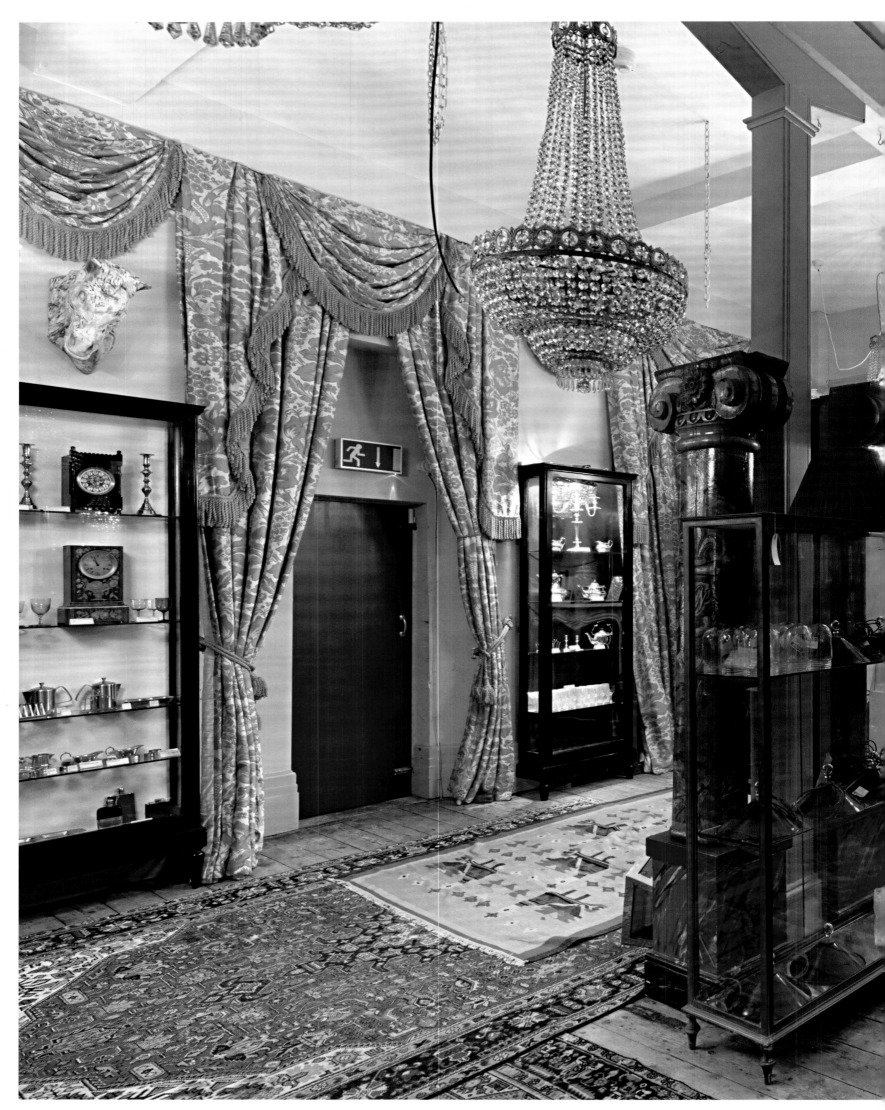

REMARKABLE SHOPS

LASSCO, Brunswick House

Brunswick House is the headquarters and flagship of LASSCO, the London Architectural Salvage and Supply Company. It is a 250-year-old mansion surviving as an island outpost in Vauxhall beside towering apartment blocks, a supermarket and one of the busiest and widest gyratory traffic systems in London. Its rooms contain hundreds of pieces salvaged from old buildings; chimneypieces and firegrates, doors, and street signs and lamp posts. Passengers riding on buses passing LASSCO can glimpse Italian statues in the courtyard and chandeliers in the upper rooms.

LASSCO Brunswick House serves different purposes. Some of its spaces are rooms made up into display areas for antiques, clocks and chandeliers, and furniture. Eclectic, sometimes eccentric and not always antique, there might be found at any one time a life-sized cutout of Tony Curtis from a cinema foyer alongside a delicate wirework birdcage. Ionic columns in imitation of the rarest of marbles stand salvaged from the unfinished conversion of Park Lane Playboy Club to a millionaire's residence.

Each room is minimally restored. There is a roof terrace and courtyards with statuary, fountains and garden curiosities. Other places – the saloon, smoking room, study parlour, library and cellar – may be hired for receptions and meetings. Throughout, nearly everything on display is for sale. Also in business at Brunswick House is a restaurant and bar.

PREVIOUS PAGE *A typically eclectic display room at LASSCO, including marble columns recovered from an old house in St James's, a pair of painted wooden columns from a fairground ride, an English Rococo Revival white Carrara marble chimneypiece and glass-and-gilt chandeliers.*

RIGHT *This office does double duty as a showroom at Brunswick House, with everything in the picture for sale: from the steel-and-cast-iron firebasket to the six-branch chandelier dating from around 1800.*

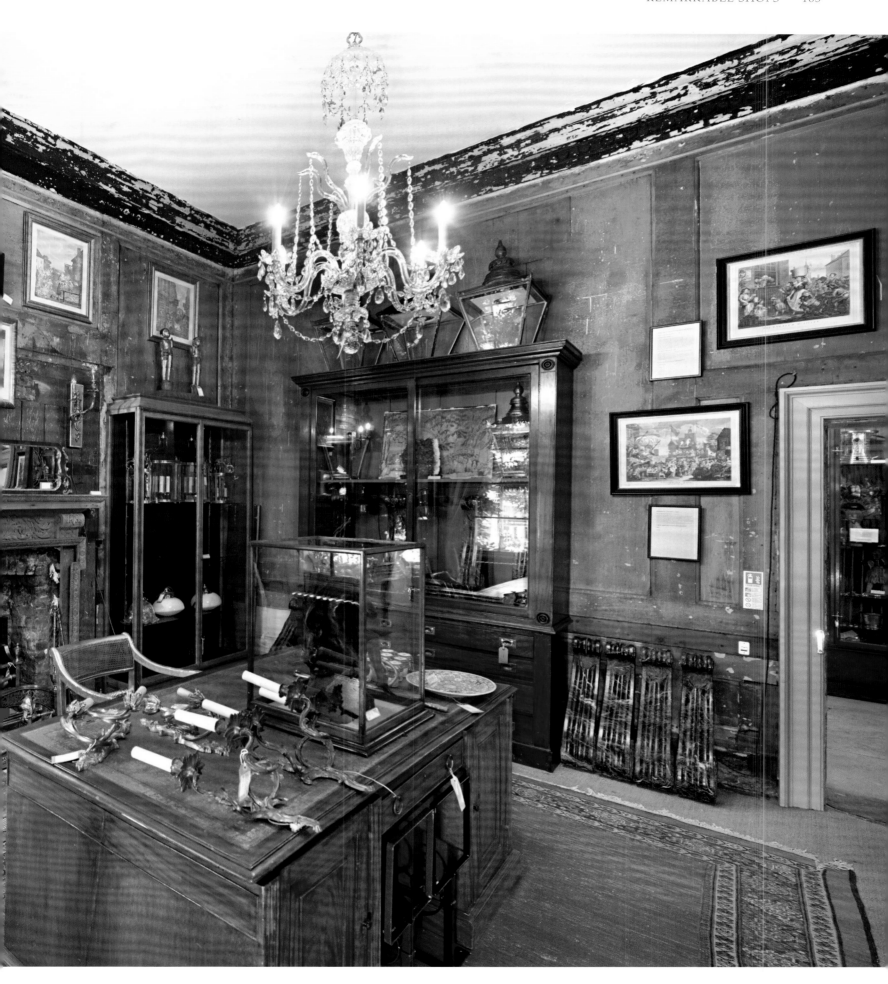

The saloon was once the drawing room of the Duke of Brunswick, and later the snooker room of the London South Western Railway Scientific & Literary Institute, and it is described as 'impressively shabby'. Below on the ground floor is the library, with its ceiling braced with what is reputed to be a piece of railway track against the weight of the snooker tables, and refitted with an elegant reclaimed fireplace. There are a series of cellars with ancient flagstones and old brickwork, which are the remains of an earlier building used as further display and entertainment areas.

Brunswick House dates from 1758, standing in what were once acres of parkland close to the river, going down to a mooring stage on the Thames. Part of the house was leased by the exiled aristocrat Freidrich Wilhelm, Duke of Braunschweig-Wolfenbüttel, this being anglicised to Brunswick. His German home had been overrun by Bonapartists, and his father killed in battle against Napoleon. All his adult life the Duke fought against Napoleon. He lived briefly at Brunswick House, returning to the fray on the continent in 1813 to be killed at the Battle of Quatre Bas just before Waterloo.

Brunswick House's pleasant location was quickly eroded by encroaching industry. The London South Western Railway built its first London terminus close alongside in 1838. Gasworks, a locomotive building works, Nine Elms engine shed and goods yards grew up around the house and alongside the river. A railway viaduct cut off the view southwards. Brunswick House, damaged and much

This eclectic dining room display spans the styles. Every piece is labelled and for sale, including two sets of Hogarth prints: Marriage à-la-mode *and* The Four Stages of Cruelty.

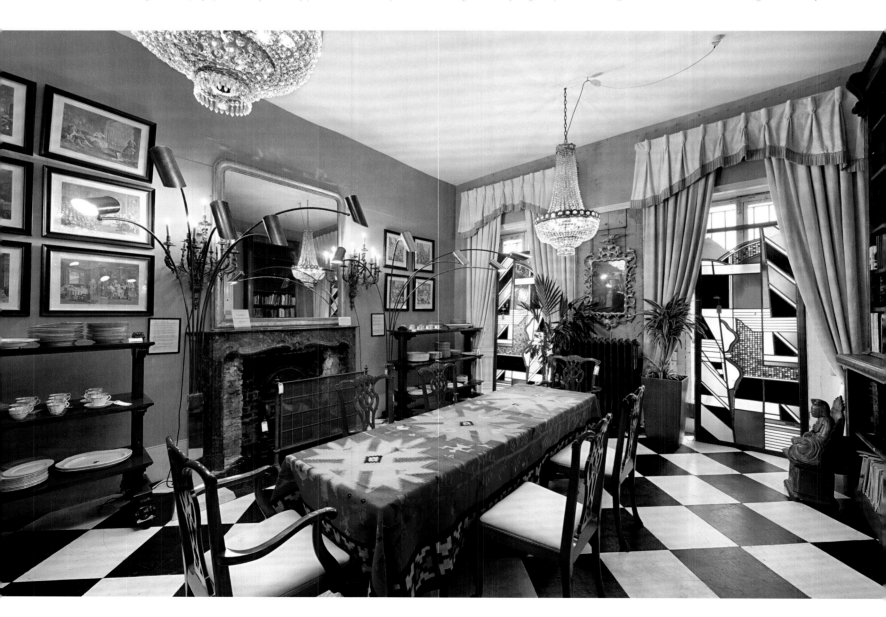

ABOVE *A Late Victorian stained-and-painted trefoil, by Cottier & Co. of London, dated c.1890. It was removed from St George's Church, Perry Hill, Catford.*
OVERLEAF *Cast-iron street signs from around London. The stars are decorations from American barns. The giant aluminium E is one of several salvaged from a prominent building along the South Bank, all displayed in the cellar rooms.*

neglected, was bought first by a gas company and then by the LSWR. The railways used its ground floor as goods yard offices from 1860, with a railwaymen's club on the upper two levels. A huge cold store was built close behind. In this landscape the survival of Brunswick House was freakish. The rail tracks and sheds surrounding it were built up in the nineteenth century and then run down in the mid-twentieth. When the Victorian gas works and rail yards were demolished, the building remained the British Railways Staff Association Club. The much-run-down area started to undergo regeneration in the 1990s, with the opening nearby of the MI6 headquarters building at Vauxhall Cross in 1994 and the apartment towers of St George Wharf in 2000. Brunswick House remained in the ownership of the railway social club until 2002.

It was purchased by in 2002 Adrian Amos, a pioneer of the business of architectural salvage, who had started the LASSCO firm at a redundant church in Shoreditch during the 1970s. LASSCO had owned a salvage yard at Bermondsey since 1999 for reclaimed building materials and Brunswick House was acquired to operate as showrooms and offices. The house was first restored from the ravages of squatters who had stripped much of the interior before LASSCO opened shop in 2005. It is a distinctive landmark where Wandsworth Road meets Nine Elms Lane alongside the bus station and the roaring one-way road system with five lanes of traffic. Brunswick House will continue to stand out in the regeneration of Vauxhall, stamnding close to what is dubbed the Embassy Quarter, where the giant cube of the new US Embassy is developing.

VISITING INFORMATION

LASSCO, Brunswick House, 30 Wandsworth Road, London SW8 2LG

http://www.lassco.co.uk

Open 9am–5.30pm Monday–Friday, 10am–5pm Saturdays, 11am–5pm Sundays.

L. Cornelissen & Son

L. Cornelissen & Son is a supplier of artists' materials on Great Russell Street, not far from the British Museum. The charm of the store is in the Victorian shop-fittings, which are exactly those created by the founders, and also in the range of specialist artists materials they contain; drawer after drawer is filled with pigments, brushes, prepared colour, gold leaf and printmaking equipment. It is possible to buy traditional quill pens made from goose and turkey feathers, cut by hand and cured in hot sand.

Cornelissen has been trading since 1855. The sign above the door states 'Artists' Colourmen', a description of those who blended pigments for painters from the eighteenth century onwards. Originally, the 'colourmen' bought pigments from an apothecary in order to grind and mix bespoke colours for individual artists. The colourmen developed into suppliers of ready-made colours off-the-shelf, firstly oil paints, then watercolours. By the middle of the eighteenth century many of the larger colourmen's shops offered a wider range of products, including brushes, paper and canvas.

Louis Cornelissen was a Belgian domiciled in Paris who, after the 1848 Revolution, left for England to set up shop in Covent Garden. His first line of business was supplying lithographic materials to printmakers and artists. Later, Cornelissen offered a full range of materials.

Colourmen marked their canvases and stretchers with individual stamps and labels, and it is possible to trace Cornelissen-supplied canvases used by painters such as Rex Whistler and Walter Sickert. These stencils give the company address as 22 Great Queen Street; this was L. Cornelissen's home from 1861 to 1987.

It remained a family-owned company until Leonard Cornelissen, grandson of the founder, died in 1977. The business

Sable, synthetic, signwriting . . . brushes of more than a hundred types are stocked.

L. Cornelissen's green frontage has been its signature for more than a hundred years.

was purchased by Nicholas Walt. It was compelled to move from Great Queen Street after the lease there expired in 1987. The shop in Great Russell Street, Bloomsbury, is a listed late-seventeenth-century building, with a nineteenth-century front that closely resembled the former premises. It was completed in the same distinctive sea-green finish. Everything was done to maintain continuity. All the original numbered drawers, cabinets, shelves and fittings were transferred and reinstalled. Cornelissen continues to look much like an apothecary where the early colourmen would have sourced their ingredients. It continues to stock several varieties of linseed oil, poppy oil, walnut oil and safflower oil. More than a hundred varieties of pigment are held; among the most specialised are obscure pigments known as 'early' colours, including genuine malachite, as used by the ancient Egyptians, and rose madder, in use since Roman times. Francis Bacon used Cornelissen's rose madder. Ford Madox Brown and Dante Gabriel Rossetti were past customers and Damien Hirst is a customer today. As a specialist supplier, the company keeps busy in unexpected ways. It receives regular orders for bulk artist-grade titanium white from a cosmetics manufacturer, from gilders restoring icons, and dozens of sword pinstriping brushes were recently supplied to a Californian bikers' club for the purpose of helmet decoration.

VISITING INFORMATION

L. Cornelissen & Son, 105A Great Russell Street, WC1B 3RY

http://www.cornelissen.com

Open 9.30am–6pm Monday–Saturday.

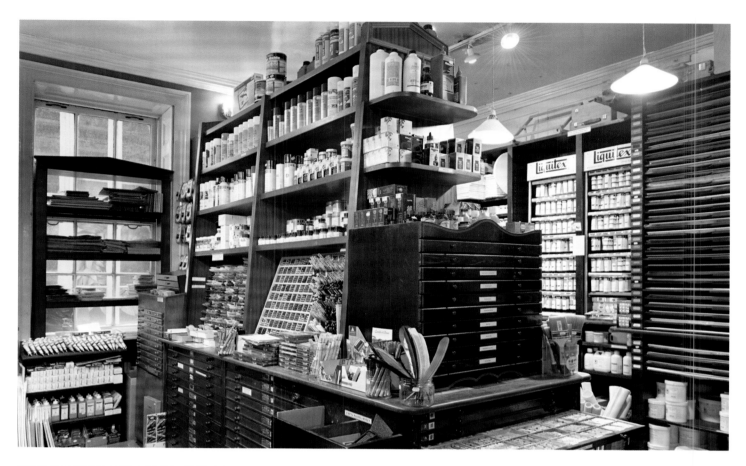

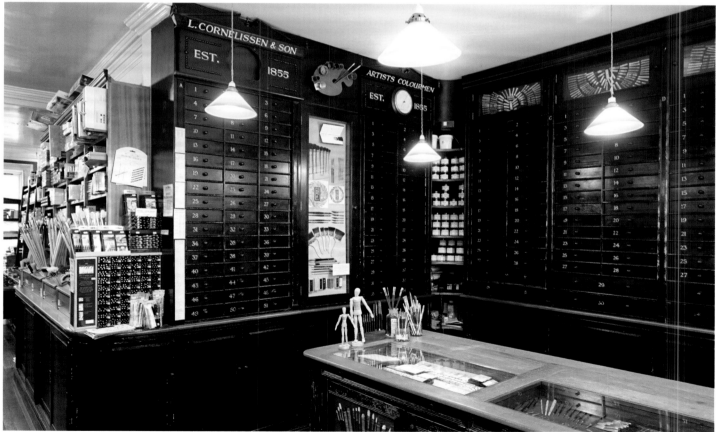

TOP *In the calligraphy section, four different types of quills are offered.*

BOTTOM *The drawers and cabinets for canvas, parchment and paper date from the 1860s.*

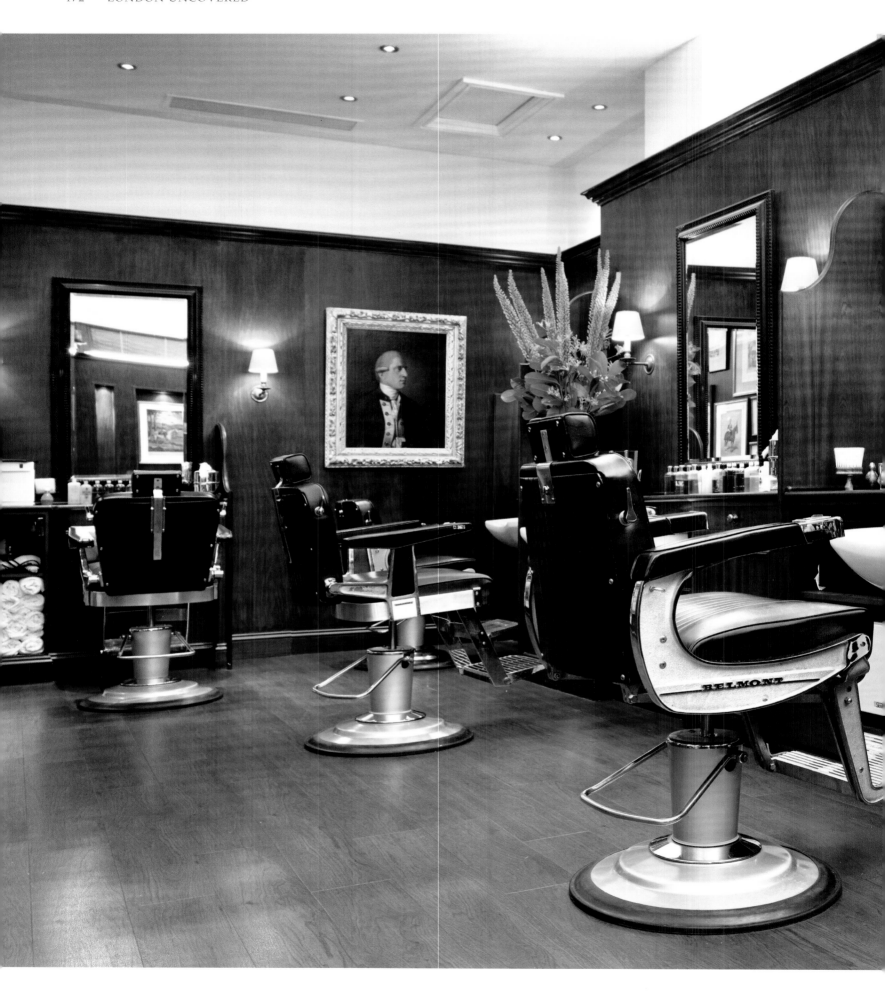

Truefitt & Hill

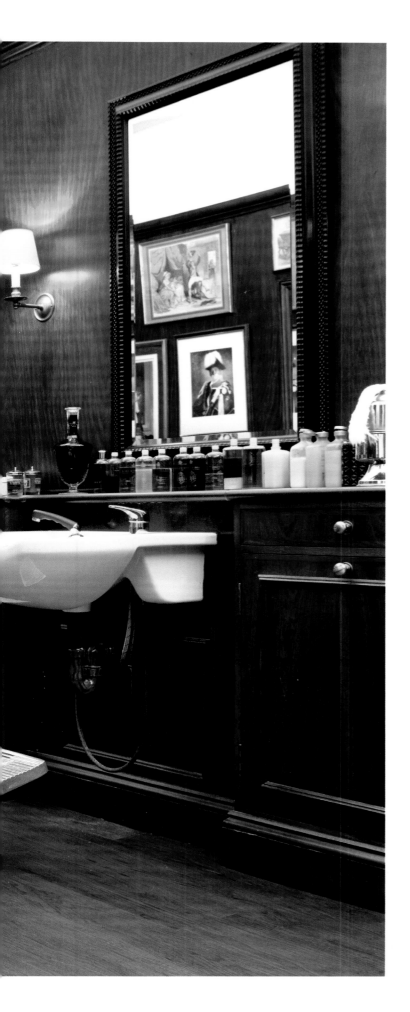

William Francis Truefitt opened a gentlemen's barber shop in 1805 at 2 Cross Lane, Long Acre. By 1811 he had moved the business with its sole employee, his brother Peter, to 40 Old Bond Street, and became established as Court Hair Cutter and Court Head Dresser. He was soon also Wigmaker by Royal Appointment to His Majesty, King George III.

In the early years of the nineteenth century, when regular visits to the barber were essential to prepare the head for the wearing of wigs by gentlemen, the Truefitts' barber shop flourished and Old Bond Street became increasingly fashionable. It may be fact or legend that the good fit of Truefitts' wigs gave the raise to the English phrase 'right as a trivet', which was a corruption of Truefitt, referring to anything that was a perfect fit. The business was poised to move to the shaving of faces and the cutting of hair.

George III was destined to be the last British monarch to wear a wig, and after his death in 1820 the wig quickly disappeared from society outside the legal profession. High fashion for men was already favouring a neo-classical style of natural hair with a closely clean shaven face, as pioneered by Beau Brummel. Lord Byron and the Duke of Wellington had that style, and Truefitt was the barber to all of them. Later in the Victorian age, Gladstone was a Truefitt client and so was Oscar Wilde. Branches were established in Brighton and in Aldershot and Sandhurst, the grooming of military personnel being good business. In the high Victorian period, male fashion shifted to permit the full beard, chin-strap beard or full moustache, all requiring grooming.

Truefitt opened a ladies' salon in Bond Street in 1870. In 1878 it started commercial manufacture and marketing of the products used in its shops. This included colognes, pomades and hair

The world's oldest barber has just five exclusive chairs. The portrait in the salon is of Naval Lieutenant, later Admiral Charles Holmes Everitt Calmady by William Pars, dating from around 1773, bewigged in the style of the day.

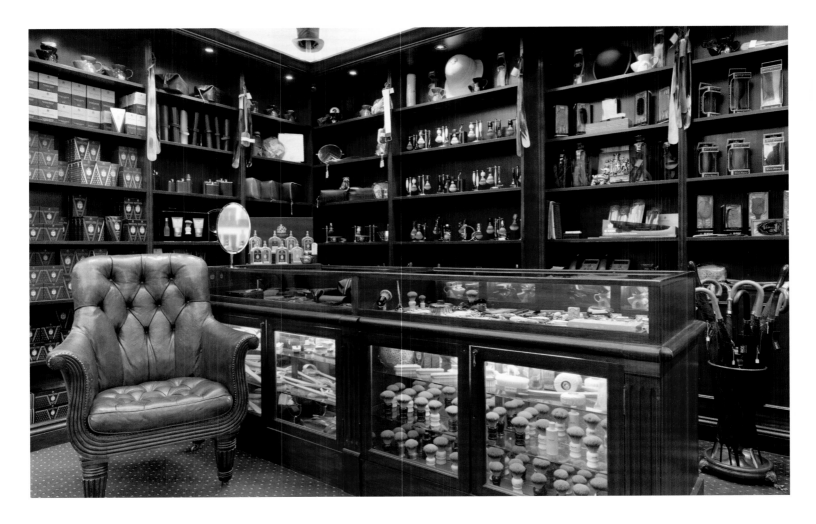

Colognes and creams in abundance at Truefitt & Hill. There are also beard combs and moustache wax.

tonics. Known by this time as H.P. Truefitt, it described itself as a ladies' and gentlemen's hairdresser, perfumers and ornamental hair manufacturer.

In 1911, Edwin Hill & Co had established a barber shop close to Truefitts' at 23 Old Bond Street. Later, a merger of the two companies was arranged and it was to this address that H.P. Truefitt moved in 1935 to form Truefitt & Hill, now specialising in hairdressing for men.

Mayfair and St James's had become the centre of high-end masculine grooming and clothing in London, with a concentration of hair-cutting establishments and also tailors, shirtmakers and bootmakers. As well as Old Bond Street, Truefitt & Hill have been based in Grafton Street, in Burlington Arcade, and it moved to its present location of 71 St James's Street in February 1994.

Illustrious clients in more recent times have included Laurence Olivier and visitors Fred Astaire, Cary Grant and Frank Sinatra. Another client was Field Marshal the 1st Viscount Montgomery of Alamein, who commissioned Truefitt to manufacture pairs of hairbrushes for himself and

General Eisenhower, made from a piece of captured German aircraft propeller. The company has the correspondence showing that Field Marshal Montgomery received his brushes the day before the European invasion. On the same day, he wrote to Truefitt to confirm receipt and to give his assurance that he was 'taking them all the way to Berlin'.

Having celebrated its 200th anniversary in 2005, Truefitt & Hill claims to be the oldest barber shop in the world. It is royal warrant holder as hairdresser to the Duke of Edinburgh. The company reports an increase in traditional business in London, with 25 per cent of its customers requesting a hot shave with hot towels. It has stores in Toronto, Chicago, Washington, Kuala Lumpur, Singapore, Bangkok, Mumbai, Delhi, Baku, Shanghai and Beijing.

VISITING INFORMATION

Truefitt & Hill, 71 St James's Street, SW1A 1PH

https://www.truefittandhill.co.uk

Open 8.30am–5.30pm Monday–Friday, Saturday 8.30am–5pm.

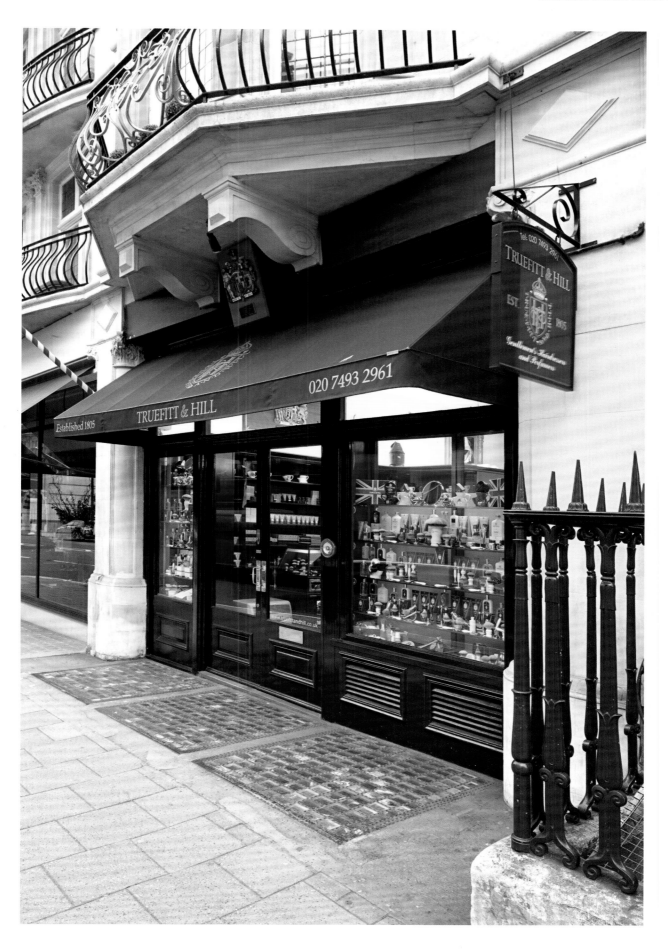

Despite its long history, Truefitt & Hill has occupied its current premises since only 1994.

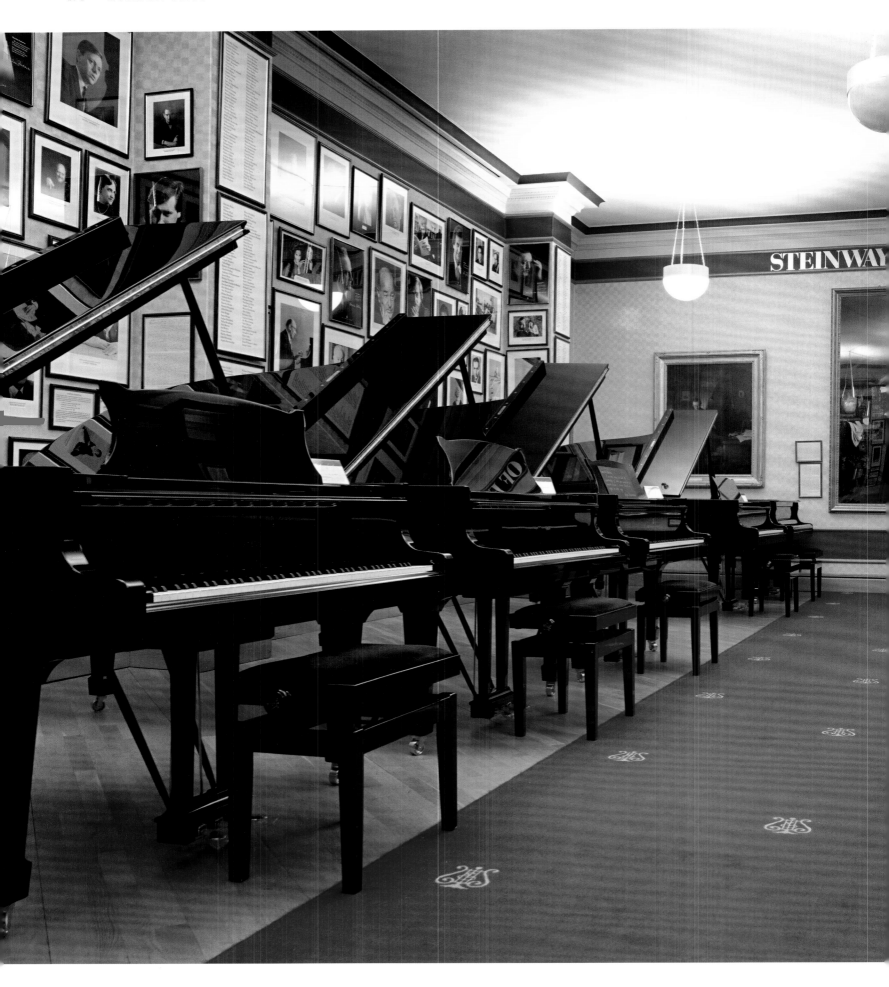

Steinway & Sons

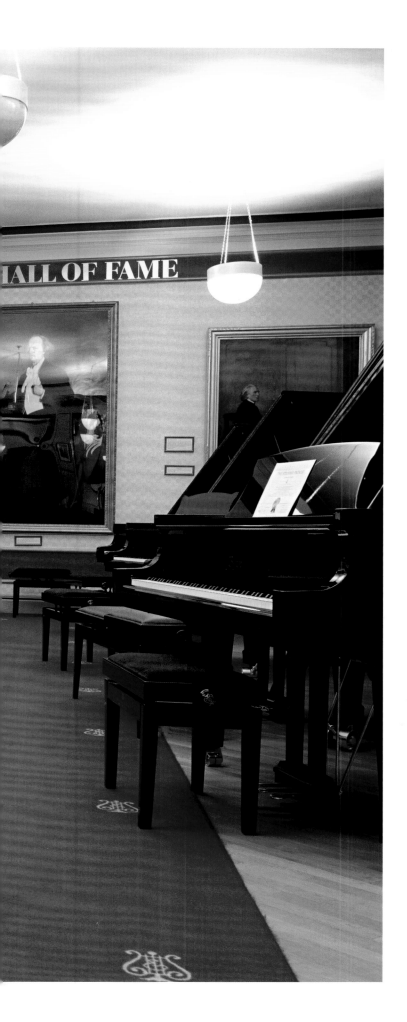

Steinway & Sons is long established in London, the piano company first coming to England in 1875. Steinway is an American company that did much develop the piano in the middle of the nineteenth century. London piano makers had been producing instruments in quantity during the first half of the century, and Italian craftsman made pianos a hundred years before that, but it was the introduction by American makers of refinements such as the cast-iron frame and oblique stringing that set the style for the modern instrument.

Steinway opened its first London showroom in Wigmore Street, moving to St George Street in 1924 and then in the 1980s to 44 Marylebone Lane. Here are located the Steinway piano showrooms and Hall of Fame, recital room, practice facilities and administrative offices. Here can been seen the grand pianos, from a baby grand at £55,000, to a B model at £78,000, to the longest model, D-274, favoured by many of the world's great pianists, at £132,000.

German instrument maker Heinrich Steinweg emigrated to the United States in 1850 with his family, changing their name to Steinway. Soon, he and his sons were making and selling pianos. After steady growth, and establishment of a showroom in New York, a large factory was developed in Queens. The London showroom followed and, with an eye for European markets, Steinway considered developing a piano factory in England, but the second factory was opened instead in Hamburg in 1880.

Part of the Steinway legend is how five uprights from the Hamburg factory were ordered by London and installed and lost on the RMS *Titanic*.

Operating in both the United States and Germany under

Hall of Fame ebonised satin grand pianos; over 1,300 concert artists and ensembles are recognised as Steinway Artists.

The cast-iron frame is smoothed, bronzed and lacquered before the maker's name is hand-painted.

American ownership has meant that turbulent world events have shaped the fortunes of Steinway & Sons on several occasions. The Germany factory was damaged by Allied bombing in 1944. A stock of Hamburg pianos that had been quickly shipped to Britain shortly before the war was destroyed by German bombing in 1940, together with Steinway's Park Royal Service Centre in west London. Both the Hamburg and Queens factories were co-opted into war work on opposing sides.

Steinway Hall London Concerts and Artists department maintains a 'piano bank' of concert grands, from which artists can make their selection for upcoming performances. It also provides pianos for major institutions, competitions and recording companies in the UK. These pianos mostly come from Hamburg, although New York models can be supplied. Worldwide, the Steinway concert piano bank has over 300 instruments in use. In London pianos are serviced and restored at the centre, which opened in 1965.

It takes a year to make a Steinway grand. Spruce, sugar pine, maple, mahogany and birch are the woods employed, some of which must be left for nine months to dry and cure. Maple and mahogany are glued together in long thin sheets as veneers and then bent into the shape of a harp to form the outer case. This is clamped and stored for three months under controlled conditions. The cast-iron frame plate is the backbone of the piano and must be able to bear 20 tonnes of string tension.

Around 1,600 pianists from different musical genres are classified as Steinway Artists by the company, which means that they have chosen to perform on Steinway pianos exclusively, and each owns a Steinway. Steinway Artists include Daniel Barenboim, Harry Connick Jnr, Billy Joel, Evgeny Kissin, Diana Krall, and Lang Lang; historic Steinway Artists include Irving Berlin, Benjamin Britten, George Gershwin, Vladimir Horowitz, Cole Porter, and Sergei Rachmaninoff.

VISITING INFORMATION

Steinway & Sons, Steinway Hall, 44 Marylebone Lane, W1U 2DB

http://www.steinway.co.uk

Open 9am–5.30pm Monday–Friday, 11am–5pm Saturday, closed Sundays.

The action for a single key is made up of more than fifty parts.

James Smith & Sons

James Smith & Sons is one of the most distinctive shops in London, an unmistakeable landmark on New Oxford Street.

Its brass, mahogany, wrought-iron and glass exterior is emblazoned with signage, which, besides declaring umbrellas and sticks for sale, also advertises tropical sunshades, sword sticks and dagger canes. Outside and in, the James Smith & Sons store has a patina that denotes character rather than neglect. The shop has been sympathetically refurbished and it does not show. It is a thriving place that attracts thousands of visitors. The interior was designed and built by a single craftsman shopfitter. Part of the interior dates from the 1880s, when the business was already more than fifty years old. At that time, New Oxford Street was one of the most fashionable shopping streets in London and the shop design is a monument to the commercialism and branding of the era, taking every opportunity to promote and display the range. The aim was to display as many products as possible and that is still the case, with hundreds of umbrellas and sticks in baskets and racks.

For the serious purchaser of a good umbrella, the main problem is one of choice. Given the number of styles, materials and colours available there is a strong chance of creating a unique item. A crooked handle of knurled bamboo, known as whangee, fitted with a silk cover, may be considered classic. An umbrella made from a one-piece solid stick is better to lean on. The stick is cut to length to suit the user. Smooth handles may be made from cherry, chestnut, hazel or hickory, and the handle can be covered in various leathers. A lighter city umbrella can be built around a steel tube. There are styles for town and country. There are travel umbrellas, which dismantle to fit a suitcase, folding umbrellas,

Built on a tapered ground plan on the corner with Shaftesbury Avenue, James Smith & Sons is a distinctive shape and a monument to Victorian branding, with its extensive signage and packed window displays.

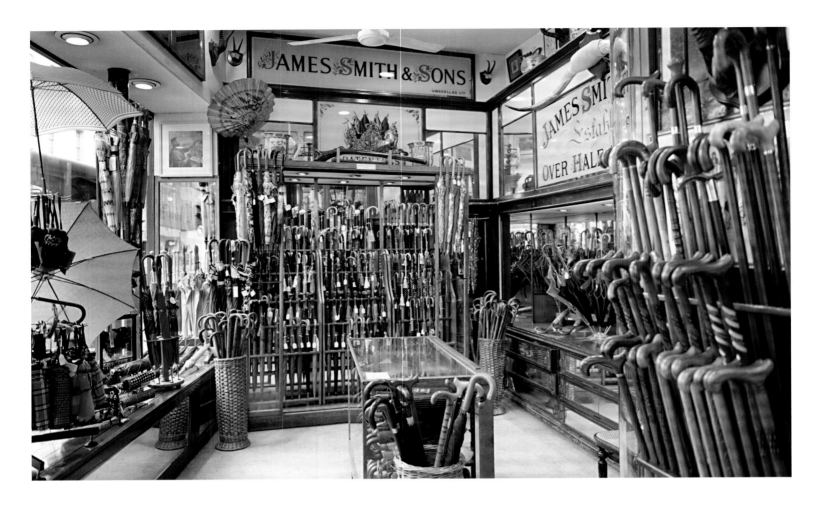

Showcases and counters are original to the design of the Victorian craftsman working for Smiths.

sun umbrellas and umbrellas with animal-head handles in wood, nickel or resin. Styles of umbrellas for ladies come in walking length or pencil length. A choice almost as wide applies to walking sticks.

The company was one of the first to use the famous Fox umbrella frame invented by Samuel Fox, which replaced whalebone with lightweight u-section steel ribs. This type of frame was still being produced and fitted until recently. The company says there has been little change in the design and materials of the traditional umbrella over time, apart from the fact that most covers are now made from nylon rather than silk.

James Smith founded the firm in 1830 at Foubert Place, off Regent Street. There was once a James Smith branch shop just off Savile Row, which sold umbrellas to Prime Ministers Gladstone and Bonar Law. That branch moved to New Burlington Street, but was destroyed in the Second World War. The founder's son established the main shop in New Oxford Street in 1857.

Traditionally, umbrellas were made at the back of the shop and customers were served at the front. The tradition continues at New Oxford Street, where there are workshops in the basement. Some umbrellas and walking sticks are still made there, although sales are such that some production has to be outsourced to small family companies.

For years the company has made ceremonial umbrellas and it has produced maces for African tribal chieftains. During and after the First World War, many hundreds of thousands of military swagger sticks were sold to soldiers. James Smith once sold whips and crops. It can still supply the kind of stick known as a staff, which is associated with shepherds, and it also produces a wide range of seat sticks. One of the faded window signs even promotes 'life preservers': not a flotation device but a type of heavy stick suitable for use a club and no longer stocked.

VISITING INFORMATION

James Smith & Sons Ltd, Hazelwood House, 53 New Oxford Street, WC1A 1BL

http://www.james-smith.co.uk

Open 10am–5.45pm Mondays, Tuesday, Thursdays and Fridays;

10.30am–5.45pm Wednesdays; 10am–5.15pm Saturdays; closed Sundays.

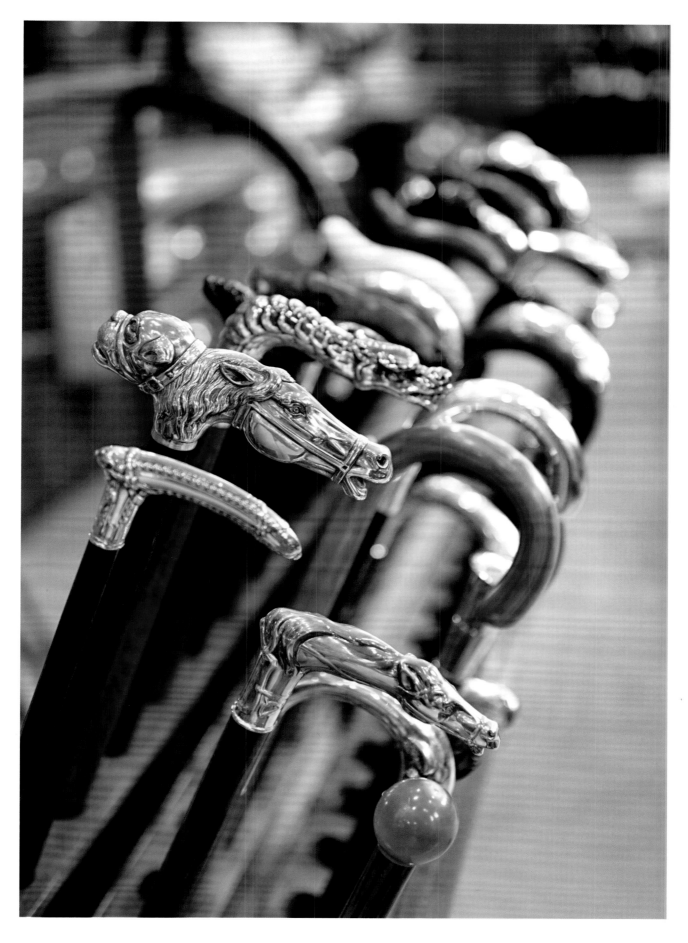

Animal heads in nickel for canes or umbrellas; the straight style is called a derby, the rounded style is a crook.

John Lobb Ltd

At Lobb a pair of shoes can cost £4,000, but it is acknowledged as representing the pinnacle of the shoemaker's art.

The styles offered by Lobb may be recognisably classic, but the descriptions denote something special. Shoes made to the outline that most would describe as loafers can be 'Norwegian slipper with raised lake and lace through quarters and tassels'. The Derby styles bespoke at Lobbs are curiously named 'navvy shoes' and it is possible to order a 'two-tone plain golosh Oxford'. Whether you wish for calf, cordovan, patent, kangaroo, ostrich or snakeskin, Lobb advises that its extensive catalogue is merely a guide. 'We can make any style', the company says.

In the workrooms at St James's, which flank the wood-panelled shop area, the 'last-maker' uses maple, beech or hornbeam to reflect the shape of the foot; the 'clicker' cuts the uppers from eight pieces of leather; and the 'closer', who sews, assembles the uppers around the last. The sole and heel pieces come from the misleadingly named 'rough stuff' department, which shapes the thicker pieces of leather. Including the 'pattern-maker', 'socker' and 'polisher', all the thirty-or-so craftsmen and women are apprentice-served. The first pair of shoes for a new customer will take six months or more from the moment the fitter takes the measurements to delivery; after the last has been established, subsequent orders take three months. In the shop, display cases provide a history of style in bespoke shoes.

The first floor office of John Lobb has ledgers listing orders from illustrious, famous customers, and very rich customers. They list Princess Diana, Fred Astaire, Frank Sinatra and Mick Jagger. The basement houses rack upon rack of lasts, while some of them are displayed in cases in the showroom, among them the lasts for Queen Victoria from 1898 and, more recently, Duke Ellington, and Aristotle and Jacqueline Onassis.

The Lobb company history from modest beginnings to high

The ground floor showroom displaying Royal Warrants as Bootmaker to HM Queen Elizabeth II, HRH the Duke of Edinburgh and HRH the Prince of Wales.

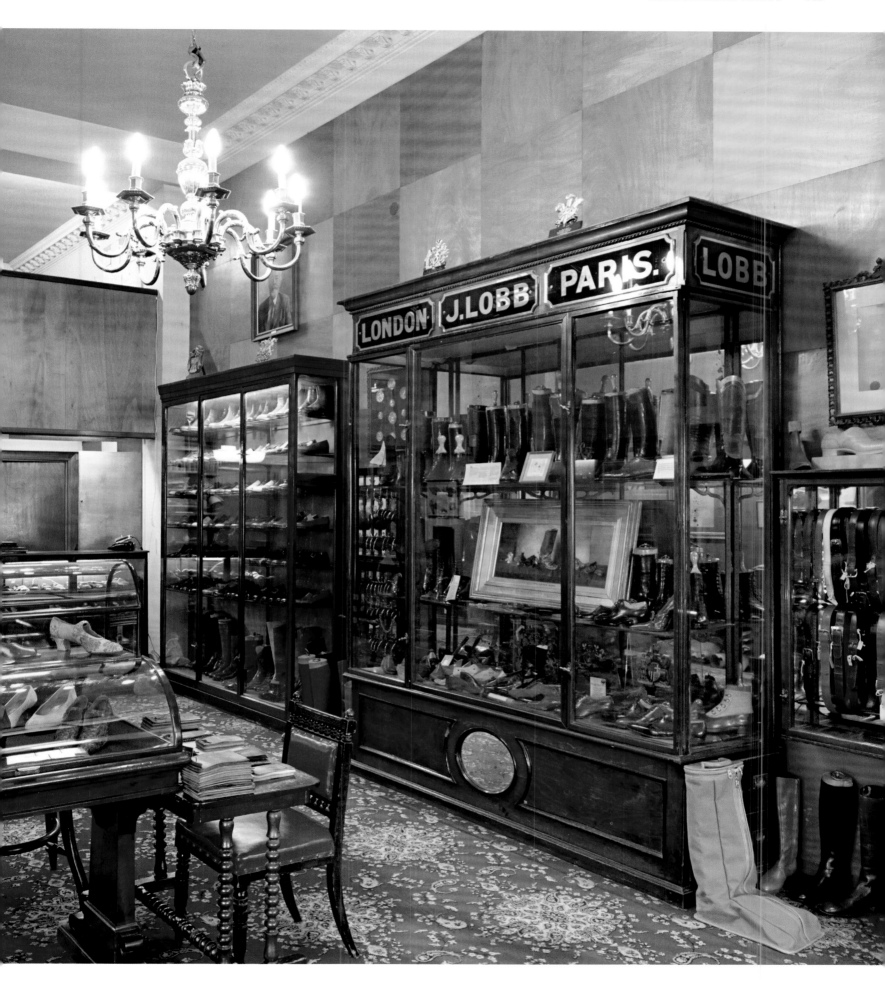

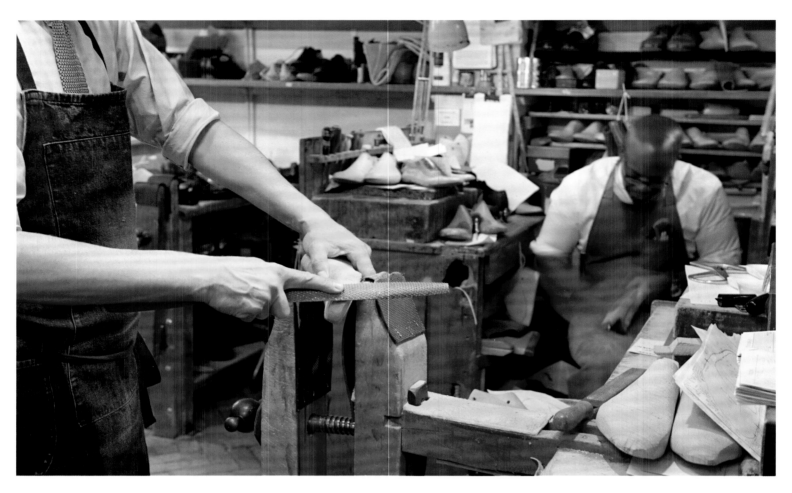

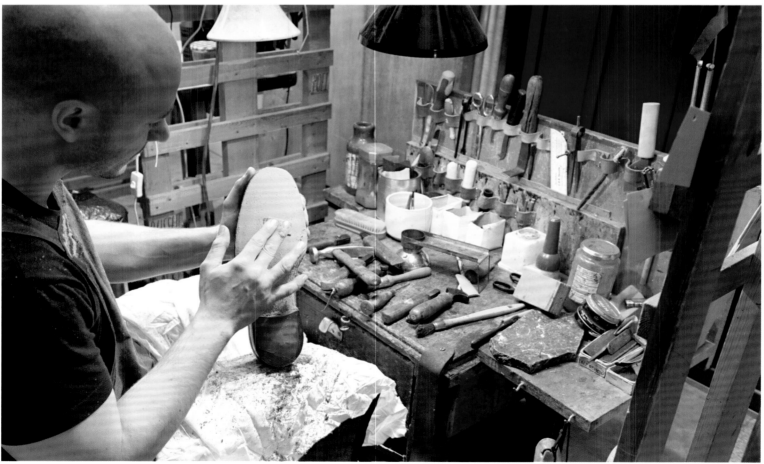

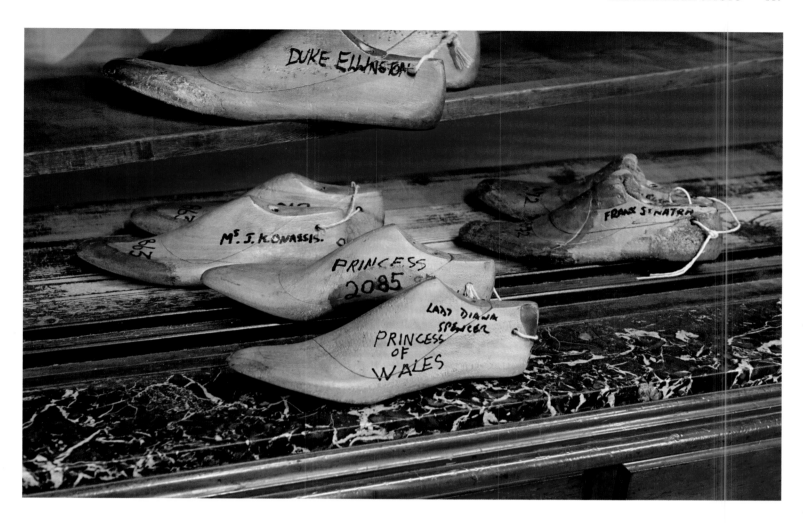

OPPOSITE *The 'last-maker' (above) carves the mould. Repairs (below) are part of the service.* ABOVE *The lasts of illustrious clients – Duke Ellington, Jacqueline Onassis, Frank Sinatra and Diana, Princess of Wales.* OVERLEAF *Thousands of lasts are stored in the basement.*

achievement has elements of epic legend. Cornish-born John Lobb, despite being made lame by a childhood fall, walked to London in search of his bootmaking fortune. He had completed an apprenticeship to a shoemaker in Fowey, and was recognised as a good craftsman in the days before all shoes were lasted and sewn on machines. But when Lobb entered the premises of London's leading bootmakers of the time, Thomas's of St James's, and offered his skills, he was ejected. Disillusioned, Lobb travelled to Australia on the strength of reports of gold being discovered and prospected for a while. He then shrewdly switched to making boots for prospectors and miners. This included a special hollow-heeled design for concealment of gold. John Lobb established a good business in Sydney. He despatched footwear to the London Exhibition of 1861, winning a gold medal, and two years later received a Royal Warrant to the Prince of Wales as bootmaker. Lobb sold up in Australia in 1866 and set up business in London. His first St James's shop opened in 1880 alongside the fashionable hat makers, gun makers, wine merchants, tobacconists and gentlemen's clubs of the street.

The company has experienced turbulent times. No. 55 St James's Street, the shop founded by John Lobb, was destroyed by bombing in 1944, forcing a move across the road to No. 26 and then in 1962, when the Economist tower block was built, the business moved again to No. 9 St James's Street, an address once occupied by Lord Byron.

This is where the business resides today. The family continuity has remained unbroken across five generations. John Hunter Lobb is Chairman. Luxury goods manufacturer Hermès trades under the name John Lobb for some of its ranges of shoes, but the Lobb shop in St James's Street remains in the hands of the Lobb family. There are stores today in St James's Street where an ocean-going yacht can be commissioned or chartered, but nowhere more exclusive or truer to the spirit of that street than John Lobb, bootmaker.

VISITING INFORMATION

John Lobb Ltd, 9 St James's Street, SW1A 1EF

http://www.johnlobbltd.co.uk

Open 9am–5.30pm Monday–Friday, 9am–4.30pm Saturday, closed Sundays.

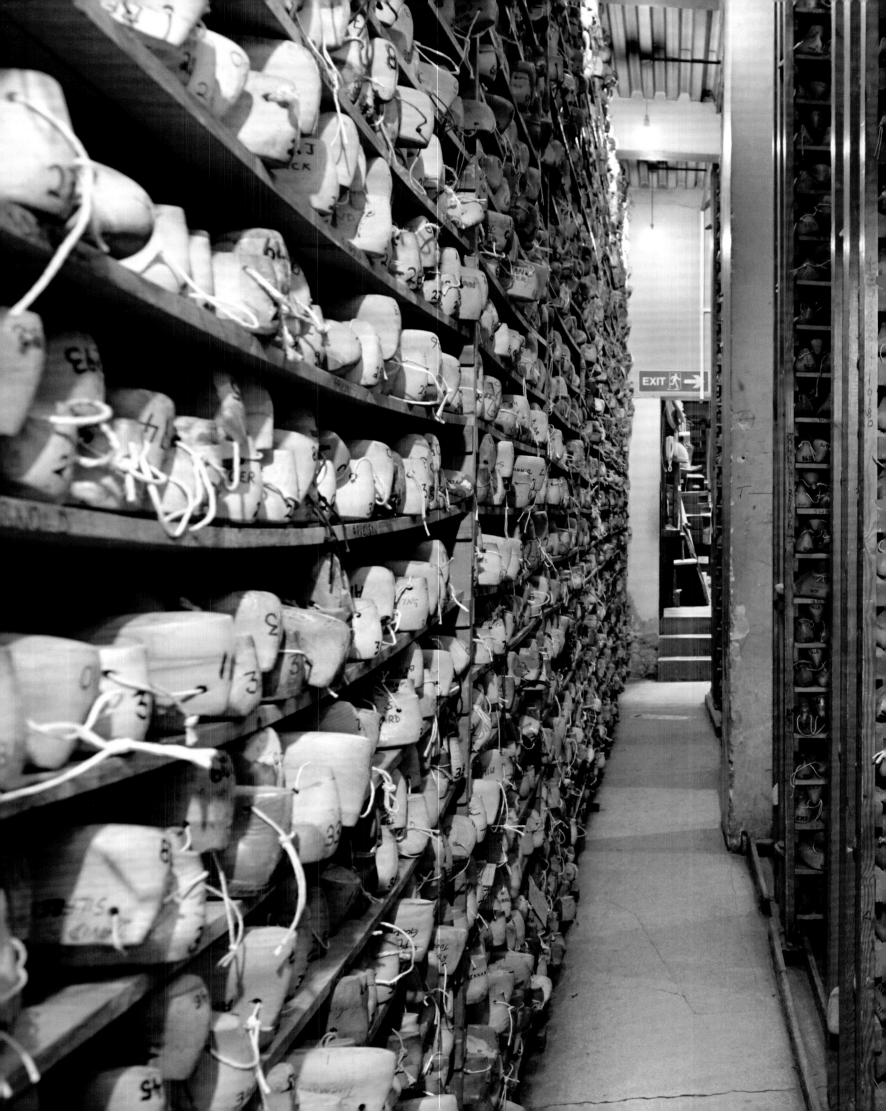

Roof Gardens in Kensington

The Roof Gardens in Kensington are found high above the chain shops on Kensington High Street, on top of what used to be Derry & Toms department store. The gardens were created in 1938 by one of the leading landscape gardeners of the time, Ralph Hancock. Owned by Virgin Group today, the gardens have been extensively replanted and restored, but still correspond to the original plan of the three garden areas.

The 'English Woodland' stretches along the length of the roof with, it is claimed, almost a hundred species of trees, some dating back to the original planting. There are mosses, ferns and lichens, along with small flowering herbs and shrubs around a running brook and pond. There are resident birds, including pintail ducks and a quartet of flamingos. The 'Spanish Garden', inspired by the Alhambra, has a pergola known as Cloister Walk and overlooks a quiet, cool area for relaxation and rest. The lawn has a miniature canal connecting five small fountains alongside palm, olive, pomegranate and fig trees. 'Tudor England' has herringbone brickwork walls, stone paving and arches covered in climbing roses and wisteria.

The building's roof was covered with bitumen, hardcore and a drainage system, so that everything could grow in soil less than a metre deep. It is now maintained on sustainable principles. Far from being a secret, but still discrete, the gardens were a celebrity rendezvous from opening and continue as an exclusive venue for events based on the Babylon restaurant.

VISITING INFORMATION

Kensington Roof Gardens, 99 Kensington High Street, W8 5SA

(entrance in Derry Street)

http://www.virginlimitededition.com

Open during the day, but often closed for private events. It is essential to check before visiting: 020 7937 7994.

The Spanish Gardens have a distinctly Moorish flavour.

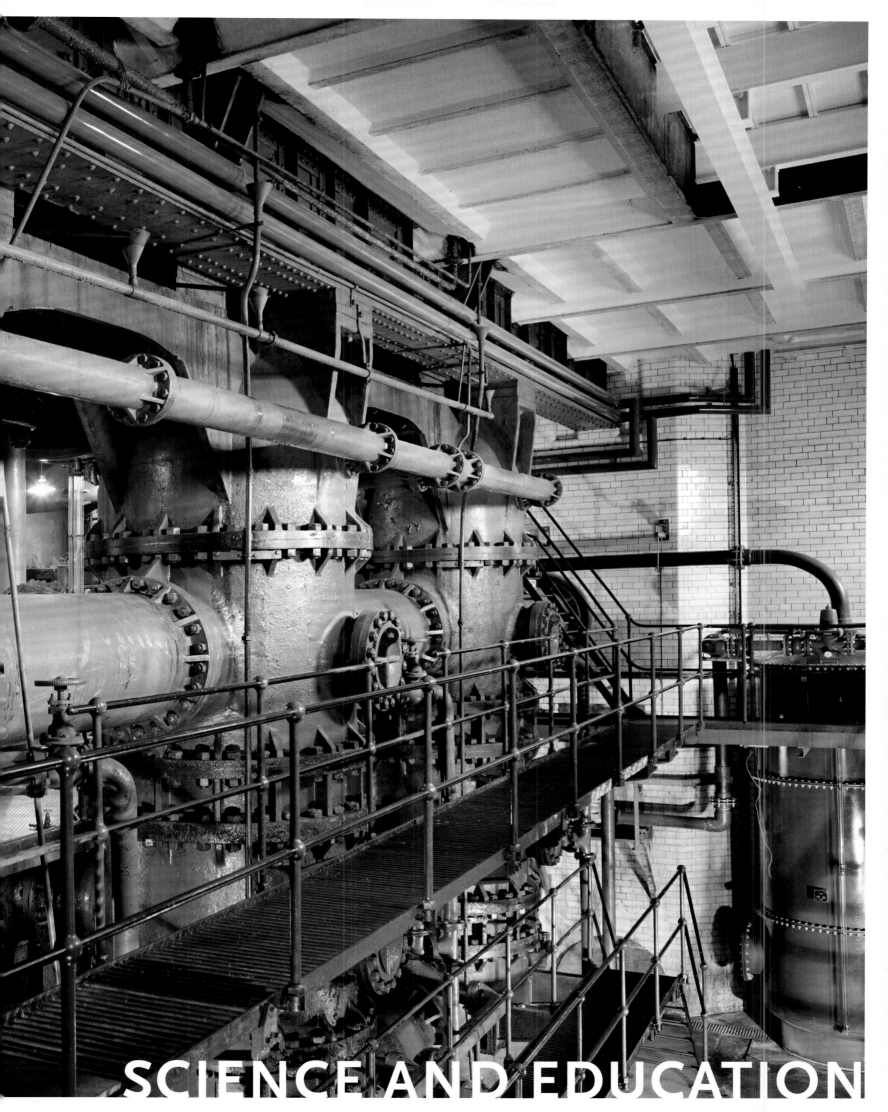

SCIENCE AND EDUCATION

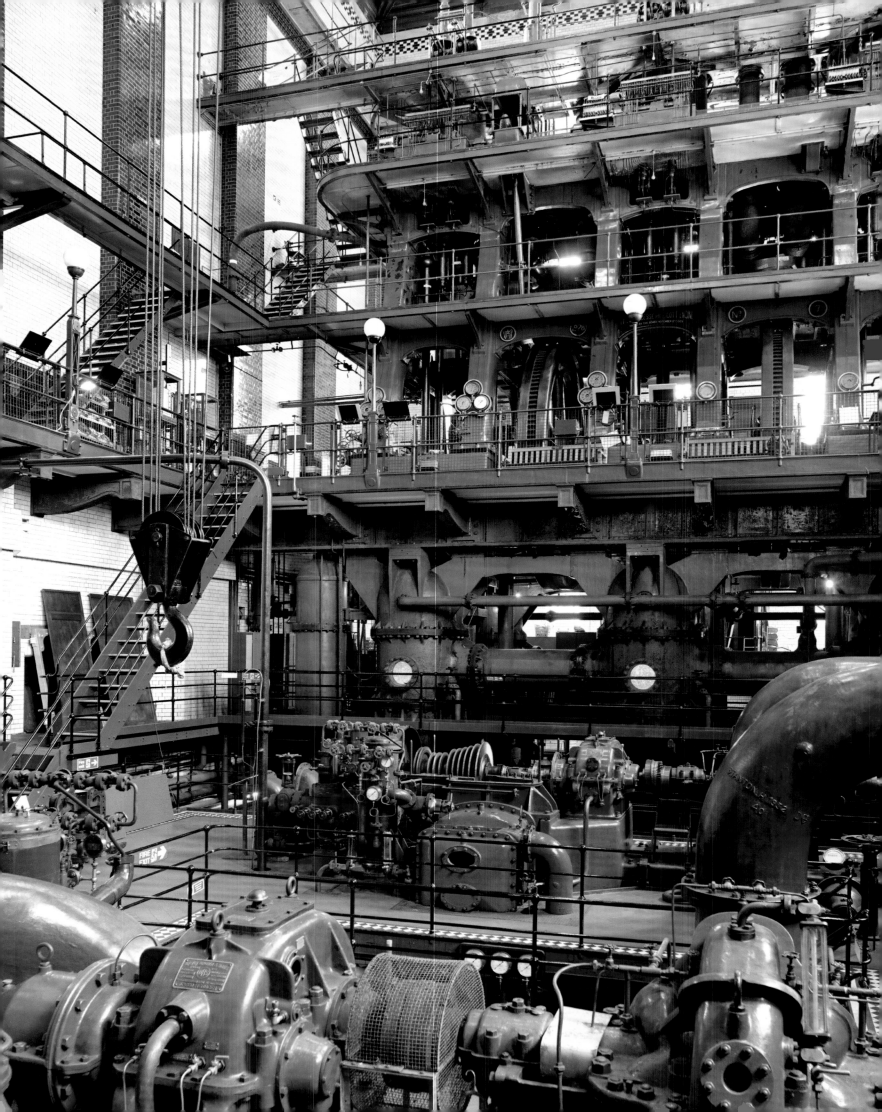

Kempton Steam Museum

Kempton Steam Museum qualifies as a true cathedral of steam, with a monumental engine house containing colossal pieces of machinery in the form of two triple-expansion engines, the largest ever made in the UK.

These engines have also been described as being among the most sophisticated reciprocating steam engines ever built, coming at a time when pistons reached their peak of efficiency and started to be bettered by electric motors and turbines. For good measure, Kempton also has its own pair of early turbines displayed in the museum between the triple-expansion engines.

Kempton Park Works, once owned by the Metropolitan Water Board, was a water treatment and pumping station supplying water to reservoirs in north-west London. This rather distant arrangement followed the 1852 Metropolis Water Act ruling that drinking water from the Thames had to come from above the tidal reaches of the river. The MWB was well-established with feeds from the upper Thames above Teddington Lock, but when it needed to expand its capacity at Kempton during the mid-1920s, the decision was taken to commission new triple-expansion engines, numbered Kempton 6 and 7, from Worthington Simpson of Newark, each rated at just over 1,000 horsepower.

The tall Engine House, in red brick with Portland stone facing, has been attributed to Henry Stilgoe, chief engineer of the MWB, and is lined with glazed bricks and quarry tiles. An overhead travelling crane, which remains in place, was used to assemble the engine from components shipped by rail from Nottinghamshire in loads not greater than

16 tonnes. Yet each finished engine weighs between 800 and 1,000 tonnes. Triple expansion is particularly efficient engine architecture, at the expense of some complexity and bulkiness. Steam was provided by six moving-grate boilers. It flows through three cylinders of progressively increased diameter, with carefully calculated timings of valve cut-off. Superheaters and condensers add to the steam's effectiveness as it travels through the engine.

The first triple at Kempton was named The Sir William Prescott, after the MWB Chairman, and the second after his wife The Lady Bessie Prescott. The official opening of the new engine house was in October 1929, and the engines ran from that date until 1980, generally being operated alternatively. They pumped about 38 million gallons of water each day across a distance of 12 miles to reservoirs at Maiden Lane, Shoot-Up Hill, Fortis Green and Bishops Wood.

Provision for further increase in capacity had been made, with a space left for a third engine of the same type to be placed between the original pair, but the plan was changed in favour of a pair of steam turbines made by Fraser and Chalmers, driving centrifugal pumps through David Brown gearboxes. Although the turbines were only a fraction of the size and weight of the reciprocating engines, on paper their power was at least equal and their efficiency far greater, yet they do not seem to have fulfilled their promise and they were not extensively used. One of the turbines is now partly dismantled for display at Kew.

When Kempton was at its coal-fired peak, a considerable

PREVIOUS PAGE *The lower level of the four-storey Kempton engine, showing pump valve chambers.*

LEFT *The triple-expansion engine is laid out on four storeys, with a turbine of equal rating on the left, together with the hook of the crane which was used to assemble the engines.*

infrastructure was built up to support all the steam engines in operation at the works. A narrow-gauge railway was built from Hampton, where the MWB had a riverside wharf and took delivery of coal. Coal was shipped to Kempton from there, or from a connection to the standard-gauge railway yard nearby, and tipped into an automatic boiler feed conveyer. There are plans to revive and reinstate the railway on the original track-bed on land now owned by Thames Water.

The pumping station Engine House at Kempton Park has been designated as a Statutory National Monument. The steam engines are now a museum operated by Kempton Great Engines Trust, who have restored The Sir William Prescott to running order.

VISITING INFORMATION

Kempton Steam Museum, Snakey Lane, Hanworth TW13 7ND

http://www.kemptonsteam.org

Generally open Tuesdays and Thursdays, except in December, for viewing only. The engine steams on certain steaming weekends. Check online for dates.

The instrument panel for the two turbines at Kempton: engines number 8 and 9.

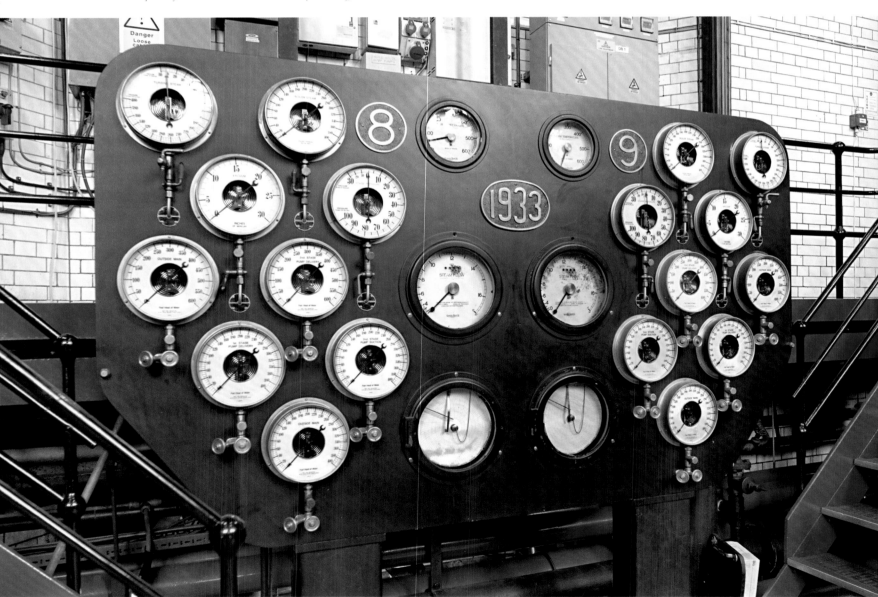

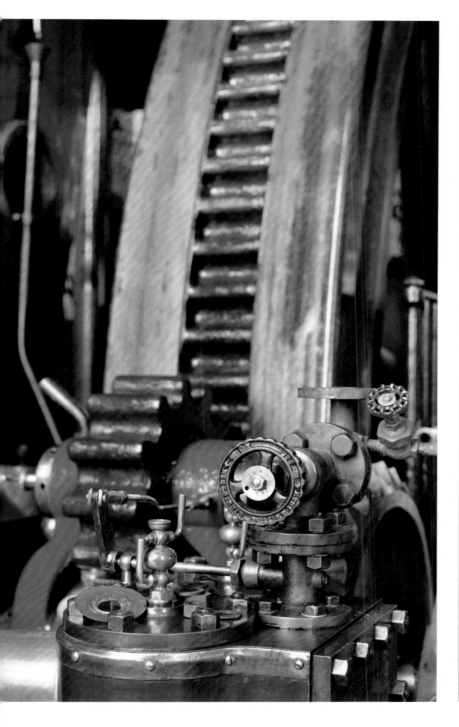

LEFT *The starting system is itself a small steam engine, which engages with the flywheel.*

RIGHT *Clocking in at Kempton time card machine.*

Markfield Beam Engine Museum

An outstanding specimen of a Victorian beam steam engine stands today in working order on the spot in north London where it was built and set to work in 1888. Markfield Park is a pleasant recreation space on what was once the site of the extensive Tottenham sewage treatment works, and the Markfield beam engine is a living monument to the public health programmes and engineering of the Victorian age.

The railways caused the suburbs of north London to expand into the countryside at a rapid rate from the middle of the nineteenth century, and Tottenham went from being a farmland parish comprising mainly smallholdings to a densely populated area in the space of forty years. One of the worst problems caused by the new concentration of population was the disposal of sewage. London suffered four cholera epidemics between 1831 and 1866. Flush toilets were becoming increasingly popular but these discharged into cesspits and much sewage found its way into the River Lee. Tottenham had piped water, but the local board of health needed to take extra measures to keep water and sewage separate. The sewage works built at Markfield in the 1850s had a steam-driven pump which filtered sewage through sand before discharging water directly into the River Lee, but eventually the system allowed sewage water to seep into local land from where the water was drawn.

A better system was required to push the effluent into the Northern High Level Sewer at Hackney, and this needed more pumping power. The engine commissioned for the job was a 100-horsepower beam engine designed by Wood Brothers of Sowerby Bridge, Yorkshire. Component parts were cast and machined at Sowerby Bridge and shipped to

The main crank, with its 27-tonne flywheel, turns at 16 rpm, controlled by the centrifugal governor on the left.

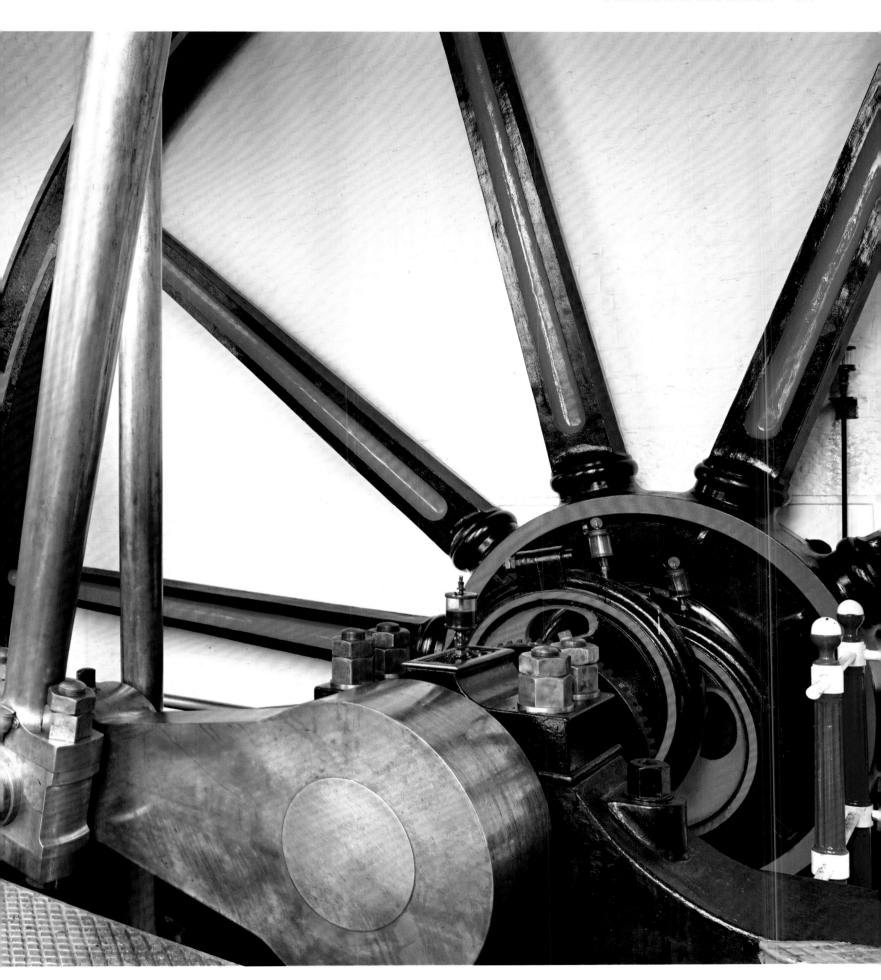

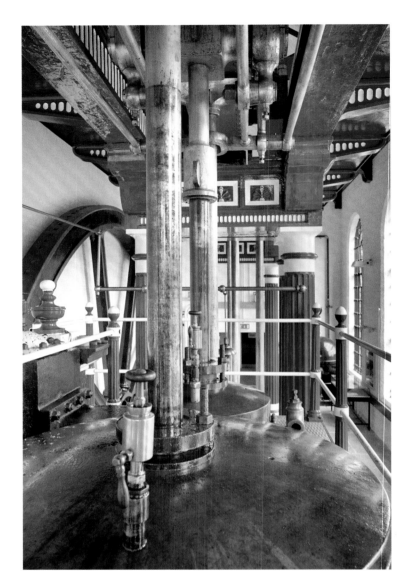

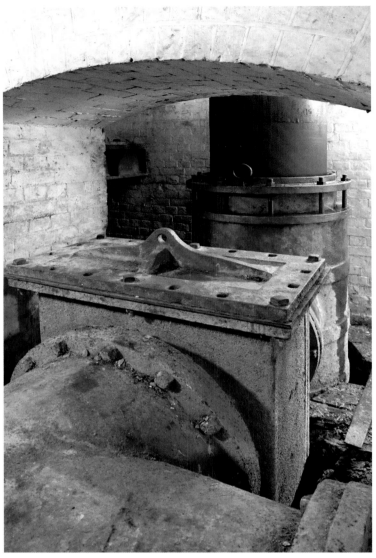

LEFT AND RIGHT *All visible parts of the engine are highly decorated. The plunger pumps below floor level, where the sewer mains have a functional finish.*

London for assembly, starting in 1886. The engine was closely integrated with the structure of the brick engine house, with the end of the flywheel axle main bearing supported within a cast-iron frame built into the wall. It commenced operation on 12 July 1888 and continued until around 1905, when it was relegated to standby duty for stormwater pumping.

One of the charms of the Markfield engine is the extraordinary amount of decorative detail applied to such a functional instrument. It has a Greco-Roman temple for its framework and decoration inspired by classical architectural orders has been freely applied to the eight cast-iron columns that carry the beam above the cylinders. They appear to be Greek Doric but also feature Roman elements. The speed-control governor has a base pillar that is more Corinthian in style, which

forms into a vase adorned with cast acanthus leaves. The authentically Victorian green-and-scarlet paint scheme is based on colour analysis of scrapings of previously applied finishes.

Many of its working parts are highly visible, the engine taking on a dynamic personality when it is steamed. This can be seen particularly in the parallel-motion linkage invented by James Watt, which links the driving connecting rods (which work in a straight-line motion) to the beam (which rocks in an arc to drive the pumps). A spinning centrifugal speed flyball governor regulates the engine.

Some important features are hidden. It is a double-acting engine, which permits steam to enter the cylinders on each side of the piston, making every stroke of the engine a powered working action. It is also a compound engine, using high-pressure and low-pressure cylinders to

extract the maximum from the expansive power of steam. Although the different sizes of the cylinders can be clearly seen, the movement of the steam has to be imagined, entering first the smaller high-pressure cylinder, where some of its pressure is expended, before passing into the low-pressure side. A laborious starting ritual is needed on this kind of engine, and this can be seen on steaming days. When shut down, the engine stops at a dead spot in its operating cycle. A lever must be fitted to slots in the rim of the flywheel to edge the engine round a few degrees a time into a starting position.

The engine's survival was due both to its stand-by status and to far-sighted preservation. When Markfield closed as a sewage works in 1963, the engine was still in working order. Its significance was understood, and it was recognised that any restoration would be a long-term project. The windows of the engine house were bricked up for protection for several years. A group known as the River Lee Industrial Archaeology Society started restoration work. It was in 2009, with the rehabilitation of the surrounding area into Markfield Park, that the engine was restarted as an educational resource.

VISITING INFORMATION

Markfield Beam Engine Museum, Markfield Road, N15 4RB

http://www.mbeam.org

The museum is generally open 11am–5pm on two Sundays each month between March and October; the engine is steamed on eight occasions per year. Check online for dates.

Classical architecture influences are combined with the classic steam technology of parallel motion linkage; the beam is 5 metres above floor level.

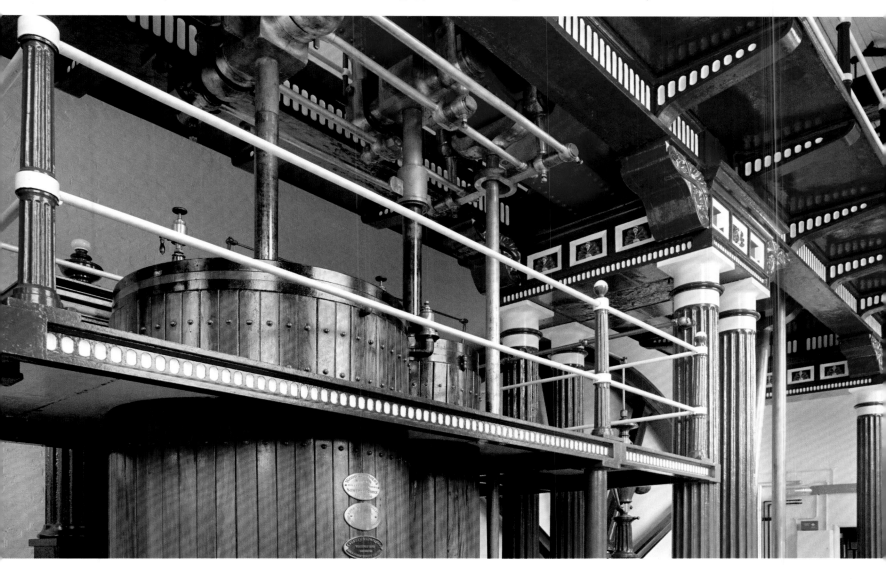

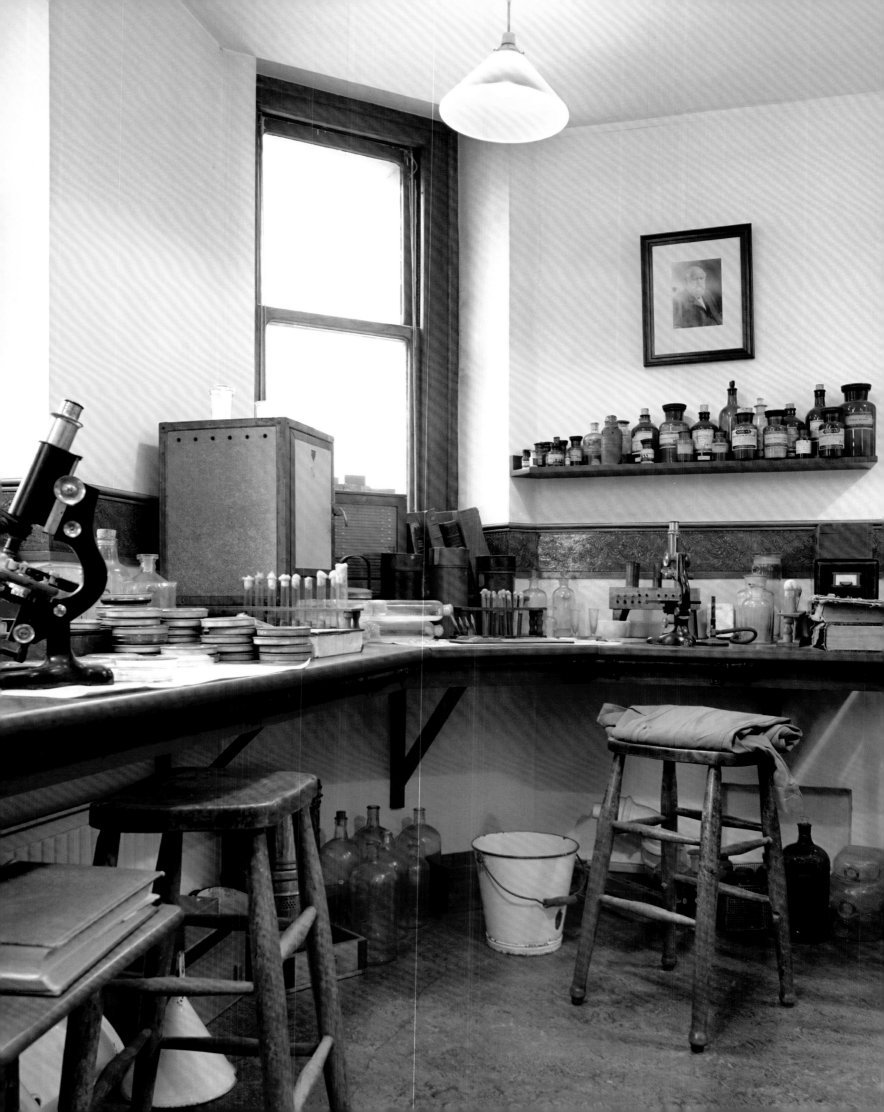

Alexander Fleming Laboratory Museum

A room in St Mary's Hospital Paddington is one of London's smallest museums and one of the most compelling. The Alexander Fleming Laboratory Museum is the place where penicillin was discovered on 3 September 1928.

Alexander Fleming, Professor of Bacteriology at St Mary's, returned from holiday to find a dish containing a bacteria sample had been left on the bench. He noticed that the sample had been contaminated by a fungus and growth of the bacteria had been inhibited. Fleming said to his colleague Merlin Pryce: 'That's funny.'

Part of the legend of the discovery of penicillin is that fungus mould spore had blown in through an open window, but a visit to the museum nails that myth and others. The museum captures the reality of a simply equipped laboratory with its narrow and cluttered wooden bench, Zeiss microscope, slide cabinet and glass sample dishes. When the laboratory was recreated *in situ* and refitted in 1993, sixty years after Fleming left it, great care was taken to make it as authentic as possible. The apparatus was assembled from relics saved in St Mary's bacteriology department. One of the greatest challenges was finding correct 4-inch glass petri dishes to the original pattern, and after an extensive search a few were discovered in old public health laboratory store. Old photographs of the laboratory, which Fleming occupied from 1919 to 1933, show a framed picture on the side wall. This same picture, a signed photograph of the pioneer of immunology Élie Metchnikoff, was found, and hangs in exactly the same place today.

Fleming had previously worked at the laboratory of a military hospital, observing the limitations of antiseptics when applied to wound infections, as they destroyed white blood cells, a natural defence against bacteria, faster than they destroyed microbes.

Displays in adjacent rooms illustrate other chapters of the penicillin story, including how a team at Oxford University devised a way of purifying and stabilising penicillin to make it into the antibiotic which changed medicine.

VISITING INFORMATION

Alexander Fleming Laboratory Museum,
St Mary's Hospital, Praed Street, W2 1NY
http://www.medicalmuseums.org
Open Monday–Thursday 10am–1pm. Other times by appointment only (Monday–Thursday 2pm–5pm and Friday 10am–5pm).
Closed on public holidays.

The original laboratory was described as musty, dusty and cramped. Fleming worked in this second-floor room for fourteen years.

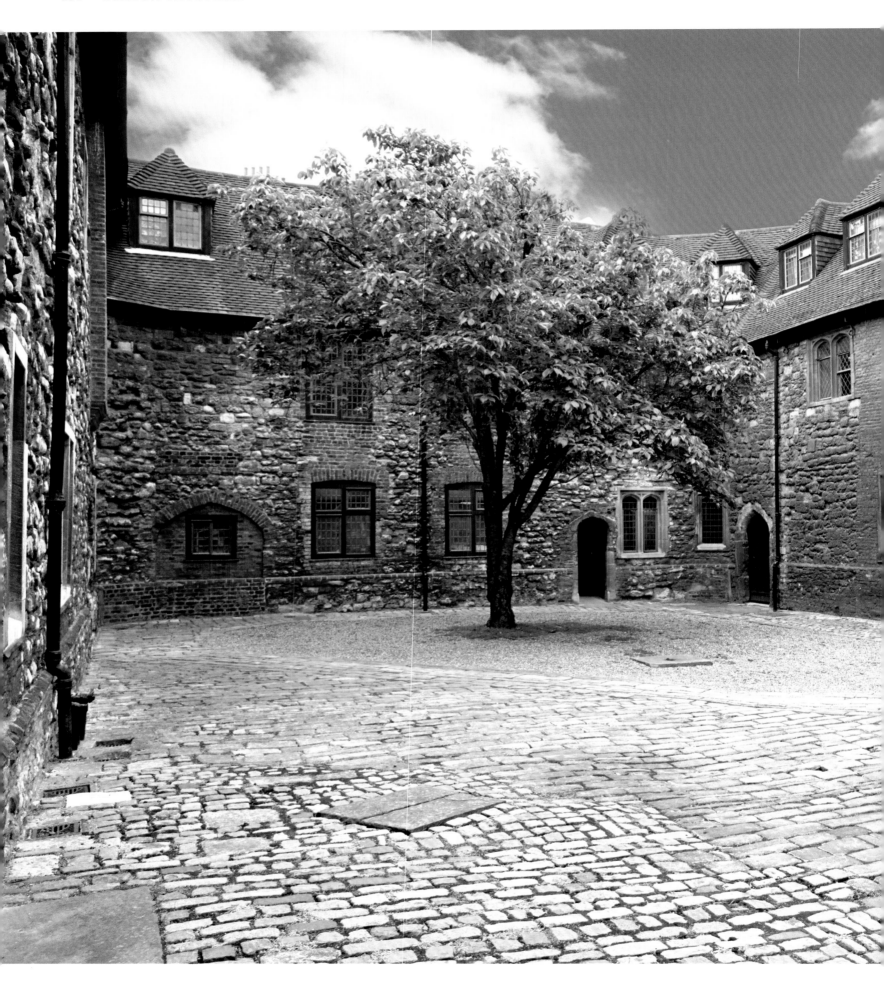

The Charterhouse

The Charterhouse lies just to the north of the City of London boundary, a collection of fine buildings hidden beyond the arch of a fifteenth-century gateway off a cobbled square. It was originally a Carthusian monastery dating from the late 1300s, which subsequently underwent several distinct changes of identity and purpose. During Tudor times it operated as a mansion house in the ownership of powerful noblemen. It once a housed a notable public school. Today, it serves as a modern almshouse and a secluded retirement home, retaining some of the fabric from the fourteenth century and some architecture from the twenty-first.

A burial ground was established on land in West Smithfield about 1350 during the Black Death, and a chapel was built alongside. The hermitage of a priory built to a square ground plan was started in 1372 under the sponsorship of Baron Walter de Mauny, a soldier much favoured by Edward III, to whom he acted as an adviser. The order of monks came from La Grande Chartreuse near Grenoble in France. They belonged to the Carthusian Order and the anglicising of this gave the name Charterhouse. A chapter house and a series of small houses for a complement of twenty-four monks were built, with surrounding cloisters. Thomas More sometimes worshipped here and possibly lived here as a young law student. The monastery was politically favoured and thrived for almost a hundred years, but the devout Carthusians would not accept Henry VIII's Act of Supremacy over the English Church, and many of the Charterhouse monks died in the turmoil of the Dissolution, brutally executed at Tyburn or starved to death during imprisonment. Prior John Houghton was hanged, drawn and quartered. One quarter

Wash House Court was the service area of the priory. The brick houses date from 1531; the stone structures are older.

The entrance to the Great Hall in Master's Court, with the Stuart coat of arms above.

of his body, including an arm, was afterwards suspended above the gateway of the London Charterhouse.

Seized by the Crown, Charterhouse was acquired by Lord North, who demolished the church and cloisters, built new courtyards and added the Great Hall to develop an expansive mansion. Lord North was close to the highest level of the establishment and Elizabeth I arrived at Charterhouse from Hatfield on the fifth day of her reign in November 1558 and stayed for five days before proceeding to the Tower of London on the way to her coronation in Westminster Abbey. The mansion complex was sold to Thomas Howard, 4th Duke of Norfolk, who

further added to it. Norfolk later became caught up in the Ridolfi plot to overthrow Elizabeth, and he was executed in 1572.

It was under the brief ownership of Thomas Sutton, a commoner made wealthy by coal mines and speculation, that in 1614 Charterhouse began its journey to becoming an almshouse and school. Sutton had long held the wish to create a benevolent institution, and under a foundation established by him endowments were bestowed for a school for forty boys between nine and fourteen years. There was also an almshouse for eighty men over fifty years of age, unmarried, army or naval officers or

ABOVE *The chapel was once the Carthusian chapter house of the early fifteenth century. The pew ends are Jacobean.*

OVERLEAF *The Norfolk Cloister garden.*

businessmen who had become disabled or disadvantaged in some way. These were to be called Brothers, and the institution known as Sutton's Hospital in Charterhouse. Although the charter had stipulated that the scholars were to be the children of poor parents, it did not intend that they were paupers, but rather those descended from the professional rather than landed classes. Fee-paying day boys and boarders were also admitted.

Some new buildings were commissioned, others enlarged or adapted and Charterhouse School was active at this site until 1872, when it moved to Godalming. Part of the site was then employed by Merchant Taylor's School, which operated here until the site was sold in 1933 to St Bartholomew's Hospital, which established a medical college there. Today this is the Barts and The London School of Medicine and Dentistry.

Charterhouse continues as a community of over forty single elderly men of limited financial means, some of whom are former military officers; others teachers, clergymen and artists. Modern Charterhouse includes the Admiral Ashmore building completed in 2000 and the Queen Elizabeth II infirmary converted from existing buildings in 2004.

With changes of purpose, and building programmes

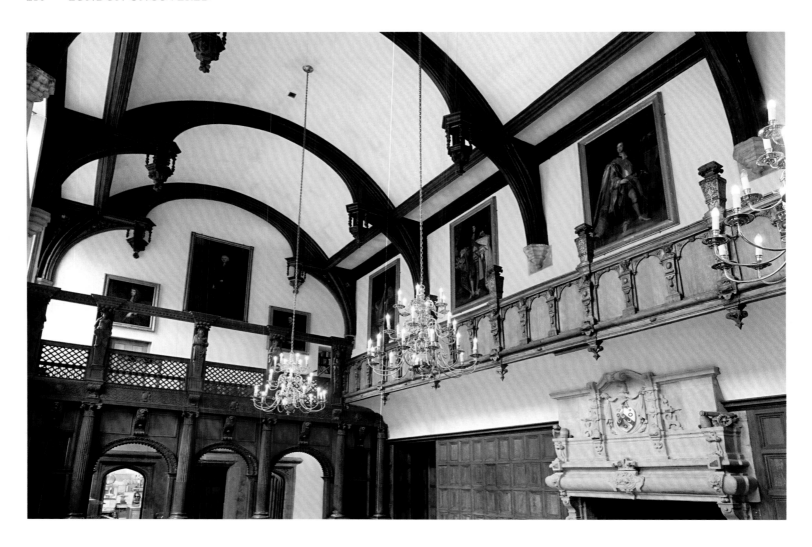

The Great Hall with its hammer-beam roof. The chimneypiece from 1614 bears the arms of Thomas Sutton.

spanning more than 500 years, with serious bomb damage in 1941, demolitions and modern additions the architecture and history of Charterhouse is varied and layered. When work was underway to restore the bomb-damaged buildings in 1947, the foundations of the original chapel from the time of the Black Death were unearthed, and the grave and remains of Baron de Mauny discovered. Today's chapel incorporates part of the old chapter house. The Great Hall and the Great Chamber are splendid rooms from Lord North's day, both expanded and extensively rebuilt in recent years. Wash House Court is an authentic quadrangle of modest brick and stone Tudor outbuildings. There was once a range of buildings erected to Sir Christopher Wren's design in 1672 and demolished in the 1820s.

There is even a persistent claim that the cloisters of Charterhouse contributed to the formulation of the rules of Association Football. Students at Charterhouse played football inside the cloisters, and when the ball was kicked outside beyond arm's reach, a player was allowed to leave and return it to play into by a throw-in, an action which was incorporated into the rules of the game. Players who tried to gain an advantage by jumping out of the cloisters and running in front of the ball were penalised: the first application of the off-side rule.

VISITING INFORMATION

London Charterhouse, Charterhouse Square, EC1M 6AN

http://www.thecharterhouse.org

Tours start 2.15pm on Tuesdays, Wednesdays, Thursdays and every other Saturday. They last approximately 90 minutes and are led by a Brother of the Charterhouse. A museum is reported to be planned, designed to tell the story of the Charterhouse from the Black Death to the present.

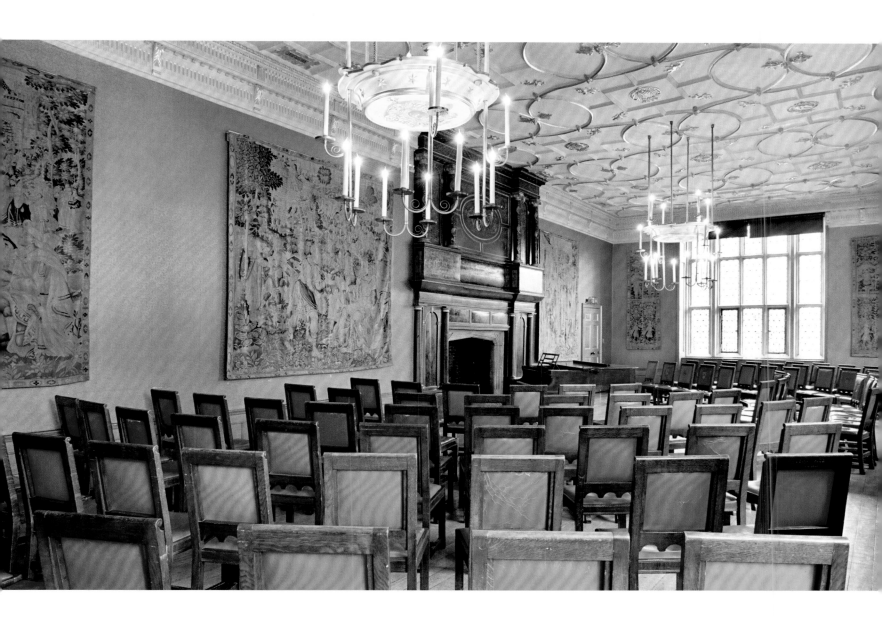

The Great Chamber ceiling, originally commissioned by the Duke of Norfolk, was much in need of restoration after damage in 1941, and the chamber was enlarged as late as 1955. Flemish tapestries cover the walls.

Old Operating Theatre and Herb Garret

The Old Operating Theatre in St Thomas Street occupies a curiously offset and concealed location in the roof of an old church, a position which caused it to be sealed up and disappear from sight for almost a century. Today it is simple for any visitor able to climb a short spiral staircase to see the once-forgotten operating theatre and the herb garret beside it.

It was diligent work by an antiquarian that led to its rediscovery. Raymond Russell, a historian researching the old St Thomas' Hospital site and the life of an eminent Victorian surgeon, found scholarly references linking an abandoned operating theatre to St Thomas' Church. These suggested that the structure of an old theatre building could be seen from the street, which did not seem to be true. The accounts said that the theatre had been on located on the church roof. One morning early in 1956 Raymond Russell climbed the church tower up to the first floor level and, using a ladder, investigated an opening high on the side of the tower chamber. A space inside, dark because the skylight glass above had long been covered with slates, contained the recognisable shell of the operating theatre. The theatre was to be found not *on* the roof, but *inside* the end of the roof space.

The operating theatre had opened in 1822 in part of the roof once completely occupied by a herb garret used by apothecaries to dry, cure and store medicinal plants. The 1703 church and its predecessor were the chapel of St Thomas' Hospital, the institutions having been interlinked from medieval times until the hospital was squeezed out of its Southwark location by the expansion of London Bridge station in 1862. The hospital moved to a new site at Lambeth, and the church closed as a place of worship. Much of the old hospital was demolished.

The five levels of terraced standings are where medical students packed the theatre to observe surgery between 1822 and 1862.

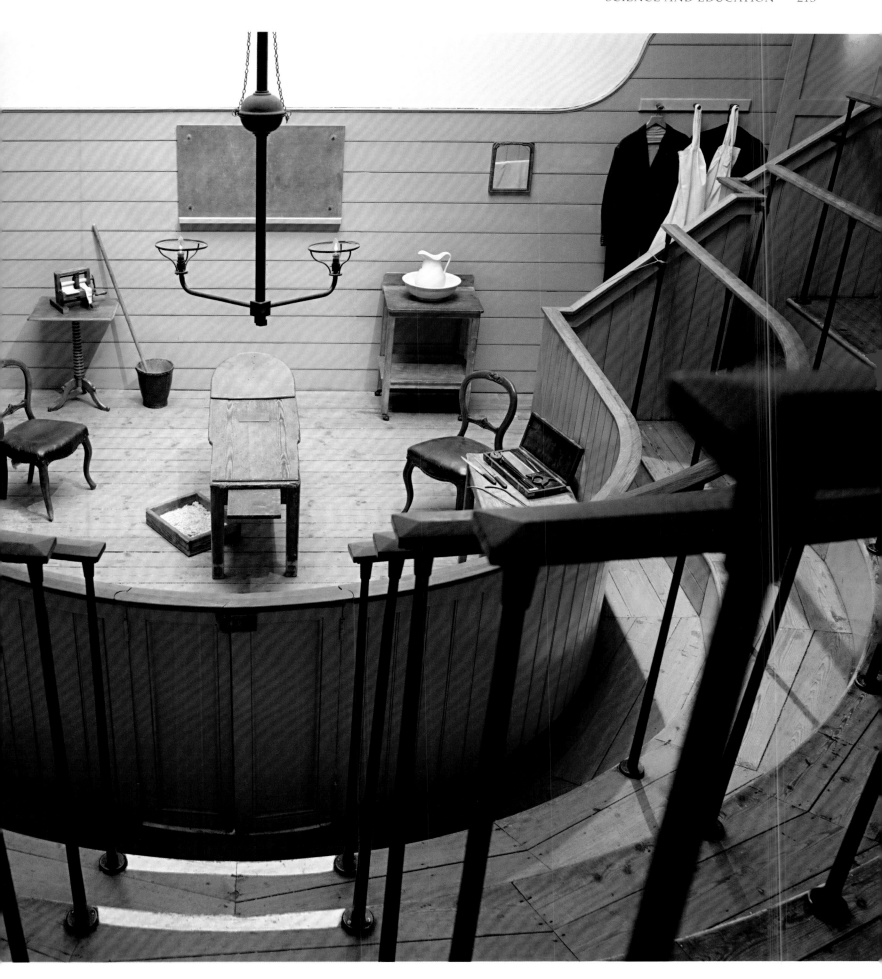

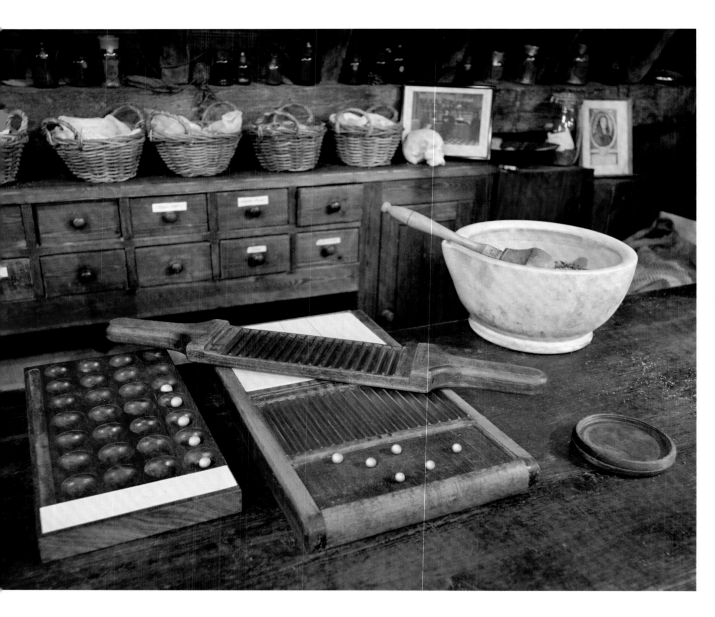

A pill-making tablet mould, displayed in the herb garret.

A surviving building, once housing the women's ward, which had been connected to the operating theatre through linking doors, was taken over by the post office. Links were severed, and the doors bricked up.

After rediscovery, the Old Operating Theatre was painstakingly reconstructed between 1957 and 1962, based on the outlines of structures remaining on the walls and from a dusty ground plan on the floor. The floor itself was found to be a false level, packed with sawdust to soak up water when the theatre was scrubbed. An inventory of the fixtures and fittings of the old hospital had been made by the railway company in 1862, which included the operating theatre. This described its layout of steeply raked semi-circular steps, with no seating, separated

with rails on iron supports. These were the five levels of 'standings' which were occupied with medical students observing operations.

A wooden operating table dating from around 1830, which was taken from University College Hospital, now occupies centre stage. The theatre was illuminated by skylight and gas light and was altogether an advanced facility by the standards of the age, but it was not until late 1840s that anaesthesia is likely to have been introduced. Traces of ether were found under the floorboards, and the antiseptics being developed by Joseph Lister came too late to be employed here. Conditions would have been primitive; the wooden drip-tray filled with sawdust positioned under the operating table is a reminder. This is claimed to be the

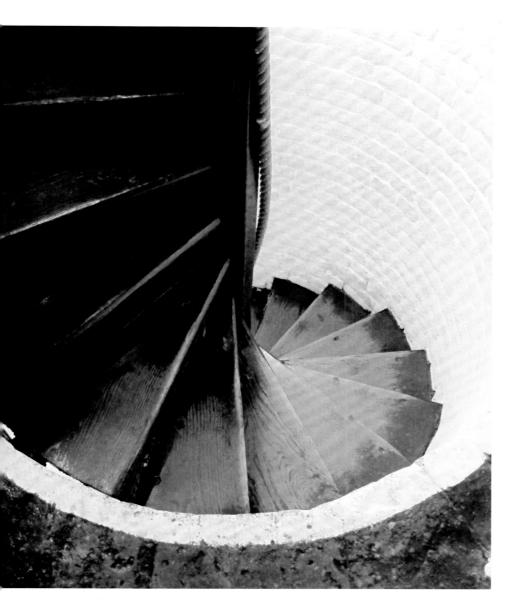

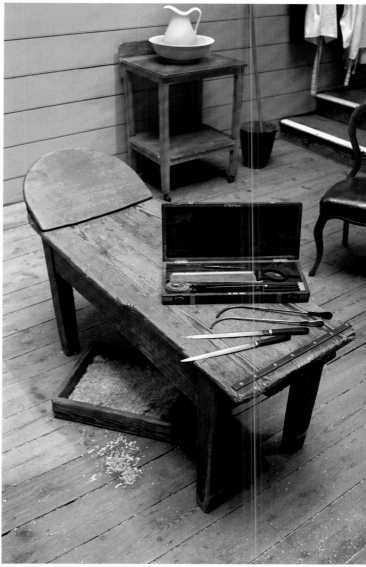

LEFT *A spiral staircase in the church tower is the only entry route, leading first to the herb garret.*

RIGHT *In the operating theatre, an amputation set stands poised, and a drip-tray filled with sawdust is in position under the table.*

oldest operating theatre anywhere in Europe, built when medicine was barely entering the age of science.

In 1962, the garret and operating theatre were opened to the public, and during the 1990s the herb garret was built up as a major display area. When the theatre was made, the herb garret seems to have been reroofed and dormer windows inserted at the rear, but these were long-covered with dirt. During restoration of the herb garret, opium poppy-heads were found in the rafters. A dark, dry and ventilated place remote from the vermin found at lower levels, the garret handled a wide variety of preparations, not all of them herbs, including snail-water, laudanum and leeches. The apothecary was at one time the chief resident medical officer of the hospital and responsible for prescriptions for surgical cases.

In recent times, the St Thomas' Church building has served as a chapter house meeting room for Southwark Cathedral, as an office for insurance brokers, then a property developer's headquarters. Hidden above in the roof space, the old operating theatre is still something of a mystery venue, undetectable from street level, although its skylight may be now glimpsed from The Shard, which towers over the area.

VISITING INFORMATION

The Old Operating Theatre and Herb Garret, 9a St Thomas Street, SE1 9RY

http://www.thegarret.org.uk

Open daily 10.30am–5pm.

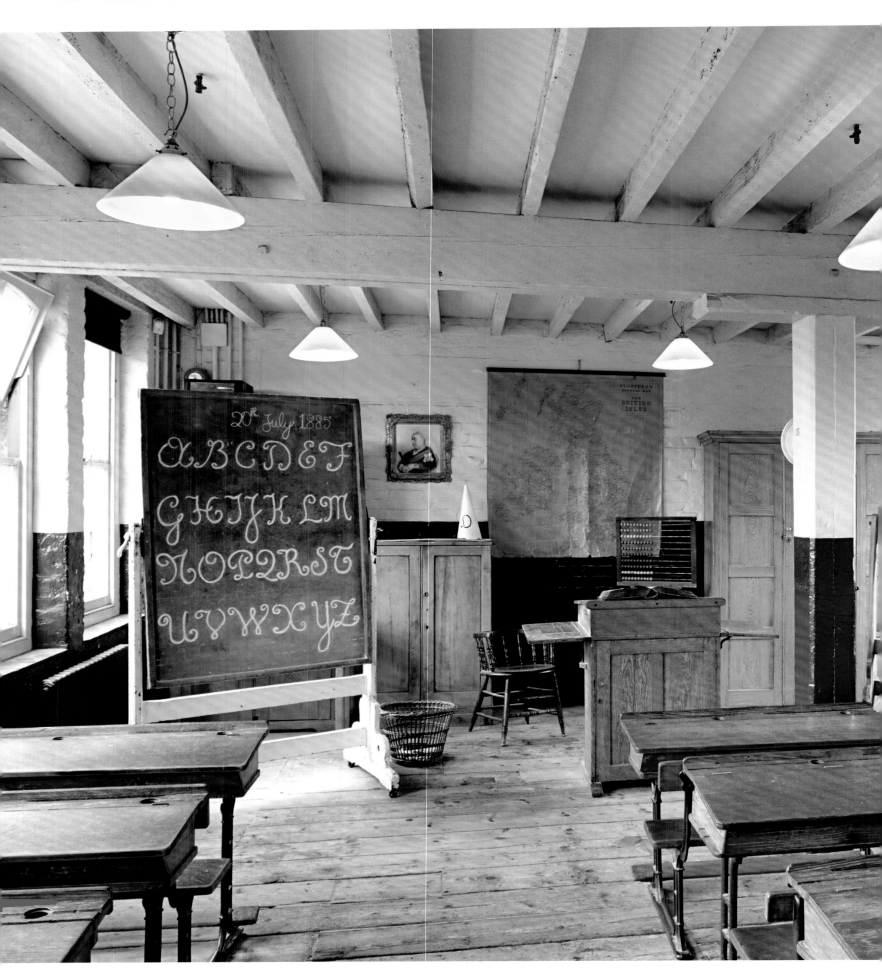

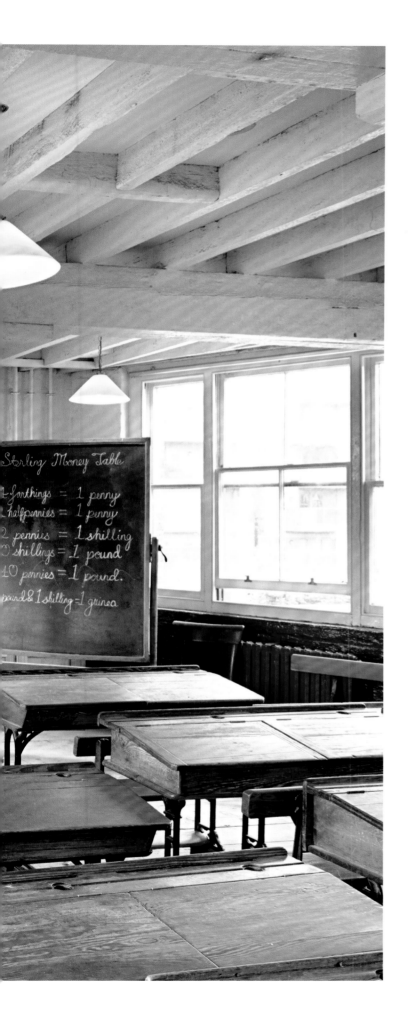

Ragged School Museum

London's largest school for poor children during the Victorian age was at Copperfield Road at Mile End, in warehouse buildings alongside the Regent's Canal. It is now the Ragged School Museum, aimed at informing mainly young visitors about a previous era of schooling, through its recreated classroom, and providing a social history of the East End in authentic surroundings.

'Ragged school' was a term used in the nineteenth century to describe free schools for the education of children from the poorest and most destitute families. In London there were pioneering individuals, such as tailor Thomas Cranfield, who between 1798 and 1838 built up nineteen Sunday, night and infants' schools situated in the poorest parts of London, free to children of poor families, and outcast children. Then there was the London City Mission, an evangelical movement of different Protestant denominations, which became a force in the early poor school movement, with its missionary Andrew Walker first opening a school in a disused stable in the City of Westminster in 1835. By 1840 the City Mission, in its annual report, used the expression 'children raggedly clothed' to describe the pupils of its schools, and 'ragged school' was the name widely applied to free schools for poor children. The Ragged School Union was established in 1844. Its President was Anthony Ashley Cooper, Lord Shaftesbury, politician, philanthropist and social reformer.

The school at Copperfield Road owed its formation to Dr Thomas John Barnardo, who established the first home for working homeless boys in 1867 in Stepney. Nearby, a pair of cottages was used as a school, and these were soon outgrown. In 1877, Barnardo started to rent the warehouses in Copperfield

How a lesson of 1885 might have looked, with Queen Victoria's portrait for period and a dunce's cap for authenticity.

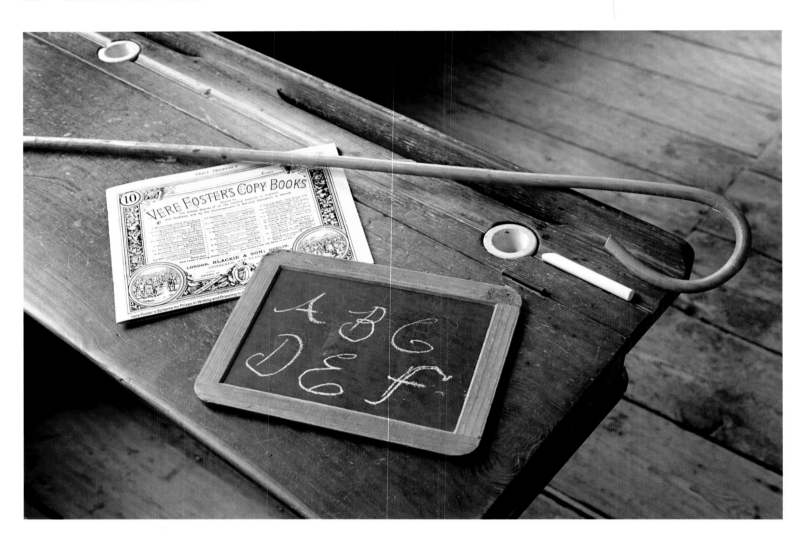

The emphasis at ragged schools was on writing, using first slate board, then ink in copperplate copybooks, and a certain degree of discipline.

Road. Each floor was fitted with a fireplace, the doors for loading merchandise became windows, and storage floors were converted into large classrooms, separate for boys and girls. Emphasis was placed upon the three 'R's and religious study. The school taught poor local children aged five to ten, gave them two meals a day and helped them to find employment. The basements were used as play areas. By 1896 the pupils numbered more than a thousand, with almost 2,500 attending the Sunday school – the largest in London.

One historian's estimate is that there were once 144 ragged schools in London, attended by 300,000 children between 1844 and 1881, but the Elementary Education Act of 1870 signalled the beginning of the end of this form of charitable free education in England and Wales. Compulsory primary education provided by government came relatively late to Britain, but now local authorities were mandated to introduce council schools. Ragged schools founded on high Victorian principles of philanthropy, and not always secular, eventually became subject to compliance and regulation. The day schools at Copperfield Road were closed down by the London County Council in 1906, the children being dispersed to council schools. Evening classes and the Sunday school continued there for another nine years.

From 1915 until 1983 and the founding of the Ragged School Museum Trust, the buildings were used as garment factories and warehouses. The warehouses themselves, built in 1872, had become the subject of increasing architectural interest in their own right, retaining their wall-mounted cranes and the imposing pediment added by Barnardo. Once used to store lime juice and general provisions, the buildings reverted to storage when the school closed. The warehouses survived the Blitz, and later housed the factory making Lewis Leathers motorcycle clothing. After the site was threatened with demolition in 1983, campaigners battled successfully to save it, and a charitable trust opened the Ragged School Museum in 1990.

There are further displays and exhibitions at the museum, including a recreation of a Victorian East End kitchen from the 1900s, complete with mangle and washboard, demonstrating what life would have been like in a one-room home with no electricity or running water.

Visitors to the Ragged School Museum can dress in Victorian clothes and sit in the schoolroom for a mock lesson and relive the atmosphere of a ragged school.

The Ragged School Museum is a lively place, even though its mission statement is to be recognised as 'the best place in London to experience the life of the Victorian poor'.

VISITING INFORMATION

The Ragged School Museum, 46–50 Copperfield Road, E3 4RR

http://www.raggedschoolmuseum.org.uk

Open 10am–5pm Wednesdays and Thursdays, and 2pm–5pm first Sunday of each month. Also open for visiting schools and group history talks.

An East End kitchen as it may have appeared in the year 1900, complete with utensils and artefacts for visitors to handle.

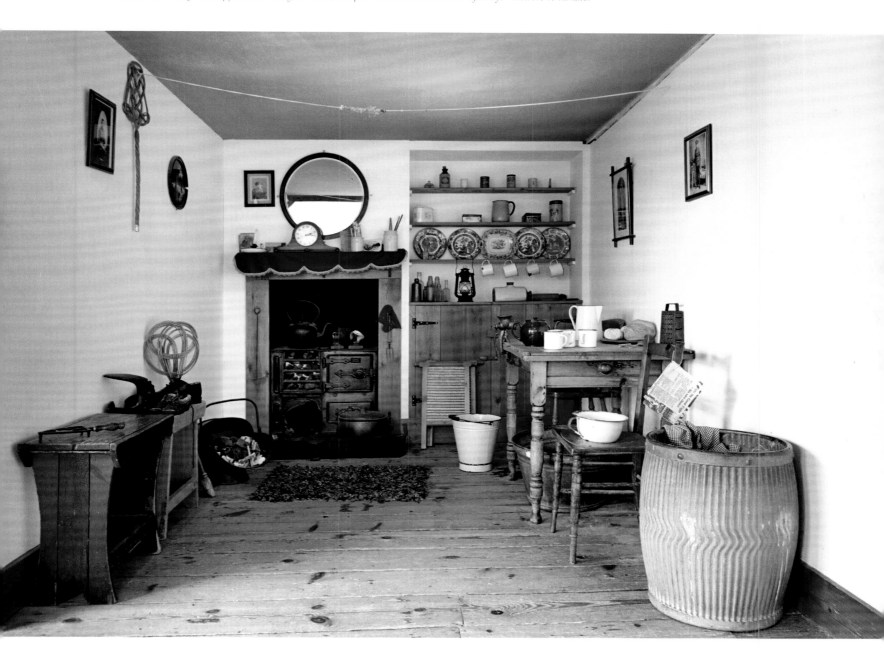

London Museum of Water & Steam

The London Museum of Water & Steam at Kew presents a history of water supply, a collection of engines, a group of early Victorian industrial buildings and a miniature railway. It is claimed to be the site of the oldest waterworks in the world, and some pieces of preserved antique machinery are regularly demonstrated here in the place they have always worked.

In 1838, the Grand Junction Water Works Company opened its pumping station at Kew in an effort to find an intake of cleaner water, having moved upriver from Chelsea, where the Thames water had become polluted. Water was taken from a place near Kew Bridge until 1852, when the Metropolis Water Act stipulated that Thames water should be taken from the non-tidal part of the river. Another intake was made at Hampton, from where water was pumped to Kew for filtration. In 1902, the creation of the Metropolitan Water Board absorbed all the water companies in London, and Kew continued with its operations with its steam engines until 1944. Some of its diesel and electric pumps still operated until the water works ceased operations in 1986. The old Metropolitan Water Board had long maintained a protective attitude to its steam engines, and had resisted scrapping some of them even in the 1930s, an early preservationist action. In June 1944, while the war raged, the Board declared Kew to be a Museum Pumping Station. Five steam engines survived in a museum that was restricted to professional visitors and not open to public until the Kew Bridge Engines Trust was formed in 1974.

For many visitors, the primary exhibit is the 90-inch Cornish beam engine, which was installed here in 1846 and

The wall of the Water Works Gallery, with examples of home appliances, including a fine collection of first-generation washing machines.

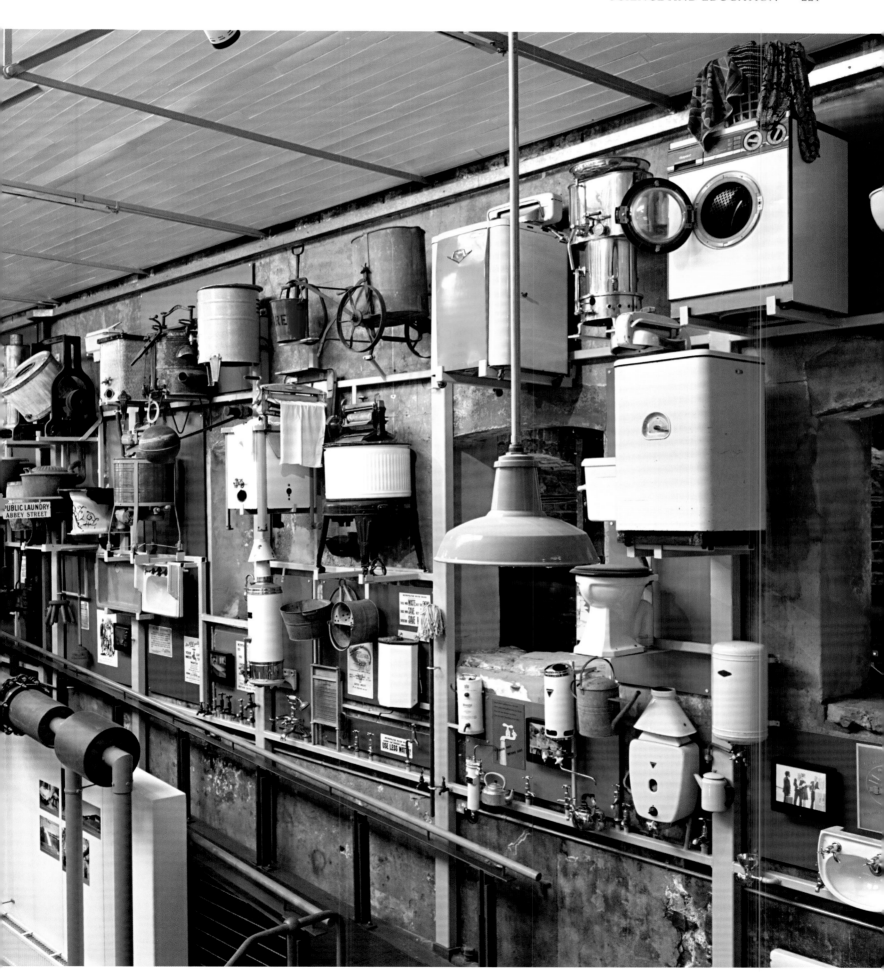

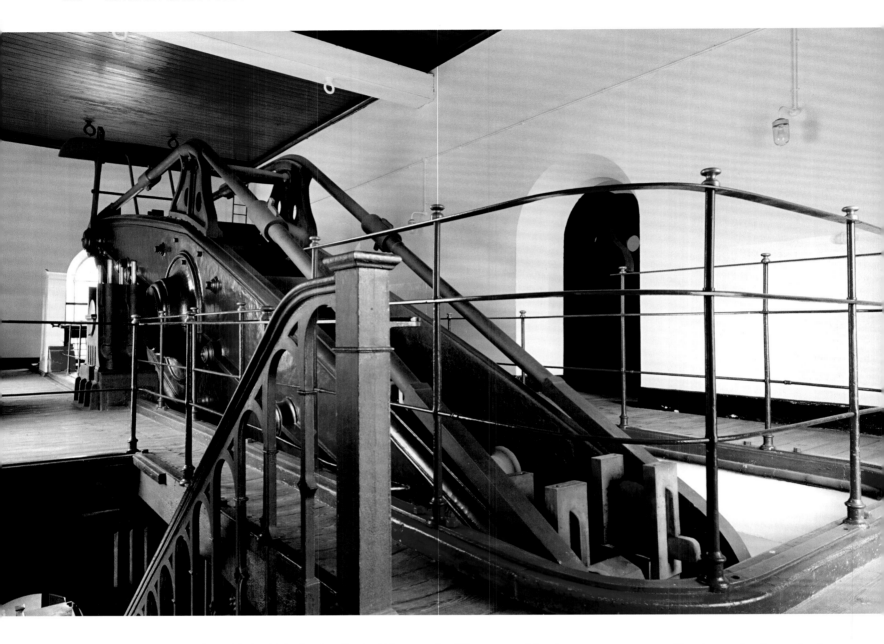

This Cornish beam engine, with its 90-inch cylinder, inspired Charles Dickens to write: 'What a monster! Imagine an enormous see-saw with a steam engine at one end and a pump at the other.'

not retired until 1944. It was the biggest steam engine in the world when commissioned and the first Cornish cycle engine built for domestic water supply, rather than for draining deep tin and copper mines. Its high-pressure operation and shorter valve timing allowed the charge of steam to expand to greater volumes, which bought improved efficiency. It was this engine that inspired Charles Dickens to write, after a visit in 1850: 'It is marvellous that so much power can be exercised with so little noise and vibration.' The engine is restored in working order and frequently steamed. Alongside is a larger and later 100-inch Cornish engine, preserved out of use. It was the last engine to pump water at Kew, during a demonstration in

1958. The oldest engine is a Boulton & Watt engine dating from 1820, at Kew since 1840.

Some engines at Kew have been saved from other sites. The last steam engine in active water-pumping service in the UK, built by James Simpson & Co of Newark, which worked at Waddon until retired in 1983, is preserved in the Steam Hall. It was restored by volunteers in 1990.

An elegant tower topped with a cupola stands over the museum and many suppose it to be a chimney. But the tower, built in Italianate campanile style, is a standpipe, housing columns of water in massive pipes to manage the pulsations generated by the beam engines. This buffering effect maintained constant pressure at the mains and a

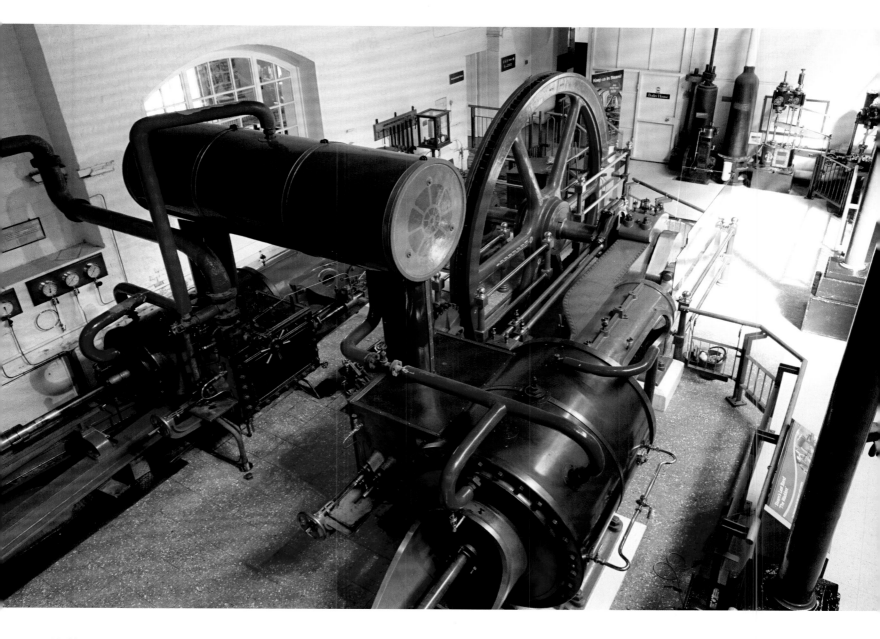

Waddon Pumping Station at Croydon was home to this engine, the last to operate at a waterworks in Britain, now in the former boilerhouse at Kew.

constant load for the engines to push against, protecting both parts of the system in case of failure.

Narrow-gauge railways were a common feature at many water works, and Kew once had a modest hand-pushed rail system to service its filter beds. A railway around the garden at Kew was opened in 2009, with a steam locomotive in the spirit of a typical water works system.

From 1974 until 2013, with the emphasis on the engines, this was known as Kew Bridge Steam Museum, but in 2014 it was reopened under the name London Museum of Water & Steam. It has a much wider focus, including the supply of water to London past and present, with exhibitions showing how cholera was eliminated from the water supply, and a display of wooden water pipes explaining the use of trunk mains and branch pipes. People who enthuse about steam engines may outnumber enthusiasts who follow the supply of water, but the revised museum has enhanced its appeal to a new generation of young visitors with its educational interactive exhibits.

VISITING INFORMATION

London Museum of Water and Steam, Green Dragon Lane, Brentford TW8 0EN

http://www.waterandsteam.org.uk

Open daily 11am–4pm.

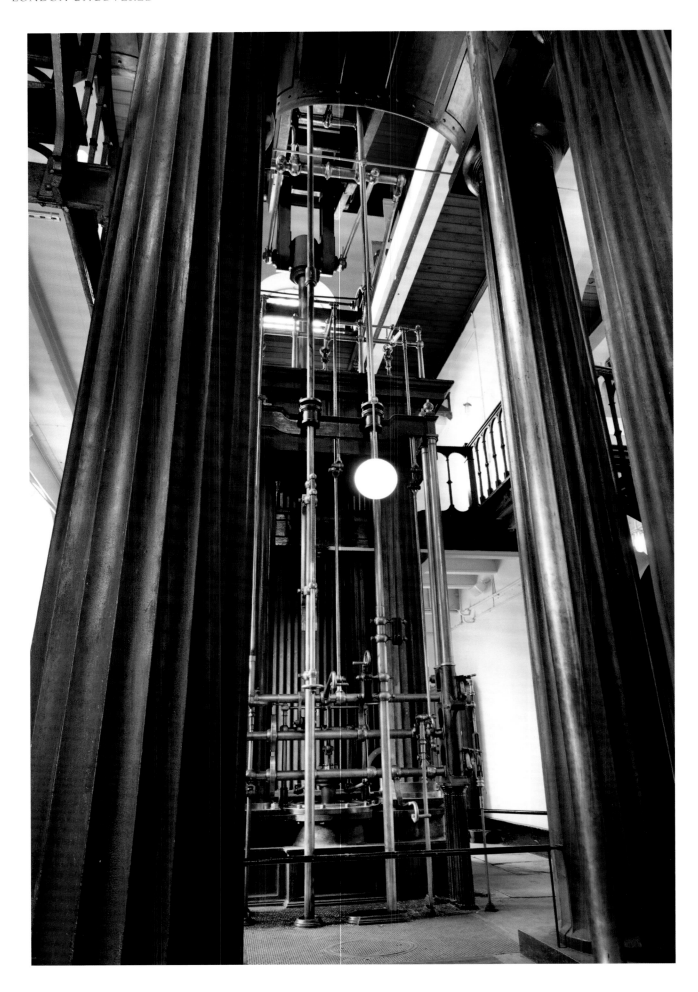

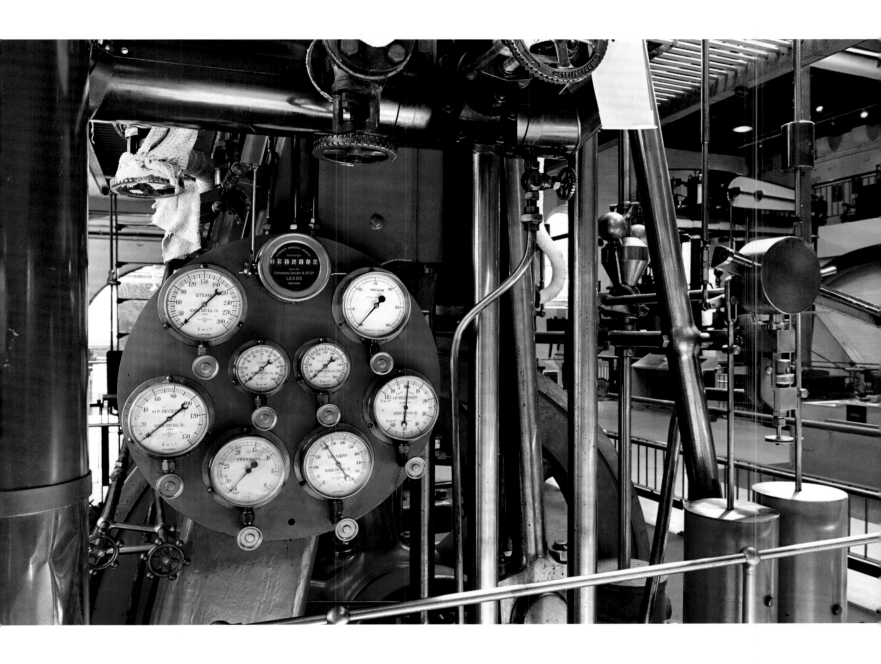

ABOVE *The gauge panel on a rare Hathorn Davey triple-expansion engine.*

OPPOSITE *The Cornish beam engine rises 40 feet through three storeys.*

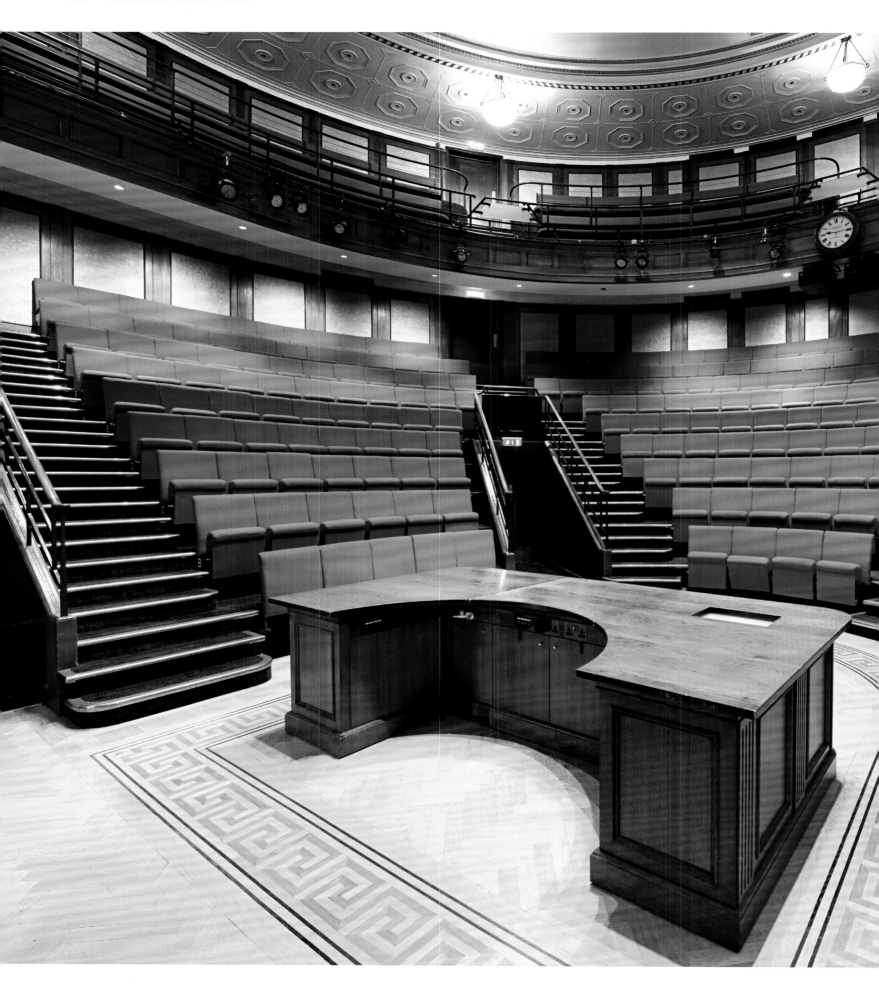

Royal Institution of Great Britain

The Faraday Lecture Theatre at the Royal Institution lies at the core of its purpose, which is to bring the knowledge of science to the public, a mission statement declared at its founding in 1799.

The Royal Institution was partly rooted in a spirit of philanthropy shared by a group of fifty-eight influential and wealthy men in late Georgian society. It was also inspired by an understanding that applying greater technical knowledge could reap advantages for society. At that time, war with France made trading with continental Europe difficult. The founders of the RI included only one man who could be described as a scientist: Henry Cavendish, the discoverer of hydrogen. The others were landowners, early industrialists, colonialists, a politician or two, and military officers. They saw that 'promoting the application of science to the common purpose of life' might gain an advantage for the nation and undoubtedly their own interests. From the start, lectures were intended to be a main instrument of the Institution and, after the acquisition of No. 21 Albemarle Street – a brick terraced house only one room deep with a long frontage – a theatre was built on one side and completed in 1804.

The lecture theatre occupies a space between the first and third floors. It is a steeply raked semi-circular amphitheatre based on the designs of anatomy lecture theatres of European hospitals. In 1846, more than 1,000 people gathered in this space to hear Michael Faraday talk about magnet-optical effect and diamagnetism. The theatre has since been rebuilt twice, firstly after an explosion in a electricity sub-station in Albemarle Street in 1927 exposed some dangerous features

The lecture theatre is home to the famous Christmas lectures. The seating is modern and the horseshoe demonstration desk is a replica, but this is the original space of 1804, and the spot where Davy, Faraday and hundreds of other leading scientists have delivered lectures.

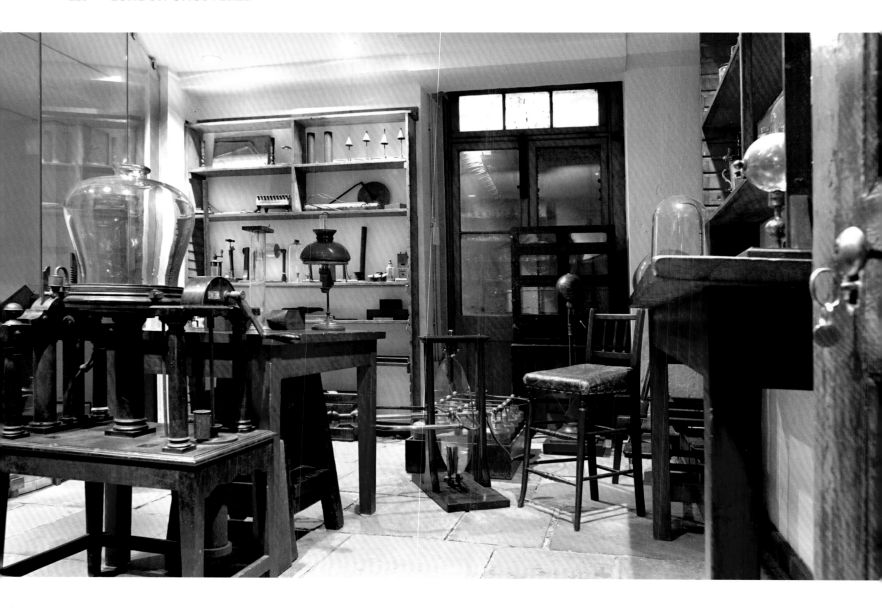

All the objects here in Faraday Laboratory, except the oil lamp, were used by the scientist, including the electric motor, homopolar generator and a large electromagnet made by winding wire around the link of a ship's anchor chain: the most powerful magnet in the country at the time.

in its original construction, and again in 2005–8, when the Royal Institution was extensively remodelled to the design of Terry Farrell. It is been estimated that more than 25,000 lectures have been delivered from the theatre.

Today, the capacity of the theatre and gallery is 450. It is air-conditioned and equipped with a modern audio-visual suite, but the original plan and layout of the theatre has been retained. During redecoration in the 1870s, when the oriental style was in vogue, Japanese moulded wallpaper was applied to curved panels behind the main theatre and gallery. The embossed paper was found to contribute positively to the acoustic quality of the theatre and was retained, requiring extensive conservation work during the latest restoration. The desk at the centre, where many spectacular experiments have been demonstrated, is a reproduction of an original, at least the fourth copy since Humphry Davy's time.

Davy, a young Cornishman appointed Professor of Chemistry in 1802, was the first star of the Institution. He established a series of lectures that generated great public interest, with so many carriages delivering people to the Institution on lecture evenings that a one-way system had to be established in Albemarle Street, the first in London. Davy isolated the elements sodium, potassium, barium, calcium, magnesium and strontium here. Michael Faraday, inspired by Davy's lectures, was first employed as a chemical assistant in 1813. He was destined to become perhaps the learned society's most famous scientist, discovering electromagnetic induction, the principle behind the electric transformer and generator. Between 1827 and 1860, Faraday gave a series of nineteen Christmas lectures

in the theatre, a lecture series which continues today.

The laboratory where Michael Faraday made his discoveries surrounding electromagnetism is preserved in the lower ground floor and is the heart of the Faraday Museum. It had been a servants' hall, but Faraday requisitioned the room in the 1820s for his own research. He used the dumb waiter as a store for his experiments and traces of this remain today. As the room is set under the main part of the building, there is little natural illumination, which made it well-suited to experiments with beams of light. After Faraday's death in 1867, the laboratory became a store and gathered dust for many years. The arrangement of the room today is based on a painting dating from the 1850s.

The original building has been developed, rooms added and enlarged several times. In 1838, architect Louis Vulliamy added an imposing neoclassical façade of fourteen three-quarter round-fluted Corinthian columns. The columns were designed to raise prestige rather than support the roof. In 1895, the freehold of neighbouring No. 20 was gifted to the Royal Insitution by Ludwig Mond, a wealthy industrialist and chemist, and joined with the original house. Mond endowed the Davy-Faraday Research Laboratory in the extended facilities. For more than 100 years the laboratory has carried out a wide range research, including X-ray crystallography and solid state chemistry. In 1998, the directorships of the Royal Institution and Davy-Faraday Research Laboratory were separated.

The Royal Institution of Great Britain has been home to the discovery of ten elements and fourteen Nobel prizes have been awarded to individuals associated with it.

VISITING INFORMATION

The Royal Institution of Great Britain, 21 Albemarle Street, W1S 4BS

http://www.rigb.org

Open 9am–6pm Monday Friday.

Sometimes closed for private events.

The library, with its Regency gilt mirror, which has hung over the fireplace in this position since 1840.

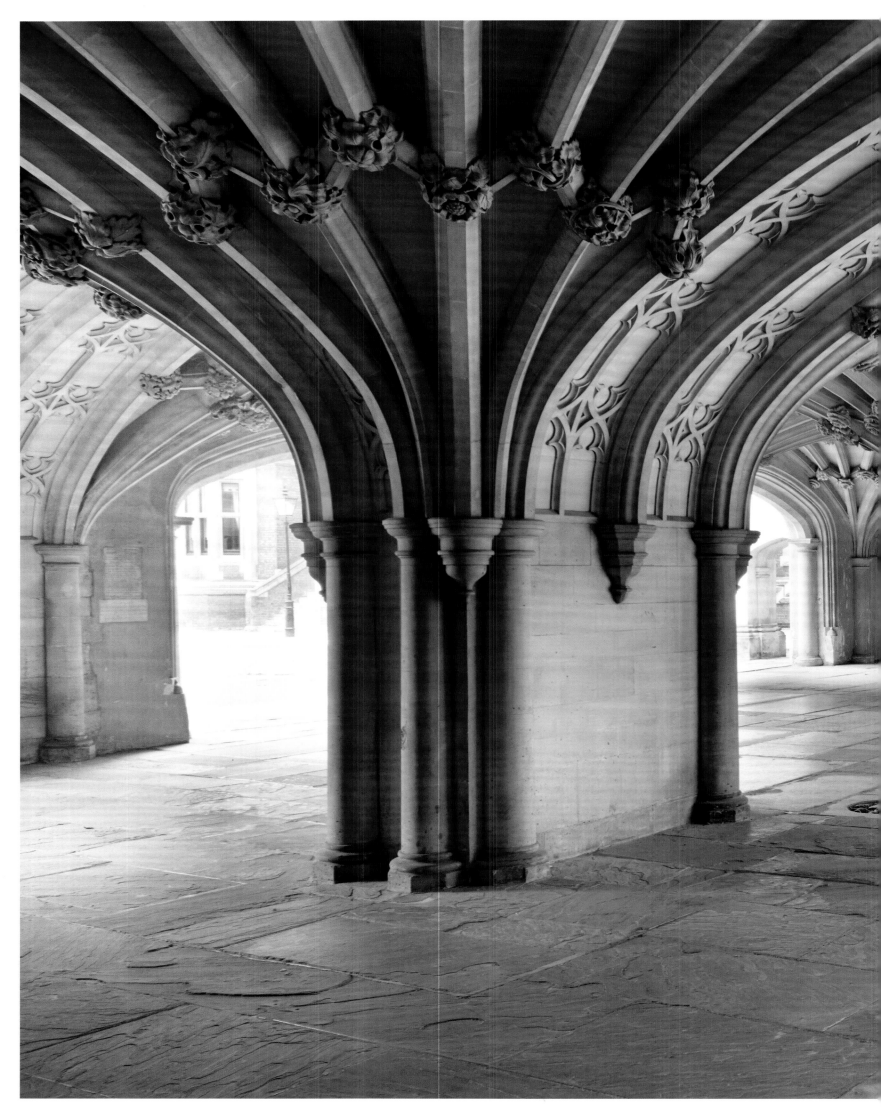

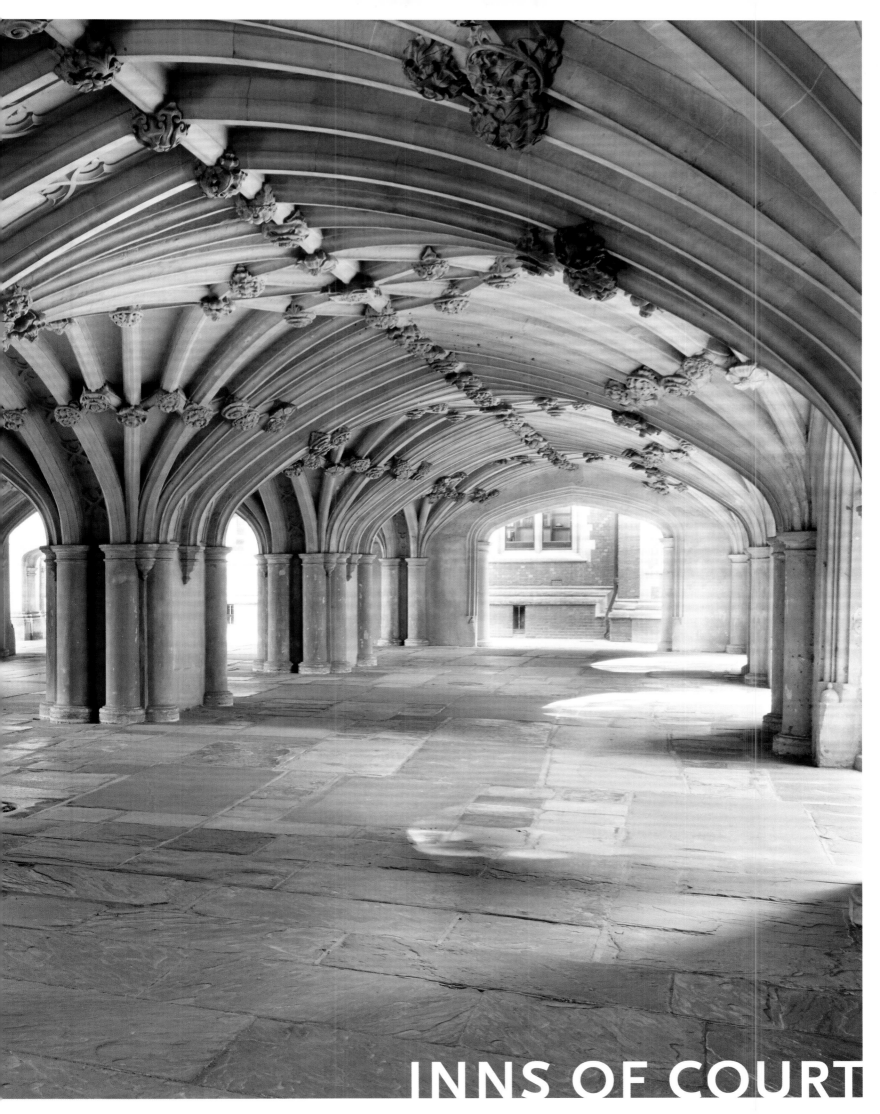

INNS OF COURT

The Honourable Society of Lincoln's Inn

London's four Inns of Court – the Honourable Societies of Lincoln's Inn, Gray's Inn, Middle Temple and Inner Temple – are the professional associations for for all barristers in England and Wales, each with a long hisory. The Lincoln's Inn sits behind a fine brick wall on Chancery Lane, and it is easy for visitors to go inside the precincts around the squares and gardens. The group of buildings comprising Lincoln's Inn span more than 500 years, from Tudor through Georgian to mid-Victorian Tudor Revival. To enter the main buildings – the Great Hall, Old Hall and Library – it is necessary to book a tour and set aside some time, for there is plenty of history to be unlocked.

Lincoln's Inn began as a legal centre in around 1311, when Henry de Lacy, 3rd Earl of Lincoln bequeathed it to London's legal fraternity. Thomas More was a student there between 1496 and 1502. The Old Hall of Lincoln's Inn would have been known to More, and much of the stone and brick of the fabric visible today dates from that time. The Hall was enlarged in the seventeenth century, with an internal wooden screen added. Later work was ill-judged, particularly the addition of an eighteenth-century plaster ceiling over the fine timbers supporting the roof, which together with other alterations, weakened the walls. Between 1924 and 1928 it was painstakingly rebuilt, removing the plaster barrel vault, and restoring the interior to something closer to its original appearance. The Old Hall was regularly used as a functional courtroom, notably as a court of chancery before the Royal Courts of Justice opened in 1882.

The next oldest part of Lincoln's Inn is its Gatehouse on Chancery Lane, built between 1517 and 1521. It is a four-storey tower with diagonal lines of inky brick, and its oak gates date from 1564. It was the brainchild of Sir Thomas Lovell, a

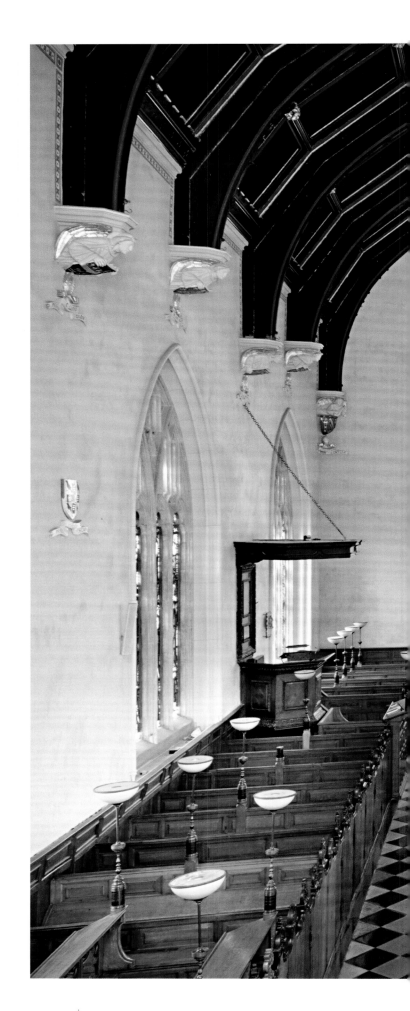

PREVIOUS PAGE *The fan-vaulted undercroft of Lincoln's Inn Chapel.*

RIGHT *The Chapel dates back to 1620, but has seen many repairs and restorations.*

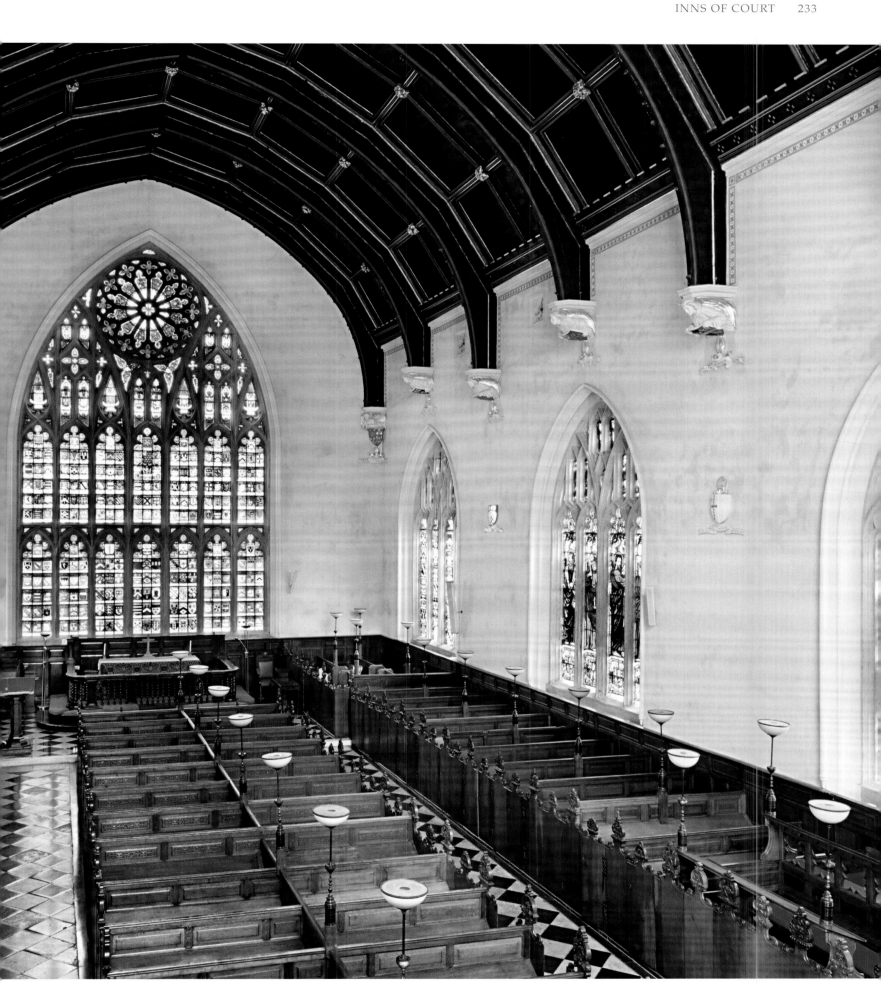

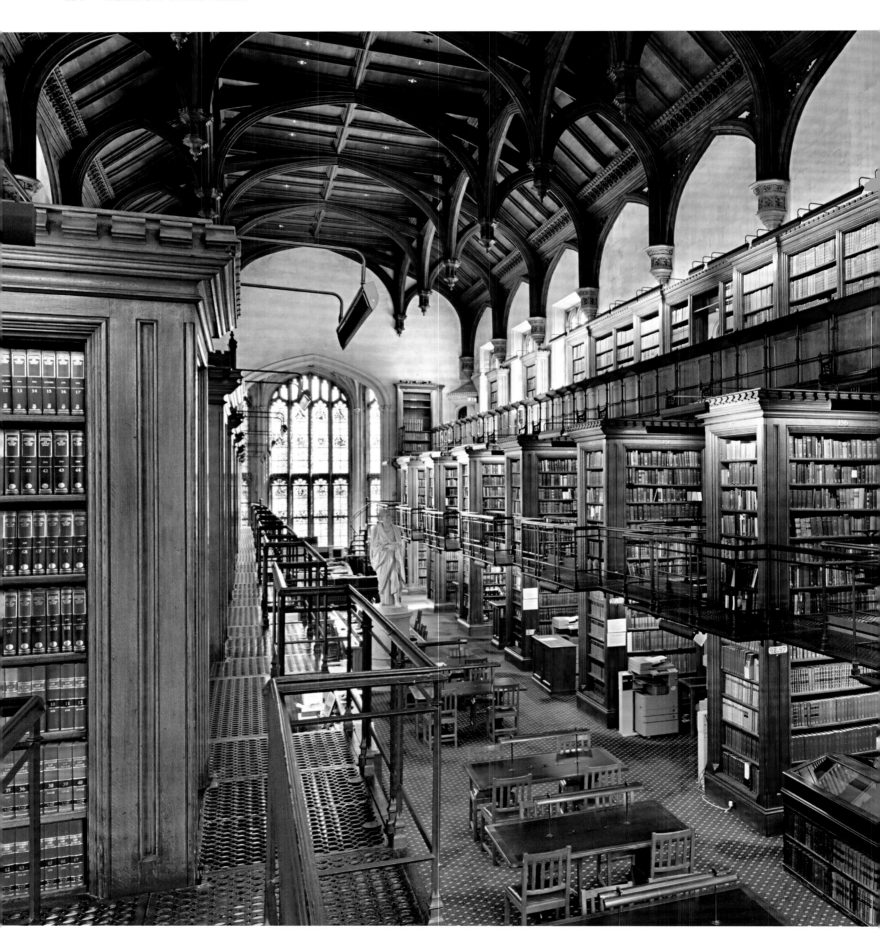

Lincoln's Inn Library is claimed to be the oldest library in continuous use in London.

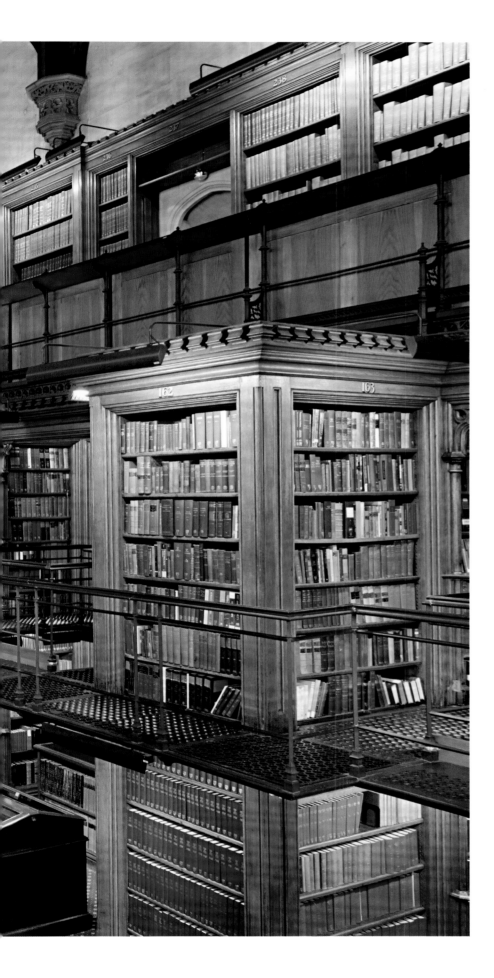

Lincoln's Inn treasurer and veteran of the Battle of Bosworth Field, who supervised the construction, and paid the bill. Lovell's coat of arms adorns the gatehouse, alongside those of Henry VIII, and the 3rd Earl of Lincoln, whose dragon insignia carried particular status, being rendered in purple, a costly colour in Tudor times.

In the nineteenth century, membership of Lincoln's Inn had greatly expanded, and a new dining hall was constructed. Known as the Great Hall, or New Hall, it was designed by architect Philip Hardwick, whose initials are etched into the brickwork. The foundation stone was laid in 1843, and the hall was opened two years later by Queen Victoria. It incorporated a new main entrance gatehouse on Serle Street. Dominating the north wall of the hall is a vast fresco whose title is *Justice*, by George Frederic Watts, with depictions including Moses and Confucius, while Norman Hepple's oil painting *Short Adjournment* is a tribute to an era when the majority of Court of Appeal judges were Lincoln's Inn members.

The Honourable Society of Lincoln's Inn claims that its collection of books is the oldest library in continuous use in London. Lincoln's Inn Library was first mentioned in 1471. The present library building, an iron-galleried masterpiece, is part of the mid-nineteenth-century building works. It contains 150,000 volumes. As well as housing a unique collection of rare books, it is also a functioning modern legal library, and the only Inns of Court library to survive Second World War bombing.

Stone Buildings, a set of lawyers offices known as chambers, was constructed during the 1770s in the distinct style of the time, contrasting with the red brick elsewhere. Although Lincoln's Inn was more fortunate than the other Inns of Court during the war, Stone Buildings was hit and badly damaged, and this damage was subsequently repaired. A rare London relic is a remaining mark of the first Blitz, as the front of No. 10 Stone Buildings still shows considerable damage inflicted during an air raid of December 1917. A disc, set into the road outside, marks the spot where the bomb exploded.

An early Lincoln's Inn Chapel is first mentioned in records from the reign of Henry VI;

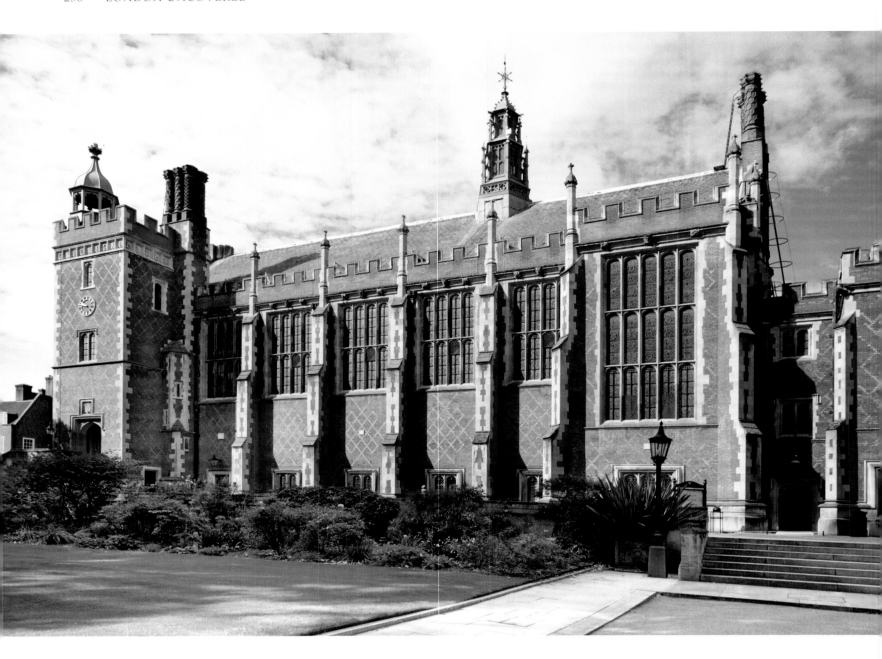

ABOVE *The Great Hall, or New Hall, designed by Philip Hardwick, was opened by Queen Victoria on 30 October 1845.*

OPPOSITE ABOVE *The Old Hall was used as a functioning courtroom.* OPPOSITE BELOW *Portraits and crests adorn the walls of the Great Hall.*

the foundation stone of its successor was laid by John Donne, poet and priest, and Preacher of Lincoln's around 1620. The stained glass in the south window pictures the Apostles, and is attributed to the Van Linge brothers. The chapel also displays colours of the Inns of Court Regiment. The vast space of the Chapel's seventeenth-century fan-vaulted undercroft, where benchers and members were once laid to rest, is a place where today's bewigged and gowned barristers pause to chat.

The Chapel bell, which is tolled at noon whenever a bencher dies, was reputedly immortalised by John Donne in the line 'therefore never send to know for whom the bell tolls; it tolls for thee'. Harder still to prove is the legend that playwright Ben Jonson worked as a young man as a bricklayer on the wall and gatehouse, but Lincoln's Inn does not need to scratch around for history. Notable members have included Walpole, Pitt the Younger, Gladstone, and Margaret Thatcher, fifteen Prime Ministers in all.

VISITING INFORMATION

The Honourable Society of Lincoln's Inn, WC2A 3TL

http://www.lincolnsinn.org.uk

Precincts open 7am–7pm Monday–Friday.

For tours of the buildings, email gina.roberts@lincolnsinn.org.uk.

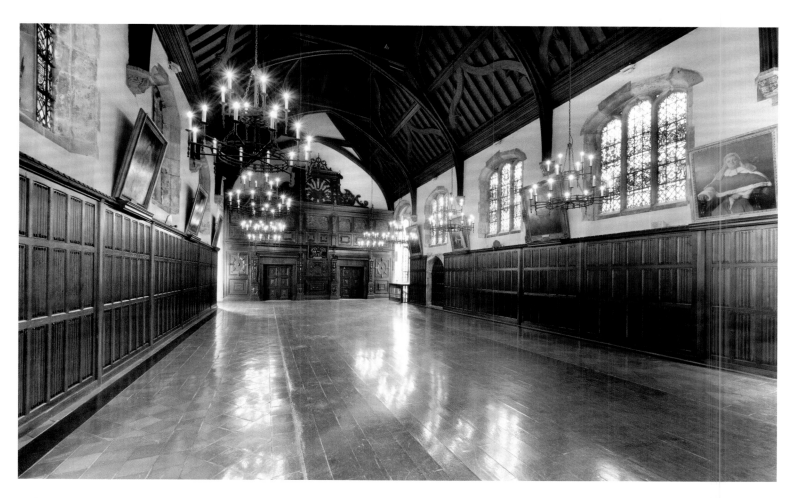

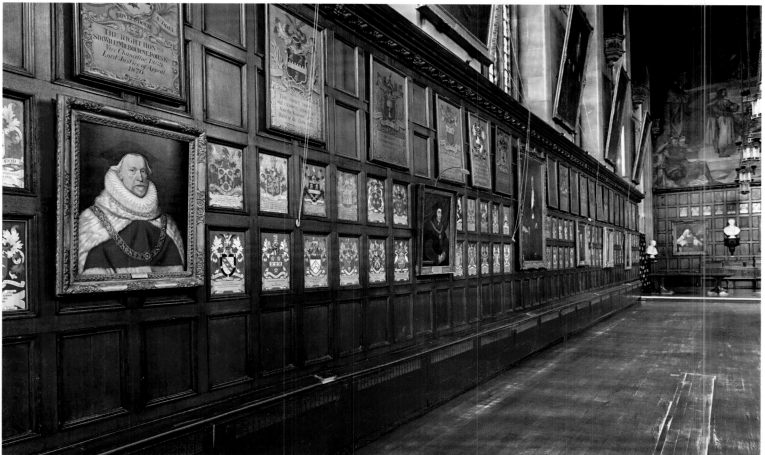

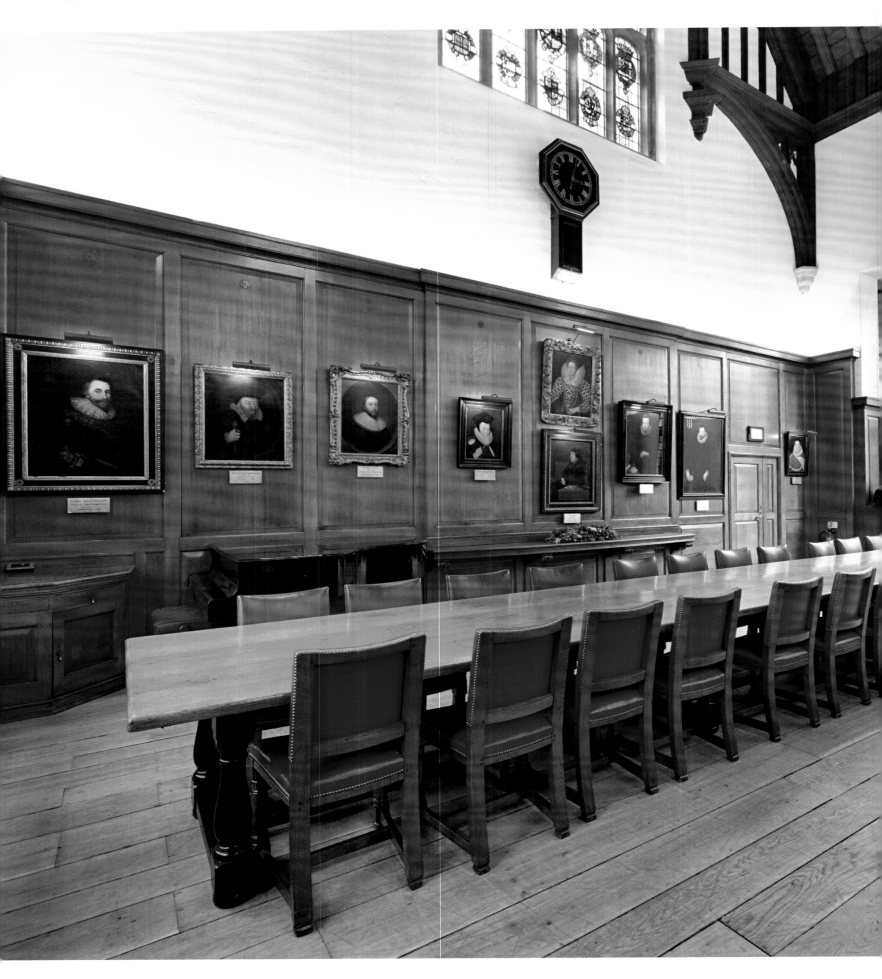

The Honourable Society of Gray's Inn

The Honourable Society of Gray's Inn, on the busy intersection of Gray's Inn Road and High Holborn, is the smallest Inn of Court. The main buildings form two squares – Gray's Inn Square and South Square – with other ranges to the west and north round the gardens, known as the Walks. Its origins lie in an estate and manor owned by Reginald de Grey (or de Gray). A close friend of Edward I, soldier, judge and High Sheriff of Nottingham, he was a scion of a noble family of power brokers. At some point, no later than 1370, the de Grey family leased the estate's manor house to lawyers, who lodged and educated students, and the Honourable Society of Gray's Inn came into being.

As medieval England passed into the golden age of Elizabeth I, Gray's Inn thrived. Members included William Cecil, 1st Baron Burghley, Elizabeth's chief advisor, Francis Walsingham, her spymaster, and Lord Howard of Effingham, the Lord High Admiral and victor of the Spanish Armada. Queen Elizabeth herself was a patron. As the favoured Inn of her court, it was strongly politicised. Diego Guzmán de Silva, Spanish ambassador to Elizabeth's court, saw Gray's Inn as a pit of anti-Catholic sentiment.

It was also a place of learning. Nicholas Bacon, Lord Keeper of the Great Seal, along with Francis, his son, a renowned scientist, statesman and jurist, were leading members. Another member, Henry Wriothesley, 3rd Earl of Southampton, gave patronage that enabled the promising young William Shakespeare to flourish as playwright and actor. Indeed, the Inn hosted an early, possibly the first, performance of *The Comedy of Errors* in Hall on 28 December 1594, at which Shakespeare himself may have been present.

The heart of Gray's Inn lies in its red brick Hall, on the site of the old manor house. The earliest surviving record of it mentions reconstruction and refurbishment between 1556 and 1560 at a cost of £863. A panelled chamber used as a ceremonial centre and refectory, 'Hall' (as it is known) is crowned by a hammer-

The high table stands at the eastern end of Hall.

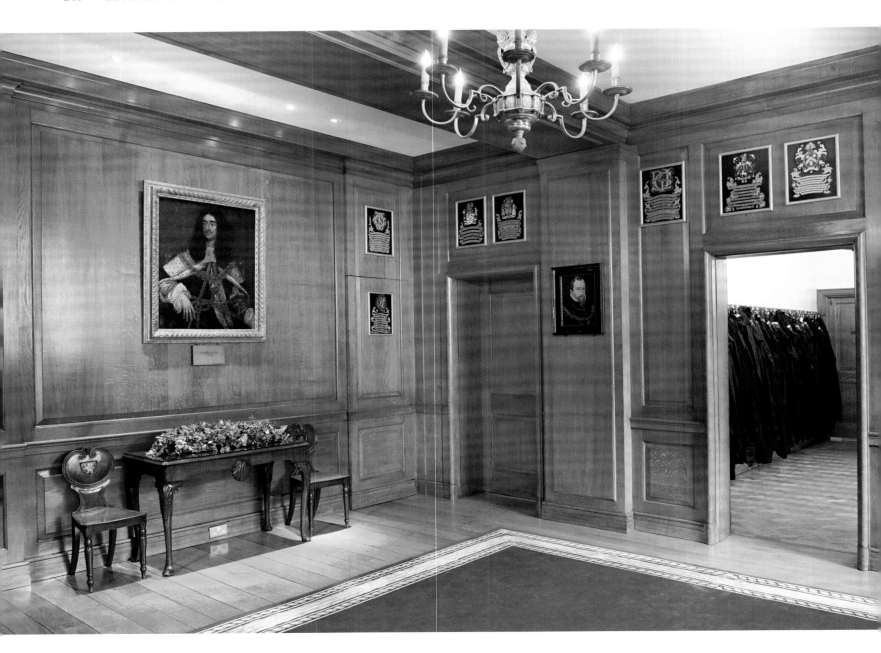

The benchers' entrance of Hall.

beam roof described as 'the most spectacular endeavour of the English medieval carpenter'. The vaulted gothic woodwork of its main body stands in contrast to a massive ground-level wooden screen of carved chestnut, reputedly a relic from a captured galleon of the Spanish Armada. At the top end of Hall, standing upon a dais, is a vast oak dining table, whose dark wood is illuminated by stained-glass windows, one dated 1462, emblazoned with the arms of Burghley, Bacon and many others, while the walls carry portraits of Elizabeth I, Nicholas Bacon and others, and wooden panels displaying the arms of Treasurers.

While Gray's Inn Hall survived the religious turbulence of the sixteenth and earlier seventeenth centuries, the Inn underwent a prolonged period of decline. In the late-seventeenth century it suffered three disastrous fires, one of which destroyed the library. At this time, qualification for the Bar depended on eating a number of dinners in Hall and the recommendation of a judge. Standards were finally raised in the nineteenth century and the Call to the Bar examination was introduced in 1872.

The Hall and other buildings in Gray's Inn Square and South Square were almost wholly burnt out in the massive incendiary attack of 10–11 May 1941, the final night of the Big Blitz. The paintings, stained glass and heraldic panels had already been moved to a place of safety, but the Armada Screen, although it had been dismantled for moving,

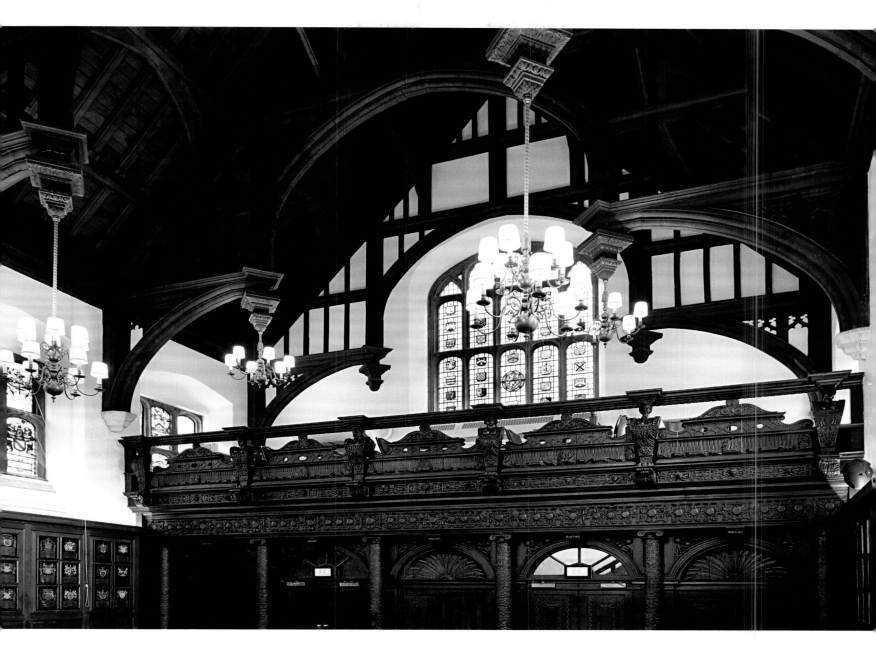

The Armada Screen in Hall, reportedly carved from a captured Spanish galleon.

remained in the Hall. Firemen braved falling timbers and molten lead to drag the sections to safety. After the end of the war, a new Hall, designed by Edward Maufe, architect of Guildford Cathedral, was opened by the then Duke of Gloucester in 1951, and Maufe was elected an Honorary Bencher.

Gray's Inn Chapel stands where a place of worship has existed since at least the reign of Edward II. By 1539, with the Reformation in full swing, Pension (the governing body of Gray's Inn) removed the stained glass image of Thomas à Becket from the Chapel windows, out of obedience to Henry VIII. The Chapel was rebuilt during the late seventeenth century. In 1893, the building was restored in the late gothic style, but destroyed by enemy action in 1941. The present building is also to the design of Edward Maufe, and contains an east window celebrating the lives of four archbishops, members or preachers of Gray's Inn, namely, Whitgift, Juxon, Laud and Wake, with, in less fractious times, Becket restored.

VISITING INFORMATION

The Honourable Society of Gray's Inn, 8 South Square, WC1R 5ET

https://www.graysinn.org.uk

Open 6am–8pm Monday–Friday; gardens open 12pm–2.30pm Monday–Friday.

Tours of the buildings are available through Open House London:

http://www.openhouselondon.org.uk

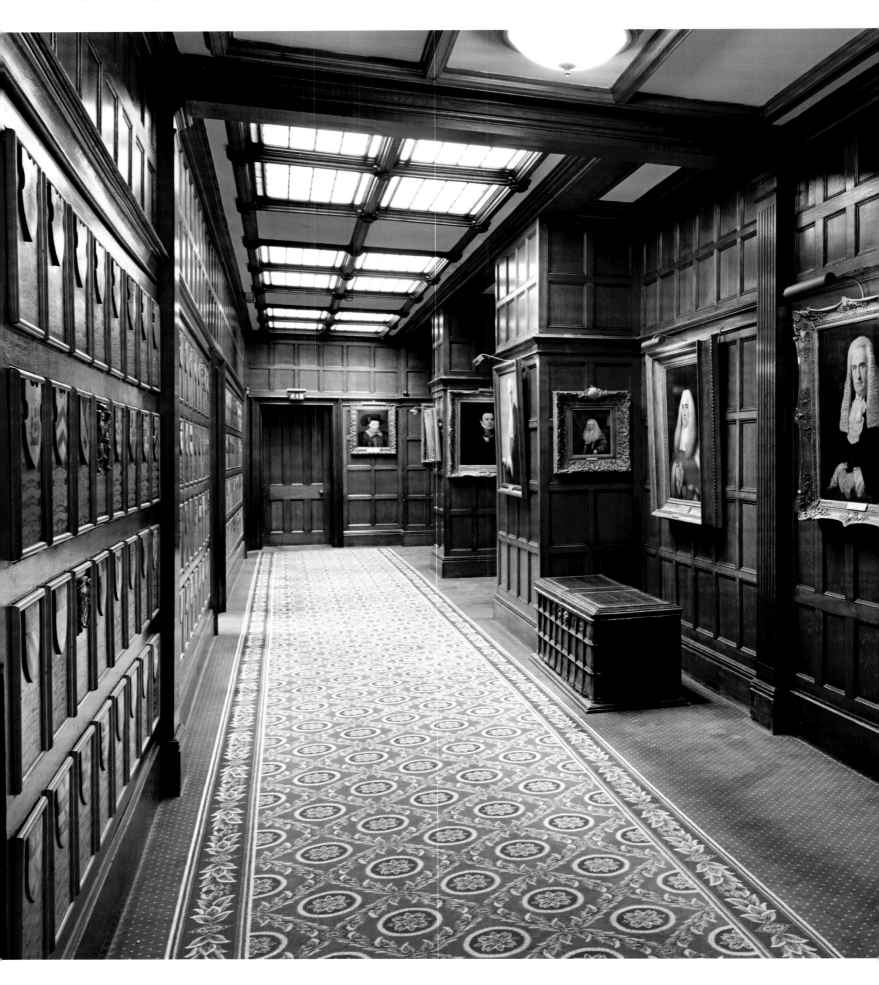

The Honourable Society of the Middle Temple

A walk south from where Strand meets Fleet Street takes a visitor through some of the most pleasing and peaceful territory in London – the Temple – comprising two Inns of Court and an ancient church. The division between the Inner Temple and Middle Temple runs along Middle Temple Lane. Temple Church belongs to and is maintained by both these honourable Societies. Courtyards of the Inn grounds are open during the day for varying periods during the year. This is at the discretion of the individual Inn, as the precincts are classified as private with public access, but it is generally possible to walk through at reasonable times. To visit the buildings of these Inns of Court, it is necessary to pre-book a tour.

The Temple was once a headquarters of the English Knights Templar, and lawyers associated with the Knights had occupied parts of the area. That organisation was dissolved in 1312, and rights to the Temple devolved on to the Knights Hospitaller, who were in turn closed down by Henry VIII in the Reformation. The barristers remained and gained the tenure of Temple from a charter granted by James I in 1608.

The charter gave sole use of the land to house and educate lawyers and preserved some privileges inherited from the Knights Templar, including independence from neighbouring authorities. This still applies in the twenty-first century, enabling both Temples to enjoy the unique status of extra-parochial area, functioning as a local authority outside the City of London's civil jurisdiction and outside the Bishop of London's ecclesiastical authority.

Although occupying the same space, it seems that the two Inns were distinct bodies long before formal separation in 1732, and it is possible to see either the Middle Temple's Lamb

Carved coats of arms and portraits of members and barristers of the Middle Temple.

The Lamb and Flag is the emblem of the Middle Temple.

and Flag emblem or the Inner Temple's winged horse Pegasus at various places around the courts.

The Inns survived the Civil War in England, having members on both sides of the conflict, but legal education fell into abeyance when Middle Temple closed for four years. The buildings of the Middle Temple were spared London's Great Fire in 1666. The fire abated just yards to the east.

A number of idealistic Middle Temple barristers sailed to the Americas in search of Arcadia, five of them signing the American Declaration of Independence. In the twentieth century, women were first called to the Bar of England and Wales, including Barbara Calvert, first female head of chambers, and Patricia Scotland, first female Attorney-General.

Hammer-beam ceilings attract much attention in architectural guides, and Middle Temple Hall possesses an example that is particularly impressive. Short straight beams and curved collarbeams are stepped up into the roof. This process is repeated, making it a visually complex double-hammer-beam, giving greater height, and generating a greater sense of space. It supports the claim that Middle Temple is the finest Elizabethan hall in England.

Dating from 1562, Middle Temple Hall lies in the heart of the Inn. Historical fact and legend rub shoulders here. There is solid evidence that Shakespeare's *Twelfth Night* was performed in Hall on 2 February 1602, most likely its premiere. Less certain is the legend attached to the high table, which is reputedly a gift from Elizabeth I. It was constructed from twenty-or-so oak planks cut from a single oak in Windsor Great Park, and floated down the Thames. Still in use today, it was in place in 1586, when a triumphant Francis Drake, flushed with success in the Spanish West Indies and North America, was cheered in Hall by the benchers and members. The *Golden Hind*'s hatch cover is said to have been used to construct what is called the 'present' cupboard, a table standing below the benchers' table, on which rests the book signed by barristers newly called to the Bar. As with the other Inns of Court, Hall's windows commemorate famous members,

The library, displaying its prized Elizabethan globes.

who include the explorer Raleigh, while panelled walls are adorned with members' coats of arms dating from 1597.

A Tudor library once existed here, but its shelves were reduced by theft. Re-established in the seventeenth century as a chained library, the collection grew to include 250,000 textbooks, law reports, journals and parliamentary papers, plus volumes on topography, geography and theology, and a 1571 biography of Columbus penned by his son. In 1861, Edward, Prince of Wales, later Edward VII, opened a new library building in 1861, but this was damaged beyond repair in the Second World War. Sir Edward Maufe, architect of Guildford Cathedral, designed the current library, completed in 1958.

The library today displays on its upper floor two Elizabethan globes, by Emery Molyneux, possibly the first to be made in England. One is the terrestrial and the other celestial. They were based on the most accurate mappings and projections of the day and the terrestrial globe was updated in 1603 to include the latest discoveries of Raleigh.

VISITING INFORMATION

Middle Temple Hall, Middle Temple Lane, EC4Y 9AT

http://www.middletemplehall.org.uk

The grounds are open to the public. Tours of the buildings may be booked online.

The Honourable Society of the Inner Temple

There is a marvellous feeling of enclosure about the Inner Temple, which is completely hidden behind Fleet Street and separated from the noisy Victoria Embankment by an extensive garden. Although this Inn of Court has two distinct gateways, according to tradition its main entrance has always been on Fleet Street. It is easy to miss the archway under a Jacobean house at No. 17. The house does not belong to the Inn, but the pathway does, and it leads first to Temple Church and then opens out to the Inner Temple.

While the buildings of the Honourable Society of the Inner Temple today carry a powerful sense of history, the relatively pristine look of much of the fabric needs explanation. Most of the Inner Temple comprises post-Second World War buildings or structures, described as reinstatements. A bomb damage map compiled by London County Council between 1940 and 1945 shows more than half the array of Inner Temple's buildings marked purple, meaning 'damaged beyond repair' and most of the others denoted in red as 'seriously damaged, doubtful if repairable'. Over a period of four years its buildings had suffered hits from high-explosive incendiaries and blast damage from a V-1 flying bomb; rebuilding took thirteen years.

A senior former bencher has described the Inn of the 1930s as 'grubby, sooty . . . marvellous Victorian buildings', with certain small courtyards now disappeared. The changes before then and since have been numerous, and the precise antiquity of buildings should perhaps be set aside. In the nineteenth century, much of Inner Temple had been rebuilt. By then, the Hall was an 1870 gothic design, with stained glass showing episodes of English history, and a huge window depicted Queen Victoria surrounded by four Virtues representing Government and Law.

The Inner Temple Hall is one of the very few Georgian-style banqueting halls in the City of London.

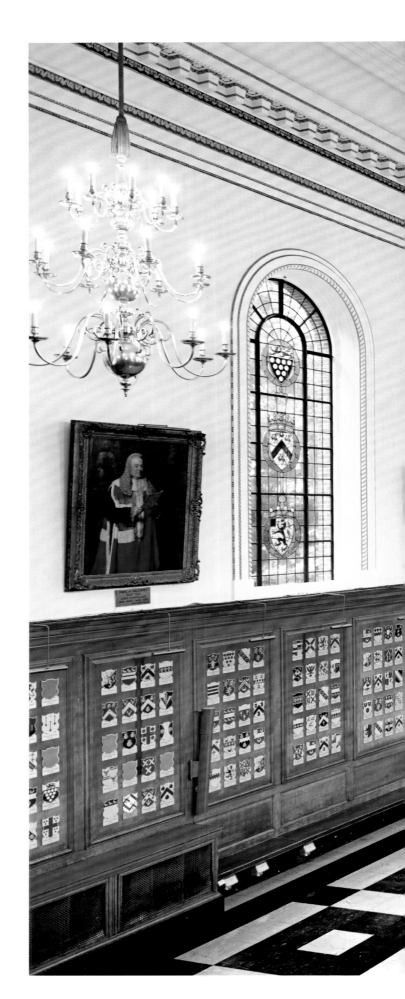

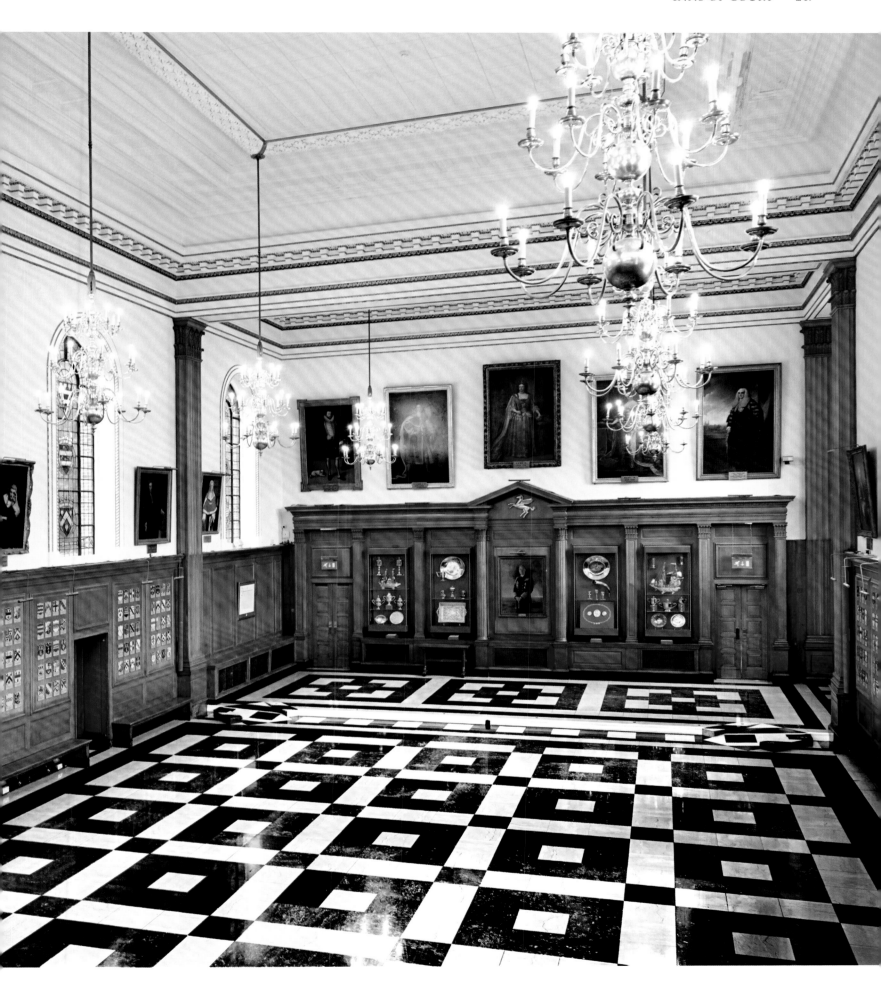

ABOVE *Robing hooks inside the benchers' entrance at Inner Temple. Lady members who are benchers are still known as 'Master'.*

OPPOSITE ABOVE *The Parliament Chamber.* OPPOSITE BELOW *A secret ballot box, adorned with the Pegasus emblem of the Inner Temple.*

At the west end of Hall, two Elizabethan doors, supposedly remnants of a carved screen erected in 1574, stood beside bronze statues of Knights Templar and Hospitaller. Nearly everything of the Hall and its contents was destroyed in 1941. At the west end, an old buttery and a crypt with a fifteenth-century fireplace survive from a much earlier structure, the oldest part of the Temple.

The foundation stone of the modern Hall, designed by Hubert Worthington, was laid by Queen Elizabeth II in 1952 and opened in 1955.

It was not until 1958 that a new library was completed to a design in the style of an eighteenth-century room. An earlier library had burned down in the Great Fire of 1666. It was quickly replaced but this had to be destroyed by explosives in 1678 during another fire in order to prevent destruction from spreading throughout the Temple. In 1828 a gothic library followed.

Celebrated members of the Inner Temple who studied in those libraries included Edward Coke, the great Elizabethan /Jacobean jurist, the advocate Sir Edward Marshall Hall,

who saved many from the noose, Lord Rayner Goddard, famously in favour of hanging and corporal punishment, Lord Justice Birkett, a presiding judge at Nuremberg, British Prime Ministers Clement Attlee and George Grenville, with India represented by Gandi (disbarred 1922, reinstated 1988), and Nehru.

To the south of the Inner Temple lies a 3-acre garden, with lawns, herbaceous borders and a collection of rare trees. The garden area was extended when the Thames was pushed back by the new Victoria Embankment in 1870. The Royal Horticultural Society Great Spring Show was first held here from 1888 before switching to its current site at Chelsea Hospital in 1913.

VISITING INFORMATION

The Inner Temple, EC4Y 7HL

http://www.innertemple.org.uk

Open 9am–5pm Monday–Friday; gardens open 12.30pm–3pm Monday–Friday.

Tours of the buildings for groups of at least five may be booked by email:

visits@innertemple.org.uk

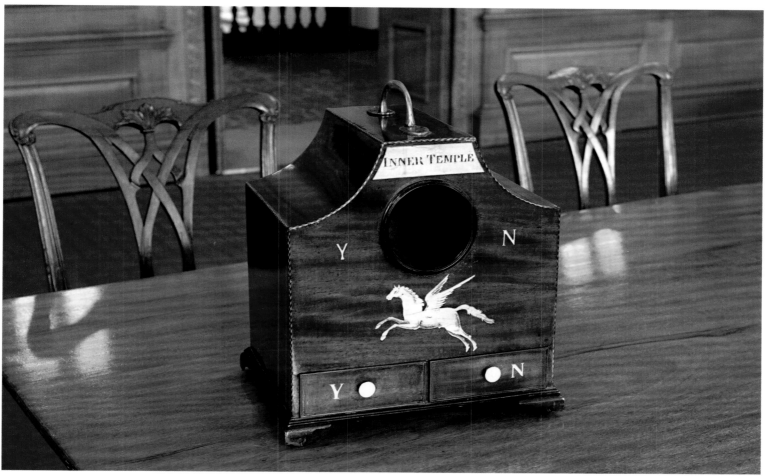

Temple Church

The Temple Church, with all its facets of history, symbolism and myth, surprises visitors today with its well-lit simplicity. It was built to the round design of Jerusalem's sixth-century domed Byzantine Church of the Holy Sepulchre, faithful to the tradition of the Order of the Knights Templar. Circular-naved churches are rare in the British Isles, although not all round churches are associated with military orders. The Temple Church was consecrated in 1185 in the presence of Henry II, England's first Angevin king. It comprises two distinct parts: the original circular building, known as 'the round', which is now the nave, and the rectangular addition on its eastern side, now the chancel, built half a century later, in 1240. The round church, some 55 feet (17m) in diameter, accommodates a circle of Purbeck marble columns. It is likely both Temple Church's walls and gargoyles were initially painted in bright colours.

Temple and its Church were commandeered between 1214–15 by King John – who was then in conflict with both the Pope and the Barons of England – for use as a government office. It was here that he was confronted by the Barons and compelled to ride to Runnymede, where he signed the Magna Carta. William Marshal, 1st Earl of Pembroke, re-issued Magna Carta after John's death to ensure its survival, before being laid to rest here in Temple Church.

During the era of Templar initiation ceremonies, new recruits entered the west door of the round church at dawn, and swore vows of piety, chastity, poverty and obedience to the order. Some of the strangeness and secrecy attached to these Templar ceremonies became the source of interest when an inquisition was launched, contributing in part to its downfall. In 1307, Pope Clement V ordered Christian

'The round' is the oldest part of the Temple Church.

monarchs to arrest the Templars across Europe and to seize their assets, leading to Edward II's control of Temple Church before its transfer to the rival organisation the Knights Hospitaller, and then reversion to the Crown in 1540.

In the 1580s, Temple Church played out the stresses within the Church during what was called the 'Battle of the Pulpits'. Master Richard Hooker preached his Gospel interpretation, a moderate fusion of Anglican/Catholic tenets, whereas Reader Walter Travers took up the austere ideals of Calvin, causing one observer to comment: 'If Canterbury was preached in the morning, come afternoon it was contradicted by Geneva [the headquarters of Protestant reformation].'

Although it was spared serious damage in the Great Fire of 1666 – the maximum westerly spread of the blaze just touched Temple Church – it did receive some revisions by Christopher Wren, including a fine carved altar screen. There were plans to introduce an organ for the first time, but the two Inns of Court could not agree which design of organ to install, and two trial instruments were built. Many organists, including George Frederic Handel, played on them.

The controversy resulted in deadlock and it was decided the choice should be made by the Lord Chancellor, the notorious Judge Jeffreys. Jeffreys, a member of Inner Temple, diplomatically chose the organ designed by Father Smith, favoured by the Middle Temple. Even if honour was satisfied, each of the Inns continued to appoint their own organist for nearly a hundred years until 1814.

The church underwent further restoration in 1841, under direction of architects Sydney Smirke and Decimus Burton, who decorated the walls and ceiling in high Victorian gothic style. Exactly one hundred years later, incendiary bombs set the round church's roof ablaze, with the organ and internal wooden sections destroyed, and the Purbeck marble columns in the chancel cracked in the searing heat.

The church was rededicated in 1958. Much has been changed or restored over 830 years, but the title of the chief priest remains the

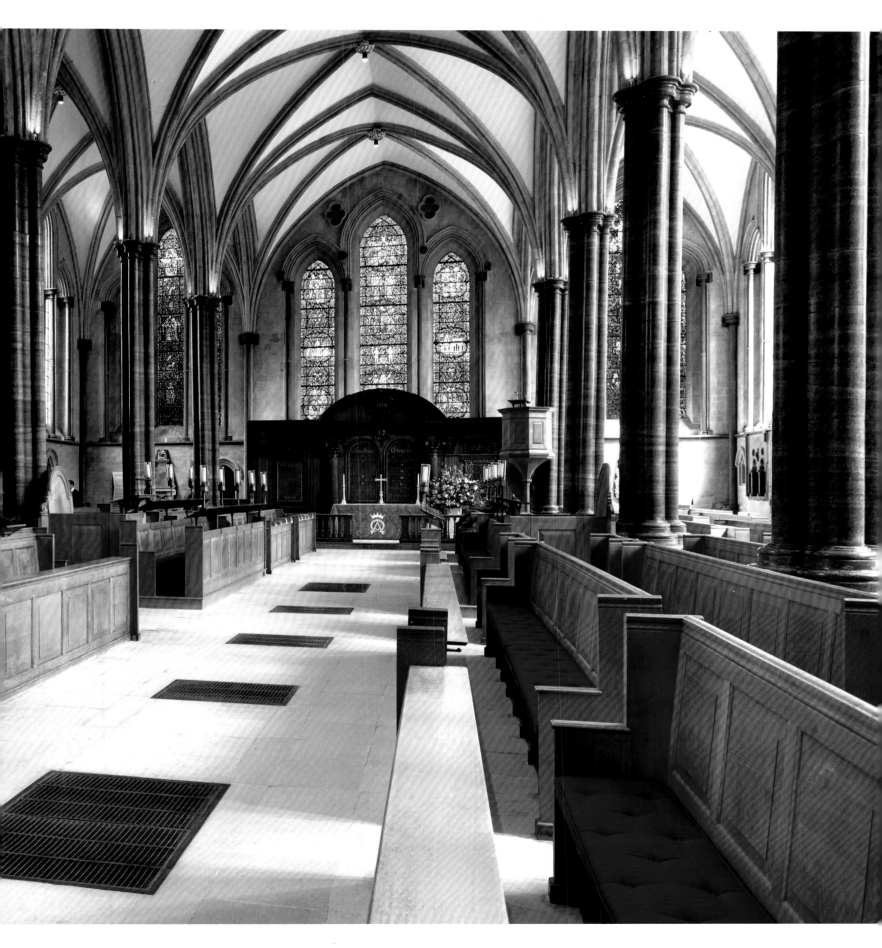

The chancel is a later addition to 'the round' nave, dating from the early thirteenth century.

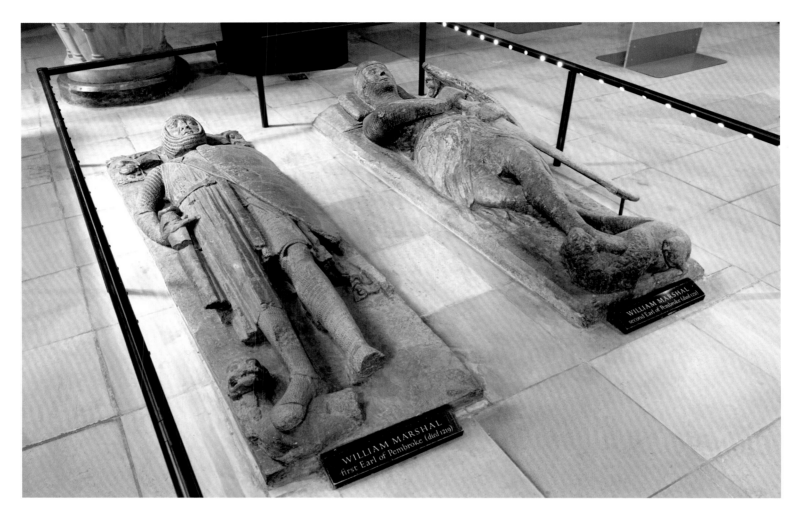

The monument to William Marshall, 1st Earl of Pembroke (left), and the 2nd Earl (right).

Reverend and Valiant Master of the Temple. At Temple Church, the distinctive ground plan has endured and much of the porch of the Norman west door is original stone.

An exceptional stroke of luck enabled the architects of the 1945–58 restoration, Walter and Emil Godfrey, to use the carved reredos designed by Wren (and executed by carver William Emmett). Removed by the Victorian restorers and salvaged, the screen had spent over one hundred years in a museum in County Durham, and it was possible to recover it and refit it in its original position. The marble columns in the round were replaced to their original shape after 1945; their authenticity includes a curious outward lean.

A visitor entering through the south door sees nine marble effigies of martial figures lying on the floor of the round; these include William Marshal, Geoffrey de Mandeville and Robert de Ros, dating from 1227. With the extensive reworking over centuries, these effigies are best understood as monuments rather than as marking tombs, although the men represented were interred nearby. The visible damage to the figures mostly dates from the Blitz, relatively recently restored.

The east window, a gift from the Glaziers' Company in 1954 to replace glass destroyed in the war, shows Christ's connection with the Temple at Jerusalem. In one panel he talks with the learned teachers, in another he ejects the money-changers. The window also pictures some of the people associated with Temple Church over the centuries, including Henry II, Henry III and several of the medieval Masters.

VISITING INFORMATION

Temple Church, Temple, EC4Y 7BB

http://www.templechurch.com

Open weekdays only. Check online for times and entrance fees.

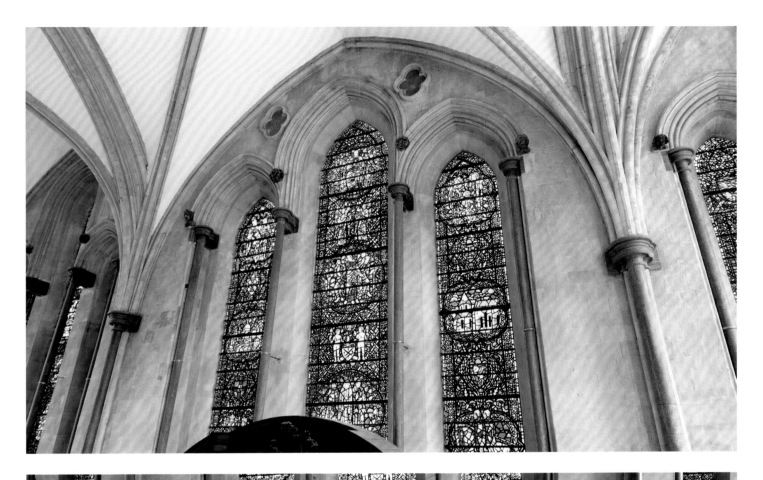

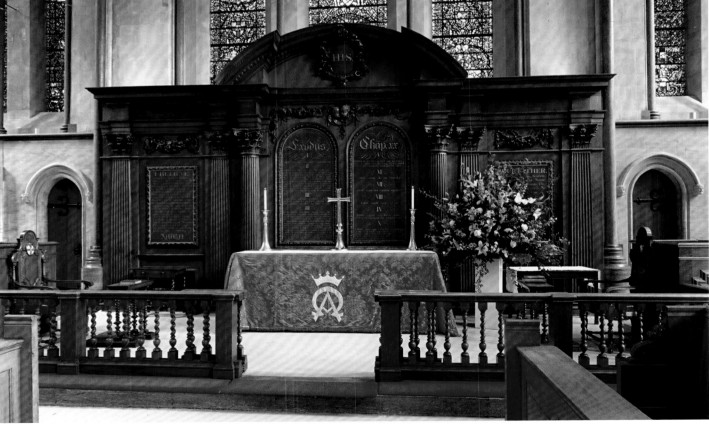

Stained glass and altar at the eastern end of the church. The restored altar screen was designed by Sir Christopher Wren.

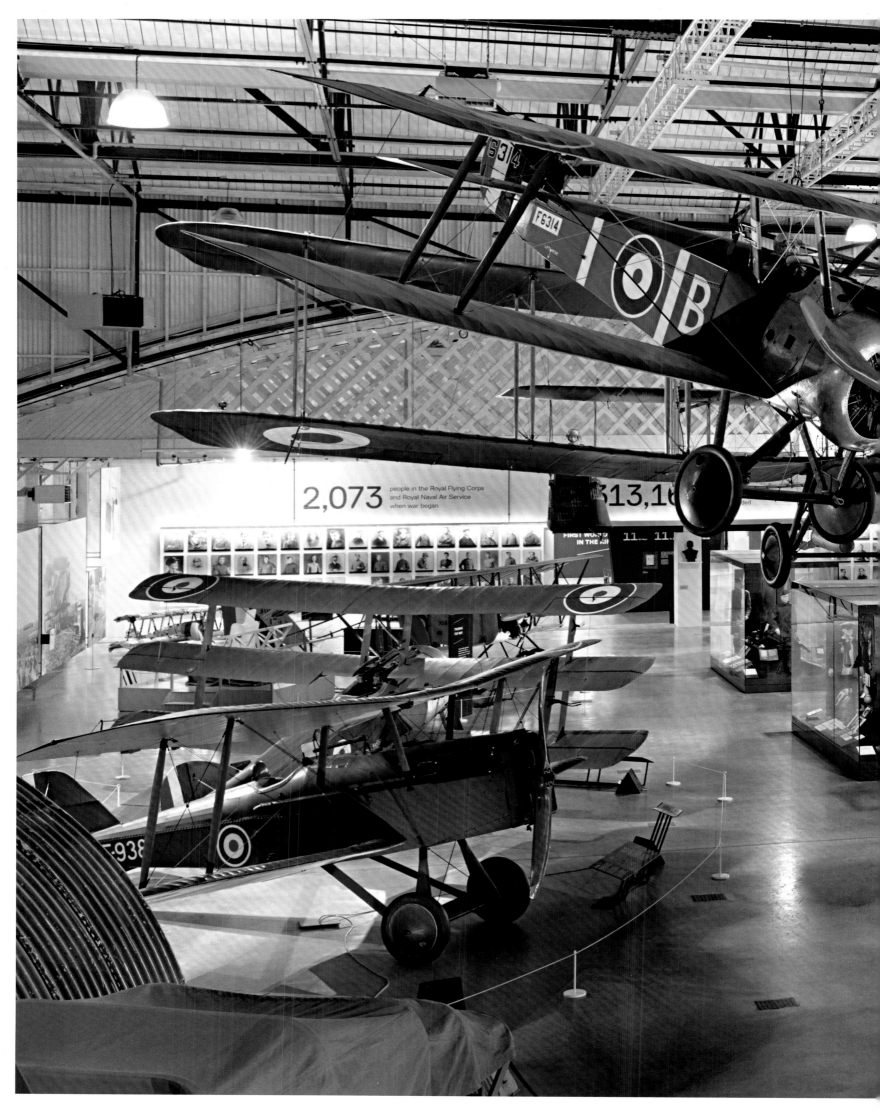

2,073 people in the Royal Flying Corps and Royal Naval Air Service when war began

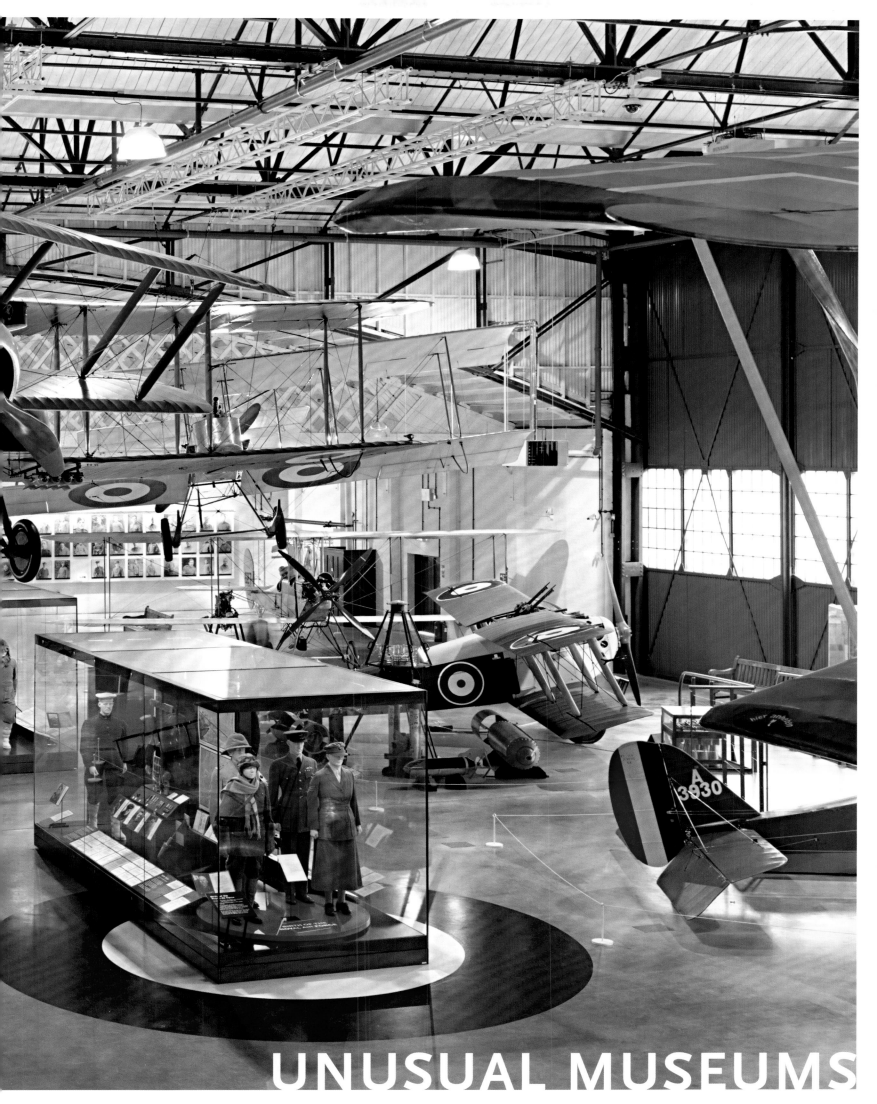

UNUSUAL MUSEUMS

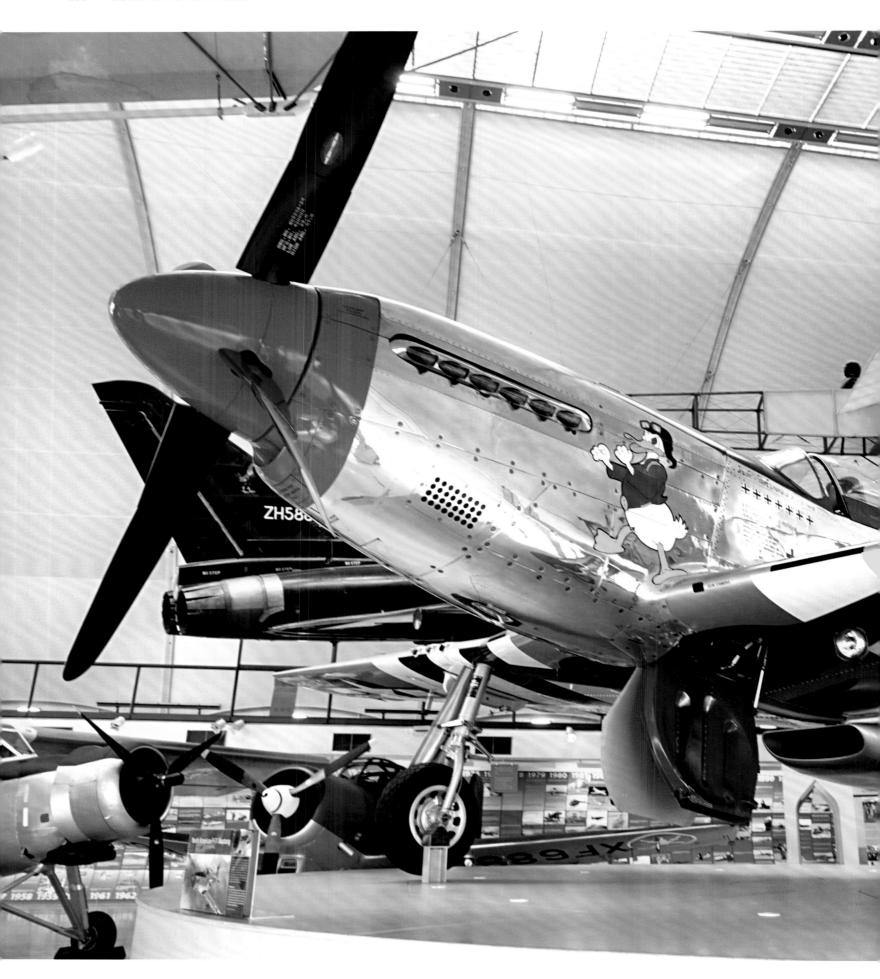

Royal Air Force Museum

In the early days of British aviation, pioneers established bases where the London suburbs met open country, at Brooklands, Croydon and at Hendon, which was the original London Aerodrome. The Royal Air Force Museum at Hendon today upholds all sorts of aviation connections, although it is hard to imagine that an airfield with hard runways ever existed close to here. All this area was once aircraft country, home to manufacturers such as Handley Page, Airco, and later de Havilland.

The RAF museum is a clever mix of modern and historic preserved buildings, where vintage hangars sit alongside and inside modern concrete and steel structures. Hendon Museum relates the history of the RAF and also marks the place where, in the Edwardian era, many Londoners set eyes on an aeroplane for the first time. There were aircraft factories at Hendon from 1910, one of them established by Claude Grahame-White, engineer and pioneer aviator. The Grahame-White company headquarters building and factory hangar remain at Hendon. Some careful dismantling and repositioning moved them 500 metres from the old airfield site to alongside the museum in 2003 and 2010.

Since its opening in 1972, the museum has been developed into six exhibition halls. There are always about a hundred aircraft on show, and hundreds more exhibits; the curators advise that it can be hard to take it all in between the 10am to 6pm opening hours. Some visitors go straight to the Bomber Hall to marvel at the mighty Vulcan and its ancestor, the Avro Lancaster. Sometimes it is possible to stand under the Vulcan and watch a film projected in the bomb bay showing a V-bomber scramble, a Cold War

PREVIOUS PAGE *A Sopwith Camel swoops on First World War exhibits under the lattice-truss roof of the Grahame-White factory.*

LEFT *This P-51D Mustang is representative of the USAAF in 1944. Elsewhere, a B-17 Flying Fortress is among several US aircraft displayed.*

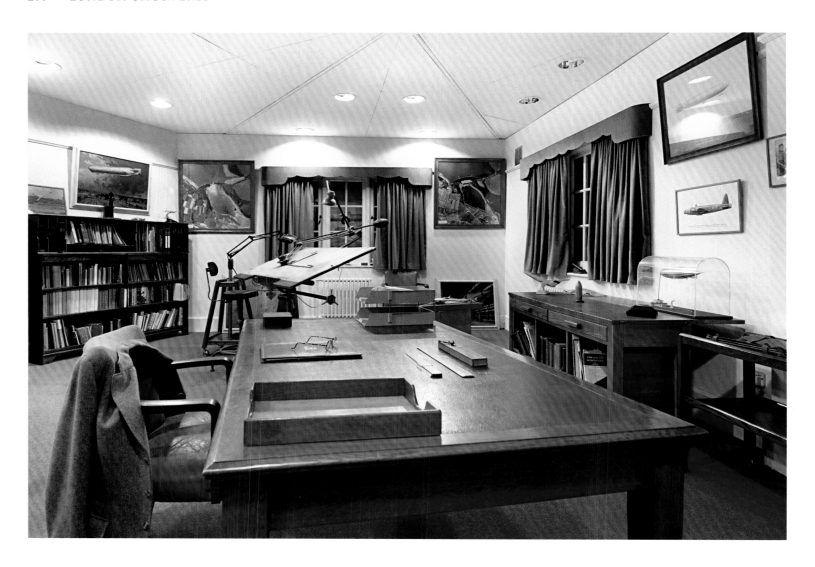

A reconstruction of the office of inventor Barnes Wallis, most famous as the creator of the 'bouncing bomb', with his drawing board and before-and-after aerial photographs of the Möhne Dam.

classic. For a visitor with just a slightly deeper interest in aircraft, the museum is a special place. While Spitfires and Hurricanes are commonplace in UK collections, Hendon has a number of aircraft that are unique or extremely rare: the Hawker Tempest V, a Bristol Beaufighter and the Boulton Paul Defiant, the complete remains of a Handley Page Halifax bomber, a German Junkers Ju88 night fighter, and two early German jets, the Heinkel He162 and Messerschmitt Me262.

The other rare birds in the collection are older aeroplanes dating from 1914–18 and earlier, when the Royal Flying Corps and Royal Naval Air Service first represented air power for Britain. It is the Grahame-White factory building, with its lattice-truss roof, that houses the 'First World War in the Air' exhibition. There are more than a dozen aircraft from this age, and the diminutive wood-and-canvas Sopwith Triplane and Camel can be examined in close up alongside a German Fokker DVII and Albatross.

The Battle of Britain Hall, opened in 1978 and revamped in 2009, is likewise naturally a major feature, and includes a Spitfire and Hurricane that fought in the battle. There is a recreation of the 11 Group operations room at Uxbridge, nerve centre of Britain's air defence during the Battle of Britain.

The museum aims for completeness. There are three sea-going vessels, representing the RAF Marine Branch, and across the collections are four flying boats, several helicopters, a V-1 flying bomb and a V-2 rocket, a cruise missile, a number of aero-engines, uniforms and hundreds other artefacts. In most cases the hardware exhibited inside is the real thing in every sense, the handful of replicas of older aircraft are perfectly rendered. Although serious-minded to a high degree, the museum makes generous concessions to the interests of the younger visitor. The Aeronauts Centre is an interactive gallery, with hands-

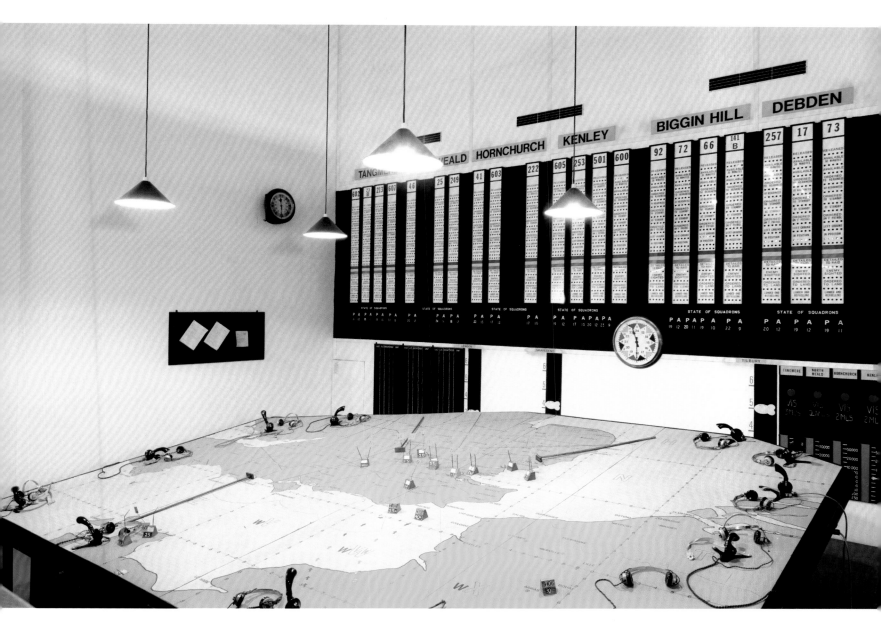

A recreation of Fighter Command's 11 Group operations room, nerve centre of Britain's air defence during the Battle of Britain.

on exhibits demonstrating how aircraft fly and inviting participants to test their reaction times and vision. Here it is possible to take the controls of a helicopter or try low-level hang-gliding. Elsewhere in the museum there are also some other simulators, for which a small charge applies, otherwise all the exhibition halls are free entry.

More than a hundred years ago, the carnival atmosphere of the first Edwardian aerial pageants set the style for Hendon. This was revived after the First World War, and Hendon became home to RAF air displays in the 1930s, with thousands flocking to the suburbs to see biplanes – such as the Bristol Bulldog on display here – performing synchronised aerobatics. Later, it became a base for transport aircraft. The last RAF squadron to operate from

Hendon stopped flying from here in 1957, the runways were removed and the airfield site mostly built over.

Hendon museum has faced competition in recent years from the Imperial War Museum collection at Duxford in Cambridgeshire, and from the other main RAF museum site at Cosford in Shropshire, which has built up its collection of large RAF historic aircraft, but neither of these can be reached by an eight-minute walk from Colindale station on the Northern line.

VISITING INFORMATION

Royal Air Force Museum, Grahame Park Way, NW9 5LL

http://www.rafmuseum.org.uk/london

Open daily 10am–6pm

Horniman Museum

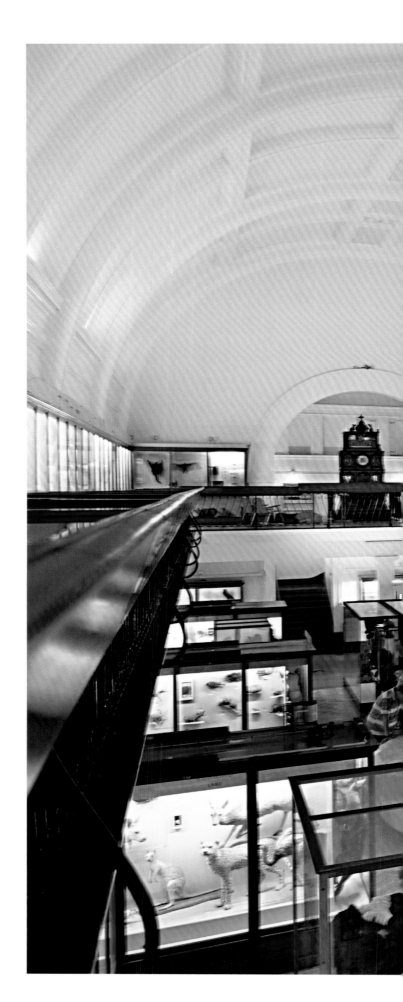

The Horniman Museum in Forest Hill, south London, is frequently described as 'eclectic', 'diverse' or 'curious', mainly because it hard to define the museum in a sentence. Many exhibits relating to anthropology, archaeology and natural history are housed there. Its founder was an amateur collector in the Victorian tradition, an enthusiast rather than a scholar, whose aim was to 'bring the world to Forest Hill', but its ethnographic collections have been assigned the Arts Council distinction of designated status, which marks pre-eminent collections. It has a separate major collection of musical instruments with the same status. The Horniman is a serious museum, and at the same time a children's favourite and some of its development in recent years has been directed towards young visitors. Its architecture is diverse and there are large gardens, an aquarium and a performance pavilion.

Frederick John Horniman was chairman and managing director of the Horniman Tea Company, whose fortune was built on being the first to wrap tea in machine-sealed packets. The first pieces Horniman collected as a schoolboy were butterflies; as a man he travelled widely across Asia to China and Japan and to Africa and North America. From 1860 he accumulated objects which 'appealed to his own fancy . . . illustrating natural history and the arts and handicrafts of various peoples'. He was a classic Victorian philanthropist, in the sense of being a Quaker, a Liberal MP and extremely wealthy, and the breadth of his interests was wide and diverse.

Horniman first made his own house into a museum in 1890, before commissioning a purpose-built museum, which was constructed in 1898–1901. Designed by Charles Harrison Townsend (whose work includes Whitechapel Art Gallery), it is a rare example of Arts and Crafts design, a style usually

The Natural History Gallery, with the famous overstuffed walrus at its centre.

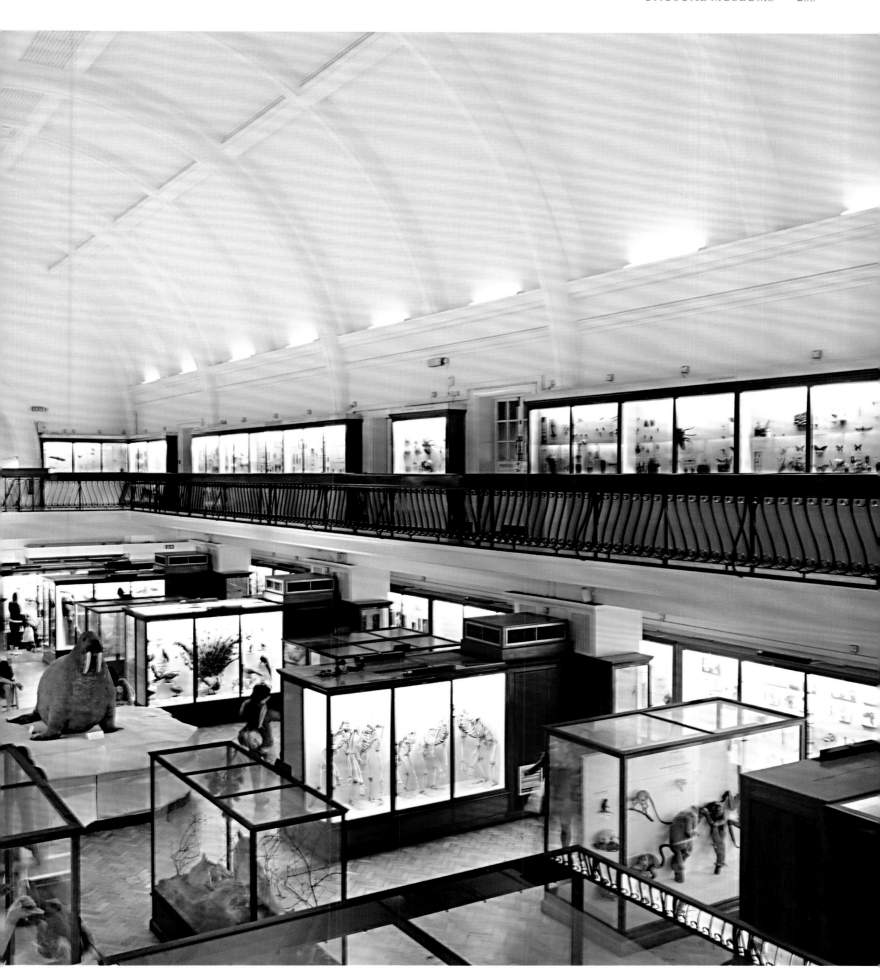

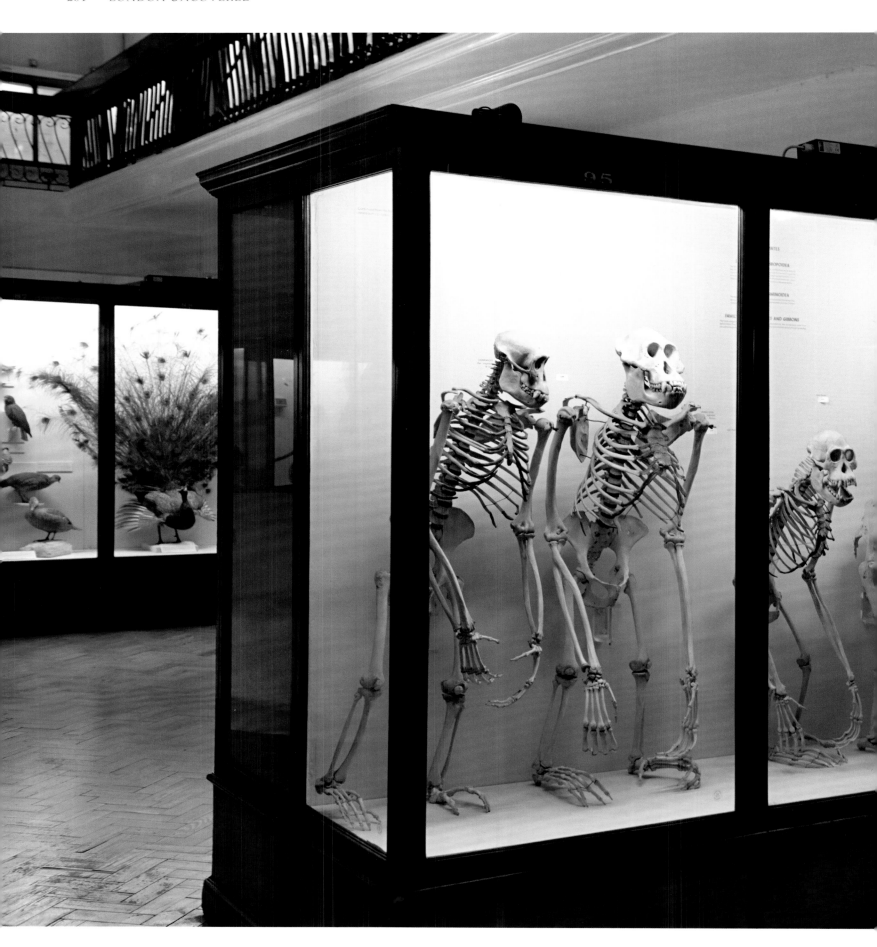

Five primate skeletons, a characteristic Horniman display fascinating for children.

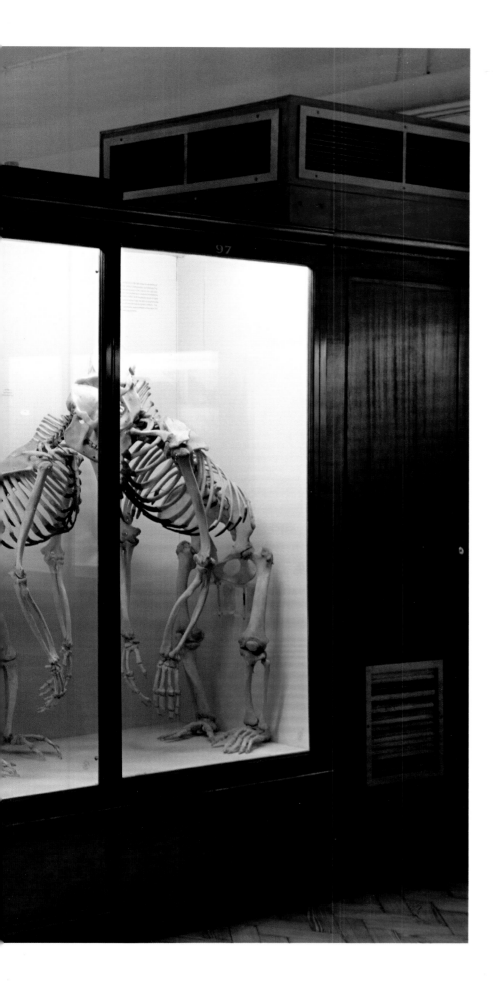

seen in houses, applied to a large building. The frontage incorporates a pictorial mosaic created over 210 days during the construction period. The round-cornered clock tower is a local landmark. An adjoining building by the same architect was commissioned by the founder's son, Emslie Horniman, and opened in 1912. Recent buildings include an grass-roofed ecological building of sustainable materials now housing the library, a further extension in sequence with the Townsend buildings housing new galleries, and an ornate Victorian cast-iron conservatory moved from the former Horniman family home in 1987.

Today the collections are grouped under the headings Natural History, African Worlds and Musical Instruments. Artefacts from cultures and civilisations across the world are displayed in the Centenary Gallery, which contains masks, tribal costumes, tents, and all kinds of folk art. Archaeology is represented by collections of tools, weapons and ceramics.

A highlight of the Natural History Gallery is a massive unwrinkled walrus from Hudson Bay, Canada, overstuffed by London taxidermists, who, in the nineteenth century, had never seen such a creature. Somewhere between natural history and cultural artefact is the merman, otherwise known as the Japanese monkey-fish, a sculpture fashioned from *papier mâché* and fish remains.

The Horniman gardens are extensive and include formal and natural display areas, a sunken garden and educational garden areas. A Gardens Pavilion, opened in 2012, hosts lectures and performances. A bandstand on the terrace, dating from the 1900s, also designed by Charles Harrison Townsend, provides good views over London.

VISITING INFORMATION

Horniman Museum, 100 London Road, SE23 3PQ

http://www.horniman.ac.uk

Open 10.30am–5.30pm daily except 24, 25 and 26 December.

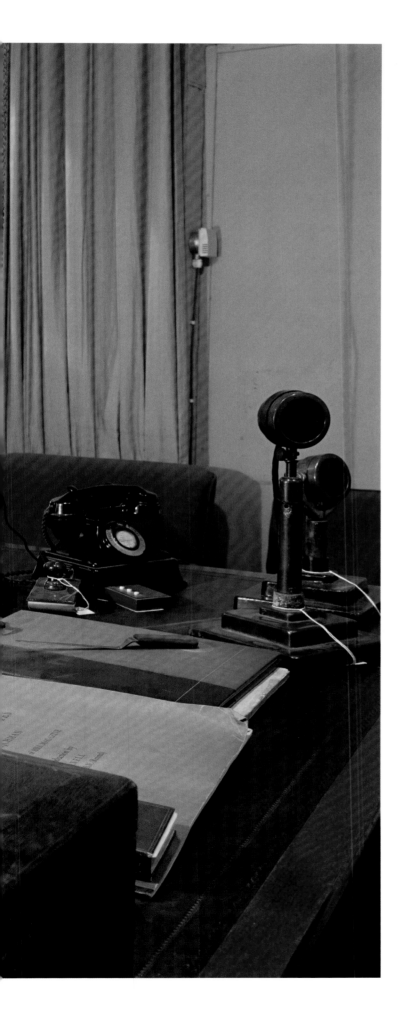

Churchill's bedroom and desk, with dispatch box.

Churchill
War Rooms

Churchill War Rooms is the name of the museum which includes the underground Second World War command centre known as the Cabinet War Rooms and the intertwined Churchill Museum which profiles the life of the statesman.

Before entering the War Rooms through their bronze doorway in King Charles Street, some visitors stop to look at part of the Treasury building facing St James's Park, under which the War Rooms lie. A long concrete apron wall runs along the face at ground level, quite different to the Portland stone cladding, and clearly a later addition to the frontage. It covers a feature of the War Rooms known as the Slab, a metre-thick layer of concrete with steel-rail reinforcement added in 1940, testimony to a time of great danger, and sign of desperate measures.

Authoritative studies reporting in the 1930s advised that the top level of government should be moved away from central London in case of war, and plans were drawn up for moves to fortified buildings located in the suburbs or dispersed across the countryside. Above all, a move away from Whitehall was imperative because of the threat of air attack on central London, but despite this, when war came, the best action that could be taken was to move the cabinet to converted rooms in a basement in the centre of Whitehall under the New Public Buildings, close to Downing Street and the offices of state. Although the NPO housing the Treasury had the advantage of being partly of steel-framed construction, it was by no definition bomb-proof and the basement was shallow. In 1938 the roof had been reinforced with steel girders, the Slab was added in 1940 and later extended, but it was always understood that the Cabinet War Rooms would not withstand a direct hit from a penetrating high-explosive weapon. Churchill, who

knew this, nevertheless declared after becoming Prime Minister and visiting the underground Cabinet Room: 'This is the room from which I'll direct the war.'

He had no liking for underground quarters, and still favoured working and living at 10 Downing Street. This is where he was dining on 14 October 1940, when a bomb exploded on buildings only yards away across the road. Churchill was unhurt but Downing Street was badly damaged. As the war came dangerously close to Churchill, he came to rely more and more on the War Rooms, and his domestic accommodation was extended into a suite of rooms known as the Downing Street Annexe, both alongside the War Rooms in the basement and in more comfort upstairs on the ground and first floor in the Treasury Building. He slept in his basement bedroom only a few times.

The rooms that can be seen today represent only part of what the Cabinet War Rooms once comprised. Over the course of the war the rooms were extended laterally under the Slab, above into the Treasury building annexe and downwards into a grim sub-basement known as the Dock. Besides the cabinet ministers and the Chiefs of Staff, who were supported by civilian aides and military officers, dozens of secretaries, telephonists and guards worked in the Cabinet War Rooms, which were permanently operational.

The Map Room and the Cabinet Room are the most important. Churchill's chair in the Cabinet Room carries an indelible link between the man and the place. On the wooden armrest can be seen the marks the Prime Minister made with his signet ring and fingernails.

There is a minimum of finish to any of the rooms, even in their restored state, which accurately represents the swift conversion from storage in 1938–9. Air-conditioning trunking hung on the ceiling comes from a warship supplier, the lighting is harsh and direct, pneumatically powered Lansom tubes deliver hard-copy messages in canisters and the only wall covering is maps. The little cubicle with vacant/engaged lavatory lock opposite the Map Room housed the Prime Minister's secure

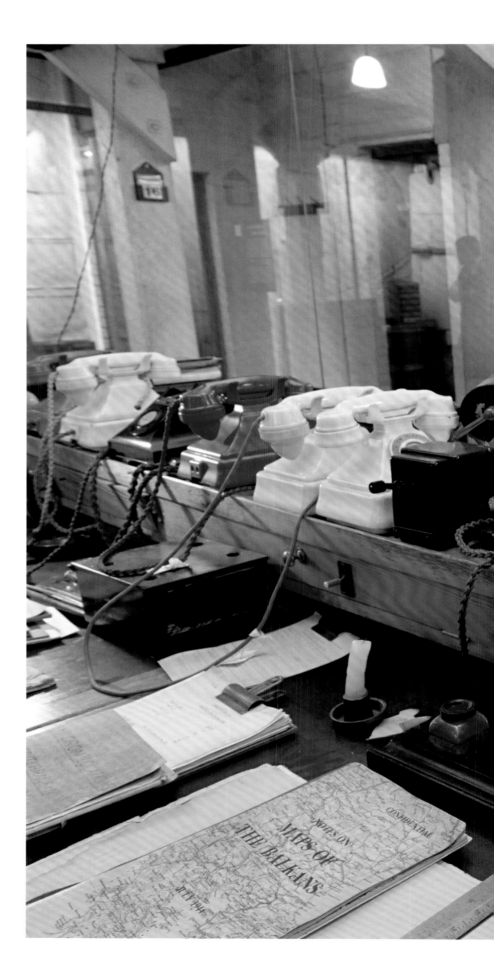

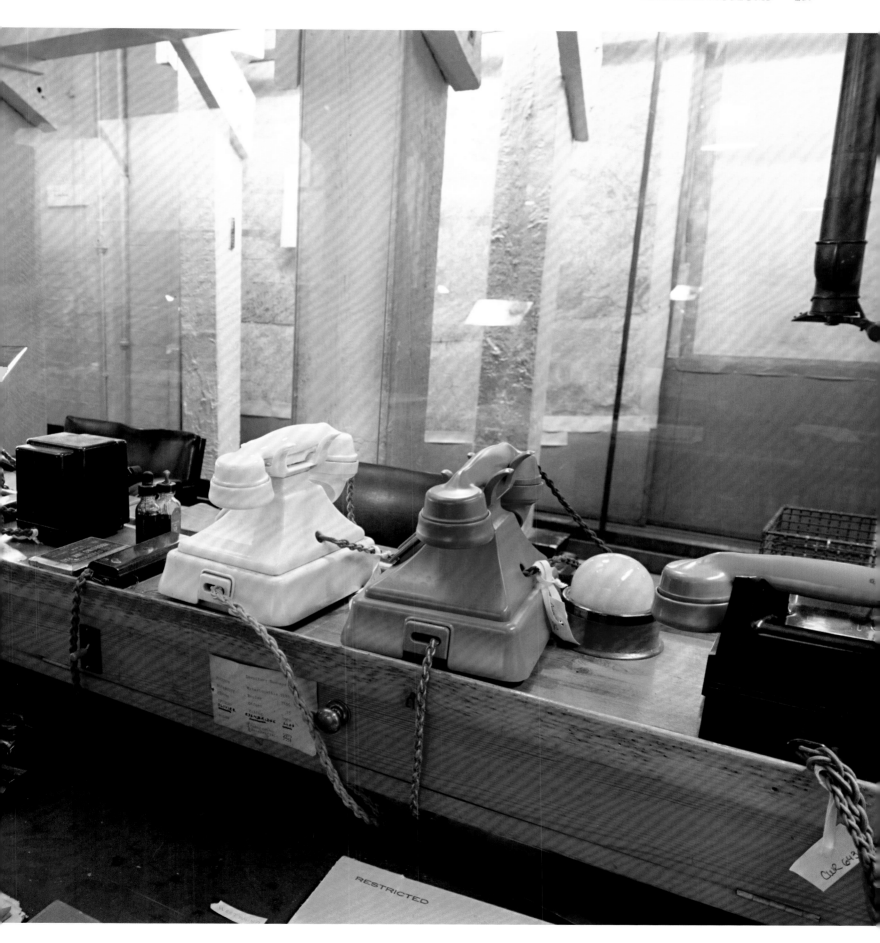

Colour-coded telephones linked the Cabinet War Rooms to operational commands.

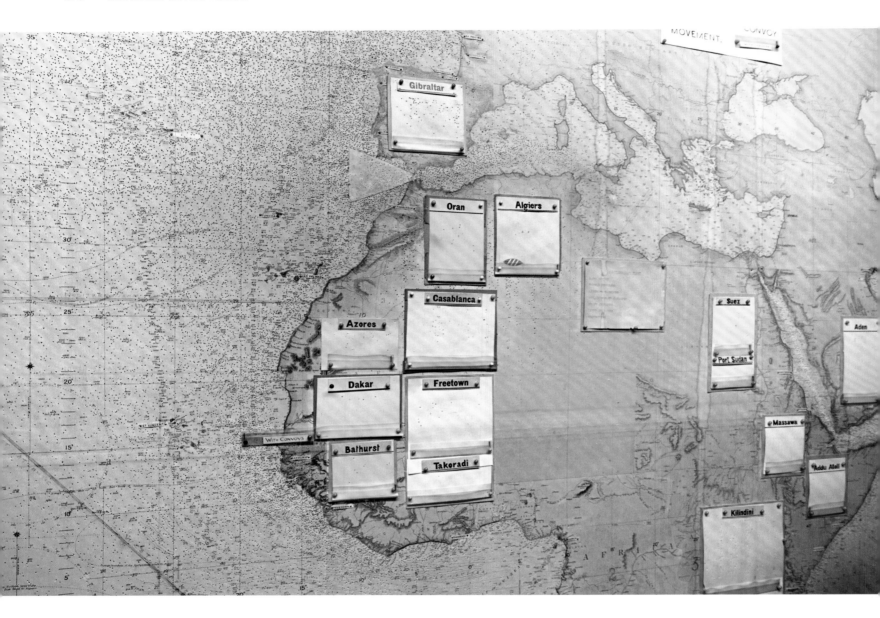

ABOVE *A map showing the disposition of forces in North Africa and the Mediterranean in 1944.* OPPOSITE ABOVE *The scuff-marks of Churchill's signet ring are visible on the arm of his chair in the Cabinet Rooom.* OPPOSITE BELOW *Kitchen facilities were basic.*

speech telephone link to President Roosevelt. In the Map Room, crowded ranks of colour-coded telephones linked the Cabinet War Rooms with operational commands.

After the Blitz, a further series of deep shocks was delivered to London across the span of the war, even as the tide turned in favour of the Allies. In early 1944, after a long comparative lull, bombers returned in what was called the Baby Blitz, and just after D-Day V-1 flying bombs started to fall on the city. As that threat was countered and controlled came the unstoppable V-2 missiles. The threat of more powerful secret weapons had been dimly glimpsed in 1943, and plans were drawn up to move to a secure citadel but not implemented. Churchill and his

cabinet continued to work in the Cabinet War Rooms as flying bombs and rockets fell, through to the end of the war in Europe. The final duty officers in the Map Room signed out on 15 August 1945. The Cabinet War Rooms survived largely intact, opened only to a few selected visitors until adopted by the Imperial War Museum and opened as the Cabinet War Rooms in 1984, and developing into the Churchill Museum in 2005.

VISITING INFORMATION

Churchill War Rooms, Clive Steps, King Charles Street, SW1A 2AQ

http://www.iwm.org.uk/visits/churchill-war-rooms

Open 9.30am–6pm daily, except 24, 25 and 26 December. Last admission 5pm.

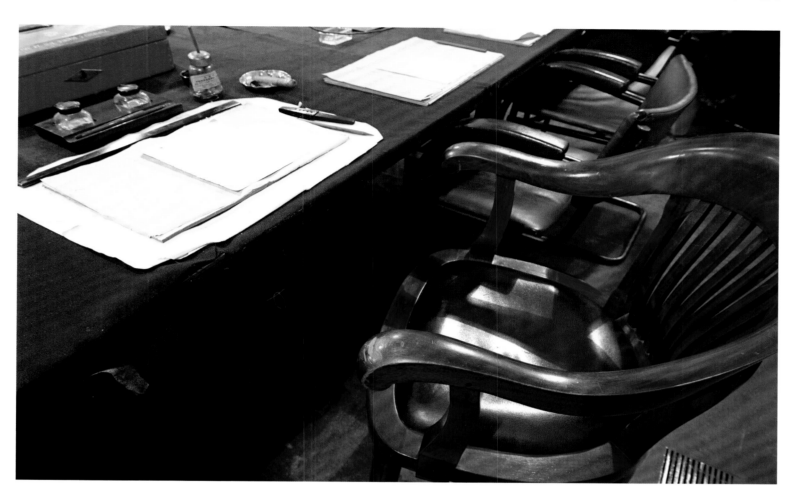

A typical urban loft apartment from c.1998.

Geffrye Museum

The Geffrye Museum, a step away from Kingsland Road in Shoreditch, can be easily missed behind its innocuous brick wall and railings. Set back from the street, this Queen Anne style building is in a U-shaped block, situated around a lawn bordered by trees. Beyond the wrought-iron gate, the chapel with its bell turret stands in the centre of the block and is the first and most striking part of the building to be seen.

Formerly built as almshouses in the early 1700s, the Grade I listed building has Hoxton station to its rear and Kingsland Road to the front, part of this road forming the boundary between east and north London in the London Borough of Hackney. The Geffrye Museum, off the main tourist route, is something a favourite place for those who grew up in London, as thousands of London children have seen it for the first time on school visits.

The focus of the museum is as a 'Museum of the Home', specifically showing how domestic interiors, particularly those of the urban middle classes, have altered over the past four centuries. There are eleven period rooms in total, spanning from 1600 to the present day, through which visitors can walk. These rooms, set out in chronological order, are in the longer east wing of the building.

Behind this wing there is a series of period gardens, used to illustrate the change in English town gardens over the years. Over in the north-east corner is a walled herb garden, which was opened in 1992. This is centred around a bronze fountain and is used to demonstrate the use of herbs in the home.

The building itself was constructed in 1714 by the Ironmongers' Company, at the bequest of its namesake, Sir Robert Geffery. Geffery was a former Mayor of London, elected in 1685, as well as being twice master of the Ironmongers'

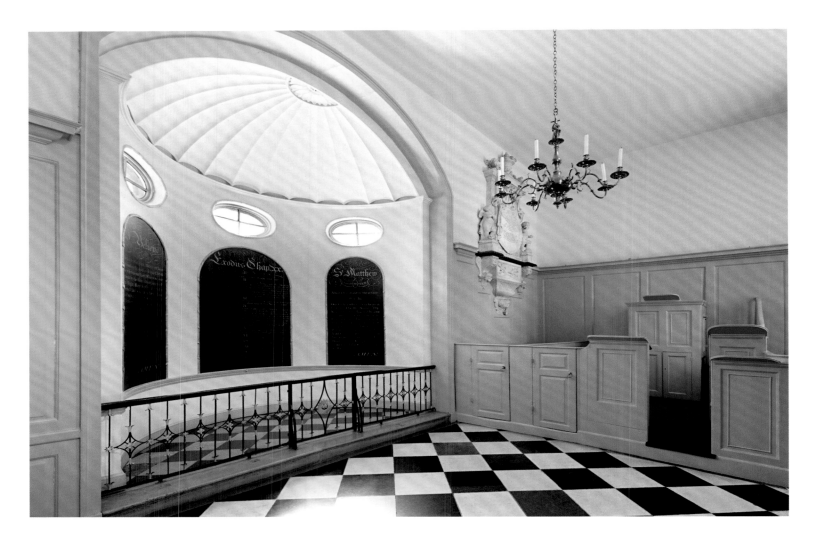

The chapel. A memorial to Sir Robert Geffery and his wife overlooks the pulpit.

Company. Fourteen almshouses were built at a cost of approximately £4,500, to provide for around fifty poor pensioners. Shoreditch was chosen as the location, being, at that time, quieter than central London. On later selling the building, the Ironmongers' Company moved the almshouses to Kent and then later to Hampshire, where they remain today. Each almshouse typically had a room each side of the main doorway, a staircase in the centre, and two further rooms upstairs. The residents, often widows of ironmongers, were required to attend the chapel each week.

The chapel itself is a central focus of the museum. Inside, a small semi-circular area is set back from the main part of the chapel. There is a covered walkway, constructed of timber, around the outside rear of the chapel and a nearby reading room. Inside the chapel is also a memorial to Sir Robert Geffery and his wife.

Other signs of Sir Geffery can still be seen around the museum. Indeed, the tomb of Sir Geffery and Lady Geffery is in the burial ground in the north-west corner of the site. Their bodies, originally buried in St Dionis Backchurch, were relocated here when the church was demolished in 1878.

In 1910, when the almshouses were moved, London County Council purchased the building following petitions to prevent it being demolished. The council, wanting to provide more open spaces, opened the gardens to the public.

The Geffrye Museum was then opened in 1914 and focused on furniture. This neighbourhood historically centred round the furniture-making trade, being near enough to the centre of the city to trade, but far enough away that rents were lower.

As the furniture trade began to decline in this area, the focus of the museum became more education and family orientated. It continued to evolve over the years and, in the 1990s, the museum refurbished all the period rooms. A new horseshoe-shaped extension to the museum was also built,

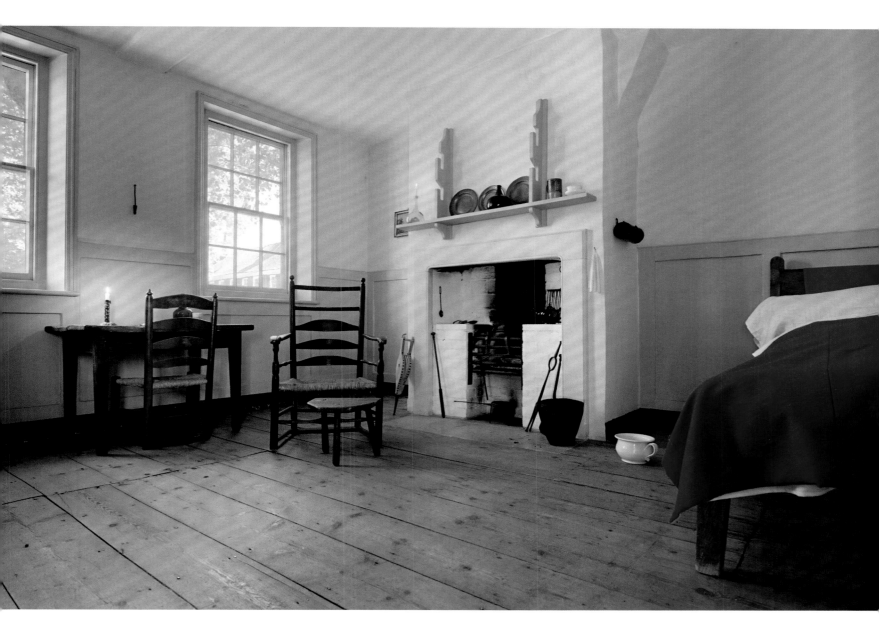

ABOVE *A reconstruction of a simple almshouse room from the 1880s.* OVERLEAF *A 1830s-style drawing room.*

opening in 1998. This extension is to the south-east of the site and has rooms dedicated more to the twentieth century.

Further developments are forthcoming, with the museum being awarded a Heritage Lottery fund of £11 million in May 2015. Earlier designs met with local opposition, when they included the proposed demolition of a nearby former public house. The new plans, however, will see an additional entrance opposite Hoxton station, at the rear of the site, as well as opening up previously unseen areas and improving access throughout.

The Geffyre Museum's particular appeal lies in the way the period rooms can generate a personal response in every visitor. The drawing room of 1910 is recognisable for many and does not seem particularly remote. The living room of

1965 in contemporary Scandinavian style evokes for the middle-aged certain memories of a childhood home, or for others serves as a reminder of their grandparents' house. It is too early to guess how most visitors feel about the lovingly reconstructed loft-style apartment of 1998 but it will doubtlessly be equally evocative for someone.

VISITING INFORMATION

Geffrye Museum, 136 Kingsland Road, E2 8EA

http://www.geffrye-museum.org.uk/

Open 10am–5pm Tuesday–Sunday and Bank Holiday Mondays.

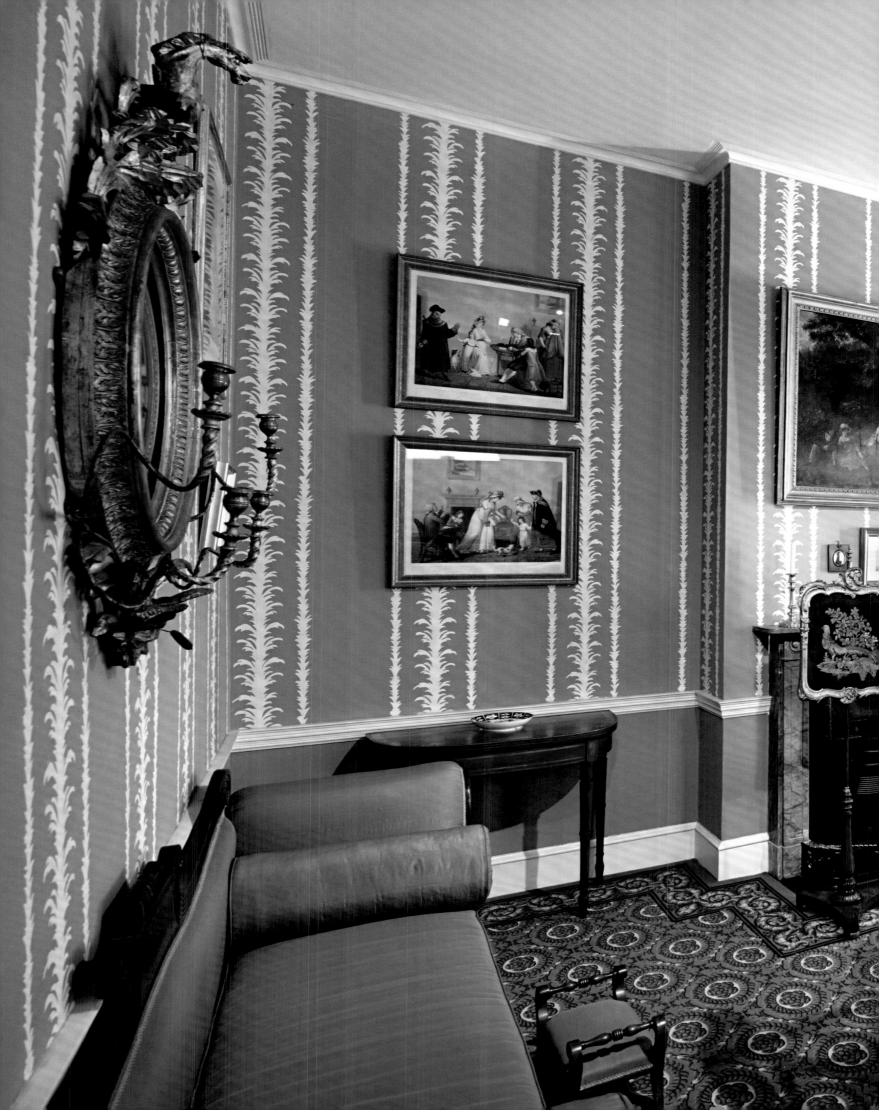

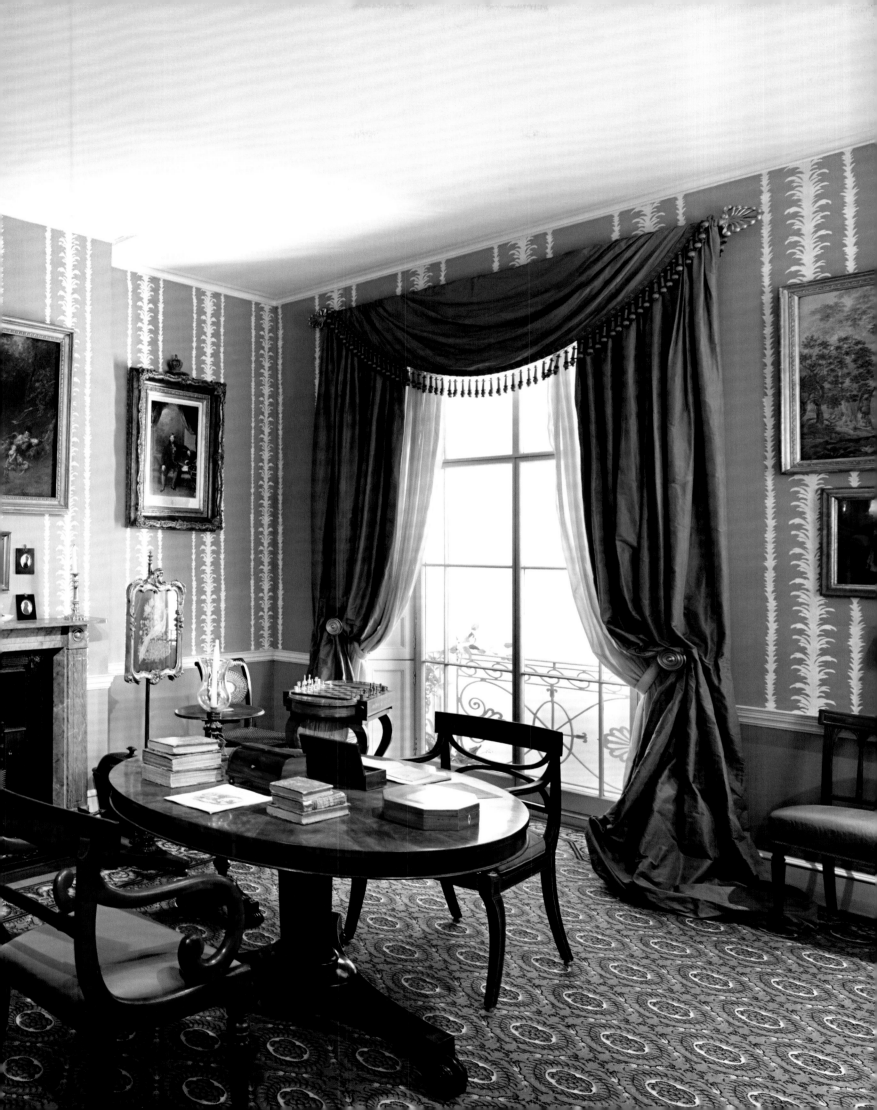

HMS Belfast

Belfast has been a Londoner for a long while now. Anchored in the Pool of London since 1971, the cruiser may now be taken for granted by many, but she is a rare survivor worth close examination. While Britain loves museums and relics, the nation is strangely hard-hearted when it comes to preserving ships. HMS *Belfast* was the first warship preserved for the nation since HMS *Victory*.

Commissioned in August 1939 and paid off in August 1963, HMS *Belfast* has survived several layers of modern naval history, for the cruiser preserved across from the Tower of London is not quite the same ship completed at Harland and Wolff's Belfast yard in 1938. Part of its fascination is in charting the changes in the last big gun warship in Royal Navy service.

It is necessary to imagine that a pair of Supermarine Walrus amphibious biplanes were carried in hangars alongside the forward superstructure. These were launched from a cordite-powered catapult forward of the leading funnel. After landing, the aircraft were recovered using cranes. By 1943 the aircraft had gone. One of these cranes, repositioned, remains.

Unchanged across the active life of the ship was the deeply embedded main armament of 12-inch guns in four turrets, and the monumental nature of this weapon system can be better understood by seeing them than by description, but it required twenty-seven men in each turret gun house to load and fire the guns and twenty-two more in the shell rooms and magazine to keep them supplied. The electromechanical carousel and shell hoist is particularly fascinating, but the ship is bristling with so many features across nine decks. There is a chapel, a

telephone exchange and an archaic-looking steering position. The main propulsive machinery is 1930s vintage and engineering enthusiasts are drawn to the forward engine room and boiler room. For those who belong to the touch-screen age, the extraordinary Admiralty Fire Control Table, a mechanical computer resembling a massive piece of kitchen equipment, is hard to comprehend, but clearly labour-intensive, and this applies to all the systems. *Belfast* required a crew of 800.

HMS *Belfast* was hard used during the Second World War, her back broken in the early weeks of the conflict by the new menace of the magnetic mine, against which no countermeasures existed at the time. A three-year-long refit bought the cruiser back from the dead, equipped this time with an improved array of radars and an Admiralty Type 25 Disruptive Pattern Camouflage scheme in the cool shades of the sea and skies of the north, which she wears today. The cruiser's next deployment was the protection of convoys to Russia. Northern waters were the scene of HMS *Belfast*'s most famous action, playing a decisive role in the destruction of the German battle cruiser *Scharnhorst* using her radar, guns and torpedoes in the Battle of North Cape, the last surface engagement of big ships in Second World War in Europe.

Six months later, on D-Day, Belfast fired broadsides into areas behind Juno beach, being one of the first warships into action.

The cruiser was refitted twice between 1944 and 1948 with the torpedo tubes, some of her secondary 4-inch gun armament and the catapult removed. Nearly all the rest of her career was spent in the east. At the start of the conflict

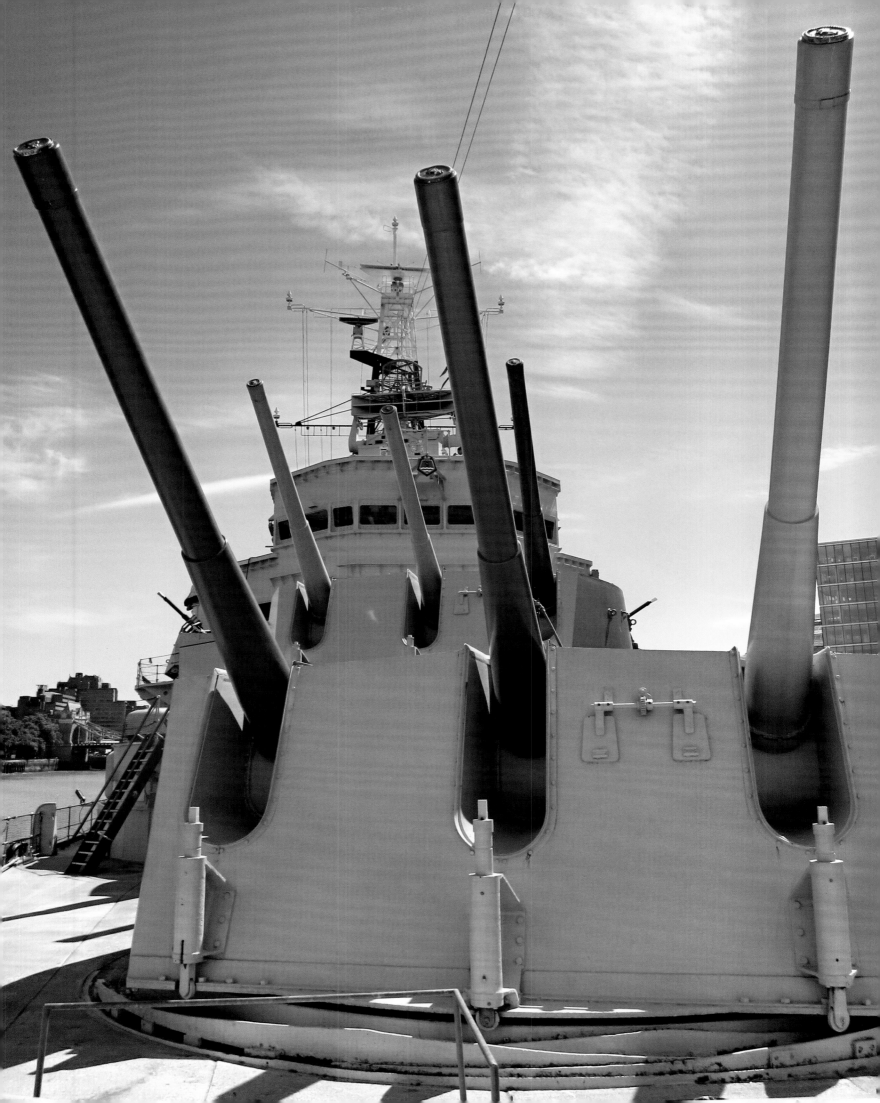

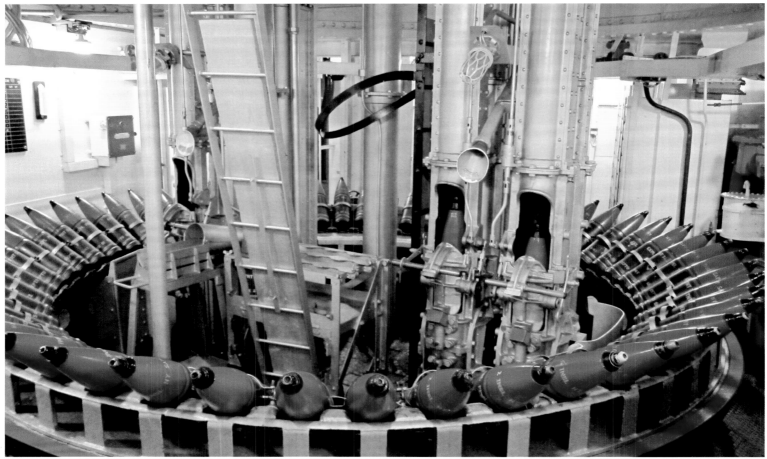

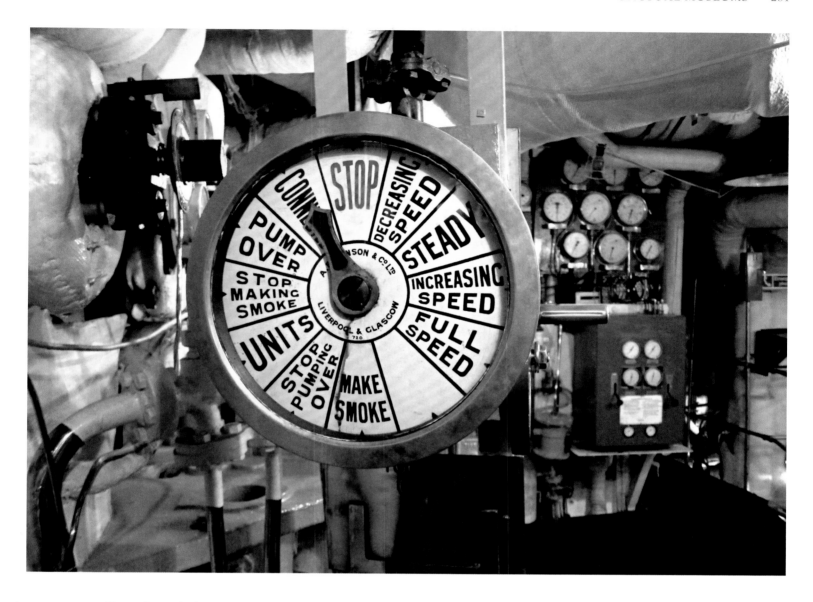

OPPOSITE ABOVE *Hammocks remained in use on cruisers into the 1950s.* OPPOSITE BELOW *Electromechanical carousel and shell-hoist.* ABOVE *The ship's telegraph.*

in Korea, the cruiser went into action again with shore bombardments, operating over 400 days of patrols.

A last refit and modernisation between 1956 and 1959 gave air conditioning, a modern fire control system and finally an enclosed bridge. HMS *Belfast* did not quite make it to having a guided missile armament or operating a helicopter, but the cruiser remained a viable warship to the end. She was in good order on decommissioning, continuing as an accommodation ship for a while. The passage into preservation was tricky and her survival was freakish. When the Imperial War Museum in 1967 went looking for a gun turret to preserve, the good condition of HMS *Belfast* was noted. The government first agreed to preservation of the complete cruiser, but later denied all funding, and scrapping beckoned. It was a private trust that transitioned the cruiser into being a museum and launched its restoration. In 1978 the Trust became a branch of

the Imperial War Museum.

Since then, the ship has twice been dry-docked to maintain her hull in a good state of preservation and more areas of the ship have been opened to visitors. A fine story is attached to the restoration of the two lattice masts, found to be decaying from internal corrosion. Replacement masts were manufactured at a shipyard near St Petersburg and fitted by a working party of Russian engineers in 2010. The programme was supported by Russian businesses, a tribute to a cruiser which once escorted convoys to the beleaguered Soviet Union.

VISITING INFORMATION

HMS *Belfast*, The Queen's Walk, SE1 2JH

http://www.iwm.org.uk

Open from 10am every day except 24, 25 and 26 December

Massey Shaw

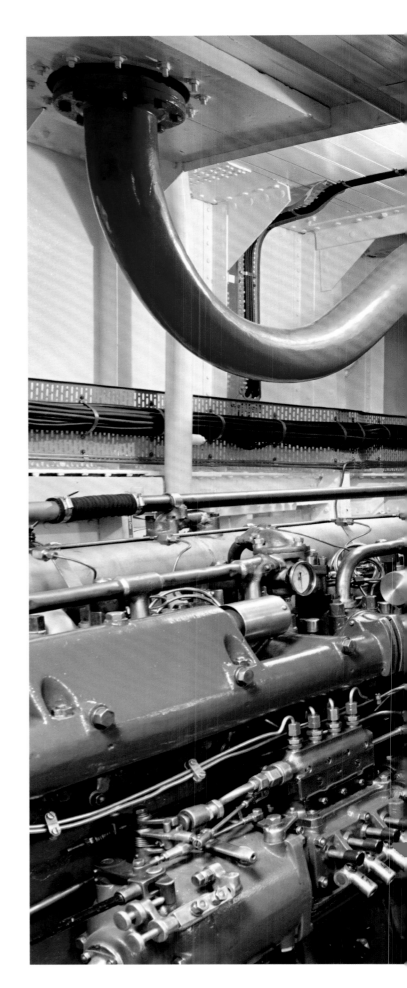

Heroic status is sometimes assigned to ships and boats, and *Massey Shaw* qualifies effortlessly, made famous by its role in the evacuation of British soldiers from Dunkirk in 1940 and by being the last remaining wartime London fireboat.

When *Massey Shaw* was deployed to Dunkirk it did not even possess a compass, and one had to be bought from a chandler's in Blackfriars and quickly fitted. The compass deviation caused by interactions the steel hull was not properly compensated on departure, and crossing through minefields in the Channel proved alarming. It was the first time *Massey Shaw* had navigated in open waters since her delivery from the Isle of Wight in 1935. The first intention was for her to operate as a fire-fighting vessel at Dunkirk where refineries were ablaze, but that plan was abandoned. Manoeuvring close to the beaches, the fireboat ferried 500 soldiers to ships standing off from the beaches, and then directly bought back 110 to Britain. At one point during the three crossings made by *Massey Shaw*, seventeen injured were being treated in the engine room, the warmest place. As the fireboat returned to the Thames, the French vessel *Emile Deschamps* sank nearby in seconds after hitting a mine. *Massey Shaw* rescued forty of the survivors.

Massey Shaw, named after a former Superintendent of the London Fire Brigade, was very closely tailored to its fire-fighting mission, with a shallow draught allowing deployment anywhere on the Thames and connected rivers and canals. It can pass under all London's bridges at almost all states of tide. Two narrow straight-eight Gleniffer DC8 diesels mounted side by side provide propulsion and are also harnessed through clutches to drive the two pumps. These are four-stage Merryweather & Sons centrifugals made in Greenwich. This machinery arrangement requires two sets of telegraphs and repeaters for directing engine

The two Gleniffer DC8 diesels provide both propulsion and pumping power.

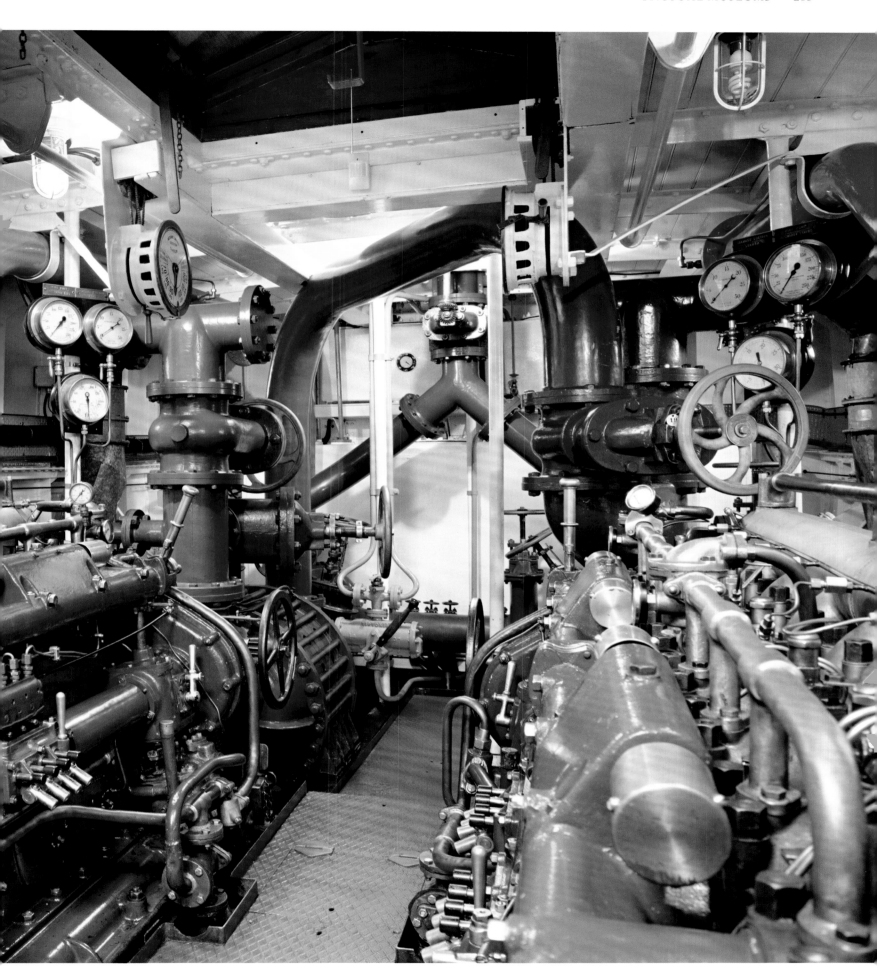

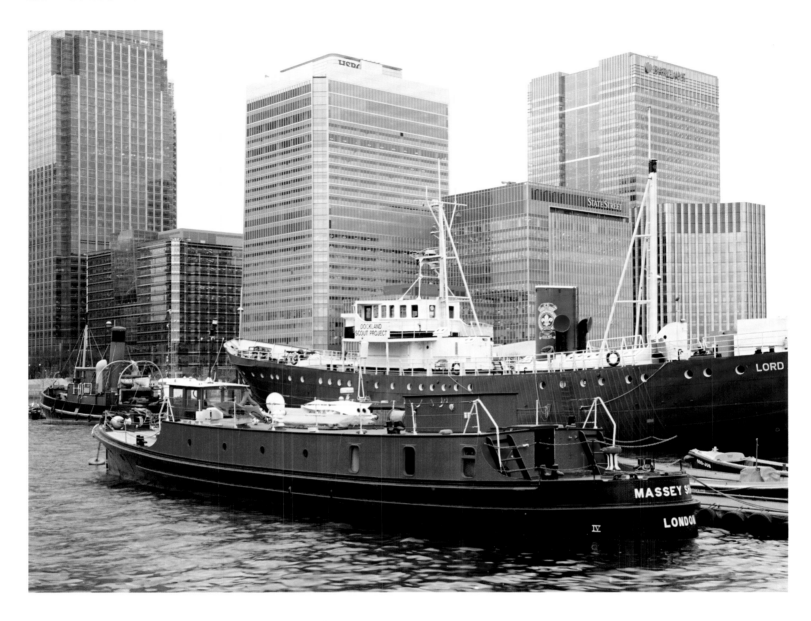

Massey Shaw *moored at Canary Wharf. It still has no permanent home.*

power in either propulsion or pumping. A two-cylinder Russell Newbury engine provides compressed air for starting.

A two-year overhaul at Neilson's shipyard in Gloucester, completed in 2013, replaced some of the hull platework and renewed many rivets, and most of the deck was fitted with replacement Burmese teak board. New propellers and propshafts were made and fitted. One engine was completely overhauled, the other partly reconditioned, and both fitted with new bespoke stainless-steel exhaust manifolds. Some electrical systems have been replaced by modern electronics, but as much as possible of the original vessel has been retained and repaired. On the hull some dents and scrapes were left untouched, authentic testimony to a hard life, but *Massey Shaw* is claimed to have the same capabilities now as when completed at Scott's yard on the Isle of Wight in

1935. The main fire-fighting weapon, the counter-balanced monitor mounted behind the wheelhouse, can generate a water jet capable of punching holes in brick walls. It was required to perform this duty at a major warehouse fire at Colonial Wharf, Wapping, in 1936, blasting a fire break through buildings to prevent the blaze from spreading. *Massey Shaw* was more effective than fire engines in many London fires around Dockland, particularly if the blaze was on the river-facing side of a warehouse or on a ship.

Massey Shaw was one of the fireboats deployed fighting the great fire of 29 December 1940, which is recalled by a famous photograph of St Paul's Cathedral ringed by a sea of flame. Fire-fighting from resources available on land was hampered by limited available water, and the Thames was subject to a particularly low tide, making pumping water from the bank

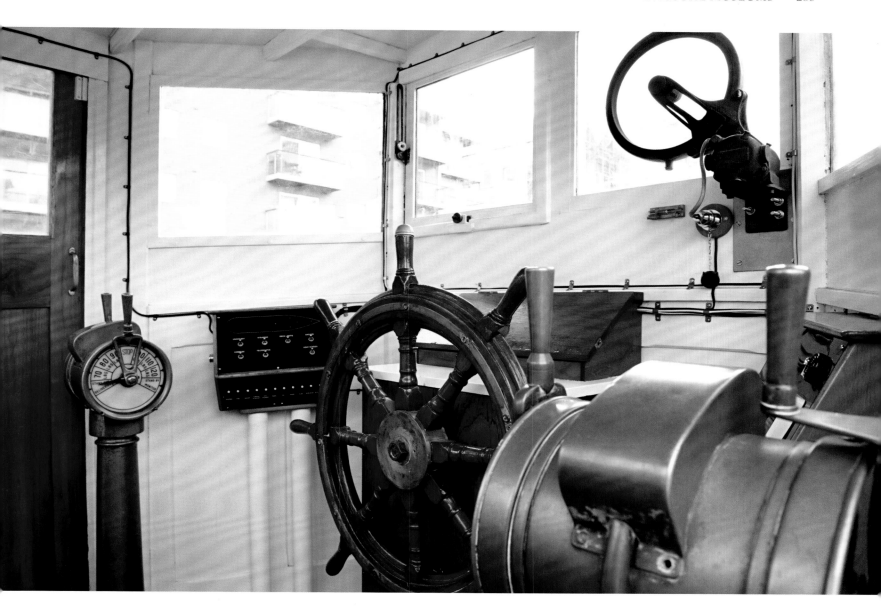

The wheelhouse was added in 1947. Formerly it had an open bridge.

difficult. *Massey Shaw*, as its design allowed, operated as a remote fire pump, its banks of eight side-nozzles providing an unlimited supply of water to firefighters battling near St Paul's Cathedral. A tender was always towed by *Massey Shaw*, which enabled hose lines to be carried ashore, and a mile and a half of hose was carried.

An absolute minimum of five are required to move *Massey Shaw* today, but during operational fire-fighting eight or ten crew were embarked, including a river pilot. The coxswain occupied a steering position protected only by a canvas screen, until a wheelhouse was added in 1947.

The fireboat was decommissioned in 1971. Volunteers worked on preservation, and the Massey Shaw & Marine Vessels Preservation Trust was established in 1982. The ship has twice been sunk by vandalism, refloated and repaired.

It was a Heritage Lottery Fund grant which enabled the major 2012–13 restoration.

Massey Shaw has appeared in two feature films – *Dunkirk* (1958) and *Battle of Britain* (1969) and has returned to Dunkirk on five occasions up to 2016. Since restoration, it has been active and mobile, attending the London Boat Show and participating in special events on the Thames. In the future it may prove possible to base the fireboat alongside at some accessible berth, ideally one close to the Museum in Docklands, although the fireboat remains at a secure site.

VISITING INFORMATION

Massey Shaw, West India Dock, E14 3NU

http://www.masseyshaw.org

Massey Shaw is not publicly accessible, but visits may be booked via the website.

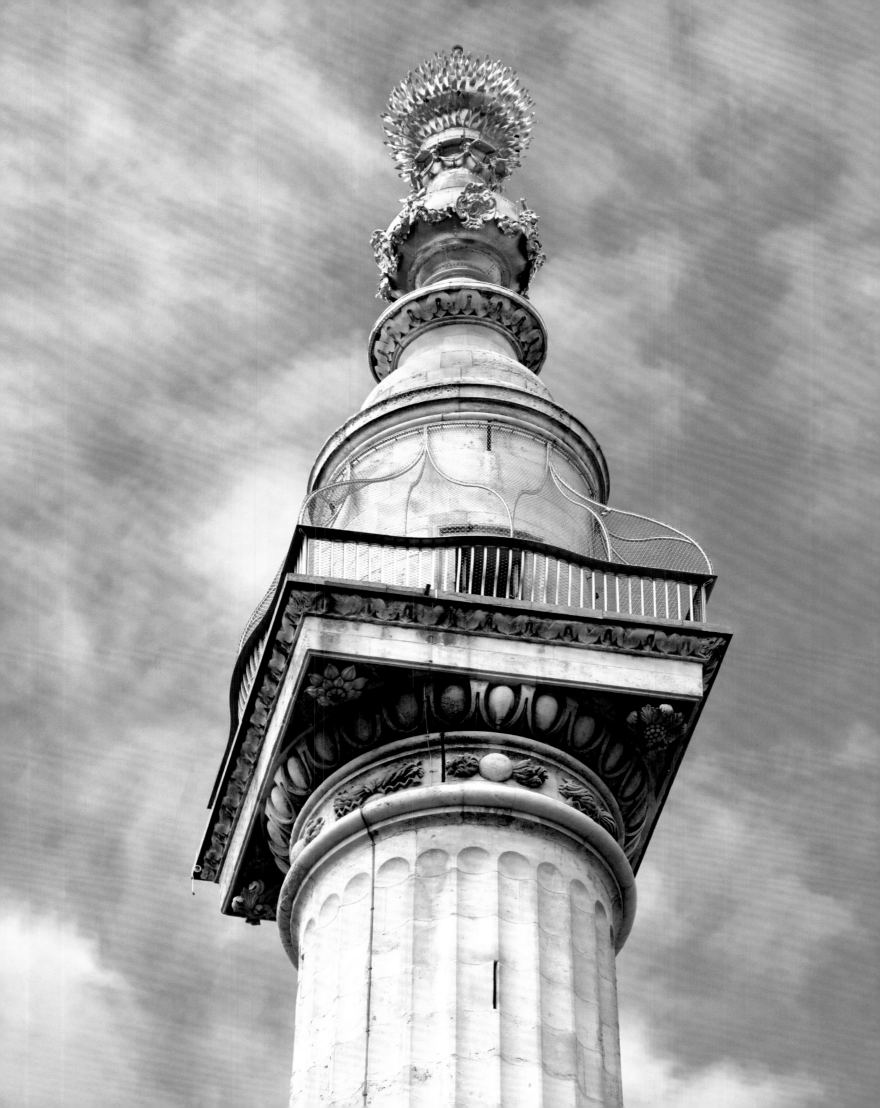

Monument

Around the world cities use architecture and art to commemorate great military victories or to mark defeats and tragedies. It is eternal testimony to the destructive power and impact of the Great Fire of London (1666) that the memorial to commemorate it is forever known quite simply as 'Monument' or 'The Monument'. Such was the scale of the fire that nothing further was needed. Today the street in which it is set also takes the same understated title, as does an Underground station that lies just to its north.

The Doric column of Portland stone, crowned with a gilt bronze sculpture, was created by Sir Christopher Wren and Dr Robert Hooke, and was opened to public visitors in 1677. Designed to combine a scientific role and a public attraction and memorial, the structure rises to some 61 meters (202 feet) and contains 311 steps. This set of measurements was chosen to remind visitors that the monument's location was precisely this distance from the source of the outbreak of the Great Fire. Wren's original intention was for it to also be a place of experiments of the Royal Society, but that proved impossible. In its time it was the highest structure in the capital and it began the modern metropolis's addiction to high-rise structures. Largely grey, a visitor would be forgiven for walking past the narrow and now relatively low-rise structure. However, its most impressive external design feature, a gilt-bronze urn that sits on its top evoking the flames of the fire, can be seen very quickly from a distance.

After restoration projects in the early 2000s, today its viewing platform is caged in for safety purposes. This is not a new health-and-safety feature but an improvement to an essential amendment of the nineteenth century that was first established in 1842 to prevent both accidental falls and suicides. To that date the monument had witnessed seven such deaths, the last of which being that of a servant girl in her early twenties, Jane Cooper. That incident was reported sensationally at the time with the words 'Dreadful Suicide of a Young Woman by Jumping off the Monument'. It seems the need to protect the public from the monument stretched from the sinister to the bizarre. After all it is reported too that in 1732 a sailor turned acrobat had used it to conduct an experiment in flying (using ropes he was no doubt familiar with from his nautical background).

For the visitor with less grave intentions, panoramic views spread out across the east and south of the city, including City Hall, HMS *Belfast* and Tower Bridge. To east and north, Monument provides a bird's-nest view of The Gherkin (30 St Mary Axe, designed by Sir Norman Foster) and to Docklands and the upper Thames beyond. Inside the structure, its stairwell remains a mesmeric corkscrew that would not be out of place in a picture by Escher, Magritte or Dalí. It was a stairwell climb that the Scottish writer James Boswell found all too much when attempting to reach the summit in 1762. Famously he paused in his journey not knowing whether to continue or return down the steps to earth. Bravery saw out and he reached the viewing platform. This was an experience he most memorably recorded with the words: 'Horrid to be so monstrous a way up in the air, so far above London and its spires', and adding his concern that the structure would itself topple because of the force of the wagons

Monument's flaming urn is in gilt bronze. The viewing platform is now caged in for safety.

ABOVE *This modern memorial to the outbreak of the Great Fire of London stands in Pudding Lane, at a distance equal to the height of Monument.*

OPPOSITE *Northwards from the top of Monument there are fine views of some of the City's iconic skyscrapers: Tower 42, The Cheesegrater, The Gherkin and The Walkie-Talkie.*

driving on nearby Gracechurch Street. Perhaps this then is the first recorded modern expression of a need to improve traffic congestion in the capital, as well as an early record of a panic attack caused by a sense of vertigo.

Amendments to Monument mark the political and religious mood of the capital. For instance, in 1681 new text attacking 'Popish frenzy' was added to the work and, while criticised by the poet Alexander Pope in the eighteenth century, it remained until removal of the offending passage in 1830. Remarkably, the Monument survived the Second World War and was only marked by shrapnel damage during the Blitz. Monument has drawn the attention of a number of writers, including in children's literature (Charlie Fletcher's *Stoneheart*) and fantasy fiction (see the work of Neal Stephenson). Charles Dickens had seen the building's metaphorical significance long before them, when he included it as a symbol of the city in *Martin Chuzzlewit* (1844). There are taller buildings right across the city, memorials to tragedies within living memory, as well as of course other architectural gems by important men of the past. Nonetheless, Monument has a beauty precisely because of its originality and indeed bold simplicity, a dignified, immutable, reminder to the perils of urban life. It is an essential part of London that will always be part of its citizens' story.

VISITING INFORMATION

The Monument, Fish Street Hill, EC3R 8AH

http://www.themonument.info

Open daily 9.30am–5.30pm October–March, 9.30am–6.00pm April–September

Musical Museum

Today it is hard to imagine that self-playing instruments were responsible for bringing music to hundreds of thousands of people, but that is because the age of operation for those instruments did not last for long. The golden age of automatic instruments spanned no more than fifty years, from about 1880 to 1930, after which they quickly melted away. A lively collection of survivors can be heard and seen in The Musical Museum at Brentford. While such a specialised museum might seem esoteric, those encountering these strange instruments for the first time find them unexpectedly fascinating. The guiding principle of the place is that the instruments played should be heard and not just seen.

Frank Holland, a British electrical engineer, started the museum. He had developed an enthusiasm for the player piano and built up a collection while working in North America. In 1963 he was able to house his collection in the disused St George's Church at Brentford and open it to the public; from 2007 the Musical Museum moved to its own three-storey building by the Thames near Kew Bridge. It includes a concert hall that seats up to 230 people, a shop and café. The guided tour is recommended for the visitor, the collection being hard to appreciate otherwise. Headset guides are also available. The mechanical, electrical, pneumatic and acoustic instruments on display are sometimes extremely intricate and range far beyond the player piano.

Automatic instruments were even developed which played music using real violins, and two examples are shown at Brentford. One is the Violana Virtuoso, incorporating two violins together with a forty-four-note piano, all electrically powered through motors and electromagnets. The strings are 'bowed' by rotating celluloid wheels and vibrato applied by

The colour-changing Wurlitzer organ.

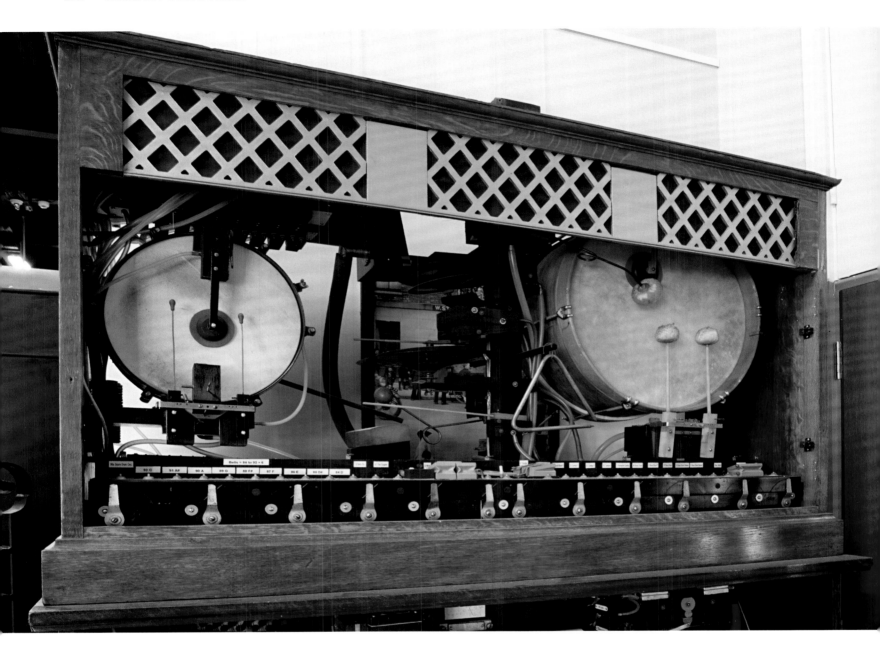

ABOVE *The percussion section of a Hupfeld Café Orchestrion.*

OPPOSITE *This Regina musical box (USA, 1899) plays 40cm metal discs; behind is a Hupfeld Phonolist Violina, comprising three single-string violins with a rotating bow hidden in the frame of the cabinet.*

a pressure plate. Five popular tunes of the day could be played according to the paper music roll loaded in the machine. The Mills Novelty Company of Chicago designed the Violana Virtuoso strictly for commercial applications. It is activated by a coin in a slot.

More complicated still is the German-made Hupfeld Phonoliszt-Violina, which incorporates three violins, bought to life by a horsehair bow ingeniously hidden in a rotating circular frame. The violins each have only a single functioning string, but the piano part of the instrument is full range.

Unlike most automatic instruments, which were intended for public places, the biggest examples were built for private residences. Known as orchestrions, these monumental organ pipe instruments used electrical power and sometimes incorporated drums and cymbals. It was said to be possible to produce the sound of a small dance orchestra, and in their time the complex orchestrions were extremely expensive.

A church choir, village band or possibly the music hall was the sole contact with music for most people towards the end of the nineteenth century, but that started to

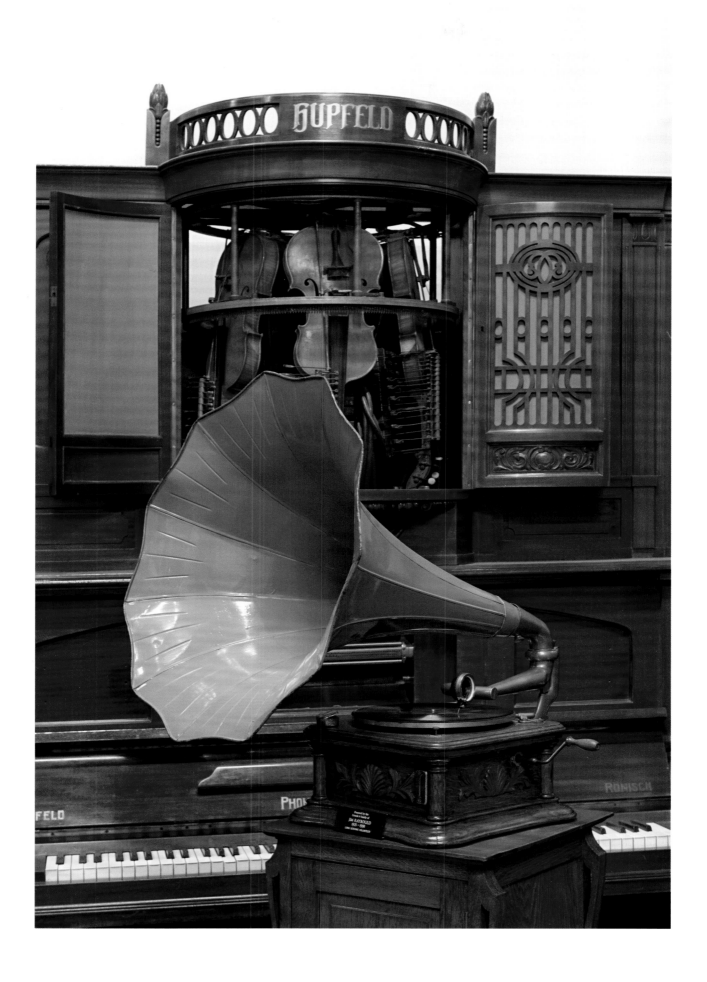

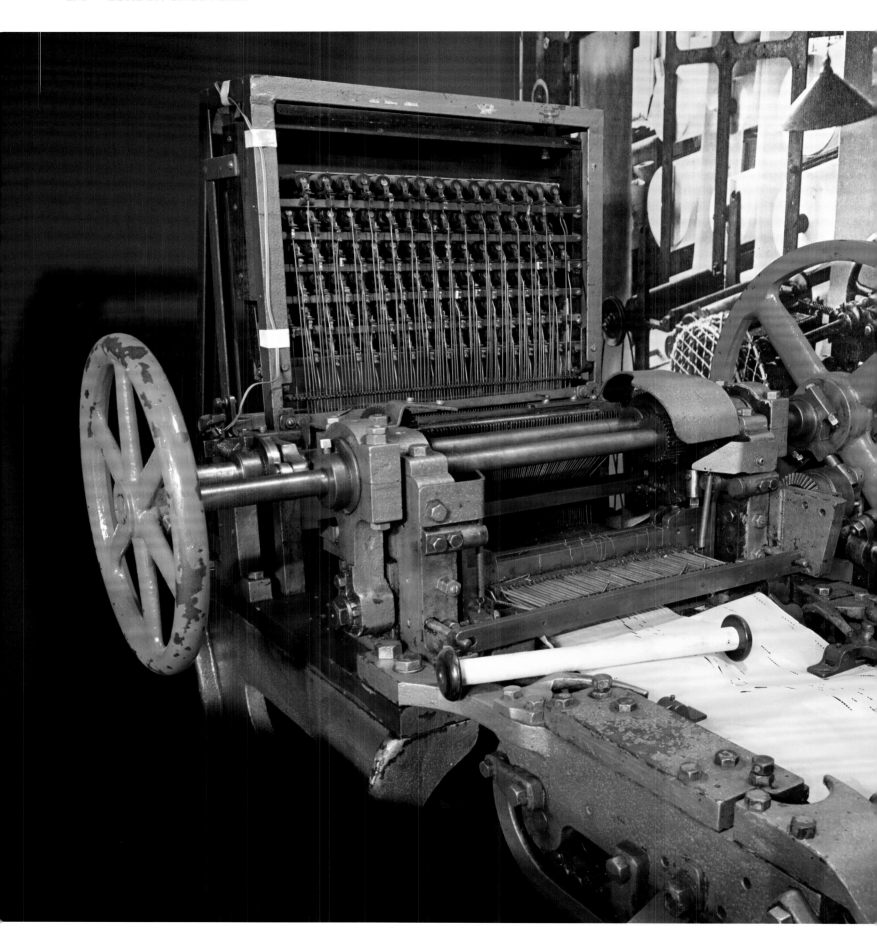

A machine for cutting paper piano rolls, dating from 1910.

change with the coming of the phonograph or gramophone. The music box had emerged at the end of the 1700s, with crank handle or clockwork-driven cylinders carrying pins plucking steel combs. Changing from handmade metal cylinders to flat metal discs in the 1890s enabled mass production, and the transition to modern gramophone records was not far away.

Manufacture of the last of the self-playing instruments lingered into the 1930s, bought down by the coming of radio into the home and the talking picture in the cinema.

Cinema was the home of Brentford Museum's own Wurlitzer organ which was installed in the Regal Theatre, Kingston-upon-Thames, having been commissioned for a Chicago millionaire's house in 1928. It is now found in the theatre at Brentford, its hundreds of pipes, and wiring and relays concealed behind panels and its transparent jelly mould casing colourfully illuminated. As well as resembling an orchestra in its range of capabilities, there are also various cinematic and theatrical effects, including steamboat whistle, horses' hooves, surf, siren, bird whistle, and fire gong. The instrument is regularly played by experts on the console, but is also attached to a playing mechanism for automatic operation from a music roll.

It is possible to buy as a souvenir a genuine old paper music roll at the museum shop, or sometimes see a silent film such as *A Trip to the Moon* by Georges Méliès or F.W. Murnau's *Nosferatu* with Wurlitzer accompaniment.

VISITING INFORMATION

The Musical Museum, 399 High Street, TW8 0DU

http://www.musicalmuseum.co.uk

11am–5pm, Friday–Sunday and Bank Holiday Mondays,

Tours with live demonstrations of self-playing instruments

and the Wurlitzer.

Wimbledon Windmill

One of the first industrial buildings in Britain to undergo preservation, conversion and restoration was the windmill on Wimbledon Common, and that happened as long ago as 1893. Wimbledon windmill had a short working life spanning 1817 to 1864 and was quickly converted into housing. Today it is a museum and an enduring curiosity, preserving its functional and residential elements.

While windmills were built from commonplace materials, they were never entirely primitive machines. Like the steam engines that superceded them, windmills appear to work on the simplest of principles, but some features of their operation, such as the aerodynamic interaction of the subtly twisted sails with the wind, are more complex than is first apparent. The mysteries of the shutters, fantail, striking gear and the cap at the top of the windmill are explained by displays in the Wimbledon museum, together with the technology of the milling machinery below.

Today there are so many trees around Wimbledon Common that the mill is blanketed from the wind on most days. Although the fantail continues to turn the cap into the wind, there is seldom an effective wind available strong enough to turn the sails. It was originally built as a hollow post mill, a type common in Holland but rare in Britain, and Wimbledon is the only remaining example in this country. It is driven by William Cubitt patent sails, where the shutters are centrally controlled by pushrods and levers. The mechanism is self-adjusting, able to handle sudden gusts, and the shutters can be opened or closed by chain and gears while the sails were turning.

The land on Wimbledon Common for the siting of the windmill was granted on a 99-year lease from the Spencer family, the lords of the manor of Wimbledon. The 5th Earl Spencer repurchased the lease when milling ceased, and announced plans to enclose the Common for a new manor house, garden and park which

The sails have a subtle twist to them; the fantail turns the cap and the sails into the wind.

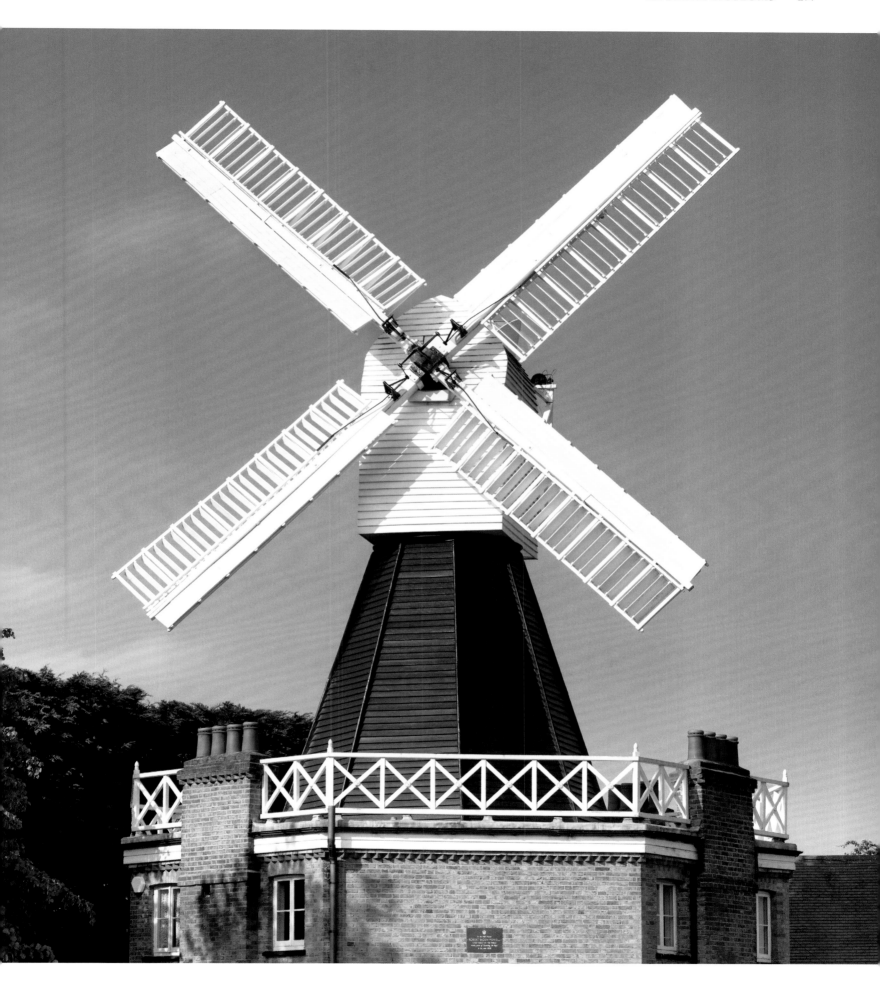

he intended to develop and to sell off the remaining acreage as building land. This move was blocked by Parliament and after litigation the Wimbledon and Putney Commons Act in 1871 assigned care of the Commons and the windmill to a Board of Commons Conservators.

The last millers to work the mill had removed the grinding stones and some of the machinery. Earl Spencer had converted the mill into housing for six families, extending the brickwork to enclose the timber of the first floor. The roundhouse – which is octagonal – acquired doors and windows and four chimney stacks. By 1890, when the windmill was under the care of the conservators, the timberwork was found to be consumed by dry rot; much of this had been caused by enclosure of the old timber by bricks. When demolition was threatened, a public appeal raised £400. A restoration in 1893 restored the roof of the roundhouse, replaced timberwork, and rebuilt some of the gearing. This first restoration is claimed as a pioneering preservation action of industrial archaeology. The mill continued to be used as accommodation, in later days for the Commons Ranger. In 1949 the building gained Grade II* listing and was restored again in the 1960s and 1970s. A new set of sails was fitted in 1967. Over time the windmill has required a great deal of maintenance, alteration and restoration work. It opened as a museum of windmills in 1976, eventually occupying the two floors of the roundhouse. Before the windmill reached its bicentenary year of 2017, more work was required after one of the sails broke away.

From the 1818 a miller's cottage stood behind the windmill and it remains today, greatly enlarged. In 1905, the Honourable Mrs Maria Fetherstonhaugh acquired the house to use as a retreat. She was an admirer of Robert Baden-Powell and offered it to him as a quiet place where he could write his new book, *Scouting for Boys*, which he completed at Mill House in the winter of 1908.

VISITING INFORMATION

Wimbledon Windmill Museum, Windmill Road, SW19 5NR

http://wimbledonwindmill.org.uk

Open normally at weekends only from April to October and at other times by arrangement. Check in advance.

Photographer's Note

As a born-and-bred Londoner I had tremendous fun recording my hidden London as it stands in the twenty-first century for my hugely successful first book *Unseen London*.

Many readers of that book told me of their frustration and disappointment in being unable to visit some of the locations, especially those which had absolutely no public access; this gave me the idea to produce a sequel, *London Uncovered*, featuring London's lesser-known institutions, buildings, homes, shops, museums and attractions that are easily accessible.

I am seen here photographing the stunning Grand Staircase in the St Pancras Renaissance Hotel, one of the amazing locations in the book. Sir John Betjeman called this Gothic treasure 'too beautiful and too romantic to survive' in a world of tower blocks and concrete. Its preservation against the odds will cause wonder; the building itself will take your breath away. After years of devoted restoration, the St Pancras Renaissance Hotel is being hailed as London's most romantic building. Its glorious Gothic Revival metalwork, gold-leaf ceilings, hand-stencilled wall designs and a jaw-dropping grand staircase are as dazzling as the day the hotel, formerly known as the Midland Grand Hotel, was built in 1873.

The locations for *London Uncovered* were photographed mostly on my trusty Nikon, over a period of a year, with access made possible through the generosity and help of friends and clients made throughout my career. As a photographer it is an absolute joy for me to share photographs of London, my wonderful city.

Dazeley photographing the St Pancras Renaissance Hotel.

Index

1 London, *see* Apsley House
2 Temple Place, *see* Two Temple Place
3 St James's Street, *see* Berry Bros & Rudd
12 Holland Road, *see* Leighton House Museum
21 Albemarle Street, *see* Royal Institution of Great Britain
48–49 Doughty Street, *see* Charles Dickens Museum

A Tale of Two Cities (Dickens) 23, 60
A Trip to the Moon (1902 film) 295
Adam, Robert 15, 16, 27, 28, 90
Agassi, Andre 99
Airco, aircraft manufacturer 259
Aitchison, George 39
Albert Bridge 137
Alexander Fleming Laboratory Museum 202–3
All England Lawn Tennis and Croquet Club 96–99
American Revolution 143, 244
Amos, Adrian 165
Andaz Liverpool Street Hotel 138–41
Anne, Queen 146
Apsley House 26–31
Apsley, Lord 27
Arbuthnot, Harriet 28
Arts Council 116, 262
Astaire, Fred 174, 184
Astor, William Waldorf 49–51
Attlee, Clement 248
Atwell, David 120
Augusta, Princess of Saxe-Gotha 52
Avengers: Age of Ultron (2015 film) 91
Avis, Joseph 146

Bacon, Nicholas 239, 240
Baden-Powell, Robert 299
Barenboim, Daniel 178
Barnardo, Dr Thomas John 217
Barry, Charles and Charles Edward 139
Bartoli, Marion 99
Battersea Park 136–7
Battle of Britain 260, 261
Battle of Britain (1969 film) 285
The Beatles 121
Bechstein, piano manufacturer 115
Becker, Boris 99
The Bee Gees, 121
HMS *Belfast* 278–81, 287
Bentley, John Francis 126, 130
Berlin, Irving 178
Bernstein, Sidney 119
Berry Bros & Rudd 80–5
Berry, George 80
Betjeman, Sir John 78, 94, 301
Bevis Marks Synagogue 146–9
Bibendum, restaurant 62–5
Birkett, Norman 248
Bismark, Otto von 50
The Blackfriar, pub 76–9
Blake, Peter 72

Blitz 51, 92, 143, 149, 152, 182, 218, 240, 246, 288
Boleyn, Anne 50
Bolton, Prior 143
Bonaparte, Joseph 28
Bonaparte, Louis-Napoléon 82
Bonaparte, Napoléon 82
Bonar Law, Andrew 182
Borg, Björn 99
Boswell, James 287
Boulton & Watt, engineers 222
Bourne, Katherine 80
Bow Bells 150–1, 153
British National Association of Spiritualists 132
Britten, Benjamin 116, 178
Brown & Barrow, architects 139
Brown, Alexander 139
Brown, Ford Madox 170
Brown, Lancelot 'Capability' 16
Brudnizki Design Studio 72
Brummel, Beau 80, 85, 173
Brunswick House, *see* LASSCO
Buckingham Palace 143
Burton, Decimus 52, 254
Byron, Lord 80, 173, 187

Callcott, Frederick 77
Calvert, Barbara 244
Caruso, Enrico 116
Casals, Pablo 116
Cash, Pat 99
Catherine of Aragon 78
Caulfield, Patrick 72
Cavendish, Henry 227
Cecil, William, Baron Burghley 239, 240
Charles Dickens Museum 20–5
Charles II 58
Charles V, Holy Roman Emperor 78
Charles XIV, of Sweden 28
Charles, Prince of Wales 107, 148
Charlotte Percy, Duchess of Northumberland 17
Charlotte, Queen 54–5
Charterhouse 204–11
Chartist riots 82
The Cheesegrater (122 Leadenhall Street) 288
Chelsea Bridge 137
Chelsea Hospital 248
Chukoshi-Mon Japanese Gateway, Kew 54
Churchill War Rooms 266–71
Churchill, Winston 267–71
cinemas
 Crofton Park Picture Palace 89
 Gate Cinema 102–3
 Regent Street 100–1
City Hall 287
City of London 71, 144, 146, 153, 243
Claudius, Roman Emperor 15
Clement V, Pope 250
Cleopatra's Needle 8, 10
Cliveden 49
Coke, Edward 248
Collcutt, Thomas Edward 115

Collins, Wilkie 60
Columbus, Christopher 50, 245
Conan Doyle, Arthur 60
Connick Jnr, Harry 178
Connors, Jimmy 99
Conran, Sir Terence 65
Cooke, Robert 68
Cooper, Anthony Ashley, Lord Shaftesbury 217
Cooper, Jacqueline 68
Cooper, Jane 287
Corbin, Chris 75
Cornelissen, Louis 169
Corot, Jean-Baptiste-Camille 39
Courtauld, Stephen and Virginia 32–7
Cranfield, Thomas 217
Crofton Park Picture Palace 89
Cromwell, Oliver 146
Cubitt, William 296

D.H. Evans 132
da Costa, Benjamin Mendes 149
Dartmouth, Lady 78
Davy, Humphry, 227, 228
de Grey, Reginald 239
De Havilland, aircraft manufacturer 259
De Lacy, Henry 232
de Silva, Diego Guzmán 239
Debenhams 116
Deleysia, Alice 72
Derry & Toms (shop) 190
Diana, Princess of Wales 184
Dickens, Charles 20–5, 60, 100, 222, 288
Dictionary (Johnson) 58
Dissolution of the Monasteries 16, 143, 205
Donne, John 235
Downing Street 267–8
Drake, Francis 244
Dudley, John, Duke of Northumberland 17
Dumas, Alexandre 49
Dunkirk (1958 film) 285

Ealing Studios 34
Earle, John 94
Edward I 239
Edward II 241, 252
Edward IV 32
Edward VI 17
Edward VII 245
Eisenhower, Dwight D. 174
Eliot, T.S. 94
Elizabeth I 206, 239, 240, 244
Elizabeth II 248
Ellington, Duke 184
Eltham Palace 32–7
Emin, Tracey 72
English Civil War 244
English Heritage 37, 66, 91, 103, 113
Espinasse, François 62
Evans, Captain Thomas Carey 134
Evans, Dan Harries 132

Faraday, Michael 227, 228, 229

Farrell, Terry 72, 228
Fassbinder, Rainer Werner 103
Federer, Roger 99
Ferdinand VII of Spain 28
Fetherstonhaugh, Maria 299
First World War 116, 143, 182, 260, 261
Fisher, St John 130
Fleet Street 58, 60, 61, 243, 246
Fleet, River 61, 78
Fleming, Alexander 203
Fletcher, Charlie 288
Food Reform Society 132
Foster, Sir Norman 287
Fox, Samuel 182
Franklin, Benjamin 143
Fraser and Chalmers, engineers 195, 196
Freidrich Wilhelm, Duke of Braunschweig-Wolfenbüttel 164
Fuller-Clark, Herbert 77

Gad's Hill Place 21, 23, 24
Gala Bingo Club 118–23
Gallati, Mario 75
Gandhi, Mahatma 248
Gate Cinema 102–3
Geffery, Sir Robert 273
Geffrye Museum 272–7
Geoffrey de Mandeville 254
George II 54
George III 52, 54, 173
George IV 27
Gershwin, George 178
The Gherkin (30 St Mary Axe) 287, 288
Giandellini, Abel 72, 75
Gilardoni Fils et Cie 62
Gill, A.A. 75
Gill, Eric 130
Gladstone, William 173, 182, 236
Glaziers' Company 255
Globe Theatre 107
Goddard, Lord Rayner 248
Godfrey, Walter and Emil 254
Goldsmith, Oliver 60
Gore, Spencer 99
Grahame-White, Claude 259
Grainger, Percy 116
Grand Junction Water Works Company 220
Grant, Cary 174
Great Expectations (Dickens) 23
Great Fire of London 58, 143, 150, 151, 244, 248, 252, 287
Greater London Council (GLC) 113, 137
Greene, Graham 85
Grenville, George 248
Guildford Cathedral 241, 245
Gwynne & Co., pump-makers 50

Hall, Peter 106
Hamilton, Lord Claud 139
Hamlyn, Paul 65
Hancock, Ralph 190
Hancock, William 103
Handel, Georg Frederic 252

Handley Page, aircraft manufacturer 259
Hardwick, Philip 235, 236
Hendrix, Jimi 121
Henry II 250, 255
Henry III 255
Henry VI 235
Henry VIII 16, 78, 85, 130, 205, 235, 241, 243
Hepple, Norman 235
Hever Castle 49
Hindu temple, *see* Shri Sanatan Hindu Mandir
Hirst, Damien 72, 170
Hitch, Nathaniel 77
Hogarth, Catherine 23
Holland, Frank 291
Honourable Society of Gray's Inn 238–41
Honourable Society of Lincoln's Inn 232–7
Honourable Society of the Inner Temple 244, 246–9
Honourable Society of the Middle Temple 50, 242–5
Hooke, Dr Robert 287
Hooker, Richard 252
Hopkinson, Simon 65
Horniman Museum 262–5
Horniman, Frederick John 262
Horowitz, Vladimir 178
hospitals
 Chelsea 248
 Normansfield 110–13
 St Bartholomew's 207
 St Mary's 203
 St Thomas' 212
 University College Hospital 214
Houghton, Prior John 205
Houston, General Sam 85
Howard, 4th Duke of Norfolk 206
Howard, Catherine 16
Howard, Charles, Earl of Nottingham 239

Imperial War Museum 281
Inns of Court 230–55
 Honourable Society of Gray's Inn 238–41
 Honourable Society of Lincoln's Inn 232–7
 Honourable Society of the Inner Temple 246–9
 Honourable Society of the Middle Temple 50, 242–5
Ironmongers' Company 273, 274
Isabella Plantation 11
The Ivy, restaurant 72–5

Jagger, Mick 184
James I 243
James II 58
James Smith & Sons 180–3
Jarman, Derek 103
Jeffreys, George 252
Joel, Billy 178
John Lobb Ltd 184–9
John, King 250

John, Elton 90
Johnson, Samuel 58–60
Jones, Horace 71

Kempton Steam Museum 194–7
Kew Bridge 291
Kew Bridge Steam Museum, see
 London Museum of Water and
 Steam
Kew Palace and The Royal
 Botanical Gardens 52–5
King, Jeremy 75
Kingston-upon-Thames 295
Kissin, Evgeny 178
Knights Hospitaller 243, 248
Knights Templar 243, 248
Komisarjevsky, Theodore 119
Krall, Diana 178
Kvitová, Petra 99

L. Cornelissen & Son 168–71
L. Manze 66–9
La Cage aux Folles (1978 film) 103
Lady Jane Grey 17
Lang, Lang 178
Langdon Down, John Haydon
 111, 113
Lasdun, Denys 105
LASSCO Brunswick House 162–7
Lee, River 198
Legend (2015 film) 90
Leighton House Museum 38–41
Leighton, Lord Frederic 39–41
Lely, Sir Peter
Lewis Leathers, motorcycle
 clothing 218
Lewis, Jerry Lee 121
Lewis, Owen 132
Leybourne, George (Champagne
 Charlie) 92
Lister, Joseph 214
Liverpool Street station 139
Lloyd George, David 134
Lloyd's Register Building 115
Lobb, John 184, 187
London Central Markets, see
 Smithfield Meat Market
London City Mission 217
London County Council 92, 218,
 246, 274
London Eye 107
London Fire Brigade 282
London Museum of Water &
 Steam 220–5
London South Western Railway
 164
London Tornado (1091) 150
London, Chatham and Dover
 Railway 77
Long, M.J. 72
Louis XVIII of France 28
Lovell, Sir Thomas 232

Machiavelli, Niccolò 50
Magna Carta 250
Mahabharata 155
Manze, Michele 68
Markfield Beam Engine Museum
 198–201
Marshal, William 250, 254
Marshall Hall, Edward 248
Marshalsea Debtors Prison 23
Martin Chuzzlewit (Dickens) 288
Masonic Temple at Andaz
 Liverpool Street Hotel 138–41
Massey Shaw 282–5
Massey, Cecil 119
Maufe, Edward 241, 245
Mayhew, Henry 66

McCulloch, Joseph 153
McEnroe, John 99
McKintosh, Peter 107
Melba, Nellie 116
Melbourne, Lord 80
Méliès, Georges 295
Metchnikoff, Élie 203
Metropolis Water Act (1852), 195,
 220
Metropolitan Water Board 195, 220
Michelin 62–5
Mill House 299
Millais, John Everett 39
Mills Novelty Company of
 Chicago 292
Molyneux, Emery 245
Montefiore, Sir Moses 148
Montgomery, Field Marshal
 Bernard 174
Monument 286–9
More, Thomas 130, 232
Muppets Most Wanted (2014 film)
 90
Murnau, F.W. 295
Museum of Learning Disability
 113
Musical Museum 290–5

Nairn, Ian 132
Nanak, Guru 155
National Health Service 112
National Theatre 104–9
Navratilova, Martina 99
Nehru, Jawaharlal 248
Nicholas I, of Russia 28
Nicholas Nickleby (Dickens) 23
Nipponzan Myohoji Buddhist
 Order 137
Normansfield Theatre 110–13
North, Edward 206, 210
North, Marianne 111
Nosferatu (1922 film) 295
Novotná, Jana 99

Olav V, of Norway 153
Old Operating Theatre and Herb
 Garret 212–15
Oliver Twist (Dickens) 23
Olivier, Laurence 106, 174
Onassis, Aristotle and Jacqueline
 184
Orbison, Roy 121
Our Country's Good (play) 107
Oxford University 203

Paget, Paul 32
pagoda
 Battersea Park 136–7
 Kew 54
Palace Theatre 115
Palm House, Kew 52–4
Palmerston, Lord 85
Paolozzi, Eduardo 72
Peace Pagoda, Battersea Park
 136–7
Pears, Peter 116
Pearson, John Loughborough 50
Peel, Sir Robert 80
Peers, Sir Charles 37
Percy, Hnery, 9th Duke of
 Northumberland
Philip, Duke of Edinburgh 148,
 152
Phoenix Theatre 119
Pickering Place 82, 85
Pitt, Brad 90
Pitt the Younger, William 236
Polly (parrot) 61
Poole, Henry 77

Pope, Alexander 288
Porter, Cole 178
Prescott, Sir William 195
Pryce, Merlin 203
pubs
 The Blackfriar 76–9
 Ye Olde Cheshire Cheese
 58–61

Rachmaninoff, Sergei 178
Ragged School Museum 216–19
Rahere, Prior 143
Raleigh, Walter 245
Ramayana 155
Redford, Robert 90
Reformation 143, 243
Regent Street Cinema 100–1
Regent's Canal 217
Renshaw, William 99
restaurants
 Bibendum 62–5
 L. Manze 66–9
 The Ivy 72–5
Rich, Sir Richard 143
Rivoli Ballroom 88–91
Robert de Ros 254
Rolán, Alfredo 144
The Rolling Stones 121
Ronalds, Tim 100
Roof Gardens in Kensington 190–1
Roosevelt, Franklin D. 270
Rossetti, Dante Gabriel 170
Royal Academy 41
Royal Air Force 144, 259–61
Royal Air Force Museum 258–61
Royal Botanical Gardens, Kew,
 52–5
Royal Horticultural Society 248
Royal Institution of Great Britain
 226–9
Royal Navy 146, 278–81
Royal Opera House 34
Royal Society 287
Ruddigore (Gilbert and Sullivan)
 111
Russell, Raymond 212

St Bartholomew's Hospital 207
St Bride's Fleet Street 146
St James's Park 267
St James's, Piccadilly 146
St Mary-le-Bow 150–3
St Mary's Hospital 203
St Pancras Renaissance Hotel 6–9
St Paul's Cathedral 46, 284
St Thomas' Hospital 212
Saint-Saëns, Camille 116
Sam Smith brewery 61
Sampras, Pete 99
Sargent, John Singer 39
Savoy Hotel 115
schools
 Charterhouse 206–7, 210
 Ragged School 216–19
Schwartzkopf, Elizabeth 116
Sebastiane (1976 film) 103
Second World War 178, 182, 246,
 260, 267–71, 278, 282, 288
Seeley, John 32
Segovia, Andrés 116
Seth, Vikram 115
Seymour Jane 16
Seymour, Edward, Duke of
 Somerset 16–17
Shakespeare, William 50, 105,
 239, 244
The Shard 215
shops
 D.H. Evans 132

Debenhams 116
Derry & Toms 190
James Smith & Sons 180–3
John Lobb Ltd 184–9
L. Cornelissen & Son 168–71
LASSCO 162–7
Truefitt & Hill 172–5
Steinway & Sons 176–9
Shri Sanatan Hindu Mandir,
 Wembley 154–9
Shri Vallabh Nidhi UK 156
Shrimad Bhagvatam 155
Sickert, Walter 169
Sinatra, Frank 121, 174, 184
Smirke, Sydney 254
Smith & Nephew, medical
 products 51
Smith, Captain John 153
Smithfield Meat Market 70–1
Socrates 15
South Bank 107
Southwark Cathedral 215
Spanish Armada 239, 240
Spy Game (2001 film) 90
St Bartholomew the Great
 142–5
stations
 Liverpool Street 139
 London Bridge 212
 St Pancras International 8
 Victoria 126
 Wimbledon 96
steam engines
 Kempton Steam Museum
 194–7
 Markfield Beam Engine
 Museum 198–201
 London Museum of Water &
 Steam 220–5
Steinway & Sons 176–9
Stephenson, Neal 288
Stilgoe, Henry 195
Stoneheart (Fletcher) 288
Strand 243
Strawberry Hill House 42–7
Sussex, Duke of 85
Sutherland, Joan 116
Sutton, Thomas 206
Syon Abbey 16
Syon House 14–19

Tate Modern 107
Temperate House, Kew 54
Temple Church 250–5
Teresa, Mother 155
Texan Embassy 85
Thatcher, Margaret 236
The Castle of Otranto (Walpole) 45
The Comedy of Errors (Shakespeare)
 239
The Haunted Man (Dickens) 100
The Pickwick Papers (Dickens) 23
The Three Musketeers (Dumas) 49
The Vicar of Wakefield (Goldsmith)
 60
The Wasteland (Eliot) 94
Thames, River 78, 164, 195, 220,
 244, 248, 282, 284, 285, 287, 291
Thames Water 196
theatres
 Globe Theatre 107
 National Theatre 104–9
 Phoenix 119
 Regal, Kingston-upon-Thames
 295
 Royal Opera House 34
 Wilton's Music Hall 92–5
Thomas à Becket 241
Tintoretto (painter) 39

RMS Titanic 177
Tomlin, Leonard 90
Tooting Granada, see Gala Bingo
 Club
Tower 42 288
Tower Bridge 287
Townsend, Charles Harrison 262
Travers, Walter 252
Truefitt & Hill 172–5
Truefitt, William Francis 172
Truro Cathedral 50
Turner, Richard 52
Turner, Tina 90
Twain, Mark 60
Twelfth Night (Shakespeare) 244
Two Temple Place 48–51

University College Hospital 214
University of Westminster 100

Van Linge, Abraham and Bernard
 236
Vaughan, Cardinal Herbert 126
Victoria Embankment 8, 50, 246,
 248
Victoria, Queen 17, 55, 184, 246
HMS Victory 278
Vincent, Gene 121
Voltaire 50
Vulliamy, Louis 229

Walker, Andrew 217
The Walkie-Talkie (20 Fenchurch
 Street) 288
Wallis, Barnes 260
Walpole Horace 43, 45
Walpole, Robert 45, 236
Walsingham, Francis 239
Walt, Nicholas 170
Walter de Mauny 205, 210
War Horse (play) 105
Watson, Maud 99
Watt, James 200
Watts, George Frederic 39, 235
Webb, Sir Aston 143, 144
Wellington, Duke 27–8, 173
Welsh Church of Central London
 132–5
Wertenbaker, Timberlake 107
Westminster Abbey 126, 206
Westminster Cathedral 126–31
Whistler, Rex 169
Whitechapel Art Gallery 262
Whitechapel Bell Foundry 152
Whittington, Dick 150
Wigmore Hall 114–17
Wilde, Oscar 173
Wilton, John 92
Wilton's Music Hall 92–5
Wimbledon Common 296, 299
Wimbledon Windmill 296–299
Wimbledon, All England Lawn
 Tennis and Croquet Club 96–99
Wodehouse, P.G. 60
Wood Brothers, engineers 198
Worthington, Hubert 248
Wren, Sir Christopher 146, 150,
 152, 210, 252, 287
Wright, Herbert 66
Wriothelsey, Henry, Earl of
 Southampton 239
Wurlitzer 121, 290–1, 295
Wyatt, Benjamin Dean 27

Ye Olde Cheshire Cheese, pub
 58–61
Yeats, W.B. 60

London Uncovered is dedicated to
my parents Bill and Freda and
to my family Jannith, Tiger and Indigo.

Acknowledgements

I would like to thank my family, Jannith, Tiger and Indigo for all their encouragement; Mark Daly for his fantastic contribution and insight; my digital assistants Simon Goodwin and Alyssa Boni for carrying all the equipment and plugging me in; digital manager Esther Salmon; agent and producer Sarah Ryder Richardson and my publisher Andrew Dunn at Frances Lincoln for believing in the project. Thanks as well to Marie Cameron, Hugo Frey, Cassandra Morgan and Brian Stater for their assistance in research. Finally enormous thanks for the kindness and generosity of all the locations that allowed me access and helped make *London Uncovered* happen.

Frances Lincoln Limited
74–77 White Lion Street
London N1 9PF

London Uncovered
Copyright © Frances Lincoln Limited 2016
Text copyright © Mark Daly 2016
Photographs copyright © Peter Dazeley 2016
First Frances Lincoln edition 2016

A catalogue record for this book is available from the British Library.

978-0-7112-3809-1

Printed and bound in China
2 4 6 8 9 7 5 3 1